Networked Music Performance

Networked Music Performance (NMP) is the essential guide to both playing music online and ensemble music through networks. Offering a range of case studies, from highly technical solutions to inclusive community projects, this book provides inspiration to musicians to try NMP whatever their level of technical expertise.

Drawing upon recent research to examine the background and history of the practice as well as specific practical approaches, technical and musical considerations are included for readers, as are ideas around accessibility and creativity. Accessibility is considered in the context of the opportunities that NMP gives to musicians working remotely, as well as some of the barriers to participation in NMP and how these can be overcome. Synchronous and asynchronous approaches to NMP are explored in detail, examining the technical and musical affordances and challenges of working remotely for musicians.

Networked Music Performance will appeal to music and music technology students as well as professional musicians and technicians who have started working online and wish to improve their practice. As NMP in the context of music education and community music are also explored, this book supplies educators and community leaders with knowledge and practical guidance on how to move their practice online.

Miriam Iorwerth is the Digital Development Manager at the Royal Conservatoire of Scotland. Prior to this, she was a Lecturer in Music at the University of the Highlands and Islands, specialising in music technology and online music collaboration. She completed her PhD in 2019 on musicians' experiences of networked music performance and is a graduate of the Tonmeister course at the University of Surrey. Before her career in academia, she worked in electronics, including at Halley Research Station in Antarctica.

"Today's musician works online, yet we haven't even begun to plumb the depths of creative collaboration over the Internet. Iorwerth's book illuminates why Networked Music Performance is an emerging force: culture and technology become more sophisticated when driven by both social necessity and obviously rich rewards of new musical and cultural opportunities."

Rebekah Wilson

"The thorough technical treatment in Miriam Iorwerth's book *Networked Music Performance* lays a groundwork for describing the present moment where it seems that whatever can go online will go online. It is not only about networks of the kind our devices are attached to but also the social aspects of music and music teaching, the human networks that emerged when going online was the only way to go. Accelerated by the COVID-19 pandemic, tools and practices for connected musical collaboration increased dramatically and this book takes stock of the moment, comprehensively."

Chris Chafe, *Director, Center for Computer Research in Music and Acoustics, Stanford University*

Networked Music Performance

Theory and Applications

Miriam Iorwerth

LONDON AND NEW YORK

Designed cover image: © David Russell

First published 2024
by Routledge
4 Park Square, Milton Park, Abingdon, Oxon OX14 4RN

and by Routledge
605 Third Avenue, New York, NY 10158

Routledge is an imprint of the Taylor & Francis Group, an informa business

© 2024 Miriam Iorwerth

The right of Miriam Iorwerth to be identified as author of this work has been asserted in accordance with sections 77 and 78 of the Copyright, Designs and Patents Act 1988.

All rights reserved. No part of this book may be reprinted or reproduced or utilised in any form or by any electronic, mechanical, or other means, now known or hereafter invented, including photocopying and recording, or in any information storage or retrieval system, without permission in writing from the publishers.

Trademark notice: Product or corporate names may be trademarks or registered trademarks, and are used only for identification and explanation without intent to infringe.

British Library Cataloguing-in-Publication Data
A catalogue record for this book is available from the British Library

ISBN: 978-1-032-21537-2 (hbk)
ISBN: 978-1-032-21536-5 (pbk)
ISBN: 978-1-003-26885-7 (ebk)

DOI: 10.4324/9781003268857

Typeset in Optima
by codeMantra

To my students, who are some of the most inspirational and creative people I know.

Contents

List of figures ix
Preface xi
Acknowledgements xiii
List of abbreviations xv

1 Introduction 1

2 Music over the internet 26

3 Synchronous networked music performance 55

4 Asynchronous networked music performance 99

5 Online music teaching and community music 148

6 Accessibility in networked music performance 198

Glossary 229
Index 231

Figures

1.1	Diagram of a League of Automatic Music Composers performance drawn by Rich Gold in 1978	8
2.1	Overview of an NMP system	27
2.2	Common directivity patterns of microphones	30
2.3	Internet Protocol layers	39
2.4	Server configurations	42
2.5	Buffering	46
2.6	Sources of latency in a synchronous NMP system	48
3.1	Diagram of trade-offs between quality, latency, and accessibility	56
3.2	Considerations for scoring in synchronous NMP	82
3.3	Playing together, apart framework (Iorwerth, 2019; Iorwerth & Knox, in press)	85
3.4	Excerpt of *Mosaic* score by Peter Longworth	90
4.1	Virtual ensemble process	101
4.2	Collaborative recording cycle approach	102
4.3	Collaborative recording hub approach	103
4.4	Synchronising tracks with timing errors	113
4.5	Normalisation	116
4.6	Bussed reverb	120
4.7	Virtual ensemble versus collaborative recording	133
4.8	Asynchronous NMP approaches flowchart	137
4.9	Audio set up for Brandywine Baroque recording	144

Preface

My interest in NMP developed out of necessity. In 2012, I was working with colleagues at the University of Highlands and Islands, developing a new blended learning music degree course that had students and staff distributed around Scotland. We had to find a way for our students to work collaboratively across these distances to support their ensemble work. A module named Remote Digital Music Collaboration was born, and I taught the students how to record themselves and work on asynchronous musical collaborations.

I always thought that live collaboration would be a more interesting approach, so in 2013, I started researching how musicians' experiences were affected by working on synchronous networked music performances. I visited conferences on audio education, music psychology, web audio, and musicology, and spoke to many musicians across genres about my work. I encountered two reactions: "why would anyone want to do that?" and "latency makes that impossible", before the person would invariably back away slowly and find someone with a more fashionable subject to talk about.

In March 2020, this all changed with lockdowns as a result of the COVID-19 pandemic. Suddenly, musicians could understand why people might want to play together online, with many ensembles embracing the challenges inherent in this (including the latency). The networked music performance community offered their support to new adopters, with many new collaborations popping up online. I hope this book will be a valuable resource for musicians, audio technicians, educators, and students across music and audio disciplines. This book will also bring together the technical, musical, educational, and accessibility issues that may be encountered in NMP.

My musical education was through a Western classical training as a percussionist and recording engineer, and I recognise that this is only one way to approach music, both in teaching and performance. I have attempted to bring in other musical cultures throughout the book, especially within the case studies, and would welcome readers to get in touch with me with further examples.

Acknowledgements

Thanks to: Hannah Rowe and Emily Tagg at Focal Press; for the case studies: Will Anderson, Ken Blair, Gillian Desmarais, Stephen Fischbacher, Peter Longworth, Iain Macpherson, Ninian Perry, Jilliene Sellner, and Rebekah Wilson; for images: John Bischoff for the diagram of a League performance drawn by Rich Gold in 1978 and David Russell for the front cover; for feedback on drafts: Professor Dave Fisher and Ben Loveridge; and to my valued colleagues and friends: Anna-Wendy Stevenson, Simon Bradley, and Peter Noble.

Abbreviations

ADC	–	analogue to digital converter
ADSL	–	asymmetric digital subscriber line
CPD	–	continuing professional development
CPU	–	central processing unit
DAC	–	digital to analogue converter
DAW	–	digital audio workstation
DHCP	–	dynamic host configuration protocol
EQ	–	equalisation
FTP	–	file transfer protocol
IP	–	internet protocol
ISDN	–	integrated services digital network
ISP	–	internet service provider
LAN	–	local area network
MIDI	–	musical instrument digital interface
MOOC	–	massive open online course
NMP	–	networked music performance
OAIM	–	Online Academy of Irish Music
PCM	–	pulse code modulation
SATB	–	soprano, alto, tenor, bass
USB	–	universal serial bus
VLE	–	virtual learning environment
VR	–	virtual reality

Chapter 1

Introduction

What is NMP?

Networked Music Performance (NMP) is the practice of musical interaction over computer networks (Gabrielli & Squartini, 2016) and is a growing area of musical activity that allows musicians to perform, compose, improvise, teach, and learn music across physical distances. The context for NMP can be wide-ranging, from musicians working in a room together connected via a local area network (LAN) to international collaborations of musicians working via the internet and from real time to asynchronous working. NMP projects vary in their interactivity from full involvement of an audience to a more formal musician/audience divide; the numbers of musicians involved – from two up to thousands; from real-time interaction to sending audio and video files between collaborators; and the experience of the participants, from amateur musicians to professionals.

Weibel (2021) highlights how music is traditionally a dialogue between instruments and people, created through reading notation from a score or through improvisation, where musicians react to one another. There are, of course, other musical traditions that are passed between musicians orally and aurally. In all of these cases, the musicians are connected mentally and acoustically. Weibel goes on to explain the difference between this tradition and networked music:

> A radical change in this line of tradition happened with the advent of the computer, when algorithms and networks became the basis of musical composition. Now the musicians have an additional, physical connection. Creative music becomes networked music.
> (Weibel, 2021, p. 13)

The name NMP suggests a performance element is essential – perhaps with an audience – however, the term has become accepted to mean any type of musical interaction that requires a computer network. This encompasses rehearsal, teaching, collaborative composition, recording, and improvisation as well as formal and informal performances. It includes approaches that use

DOI: 10.4324/9781003268857-1

the network to send and receive control signals as well as audio and video streaming approaches. It includes musicians who are playing live in a room together as well as those separated by distance. Networks may be local or far-reaching.

As we will see when we look at the history of NMP, there are multiple strands and approaches that have developed independently of one another, which are now included under the NMP umbrella. This has led to a sense of hierarchy in approaches to NMP, with perhaps synchronous (or real-time) approaches seen as more important, or creative, than asynchronous approaches. Even within synchronous approaches, some musicians place higher value on NMP within a single physical space than NMP using the internet for transmission of sound across a distance:

> It would be gatekeeping to insist that [musical interaction over the internet] is not network music; clearly it is, in the most literal sense. In terms suggested earlier, however, this is low-entropy network music; it serves a worthy purpose of making musical interaction even possible in a time of isolation, but it is still a poor substitute for actual co-located live music. In the post-pandemic world, 'internet music' will remain useful for rehearsals and collaborations that cannot be accomplished in-person. It is hoped, however, that 'network music' will not come to be synonymous with music that merely happens to travel over the internet.
>
> (Stone, 2021, p. 332)

This hierarchy is not particularly helpful, as all the approaches have their own creative affordances and challenges. Music that happens to travel over the internet rather than local networks is also probably the most accessible approach to NMP that musicians may encounter. Stone does, however, make an important point that NMP is not *only* about music that travels over the internet – there are other approaches that we explore throughout this book.

Another term for synchronous NMP is telematic music. This is a translation of the French word *télématique* – a portmanteau of *télécommunication* and *informatique* – a convergence of telecommunications and computer science. Unlike Stone's definition of network music, this term suggests that distance is an important element, and this illustrates some of the tensions inherent in NMP. Lewis (2021) highlights the tensions of this distance:

> … the interplay between two desires – first, to hide distance, and second to assert it – provides pleasure in telematic encounters, both for direct participants and for audiences. Moreover, the elimination of physical distance as an affective factor in a telematic musical interaction also creates an ironic psychic connection between the immediacy of the experience and the announced fact that the interaction is taking place between entities whose places are ostensibly widely spaced from each other geographically.
>
> (Lewis, 2021, p. 157)

Here, Lewis is describing synchronous methods of NMP. Synchronous methods focus on live events, whether they are rehearsals, collaborative compositional sessions, or performances with an audience. Audio, and sometimes video, is transmitted live via networks between musicians. As a result of using the internet for transmission of the audio (and potentially video), latency is introduced to the signal, which interrupts the usual communication channel between the musicians.

Asynchronous methods include file sharing, where musicians record their own parts and share them with fellow musicians, who also record tracks to build up a multi-tracked recording of a piece of music. This can include elements of collaborative composition and improvisation, as well as the recording of pre-composed pieces. This method has the advantage of the potential to create a high-quality recording of a piece of music while the musicians work at a distance, although it does not allow for the real-time interaction of musicians that synchronous methods do.

When the final output of a session is the most important (i.e. a high-quality recording), usually asynchronous methods are most appropriate. When the real-time interaction between musicians is the focus of a collaboration, synchronous methods may be more suitable, despite the inherent technical difficulties.

There is some overlap between these approaches. Barbosa (2003) categorises collaborative systems based on computer networks into four categories, and the examples outlined here will be explained in greater detail later in this book:

- Local Interconnected Musical Networks: these are co-located and synchronous – groups of performers in one physical space, with interconnected instruments, for example, a laptop orchestra or the approach described by Stone (2021) above;
- Musical Composition Support Systems: these can be co-located and asynchronous, or remote and synchronous or asynchronous, and are used to assist traditional forms of collaborative composition and production, for example, online digital audio workstations (DAWs);
- Remote Music Performance Systems: these are remote and synchronous, with multiple performers in remote locations playing instruments or singing for performance purposes, for example, real-time remote (or telematic music) as described in Chapter 3;
- Shared Sonic Environments: these may be remote or co-located and synchronous, and are participatory networked environments that allow interaction and improvisation, not necessarily using musical instruments.

NMP also has applications in remote music education, and a combination of asynchronous and synchronous methods can be used for successful instrumental tuition at a distance. This can happen with musicians with all levels of experience, from complete beginners to conservatoire masterclasses.

Learning through NMP may also happen in one-to-one and group lessons, in formal and informal learning environments. NMP may also be used within a broader music education to facilitate ensemble performance or collaborative composition projects.

It is likely that NMP has benefits particularly to those musicians who are isolated in some way, either for geographical or social reasons, as it may allow them to overcome some of the barriers to participation in ensemble music-making that they may otherwise face. While many NMP collaborations require a great deal of technical expertise and equipment, it is also possible to participate in NMP with typical equipment that many amateur musicians may have at home, using domestic broadband internet connections and mobile devices.

One common factor in all approaches to NMP is that it is about collaboration between musicians. NMP is a group endeavour, offering opportunities for creativity via networks that are not possible in traditional, acoustic settings.

Overview of NMP approaches

There are two main approaches for NMP: synchronous (i.e., all participants playing at the same time as one another and interacting musically in real time); and asynchronous (i.e., participants recording parts in their own time and building a final recording from these parts). Any particular project may also use a combination of these approaches. Online music teaching also has specific requirements that may use both approaches in many contexts. It is likely that alongside any musical collaboration, many other forms of online communication will take place during a project, including email, text messages, file exchange, and video conferencing, which may be synchronous or asynchronous, regardless of the musical approach taken in the project.

In general, synchronous approaches focus on the communicative and interactive nature of ensemble music. The process is an important part of these projects, and the ability to communicate with other musicians in real time (or very close to real time) is appealing. These projects may or may not result in a finished musical output, such as a public performance, and this may or may not be presented in an NMP environment. They are often most successful with small ensemble sizes, where each participant can have meaningful communication with their fellow musicians.

In contrast, asynchronous NMP approaches are more likely to focus on the creation of a final musical output, whether this is a recording of a pre-composed piece or a collaborative composition, created in the NMP environment. Asynchronous NMP can have varying levels of interaction between participants, from none at all in some virtual ensembles to highly collaborative relationships in remote composition. This approach can be suitable for any size of ensemble, from pairs of musicians up to tens of thousands of participants.

The 'problem' of latency

When discussing NMP, it does not take long before the question of latency (the delay between a musician making a sound and their fellow musician(s) hearing it) arises. There tend to be two reactions to this topic: either declare that NMP is impossible due to latency; or ask when the 'problem' of latency is going to be solved. There are several reasons why these reactions are problematic. First, not all NMP approaches are impacted by latency, and these reactions highlight a lack of awareness around the possibilities of NMP. This is not surprising, given how NMP has until recently been a niche activity. Second, not all music needs strict synchronisation and is impacted by latency. An example of this is Gaelic psalm singing, a musical tradition in the Outer Hebrides of Scotland, which is group singing with highly improvisatory elements. Rebekah Wilson, a composer who regularly works in the networked environment, highlights the example of Monteverdi's *Vespers 1609* as a piece of music that encompasses antiphonal echoes which do not synchronise (Wilson, 2019). This is seen as a key aesthetic feature of the music rather than a technical issue to be solved. Despite these examples, there are, of course, approaches to NMP and types of music where strict synchronisation is important.

The good news is that NMP is possible, even with latency (or this would be a very short book), and there are NMP systems that solve the 'problem' of latency very well. An example is LoLa (LoLa, 2020), a low-latency audiovisual system designed for music performance. The downside is that it requires very high-speed internet connections and specialist hardware, which is beyond the financial reach of most musicians. A case study of the LoLa system is included in Chapter 2.

This book takes a more enquiring approach, accepting that the majority of musicians who want to take part in NMP will not have access to high-quality, low-latency systems such as LoLa. It looks at creative ways that musicians can work with the equipment and technical skills that they have available to them and ways they can embrace some of the challenges that arise in NMP. It does not suggest the 'right' way to take part in NMP, accepting that there are many different approaches that might be suitable for different situations and different musicians. It looks at the music of NMP, including how musicians might need to adapt what they play to fit the idiosyncrasies of NMP, as well as how composers might write music that suits this particular environment and way of working. It also examines the role of NMP in music education, from the perspective of both the learner and the teacher.

Rather than focusing on questions around latency, perhaps more appropriate questions might be:

- How can musicians embrace the technical challenges of NMP?
- What are the creative affordances offered by NMP?
- How can NMP be used as a tool for accessing ensemble music-making and music education?

History of NMP

NMP has an interesting history, having developed in parallel in several different spheres, including from the performance perspective (having close links with sound art and experimental music), from the academic perspective (with many studies focusing on the impacts of latency and the development of specific software for NMP as well as some of the aesthetic considerations), and in the educational world (with the focus on the pragmatic aspects of NMP and access to music education). Up until the COVID-19 pandemic, it was seen by many musicians as a rather niche activity, which might only suit musicians who could not work together in any other way. As many more musicians have now had practical experience in NMP, attitudes may be changing, although it is likely that if musicians were forced into NMP (e.g., for teaching) with little preparation, the challenges may have outweighed the perceived benefits.

Within the academic sphere, most research has been on the synchronous approach to NMP, probably as this has been perceived by researchers to be the most interesting approach that musicians may want to engage in and the one with the most technical challenges that may be tackled with research. Since the COVID-19 pandemic, however, there has been some research into the uptake of NMP in education and community groups (see, e.g., Biasutti et al., 2021; Crisp, 2021), particularly around the community benefits of working this way. Much of this research highlights the differences (and challenges) between working in-person and working in NMP rather than examining the creative affordances offered by NMP or even acknowledging that NMP has been a part of musicians' creative practice for decades. These studies also focus on musicians and educators who have moved to NMP as an emergency measure rather than with appropriate consideration of the methods used and suitable planning and preparation.

The research on asynchronous NMP is much more limited, however, this has been developing as a practice for remote musicians for decades and has applications in music education (see, e.g., Martin & Büchert, 2021). There are also some parallels with multitrack studio recording and the use of overdubs, which is effectively what asynchronous NMP is in some settings, albeit with the musicians at a distance from one another.

John Cage's *Imaginary Landscape No. 4 (March No. 2)*, which is scored for 12 radios, is regarded as one of the first pieces of music composed for an interdependent network and could be considered to be an example of NMP (Weinberg, 2005; Rebelo & Renaud, 2006; Renaud et al., 2007). In this piece, what is being received on the radios is down to chance rather than musicians using the network to share sounds, so it may be stretching the definition of NMP somewhat to include this as an example. What it does highlight, however, is how musicians have always taken creative approaches to the technology available to them and used equipment in ways that were never intended (see, e.g., *Pendulum Music* by Steve Reich). It also highlights some of the musical methods that can be used in NMP as a result of some of the technical challenges of working musically on networks. In the case of

Imaginary Landscape No. 4 (March No. 2), this includes the use of chance elements, for example, "…in the radio piece, numbers on a tuning dial are written instead of sounds, whatever happens being acceptable (station, static, silence)" (Cage, 1952, 1968, p. 58).

The first musicians to connect computers together through networks and use them in performance were the League of Automatic Music Composers, who were based in the San Francisco Bay Area (now also known as Silicon Valley), and were active between 1977 and 1983. The group was influenced by two major factors centred on the geographical region where they were based: the development of domestic computers (known as microcomputers as opposed to mainframe computers common in academia and industry) which became available at an affordable price; and the musical influences of the West Coast of the US.

The group used microcomputers, analogue electronics, and electronic instruments, networked together, to create new forms of music, influenced by this huge technological development, but also by the aesthetics of the experimental acoustic music of the time. This included the chance music of John Cage and minimal process music of Steve Reich, the methods of which could be easily transferred to computers in live electronic music. The West Coast of the US at the time also included a melting pot of musicians coming from various non-commercial musical backgrounds, including classical, free jazz, and experimental rock (Brown & Bischoff, 2005).

The League of Automatic Music Composers built circuits for use in live performance that determined the character of the music and saw the electronic system as having a part in the music itself rather than just being a tool for its creation (see Figure 1.1). Initial connections between the computers were made using eight-bit parallel ports and various methods of communication between the machines were used. These included looking for new data arriving at the ports or using interrupt lines, to send a burst of data to another player to be used by the receiving programme immediately. Initially, the group would let their networked workstations run on their own during a performance, but later the musicians began to interact with the computers during a performance to adjust parameters and influence the music as it happened.

In the mid-1980s, former members of the League of Automatic Music Composers joined with others to form The Hub, who expanded on the previous work using networked microcomputers. In 1987, The Hub was commissioned to create a performance that linked two locations in New York City to demonstrate the potential of NMP to link musicians at a distance:

> Two trios performed together in each space, each networked locally with one of two new, more robustly built, identical hubs, and the hubs communicated with each other automatically via a modem over a phone line. Each trio performed music that sounded different from that performed in the other space, but data generated from each ensemble were shared within The Hub, so the trios were informationally linked.
>
> (Brown & Bischoff, 2005, p. 383)

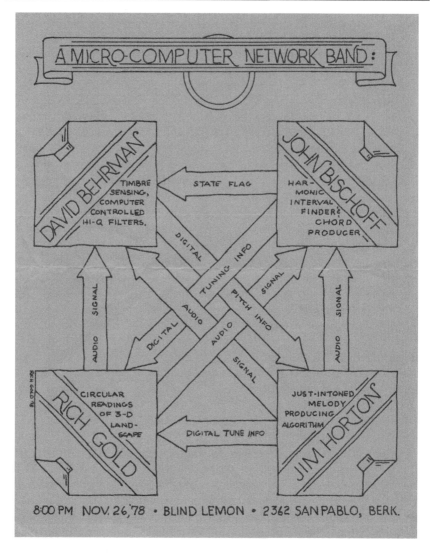

Figure 1.1 Diagram of a League of Automatic Music Composers performance drawn by Rich Gold in 1978.

While this performance proved that it was possible for musicians to work at a physical distance from one another, this particular application of NMP was not a major aim of The Hub. The musicians were more interested in the interactivity and complexity that the network provided and creating a new form of music ensemble with interaction that was unique to the networked environment. Over time, The Hub's technical approaches evolved, using

RS-232 serial communications, later using MIDI (musical instrument digital interface) for communication, and more recently an Ethernet router.

Brown and Bischoff (2005) suggest that the technical implementation of The Hub's work sometimes overshadowed the aesthetics or the musical issues, from both an audience and a musician's perspective. These are certainly issues that continue within NMP today, with sometimes more concern about the technical issues, such as latency, than the musical possibilities of the network.

A development from The Hub's approach to networked music is the idea of a laptop orchestra, where laptops are used as instruments in chamber ensembles, which may or may not be connected through networks. These are often used alongside other musical devices, such as loudspeakers and homemade instruments (Wang, 2018). Examples of these ensembles include The Princeton Laptop Orchestra (PLOrk), who first performed in 2006, and the Stanford Laptop Orchestra (SLOrk), who formed two years later.

Heidi Grundmann (2005) describes an early example of synchronous NMP in 1992 called *CHIP-RADIO*. This was a performance for radio that used acoustic instruments as well as electronics with the musicians based at three different locations. The musicians were located at radio and TV studios in Innsbruck, Salzburg, and Dornbirn. The artists used data gloves, arm interfaces, a MIDI saxophone, and graphical interfaces to play instruments and robotic devices at other locations. Instruments included violins, samplers, marimba, percussion, synthesiser, and guitars, some of which were played remotely via robotic devices. Both musicians and audiences could see the musicians on video monitors.

A project of this type and scale was only possible through the access that artists had to state-of-the-art production facilities (and associated data networks) and cultural broadcasting by public radio stations. It also required artists with technical knowledge who were able to motivate staff of the broadcasters to become innovative partners in realising art projects (Grundmann, 2005).

ISDN (integrated services digital network) is used by broadcasters to create reliable live, low-latency audio links between remote locations and was also available to the general public by subscription to an ISDN line. ISDN allows multiple digital channels to be operated simultaneously through normal phone wiring used for analogue lines, although a digital signal is carried down these lines. Although very suitable for music applications, ISDN was largely superseded by ADSL (asymmetric digital subscriber line) for consumer applications and then fibre optic broadband, although it is still used in the broadcast industry.

The development of high-speed internet through academic networks from the mid-1990s paved the way for high-quality audio links that could be used for NMP that were more accessible for musicians. One of the first research groups investigating the possibilities of NMP was the SoundWIRE group

(CCRMA, 2010) at Stanford University's Center for Computer Research in Music and Acoustics (CCRMA), continuing the geographical links between NMP and the San Francisco Bay Area. The SoundWIRE group started developing the JackTrip software in 2000, which is an audio system specifically designed for synchronous NMP over the internet, and is currently a popular method for accessing NMP.

The technical development of creating audio links across the internet instead of musicians needing to design their own equipment to send control signals has led to the way that most musicians now access synchronous NMP. It allows musicians to play acoustic instruments in NMP rather than using computers as instruments, opening up NMP to musicians without music technology or computer networking experience.

At the same time as the development of synchronous NMP techniques and projects, asynchronous NMP was being developed. An early example of an online band project happened in 1994 called ResRocket. The project had over 1,000 participants who exchanged ideas and files via a mailing list and FTP (file transfer protocol) server (Hajimichael, 2011). The development of accessible DAWs has had a major impact on asynchronous NMP, as more and more people have been able to make high-quality recordings at home. Coupled with improved domestic internet accessibility, both in cost and bandwidth, it is now very quick and easy to produce and share audio files, which previously may have only been possible in a studio setting.

Even more accessible asynchronous NMP projects require users to record themselves on their mobile phones (either in audio or in video format), so the accessibility of these devices coupled with access to the internet has also allowed 'virtual ensemble' projects to proliferate. One of the first examples to gain popular success was Eric Whitacre's *Virtual Choir*, which started in 2010, with social media used very successfully to reach a wide audience (Whitacre, 2022).

The music of NMP

The use of networks for music performance has possibilities for aleatoric music (music that involves elements of random chance), where latency and packet loss could be considered a feature of the medium to be embraced and timings of interactions between parts left to chance. Renaud et al. (2007) suggest an 'internet performance style', in which certain notes or phrases could be played within time brackets, to allow latency issues to be part of the music. The network itself could also be considered to be contributing to the music through recirculating echoes and a unique acoustic 'space' – a network reverberation (Chafe, 2003; 2009). A similar idea is described by Tanaka (2006), with music existing in the environment that it is played in. When music is played on networks the network infrastructure is the environment, along with the associated qualities of that space.

While some musicians may find network latency a technical problem, others consider it a key aesthetic consideration of their work and use the latency as a feature of the music (Tanaka, 2000; Renaud & Cáceres, 2008; Kim-Boyle, 2009). Examples of this include accepting the network delay and using it in a musical fashion; combining the acoustics of physical spaces with those of the network; translating the latencies into spatial diffusion algorithms – making the distance 'audible'; and deliberately creating music that sounds different at each performer's location by embracing synchronisation and asynchronisation (Renaud & Cáceres, 2008).

Several projects have embraced the latency issue in NMP by specifying free improvisation as the musical content. This avoids all problems with latency by allowing the musicians to react to other musicians (or other stimuli) as they hear them rather than being concerned with strict rhythmic coordination. Examples include *Flight of the Sea Swallow* (Mills et al., 2016), where musicians responded with free improvisation to interaction within a virtual environment, and *Distant Presences* (Mills, 2011), an improvisatory performance with both musicians and visual artists. Free improvisation is particularly suited to NMP, as it is a highly communicative form of music, yet is adaptable to the challenges of latency and associated technical issues. There is no specific shared performance goal, and musicians react to what they hear, as they hear it. A disadvantage for the typical performing musician is that, although accessible, it is not a style that many musicians are comfortable playing in.

Composer Rob King took another approach to the interruption caused by the internet connection in his piece *SenTENSes*:

> SenTENSes is a piece for two cellists, TENS machine, and video chat software. The cellists engage in an imitative dialogue over the video chat, exchanging similar musical gestures. Meanwhile, the TENS machine provides electrical nerve stimulation, inducing muscle spasms in the bow-arm. This interference is a metaphor for the inconvenience of the video chat; the imperfections in the video chat itself, over which the cellists are obliged to interact, means that either cellist may miss, misinterpret, or exaggerate the gestures of the other cellist, generating more interference still.
>
> (Network Music Festival, 2020)

The piece, which can only be performed using a video conferencing environment as a performance space, brings the unique features of NMP to the forefront of the music in a slightly alarming way, as the muscle spasms become clearly uncomfortable for the cellist.

Playing music designed for co-located ensembles brings its own challenges, however, in the Pacific Rim of Wire project (Cáceres & Hamilton, 2008), Terry Riley's *In C* was played. Although there are some improvisatory elements in this piece, strict timing is required. In this case, a metronome was used to ensure the musicians were playing to the same pulse, however, this

also meant that audiences in the two locations heard slightly different renditions of the piece. This particular piece was very suitable for an NMP situation due to its improvisatory elements, however, there are few similar pieces that have been composed for co-located performances that would be as suitable.

In some cases, pieces of music have been composed specifically for NMP settings, for example, Eric Whitacre's compositions for virtual choir (Whitacre, 2022). These pieces were originally written for asynchronous NMP rather than live performance, therefore minimising technical difficulties for participants. Whitacre's piece *Sing Gently*, however, has also been performed synchronously using Jacktrip Virtual Studio (JackTrip Labs, 2022). Synchronous examples of composed music for NMP were showcased in the Online Orchestra project (Rofe & Geelhoed, 2017). Amateur and student musicians took part in this project in various places around Cornwall and the Scilly Isles, UK, with groups of instrumentalists in each place. Three pieces of music were written by composers John Pickard, Jim Aitchison, and Federico Reuben, and they each demonstrated musical features such as distributed textures, polyrhythm and ostinati, blurred transitions, slow rates of harmonic change, layered textures, and semi-improvised rhythmic notation. These particular features aimed to reflect the advantages of NMP (e.g., distributed and layered textures) or mitigate the difficulties (e.g., blurred transitions and slow rates of harmonic change).

In a conventional music performance, musicians and audience hear almost identical versions of the music played (with only slight variations due to balance and small latencies due to the distance between musicians and audiences). In synchronous NMP, there are multiple versions: at each NMP location, musicians will hear a different version due to latency affecting the incoming signals. As the number of locations increases, multiple latencies are introduced, creating further versions of the music. In addition, the latency causes audio artefacts, which manifest themselves as a ringing or reverberation, or echoes, depending on the latency. A unique aspect of the NMP environment is the fact that musicians can play together while performing in different acoustic spaces (see, e.g., Renaud & Cáceres, 2008). All these factors can impact musicians and the music they play. These factors create challenges for musicians in terms of the ability to synchronise and create coherent pieces of music, however, they also provide creative opportunities that are not available in any other performance setting.

Different musicians approach NMP with various expectations: some attempt to recreate face-to-face musical encounters (see, e.g., Bartlette et al., 2006), while others embrace the technical idiosyncrasies of the equipment (see, e.g., Tanaka, 2000; Renaud & Cáceres, 2008; Kim-Boyle, 2009). The technical limitations discussed previously make an NMP environment particularly challenging if attempting to work in the same way as in a typical co-located musical setting. However, NMP offers unique opportunities for those willing to accept the technical difficulties as a creative opportunity.

Given the technical environment of NMP, many NMP projects have included elements of sound design and performance art (see, e.g., *CHIP-RADIO* (Grundmann, 2005)), and therefore have sometimes been seen as only suitable for experimental music. While it may certainly be easier for some experimental musicians to see the potential for NMP, there are no limitations on creativity or imagination within NMP. Conventional instruments can be used alongside electronic instruments, and new forms and structures for music can be developed alongside those that are currently part of musical traditions.

Distance music education

An early form of distance music education in the US was the 'School of the Air'. These were programmes broadcast on the radio specifically linked to school curricula. *Music Appreciation Hour*, launched in 1928, was programmes for specific levels covering orchestral instruments, music as expressive media, musical structure and form, and specific composers (Bianchi, 2008). Although these programmes were without interaction, they were a way of providing learning materials at a distance. While not a substitute for classroom teaching of music, they enabled small, underfunded schools to provide a high level of music instruction that otherwise would have been unavailable.

In some remote and rural parts of the world, for example, in outback Australia and the Falkland Islands, distance learning – even for primary school students – is very common. This originally took the form of education by radio, and in Australia, this was also known as 'School of the Air'. Radio was used for interaction with teachers and peers rather than teaching new concepts (Hockley, 1985). More recently, satellite phone replaced radio, with music groups taking place via satellite phone (King, 2007). The ABC (Australian Broadcasting Corporation) in Australia also has a long history of providing Australian primary school students with music educational content, both over the radio in the 1960s and then via cassette and eventually CD through to the early 2010s.

The Manhattan School of Music were pioneers in the use of video conferencing in music education, where they launched the first video-conferenced music course at a US conservatoire in 1996 (Manhattan School of Music, 2022). Throughout the late 1990s, they offered workshops and performances via video conference as well as establishing video-conferenced music education programmes for schools in the New York area. In 2002, they also established specific teacher training courses to teach prospective music teachers how to deliver online music courses. The early adoption of such technology in music education may come as a surprise, but it demonstrates the possibilities of the use of technology within music education at a time when the technical limitations of video conferencing may have made it seem impossible.

The COVID-19 pandemic from 2020 saw a large uptake in NMP, particularly among community groups and music educators, recognising the

importance of ensemble music and learning on health and well-being (see, e.g., McCrary, 2022). Asynchronous NMP was particularly popular in community ensembles, as it was seen as a relatively easy way for musicians to collaborate (although some underestimated the technical challenges of working this way). As local lockdowns extended and meeting for rehearsals (particularly for amateur musicians) was not possible in the longer term, some community groups started video-conferenced rehearsals, usually playing along to a backing track while participants muted their microphones. While this gave some sense of working within a musical community, rehearsing music composed specifically for NMP settings may have provided more sense of purpose and achievement. This sudden increase in musicians taking part in NMP also saw a move away from the experimental music origins of NMP, with many musicians wanting to perform more traditional repertoire over the internet, highlighting some of the technical challenges of doing this.

In music education, the COVID-19 pandemic caused a sudden shift in instrumental tuition from in-person to online through synchronous video conferencing. Many instructors were not prepared for this shift, which happened virtually overnight. Although online instrumental tuition can be very successful, it requires careful planning and preparation. As time went on, many educators could see the access benefits of online instrumental tuition, and their pedagogy developed to suit the environment. Some teachers have further developed their online offerings since restrictions were lifted.

Of course, music education does not only consist of instrumental tuition: composition, music listening, contextual studies, and music technology are also important elements of a general music education at all levels. These elements were also forced online as part of the COVID-19 restrictions, although some institutions (especially at higher education level) were already delivering these elements fully online. Ensemble playing is also part of music education, and this is one of the more difficult elements to deliver online, particularly if attempting to emulate in-person performance. Educators can, however, use some of the synchronous and asynchronous NMP techniques discussed in this book to encourage creative ensemble practices.

Online and distance education is nothing new – consider, for example, the Open University in the UK, which was established in 1969 – including theoretical music courses. The first blended learning practical music degree in the UK was the BA Honours Applied Music degree at the University of the Highlands and Islands, which was established in 2012. A case study of the approaches taken in this degree is included in Chapter 5.

The COVID-19 pandemic

The pandemic gave researchers an unprecedented opportunity to study participation in NMP on a large scale, with almost all musicians taking part in NMP in one form or another, if they had access to suitable equipment. Many

research papers written around this time highlight the lack of awareness in the general population of musicians around NMP, for example, stating '… in most cases these new ways of working are experimental, necessitated by the speed at which this unprecedented crisis has developed' (Crisp, 2021, p. 131). Given the history of NMP going back to the 1970s, it could be argued that these ways of working are anything but experimental (although synchronous NMP does attract experimental musicians). It may, however, feel experimental for the musicians taking part if they have had no experience of NMP. Much of this research has focused on the challenges of unprepared musicians being forced into working online rather than the creative opportunities of NMP or projects that were specifically designed to be online from the outset.

The pandemic also led to an increase in streaming of performances by professional musicians from homes, partly as a way of maintaining an income when conventional performances were not possible, but this soon moved into professional ensembles considering their streamed output. This may result in a big change in the way professional ensembles consider access for and engagement with audiences.

Playing together in NMP

NMP is an ensemble activity, requiring at least two musicians. In a traditional sense, musical performance encompasses not just the act of playing music with other musicians, but also hearing and seeing one another, musical communication, exchange of creative ideas, and the social aspects of physically being in space with other musicians. In NMP, all these elements are possible, but in many cases, the musicians are not physically in the same space as one another. This means a loss of acoustic resonance between the instruments (Wilson, 2019), which can have an impact on blending and tuning (Iorwerth & Knox, 2019). So what does playing together mean in the context of physically playing apart?

A reaction when discussing the possibilities of synchronous NMP is often that it is not the same as playing in a room together, with the implication that it is an inferior musical practice. There is no doubt that it is a different way of working and that there are some aspects of ensemble music that are impossible in an NMP environment. As Wilson and Mcmillan explain:

> It is almost an impossible task to negotiate around recreating full-bandwidth sensory connections: "being-together" is not something we can aspire to while remote connection software remains limited in transmission quality. We can, at least, aspire to be less un-together.
> (Wilson & Mcmillan, 2019, p. 10)

We explore specific strategies for this later in this book, but one of the ways that we can aspire to be 'un-together' is through collaboration. As previously

stated, by its very nature, NMP is a group activity. How the participants work together within the group and the level of interaction will depend on the approach taken. Collaboration can be described as shared ownership and shared interest in the outcome of a project, while cooperation can be described as working with others for a common benefit.

Makelberge (2012) examined different approaches to NMP and categorised them based on their level of reciprocity between participants, describing the interaction as collaboration, cooperation, or collective creation. They suggested that a jazz improvisation in synchronous NMP could be considered collaboration, while asynchronous co-authoring of a MIDI file could be considered cooperation, as it has less intense reciprocity. These categorisations appear to focus on whether the work is real time or not rather than the level of reciprocity. In a synchronous performance, there may actually be very little collaboration between the musicians, depending on the musical content, while in an asynchronous composition project there may be intense collaboration as musical content emerges. The level of collaboration is therefore less about the methods used and more related to the musicians involved and their approach to the music.

Where collaboration as opposed to cooperation is involved, there appears to be a better outcome for participants, not necessarily around the musical content of the project, but in terms of a positive experience of NMP. Daffern et al. (2021) highlight some of the challenges of NMP for community choirs during the COVID-19 pandemic, and some participants commented on the sense of disconnection, particularly in online rehearsals with one-way audio. Virtual ensemble activities (asynchronous NMP where recorded parts are assembled into a group recording) felt more rewarding for some participants. For even more collaborative projects, for example, if the musicians were also composing parts and working closely together to do this, it is likely that this sense of disconnect would reduce further.

Technical versus aesthetic concerns

NMP is at an interesting intersection between technology and the arts, where the technological environment has an impact on the aesthetics and the aesthetics must react to the technological environment. This has led to two rather different perspectives on the topic: one that aims to engineer away the challenges (which we see later may not be particularly successful with synchronous collaborations over long distances); and one that embraces these challenges as part of the unique nature of working online.

Scholz (2021) describes these two approaches to the use of technology in music, first, the teleological approach: 'Teleology has a predetermined goal in mind, and directs all efforts toward that goal; in this effort, technology is a tool for exerting more power and control towards your end' (p. 52). In this approach, there is an imagined goal which the musician has in mind, which

is arrived at through 'detailed notation, obsessive practice, correction, refinement, the elimination of chance and noise' (p. 59).

In the ontological approach:

> Technology is not an adjunct or an assistant, but the material itself. This approach seeks new sound and techniques unique to the new technology. Equipment is repurposed, surprise and unpredictability are welcomed, imperfect and the defects that engineers call "artifacts" are of interest... There is an enthusiasm for sounds newly in the world, that sound like nothing before them.
>
> (Scholz, 2021, p. 52)

They go on to describe the ontologist's sound as one that 'emerges from the playing situation, whether that situation is meticulously constructed or ad hoc' (Scholz, 2021, p. 59).

We can see evidence of these different approaches in the musical examples given in this chapter and in the development of NMP over time. In many cases, the musical approach to NMP has developed despite musicians using technology that was not designed for musical performance. In other cases, the technology has been carefully selected and optimised to make it as transparent as possible for musicians.

In parallel to the development of musical approaches to NMP, researchers and engineers are developing and refining systems specifically designed for NMP (e.g., LoLa and JackTrip as low-latency systems). As Wilson and Macmillan (2019, p. 2) put it:

> Technology emerges through a combination of purposeful and causal developments, where a particular goal is in mind [and] efforts are made to reach that goal using technology; the goal may shift according to feasibility and cost. Likewise, aesthetics emerges, alongside the act of creating within a cultural and technical context.

As we will discover, the feasibility of latency-free performance is pretty low, particularly at long distances, however, the aesthetics of NMP take this technical context into account. The cultural context of NMP has the potential to be as wide as the cultural context of music itself alongside developing conventions of working at a distance. NMP is not limited to any particular musical genre, although there are specific musical features and ways of working that are particularly suited to the environment, which are explored in later chapters. Renaud *et al.* (2007) discuss the need for an internet performance style, however, this does not need to extend to the style of music itself, rather, it refers to particular ways that musicians may need to adapt their performance conventions when playing in synchronous NMP environments.

An example of the impact of technological developments on the musical aspects of NMP is how recently several video conference software providers have included settings in their software to allow improved transmission of music as a result of demand from customers. Although, as a musician, this may seem like an obvious nod towards NMP, it will also help anyone who may be sharing content with music (e.g., videos) through video conferencing. For NMP, it has opened up possibilities for many more musicians to get involved in NMP with very little technical knowledge, therefore increasing the creative possibilities of NMP and reducing its exclusivity.

While it may seem that these issues are most important in synchronous NMP, where challenges of latency are at the forefront of many musicians' minds, these issues also impact on asynchronous NMP. Hajimichael (2011) argues against technological determinism (where the technological developments drive the music) when discussing online production tools and asynchronous collaborative projects. They argue that the societal impact of interactive creative processes is more important than the tools that are used.

As a relatively recent discipline, it is likely that there will be developments in both aesthetic and technological approaches that will move NMP, both synchronous and asynchronous, in new and interesting directions. There are also crossovers with performance art, sonic art, and sound design that are likely to influence (and be influenced by) NMP.

The future of NMP

It is perhaps foolish to attempt to imagine a future for NMP with such rapid changes in technology, but also relatively slower changes in musical practice. Chris Chafe asked in 2009:

> How close are we to adopting/adapting to this new medium? This may seem a bit of a stretch at this point in the game, but perhaps there will come a time when it seems less usual and even a bit special to congregate for music face-to-face.
>
> (Chafe, 2009, p. 416)

Chafe probably did not consider a worldwide pandemic as a factor in helping musicians to adopt NMP into their practice, but certainly, at least for a while, it was extremely special to congregate for music face-to-face. Whether musicians will adopt these practices in the longer term remains to be seen. As we have already seen, much of the online work during the COVID-19 pandemic happened with little planning or preparation, or careful considerations of the aesthetic possibilities of NMP. This may have the result of setting back the development of NMP outside the core practitioners who were involved in NMP prior to the pandemic. Alternatively, it may have allowed musicians to

take risks they would not otherwise have done and develop an interest in the possibilities of NMP.

It is likely that some of the NMP practices that music educators took up during the COVID-19 pandemic are here to stay. In particular, those relating to online instrumental instruction and more general music education through online platforms have proved to be successful and convenient for both teachers and learners. It is likely that these will be used in the long term in combination with face-to-face learning in a blended approach. These approaches are explored in detail in Chapter 5.

Chafe goes on to say:

Music-making will take place increasingly in the new medium because general trends in communication run towards lower energy expenditure, higher content. Networked music performance does reduce travel and does seem poised to raise the 'channel content' (if we consider one's daily musical life as a channel)—similar to how email had already infested the early years of the Stanford AI Lab....

(Chafe, 2009, p. 416)

This lower energy expenditure could be seen from multiple angles, including from the musician's perspective in terms of time and energy needed to travel to face-to-face rehearsals, for example, as well as from the perspective of energy resources, which are becoming more valuable in times of climate crisis.

NMP can be quick and convenient, fitted around other commitments, although perhaps this takes away from some of the elements of ensemble music-making that musicians find so special. Ensemble music-making can be an opportunity to disconnect from the electronic world and focus on the creative, with few distractions. Whether these two worlds will become more integrated over time, and with more musicians experiencing NMP during the COVID-19 pandemic, remains to be seen.

Structure of book

This book aims to examine multiple facets of NMP, including both practical and theoretical aspects of playing music through networks. It focuses mainly on projects where the participants are separated geographically and are connected via the internet. This is not to suggest that other networked approaches (such as laptop orchestras or other co-located networked music) are not important – these are, after all, the approaches that started the development of synchronous NMP – rather that online approaches are perhaps more accessible for a general musician without extensive technical knowledge.

This book is aimed at musicians and educators who are interested in taking part in online NMP projects and technicians who are supporting these projects. It is also aimed at those studying music, to gain some insight into the

creative possibilities of working in NMP. It is not a handbook on the mechanics of how to take part in NMP, nor does it suggest particular software that musicians might like to use. There are some references to NMP systems and software, but these change and develop all the time, and any specific details are likely to go out of date very quickly. Instead, it aims to guide the reader through some of the considerations, challenges, and affordances offered by different approaches to NMP and help them to make informed decisions on the types of system that may work in their own situation and with the resources they have available. NMP combines highly technical aspects of technology with highly creative aspects of music. There are crossovers between these two, and a reader may wish to concentrate on one or the other or to understand how one informs the other.

Chapter 2 explores music over the internet, including elements of an NMP system, how audio is transmitted over the internet, and the origins of latency in networked music. Hardware and software that can be used for NMP are also examined. This chapter will be of particular interest to those who are planning NMP projects and need to think about the technical implications and limitations of projects. It will also give musicians an insight into the origins of some of the technical challenges of NMP, such as latency, and why these exist in an NMP system. It includes a case study of the LoLa system to demonstrate the difficulties for musicians in setting up a low-latency system in terms of hardware, software, and networking.

Chapter 3 focuses on synchronous NMP – or musicians playing together in real time. It explores some of the common methods for working this way and includes a detailed discussion on dealing with latency, both from a technical and musical perspective. It includes a discussion on the use of video in synchronous NMP and some of the conflicting arguments around video use. It investigates some of the musical approaches possible in synchronous NMP, including a discussion around the meaning of coherent performances in NMP and considerations for composers working in this area. Practical suggestions are made for musicians working in this setting, including around choices of music and software.

This chapter will be of interest to musicians who are interested in some of the more creative approaches to working online and who are willing to explore some of the more challenging aspects of NMP. Several case studies are examined in this chapter: *Mosaic,* a composition by Peter Longworth for amateur orchestra, strongly focusing on community and using the Zoom video conferencing platform; *F. not F.*, a composition by Rebekah Wilson for remote musicians with a computer-generated score that adapts as the musicians play; and Heya, a group of female musicians based across the Middle East and Europe, who perform live jams across the internet, using whatever connectivity they have available to them.

Asynchronous NMP is explored in Chapter 4. This includes an overview of the methods of some common approaches, including the virtual ensemble

and collaborative approaches to composition and recording. It also briefly looks at remote recording, an approach mostly taken in professional environments. This chapter may be of interest in particular to those working on collaborative creative projects, where asynchronous NMP is a practical approach to remote collaborative working while avoiding some of the technical pitfalls of working synchronously. It may also help musicians who are working on collaborative recording and composition projects at a distance, using file-sharing methods to build up pieces of music. This chapter includes three case studies: the first looks at some of the interesting technical approaches to synchronisation and spatial mixing in a virtual ensemble choir recording; the second explores asynchronous collaborations between DJs in house music working internationally; and the third describes a remote recording session of Baroque harpsichord, with musicians in the US and recording engineer and producer in the UK.

Online music teaching and community music (which combines elements of synchronous and asynchronous NMP) are examined in Chapter 5. This will be of particular interest to educators and community musicians – both those who are currently working online and those who may want to explore this in the future. While it focuses mainly on instrumental tuition, it also looks at other applications of NMP within educational and community settings. It examines some of the methods for teaching online, including synchronous and asynchronous methods, and some of the specific pedagogies used in online teaching. It discusses student-centred teaching and the benefits of this within music education and when preparing students for life-long learning in music and how this relates to community music. It also looks at approaches and methods for assessment in online music learning, including assessment of, for, and as learning, and how these may be applied online. This chapter contains three case studies: the first is about Applied Music courses at the University of the Highlands and Islands and how NMP is embedding throughout these degree courses; the second examines blended learning approaches to music technology education in a school in Maplewood, Minnesota, USA; and the third describes a project by music education charity Fischy Music and their songwriting work connecting school pupils and hospice patients in Edinburgh and Athens based on themes of loss and grief.

The final chapter is dedicated to accessibility in NMP, covering both the benefits of NMP and the accessibility challenges. There are practical benefits to NMP compared to traditional, in-person music-making, which include the reduced need to travel (and associated time, cost, and environmental benefits) and the ability to form communities of musical practice online – potentially connecting people with niche musical tastes and practices. There are particular benefits for people who are not able to travel to meet like-minded musicians for many reasons. This chapter also examines some of the creative affordances offered by NMP. How can musicians make the most of the NMP environment and create music that not only suits the online

environment, but would not be possible in a traditional face-to-face setting? The barriers to participation in NMP are also examined in this chapter, including the attitudinal, technical, and musical barriers that may be encountered. This chapter finally makes suggestions on how to make NMP projects more accessible and highlights some of the areas for consideration when planning a project. It includes a case study about a collaborative project between inclusive music groups in Scotland and Mexico which involved synchronous and asynchronous NMP approaches to compose, record, and perform an album of new music.

While the three areas of synchronous NMP, asynchronous NMP, and NMP in educational settings are addressed separately, there are many commonalities and crossovers between them. This is perhaps best demonstrated in some of the case studies examined throughout this book where different approaches are taken that suit the particular aspect of the project that musicians are undertaking. These distinctions are used only to allow readers to direct their attention to the most relevant areas to their own practice rather than to limit or pigeonhole musicians' practice.

A note on definitions: throughout this book, the word 'musician' is used. Following Matarasso's definition of an artist (2019, p. 49), everyone involved in the musical act is a musician. This is used to refer to anyone engaging in NMP and does not refer to any particular level of experience – if a person is willing and able to make a sound, whether that is an acoustic or electronic instrument, their voice, or anything else, they are considered a musician. There is no specific, agreed-upon definition for a professional musician, and in this book, this term is used to describe someone for whom music is a key part of their livelihood and may have different approaches and requirements for NMP than someone who takes part in music activities for other reasons. There will, of course, be much crossover between those who consider themselves professional, or not, and it is up to the reader to decide what is appropriate in any given context.

Author's perspective

The word 'virtual' implies something that is not real – that it appears to exist but does not in the real world. Virtual ensembles are made of real musicians that do exist in the real world. I do not feel entirely comfortable with this term, but it was coined by Eric Whitacre and has persisted throughout the COVID-19 pandemic for groups of musicians creating ensemble recordings in their own homes, so I will use it to describe this particular way of working in asynchronous NMP.

References and further reading

Barbosa, Á. (2003) 'Displaced soundscapes: A survey of network systems for music and sonic art creation', *Leonardo Music Journal*, 13, pp. 53–59. https://doi.org/10.1162/096112104322750791

Bartlette, C. et al. (2006) 'Effect of network latency on interactive musical performance', *Music Perception: An Interdisciplinary Journal*, 24(1), pp. 49–62.

Bianchi, W. (2008) 'Education by radio: America's schools of the air', *TechTrends*, 52(2), pp. 36–44.

Brown, C., & Bischoff, J. (2005) 'Computer network music bands: A history of the League of Automatic Music Composers and The Hub'. In Chandler, A. & Neumark, N. (eds.), *At a distance: Precursors to art and activism on the internet*. Cambridge, MA: MIT Press, pp. 372–391.

Biasutti, M., Antonini Philippe, R., & Schiavio, A. (2021) 'Assessing teachers' perspectives on giving music lessons remotely during the COVID-19 lockdown period', *Musicae Scientiae*. https://doi.org/10.1177/1029864921996033

Cáceres, J.-P., & Hamilton, R. (2008) 'To the edge with China: Explorations in network performance', *ARTECH 2008, 4th International Conference on Digital Arts*, Porto, Portugal, pp. 61–66.

Cage, J. (1968) *Silence: Lectures and Writings*, London: Calder and Boyars Ltd.

CCRMA (2010) *SoundWIRE group at CCRMA*. Available at: https://ccrma.stanford.edu/groups/soundwire (Accessed: 21st February 2022).

Chafe, C. (2003) 'Distributed internet reverberation for audio collaboration'. In *24th AES International Conference on Multichannel Audio, The New Reality*. Banff, pp. 1–6.

Chafe, C. (2009) 'Tapping into the internet as an acoustical/musical medium', *Contemporary Music Review*, 28(4–5), pp. 413–420.

Crisp, M. (2021) 'The response of community musicians in the United Kingdom to the COVID-19 crisis: An evaluation', *International Journal of Community Music*, 14(2), pp. 129–138. Available at: https://doi.org/10.1386/ijcm_00030_1

Daffern, H., Balmer, K., & Brereton, J. (2021) 'Singing together, yet apart: The experience of UK choir members and facilitators during the covid-19 pandemic', *Frontiers in Psychology*, 12. Available at: https://doi.org/10.3389/fpsyg.2021.624474

Gabrielli, L., & Squartini, S. (2016) *Wireless networked music performance*, Singapore: Springer.

Grundmann, H. (2005) 'REALTIME – Radio art, telematic art, and telerobotics: Two examples'. In Chandler, A. & Neumark, N. (eds.), *At a Distance: Precursors to Art and Activism on the Internet*. Cambridge, MA: MIT Press, pp. 314–335.

Hajimichael, M. (2011) 'Virtual oasis-thoughts and experiences about online based music production and collaborative writing techniques', *Journal on the Art of Record Production*, 5.

Hockley, R. F. (1985) 'School of the air: Alice Springs, N.T., Australia', *Contemporary Education*, 56(2), pp. 82–84.

Iorwerth, M., & Knox, D. (2019) 'Playing together, apart: Musicians' experiences of physical separation in a classical recording session', *Music Perception*, 36(3), pp. 289–299.

JackTrip Labs (2022) *World Premiere of "Sing Gently" for Upper Voices*. Available at: https://www.jacktrip.com/eric-whitacre (Accessed: 29th January 2023).

Kim-Boyle, D. (2009) 'Network musics: Play, engagement and the democratization of performance', *Contemporary Music Review*, 28(4–5), pp. 363–375.

King, M. (2007) 'Australia's school of the air', *The Guardian*, 1 August. Available at: https://www.theguardian.com/world/2007/aug/01/australia-schools (Accessed: 25th August 2022).

Lewis, G. E. (2021) 'The Hub's telematic socialities'. In Brümmer, L. (ed.), *The Hub: Pioneers of Network Music*. Karlsruhe: ZKM | Hertz-Lab, pp. 156–158.

LoLa (2020) *LoLa Low Latency AV Streaming System*. Available at: https://lola.conts.it/ (Accessed: 11th February 2022).

Makelberge, N. (2012) 'Rethinking collaboration in networked music', *Organised Sound*, 17(01), pp. 28–35. https://doi.org/10.1017/S1355771811000483

Manhattan School of Music (2022) *Distance Learning History*. Available at: https://www.msmnyc.edu/programs/distance-learning/history/ (Accessed: 25th August 2022).

Martin, A., & Büchert, M. (2021) 'Strategies for facilitating creative music collaboration online', *Journal of Music, Technology and Education*, 13(2–3), pp. 163–179. https://doi.org/10.1386/jmte_00021_1

Matarasso, F. (2019) *A Restless Art*. Lisbon: Calouste Gulbenkian Foundation.

McCrary, J. M., Altenmüller, E., Kretschmer, C., & Scholz, D. S. (2022) 'Association of music interventions with health-related quality of life: A systematic review and meta-analysis', *JAMA Network Open*, 5(3), e223236. Available at: https://doi.org/10.1001/jamanetworkopen.2022.3236

Mills, R. (2011) 'Ethernet orchestra: Interdisciplinary cross-cultural interaction in networked improvisatory performance'. In *The 17th International Symposium 241 on Electronic Art*. Istanbul, Turkey.

Mills, R., Slawig, M., & Utermöhlen, E. (2016) 'Flight of the sea swallow: A crossreality telematic performance', *Leonardo*, 49(1), pp. 68–69.

Network Music Festival (2020) *SenTENSes*. Available at: https://networkmusicfestival.org/programme/performances/sentenses/ (Accessed: 26th August 2022).

Rebelo, P., & Renaud, A. (2006) 'The Frequencyliator: Distributing structures for networked laptop improvisation'. In *Proceedings of the 2006 International Conference on New Interfaces for Musical Expression*, Paris, pp. 53–56.

Renaud, A., & Cáceres, J.-P. (2008) 'Playing the network: The use of time delays as musical devices'. In *Proceedings of International Computer Music Conference*. Belfast.

Renaud, A., Carôt, A., & Rebelo, P. (2007) 'Networked music performance: State of the art'. In *Proceedings of AES 30th International Conference*. Saariselkä, pp. 1–7.

Rofe, M., & Geelhoed, E. (2017) 'Composing for a latency-rich environment', *Journal of Music, Technology and Education*, 10(2+3), pp. 231–255.

Scholz, C. (2021) 'One upon a time in California'. In Brümmer, L. (ed.), *The Hub: Pioneers of Network Music*. Karlsruhe: ZKM | Hertz-Lab, pp. 42–66.

Stone, P. (2021) 'Non-mathematical musings on information theory and networked musical practice', *Organised Sound*, 26(3), pp. 327–332. https://doi.org/10.1017/S1355771821000418

Tanaka, A. (2000) 'Speed of sound', In Broeckmann, A. & Brouwer, J. (eds.), *Machine Times*. Rotterdam: NAI, pp. 98–115.

Tanaka, A. (2006) 'Interaction, experience and the future of music'. In O'Hara, K. & Brown, B. (eds.), *Consuming Music Together: Social and Collaborative Aspects of Music Consumption Technologies*. Dordecht: Springer, pp. 267–288.

Wang, G.E. (2018) *Artful Design: Technology in Search of the Sublime*. Stanford: Stanford University Press.
Weibel, P. (2021) 'Foreword'. In Brümmer, L. (ed.), *The Hub: Pioneers of Network Music*. ZKM | Hertz-Lab, Karlsruhe, pp. 156–158.
Weinberg, G. (2005) 'Interconnected musical networks: Toward a theoretical framework', *Computer Music Journal*, 29(2), pp. 23–39.
Whitacre, E. (2022) *The virtual choir*. Available at: https://ericwhitacre.com/the-virtual-choir (Accessed: 14th February 2022).
Wilson, R. (2019) 'Becoming latency-native', *Proceedings of the Web Audio Conference WAC-2019*, Trondheim, Norway.
Wilson, R., & Mcmillan, A. (2019) 'Being together – or, being less un-together – with networked music', *Journal of Network Music and Arts*, 1(1), pp. 1–13.

Chapter 2

Music over the internet

Introduction

This chapter will explore how an audio (and video) signal travels via a network to arrive at another musician. Some parts of the signal chain are the same in asynchronous and synchronous networked music performance (NMP), and we will follow the audio file or real-time signal through this journey in its entirety. Some parts of this signal chain are controllable by the musician who is using the system (e.g., the use of microphones and audio interfaces), while other parts of the chain are a result of the design of the specific system. This chapter will help to explain why the internet was not designed for the real-time transmission of audio (and video). It will also explore the sources of latency on the internet. The final part of the chapter will look at some of the practical implications of working online and some basic fault-finding methods.

Brief history of the internet

The internet was originally developed in the 1960s as a network between government research facilities and universities (called ARPAnet). The key concept of ARPAnet was to have multiple routes for data to travel so that the network was robust in the event of a nuclear attack. Eventually, a communications protocol was established called TCP/IP (Transmission Control Protocol/Internet Protocol), which allowed different kinds of computers on different networks to communicate with one another. ARPAnet adopted this protocol in 1983, and this is considered to be the start of the internet as we now know it.

The internet allows the transfer of many types of data, including email and web pages, and most importantly for NMP, audio and video streams, and file transfer. Importantly, the internet was not designed for the live transmission of audio and video data. It was designed as a robust method of sending data but with no guarantees on the timeliness of this data transfer or whether every part of the data would even arrive at its destination. The impact of not offering guarantees on data transfer is that in the event of part of the network being unavailable, data can be rerouted and still reach its destination.

Music over the internet 27

As we will see, this flexibility means that the internet is not particularly well suited for time-critical information, such as the live streams that are important for musicians to play together in time with one another. Despite its limitations, musicians have been able to use some of the features offered by the internet to work together either synchronously or asynchronously and adapted their practices to suit the networked environment.

Overview of a NMP system

There are two parts to the signal in a synchronous NMP system: the audio and the video streams (although the video is not always used). While these both travel in a similar way through networks, the capture and display of video will be described separately from audio. There may be considerable differences in the way that individual musicians capture and process the audio before it reaches the internet, and this will be based on the equipment available to them and their technical expertise. Figure 2.1 shows an overview of the audio and video signal chains.

The audio signal chain starts with the musician. They may be playing an acoustic instrument, which requires a microphone to convert the sound waves into an electrical signal. If they are playing an electronic instrument, the output of this instrument will be an electrical signal. The level of this signal must be set appropriately to get the best possible sound quality: too low and there will be significant noise present; or too high and clipping will cause unpleasant audio artefacts.

At this point, the analogue electrical signal must be converted to a digital signal so that it can be processed by a computer. This happens in an audio interface, which may be a stand-alone piece of equipment or built into a device such as a mobile phone or tablet. The signal may then have some processing

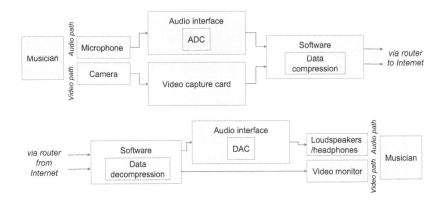

Figure 2.1 Overview of an NMP system.

applied either by the musician or automatically by the device used to capture the sound (such as a mobile phone). This processing is dynamic range compression, which is used to smooth out the levels in the signal, to make it more consistent. Depending on the software used (and usually in video conferencing systems designed for speech rather than dedicated NMP software), there may be other processing, such as noise suppression or echo cancellation, to prevent audio problems when communicating through video conferencing systems.

This digital audio signal is now routed to the software that will be used to transmit the audio signal over the internet. This is where the asynchronous and synchronous approaches to NMP diverge. In an asynchronous system, the audio will be saved as an audio file, which will be sent via the internet to the recipient, and does not require real-time transmission of the audio data. In a synchronous system, the audio is streamed to the recipient, with the aim of the audio arriving as close to real time as possible.

In both cases, data compression may be used before the transmission of the audio to reduce either the file size or the bandwidth required to transmit the audio stream. This file or stream is then split up into packets and sent out of the computer or other recording device (such as a phone or tablet), either wirelessly via Wi-Fi or via an Ethernet cable to a router. These packets are then sent through multiple switches and routers to reach the recipient's router and travel wirelessly via Wi-Fi or via an Ethernet cable to the device they are listening on.

The packets are reassembled into either the audio file that was sent or into an audio stream which is routed to the software that is used for listening. The data is decompressed, and then using an audio interface, the digital signal is converted back to an analogue signal that can be played out through headphones or loudspeakers.

The video path is very similar to the audio path once it reaches the internet, although there are some differences at the start and end of the chain, with cameras and monitors being used instead of microphones and headphones or loudspeakers. In addition, in synchronous NMP, the video and audio feeds may not be sent together through the internet. As with the audio path, the exact way the image is captured and processed will depend on the equipment available to the musician.

The first stage of the process is the video camera. This captures light and focuses it onto a silicon sensor that is made up of a grid of pixels (a contraction of 'picture element'), and the output of each of these pixels is stored as a digital value. When all the pixels in the array have been scanned and coded, this is known as a frame, and multiple frames per second are recorded to give the impression to a viewer of a moving image. A video capture card is a hardware device that converts a video signal from a camera's output into a digital format that a computer can recognise. If using a webcam (either external with a USB [universal serial bus] connector or in-built into a device such as

a mobile phone), this video capture card will be integrated into the camera. Data compression will happen at this stage, depending on the format of the output of the card.

This video stream can then be used by software within the computer, which may be recorded, in the case of an asynchronous NMP project, ready for the musician to send to others, or it may be used by video conferencing software for sending live through the internet. This then follows a similar path through the internet as the audio, with the data being split into small segments called packets, and transmitted. At the receiving end, the packetised data is reassembled, decompressed, and displayed on a video monitor for the musician to view.

Microphones

While a detailed discussion on microphones is beyond the scope of this book, an overview will be given here of microphone types and some considerations for networked music. For further information on microphones, there are many excellent technical resources available on this subject (see, e.g., Corbett, 2021).

A microphone is a transducer, a device that converts one form of energy into another, in this case from acoustical energy into electrical energy. Within an NMP system, this microphone may be built into a computer or other devices, such as a phone or tablet, or may be separate. Using a microphone that is external to the device used for NMP can help improve audio quality and flexibility. It allows the microphone to be moved independently of any screen that is being used, and microphone placement can have a large impact on the audio quality captured.

A microphone contains a diaphragm that vibrates when sound waves hit it. The output from a microphone is an analogue electrical signal, the voltage of which fluctuates to represent the acoustical energy picked up by the microphone's diaphragm. Most microphones designed for music have an XLR connection that carries this analogue signal, which can then be plugged into an audio interface. Microphones with a USB connector are also available and may be encountered by those working in NMP. These contain an analogue to digital converter (ADC) and can be plugged directly into a computer. While this may be convenient, they do not offer the range or quality available from traditional microphones with XLR connectors.

There are several considerations when choosing a microphone for NMP, alongside the obvious pragmatic consideration of cost. The first is the way that the microphone converts the movement of the diaphragm into electrical energy. These fall into four categories: dynamic (or moving coil), ribbon, condenser (or capacitor), and electret.

A dynamic (or moving coil) microphone has a coil of wire that is fixed to the diaphragm, which is free to move within a magnetic field. The movement of the coil around the magnet produces a current in the coil, which is fed to

the output of the microphone. Due to their construction, this type of microphone tends to be robust, their sensitivity is relatively low, and they are most sensitive at mid-frequencies.

A ribbon microphone has a thin ribbon of metal that acts as the diaphragm. This vibrates within a magnetic field and an electrical signal is induced in the ribbon. Given how light the ribbon is, these microphones respond well to transients and have a smooth frequency response. Their construction, however, makes them delicate and very sensitive to external vibrations. In a musical context, they would not often be used outside a studio environment.

The diaphragm of a condenser (or capacitor) microphone forms one plate of a capacitor close to a fixed backplate, which forms the other plate. The vibrations of the diaphragm cause the distance between these two plates to fluctuate. This alters the capacitance of the capacitor and so, since the microphone has a power supply which imposes a constant charge on the capacitor, the voltage across the capacitor changes in step with the movement of the diaphragm, producing a voltage at the output of the microphone. Condenser microphones require a power source to charge the capacitor (either a battery or phantom power via the audio interface), and are generally more expensive than dynamic microphones, but are almost universally of a better quality.

Electret microphones work in a similar way to condenser microphones, but the diaphragm or backplate is charged with a permanently polarised electret material. Electret microphones also require a low-voltage power source, but this is to power a preamplifier rather than to charge the capacitor. They are small and are often found in laptops, mobile phones, and other devices.

Another consideration when choosing a microphone is its directivity pattern. As a result of the method of producing mechanical vibrations from sound waves, microphones have different directivity patterns or polar patterns (Figure 2.2). This describes the sensitivity of the microphone at different angles. In most dynamic, ribbon, and some condenser microphones, this is fixed, and in some condenser microphones, combinations of capsules can be used to make the polar pattern switchable.

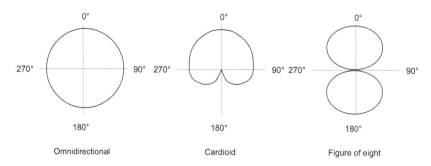

Figure 2.2 Common directivity patterns of microphones.

An omnidirectional microphone is, in theory, equally sensitive in all directions. In practice, however, this is only the case at low frequencies. At higher frequencies, the physical size of the microphone acts as an obstacle to sound waves. This means that the microphone becomes slightly less sensitive at the rear as the frequency increases. The smaller the microphone, the higher the frequency at which this reduction in sensitivity occurs.

A figure of eight microphone is equally sensitive at the front and rear, although the signal at the rear is out of phase with the front signal. At right angles to the microphone the signal reduces to zero (or close to zero), producing a polar pattern that looks like a figure of eight.

A cardioid polar pattern is a combination of the omnidirectional and figure of eight patterns, if one were superimposed on the other. Because the rear signal of the figure of eight is out of phase with the front signal, this would combine with an omnidirectional pattern to produce what looks like a heart shape. This is most sensitive directly in front of the microphone and least sensitive at the rear.

A final factor to consider when choosing microphones is proximity effect or bass tip-up. When using directional (i.e., not omnidirectional) microphones, low frequencies are increased as the sound source gets closer to the microphone. Some microphones are equalised to take this into account, and so are designed to be used very close to the sound source.

Microphone and recording techniques

The placement of microphones is a key part of achieving the best possible sound when recording. In some cases, for example, when using a phone to record, optimum microphone placement might not be possible, because a video camera on the phone may also be used. This means there may be a compromise between audio and video quality, as the phone is placed in the best position for the camera view. Using external microphones allows much more flexibility and potentially better audio quality.

There are several factors to consider when placing microphones that need to be balanced: the quality of the sound from the instrument; the ratio of direct to reverberant sound; and the isolation of individual instruments. In some cases, avoiding acoustic feedback (howlround) is also a consideration, however, this will only be a factor in synchronous NMP when monitoring on loudspeakers (which is discussed further in Chapter 3).

While there are no specific rules on microphone placement in terms of specific instruments, a pragmatic approach is to consider how an instrument produces sound and where a typical listener might be placed in relation to the instrument. This can be used as a starting point for microphone placement and adjustments made from there. Using the features of microphones (such as the proximity effect) and the different frequency responses on- and off-axis, adjustments can be made to the frequency content of the sound by moving

the microphone. Any specific unwanted sounds (such as key noises) can also be considered when placing the microphone.

The next consideration is the ratio of direct to reverberant sound. Microphones pick up all aspects of the acoustic environment – not only the direct sound from the instrument. In NMP, often the aim is to produce a coherent overall sound, and this means rejecting as much of each individual's acoustic space as possible, and usually including artificial reverberation to give a sense of bringing all the sounds into a single acoustic space. A simple way to increase the ratio of direct sound is to move the microphone closer to the instrument. The directivity of the microphone will also have an impact on this ratio – an omnidirectional microphone, for example, will pick up sound equally from all directions and so include more of the room's reverberation than a directional microphone, such as a cardioid.

The final consideration is the isolation of individual instruments. In some cases, there may be more than one instrument being played at once, either by the same person (e.g., singing and playing a guitar) or by different people. In these cases, there should be a separate microphone for each instrument if practical and their sounds isolated as much as possible. In an asynchronous NMP project, each instrument should be recorded in a separate audio file.

Audio interfaces

After the microphone, the next part of the NMP signal chain is the audio interface. For those working with mobile phones and tablets, the audio interface will be built into these devices. If external microphones are being used (with the exception of USB microphones), then a separate audio interface is needed between the microphones and the computer. As well as microphone inputs, audio interfaces often also provide a way to plug an instrument with an electrical output (such as a guitar or electronic keyboard) directly into the interface. This is often labelled 'instrument'.

External audio interfaces have multiple functions. They include analogue to digital converters (ADCs) and digital to analogue converters (DACs) as well as gain control and power for condenser microphones. They are available in many levels of complexity, quality, and number of channels (and therefore cost). They often connect to a computer using a USB connection, although other connections, such as Thunderbolt, are available.

Gain controls on audio interfaces are used to adjust the input voltage of the interface, which appears from the microphone, to a usable level. If the level is too low, the signal will be noisy, and if it is too high, there will be clipping (where the signal reaches the maximum voltage in the electronics of the audio interface), which adds unwanted harmonics to the signal. There is often a level indicator, which may just be a coloured LED (light-emitting diode) or may be a level meter, to show the level of the signal at the input to the interface.

Setting the correct level is a balance between the distance from the instrument to the microphone, the dynamic level that the musician plays at, and the setting of the gain control. The level should be set to be the highest it possibly can be without clipping. Given that musicians often play louder when playing with others than when playing on their own, it makes sense to set the gain control using the meter and then reduce it slightly to allow for louder passages. When the same person is playing the instrument and setting the levels, this may require some trial and error.

Audio interfaces can also provide the power needed by condenser microphones (phantom power is 48 volts, direct current), which travels through the XLR cable, through the same wires as the audio signal, without affecting it. There is often a switch on the audio interface to turn this on and off for either individual or all channels and may be labelled +48V. A common error when setting up condenser microphones is forgetting to switch the phantom power on, which results in no signal appearing from the microphone.

Each different audio source requires its own channel on an audio interface. A typical home user may only require an interface with one or two inputs (e.g., a microphone for speaking or singing and/or an instrument input). Depending on their set-up, more inputs may be required, for example, a drummer may wish to use separate microphones for each drum as well as stereo overhead microphones.

If using a digital audio workstation (DAW) for recording for subsequent asynchronous NMP, then each input of the audio interface will have a corresponding audio channel in the DAW. If the audio interface is being used for synchronous NMP, then how the outputs of the audio interface are routed must be considered. Some video conferencing systems allow stereo inputs, which can be routed in the audio settings of the software. Some, however, only allow one audio input. If this is the case, then only one input of an interface may be recognised by the software. For more than two inputs, some sort of mixing and routing must then take place in the computer, before it is sent to the video conference software.

Different devices deal with this routing in different ways. On Mac computers, for example, it is possible to create an aggregate audio device within the audio settings, combining multiple inputs into a device that other programmes can then use. On Windows machines, a third-party programme is needed to do the same thing. Alternatively, a DAW can be used to mix multiple input signals and then the output of the DAW can be sent to synchronous NMP software.

Video cameras

Most of this chapter is focused on the audio chain in NMP because music is primarily a sound-based phenomenon. Despite this, video potentially has a large role to play in NMP as a communicative device as well as an aesthetic

addition to an NMP project. As with the audio element of NMP, the use of video and its corresponding quality may be a pragmatic decision, based on what equipment is available to participants.

Portable devices such as mobile phones and tablets offer high-quality and accessible video facilities, and for many NMP projects, these will be sufficient. They are easy and convenient to use, often with no prior technical knowledge, and can connect directly to video conferencing software with no routing needed, or record directly to video files that can be sent for virtual ensemble recordings. Multiple cameras can also be used within video conferencing, with the video input switched between them. This can be useful in teaching situations, when wanting to focus on different parts of an instrument, for example.

Chapter 3 discusses specific issues around video in synchronous NMP and Chapter 4 contains relevant information around video formats for asynchronous NMP.

Analogue to digital conversion

NMP relies on the ability to send and receive audio (and sometimes video) from one user to another. While the definition of NMP allows any sort of network to be used, in most cases for musicians working remotely, this will rely on the use of the internet. In order to send signals through the internet, they must be digital signals – that is, they must be represented by a numerical value. Sound travels through the air, and when picked up by a microphone, it is converted into an analogue audio signal – that is, one that is continuous and can have an infinite number of values. At the other end of the signal chain, analogue signals are produced by loudspeakers and headphones, detected by our ears and interpreted by our brains. Therefore, we need ADCs at the source end of the signal chain and DACs at the destination end.

Analogue audio signals are converted to digital signals using a method called pulse code modulation (PCM). In order to create a digital representation of audio, the analogue signal is sampled. This means that its level is measured at regular intervals. The number of times per second that the signal is sampled is called the sample rate. There are standard sample rates for digital audio, such as 44,100 Hz, 48,000 Hz, and 96,000 Hz. These are usually expressed in thousands of samples per second (measured in kHz), for example 44.1 kHz. The sample rate has an impact on the frequency range that can be represented by the digital signal and must be at least double the highest audio frequency. The human range of hearing is between 20 Hz and 20 kHz, so the entire range can be represented with a sample rate of 44.1 kHz.

The level of each sample is represented by a digital word (a series of binary digits or bits), and this word can be of different sizes. Common word sizes are 16 and 24 bits. The amount of data in a digital audio signal can be calculated by multiplying the sample rate by the size of the word per sample,

multiplied by the number of channels. For example, a stereo signal will have two channels – a left and a right channel.

So, stereo audio, using 16-bit samples at a sample rate of 44.1 kHz will be the following size:

2 channels × 16 bits per sample × 44,100 samples per channel per second = 1,411,200 bits per second or 176.4 kB per second (as there are 8,000 bits in a kilobyte)

Once the audio is represented in a numerical form, it is known as digital audio. The digital signals can then be manipulated and transmitted and received at the destination. They will need to be converted back into analogue signals for the listener at the receiving end. This is a fairly straightforward operation, involving filtering the signal, which acts to smooth the transitions between the levels of the individual samples.

This analogue to digital and digital to analogue conversion will happen at different points in the signal chain, depending on the equipment that is being used. If an audio interface is being used, this is where the conversion will happen; if not, it will happen in the sound card of the device that is being used to capture and play back the sound (e.g., the sound card in a computer).

While the analogue to digital conversion happens in real time, there will be a delay as the samples are passed to the operating system of the computer and are buffered here. This is known as audio blocking delay, and Gabrielli and Squartini (2016) provide a detailed description of this.

Software

The next part of the signal chain is the software that is being used to either communicate directly with other musicians in synchronous NMP or to record each individual part in asynchronous NMP. There are many different pieces of software available for musicians to use in NMP, but for both synchronous and asynchronous approaches, they generally fall into two categories – non-specialist software that was not designed for NMP but is accessible and easy to use, and specialist audio or NMP software.

For synchronous NMP approaches, non-specialist video conferencing software can be used. In this software, audio can be routed from an external audio interface if used. Otherwise, the audio will be routed automatically from the device's built-in microphone. Video conferencing software is designed for speech communication, therefore, it prioritises speech intelligibility and acceptable delays for conversation rather than music applications. Acceptable round-trip latencies for conversation are up to 300 ms (Jisc, 2018), which is far higher than what might be considered acceptable for real-time musical collaborations without considerable changes to ways of working. Features, such as echo and noise suppression, assume that the system is used for voice

communication, with participants roughly taking turns speaking, and non-speech and periodic signals considered to be noise.

Video conferencing software should not be discounted as an option for synchronous NMP. It has specific advantages for users around accessibility, with many video conferencing platforms being available on mobile phones, tablets, and laptops, using mobile and fixed internet connections. End users need no knowledge of networking to access this software and to make calls. In addition, many video conferencing system developers have started considering how users may use their software for music, with specific audio settings that allow musicians to override features that are specific to voice communication. This is discussed in detail in Chapter 3.

There is software that has been designed specifically for synchronous NMP purposes, which attempts to reduce latency to manageable amounts for musicians, and takes into account design decisions such as whether to use peer-to-peer or client/server architecture. Examples include JackTrip, which is explored in more detail in Chapter 3, and LoLa, which is explored in the system example at the end of this chapter. Dedicated NMP systems tend not to be as accessible for the end user as non-specialist video conferencing software, as they may require specialist technical knowledge for installation or use, trading off accessibility against audio and/or video quality. Some NMP systems do not attempt to reduce latency, such as NINJAM; instead, they aim to stabilise it, so that musicians can find it easier to work with.

For asynchronous NMP, non-specialist software includes audio and video recorders that are available on many devices. These are extremely easy to use, with audio and video inputs automatically routed from the device camera and microphone, but often external devices such as audio interfaces may also be used. This software is very useful for projects such as virtual ensembles because mobile devices are so widespread and easy to use with no technical knowledge required.

More specialised audio software that is particularly useful for collaborative recordings are DAWs. These are flexible tools used to record, edit, and mix audio. Audio can be routed from audio interfaces and audio files imported for mixing and editing. Individual DAWs can be connected together using software, such as Source Connect, which allows musicians to work together in real time and synchronises audio files in the background. There are also cloud-based DAWs which allow multiple musicians to work on the same project from different locations without dedicated software accessible locally.

In video conferencing and specialist synchronous NMP software, data compression and transmission of the audio (and possibly video) is dealt with in the software itself. In asynchronous NMP, files may need to be compressed by the musician (if that is required) and sent manually, where transmission will be dealt with by the system used to transfer the file (e.g., email or a file sharing service).

Data compression

Assuming a sample rate of 44.1 kHz and 16-bit sample length, mono PCM audio produces a bit rate of 705,600 bits per second or approximately 0.7 Mb/s. For high-definition, uncompressed video, the bit rate is 1.485 Gb/s. A typical home broadband connection in the UK is currently around 24 Mb/s (ADSL2+, close to the exchange), rising to up to 300 Mb/s for superfast or fibre broadband. From these figures, it is clear to see that while some connections may be suitable for sending digital audio in its uncompressed form, in particular for video, bit rates must be reduced to make transmission practical.

This reduction in data rates happens through the use of data compression (note that this is different to audio dynamic range compression, which may also be used in NMP). This happens through the use of a codec (this is a portmanteau of *coder* and *decoder*), which is used to reduce the size of source audio and video data. The coder encodes the signal for data transmission and the decoder converts the signal into audio and video that can be played at the receiving end.

There are multiple different codecs used in audio and video, so this description will be limited to some overarching principles. There are two types of data compression: lossy and lossless. As the names suggest, lossy compression results in loss of data that cannot be recovered, while lossless compression allows original files to be recreated. Lossy codecs work on the principle that some elements of an audio or video signal are less perceivable than others, and this is the data that can be sacrificed in the codec process. Lossless codecs use prediction of samples to work out the most likely next sample and send the difference between the predicted and actual sample. This can result in good reduction of data for predictable data, but works less well when the signal is highly unpredictable (the most extreme case being noise).

Potential impacts of lossy compression on audio are reduced frequency range of the signal and addition of audio artefacts such as pre-echo and ringing sounds. Impacts on the video signal are loss of detail, blockiness, and ghost images. A consideration of data compression is the latency that they add to the signal. Codecs can add up to 100 ms delay for the coding and decoding processes (Jisc, 2018). An interested reader may wish to look up the delay introduced by coder-related processing for common audio codecs in VoIP (voice over Internet Protocol) applications in the ITU-T guidance on transmission quality for telephone connections (ITU-T, 2003).

When sending a large amount of data via the internet, adaptive bit rate streaming can be used. This works by detecting a user's bandwidth and central processing unit (CPU) capacity in real time and adjusting the quality of the audio or video accordingly. The encoder must be able to encode the source media at multiple bit rates. Streams at lower bit rates require less bandwidth for transmission, but this comes at a cost to audio or video quality.

The advantage of using adaptive bit rate streaming is that if network conditions deteriorate, less data is sent through the network, reducing the time needed to receive the signal. This is particularly useful in real-time applications, such as synchronous NMP, where the smallest possible latencies (or at least consistent latencies) help to allow real-time interaction, whereas reduced audio and video quality will have less of an impact on musicians (Iorwerth, 2019).

Audio and video streams may be dealt with separately within a network or interleaved (where video frames have their associated audio attached to them). The advantage of interleaving is that the video and audio remain synchronised, however, this results in a larger latency as video codecs take longer than audio codecs to work. Separate streams will have no synchronisation, although they may arrive at approximately the same time. There is no established practice in NMP software for audio and video transmission (Gabrielli & Squartini, 2016), and the video may be up to one second behind the audio. The potential impacts of this on musicians are discussed further in Chapter 3.

Internet protocol

Internet Protocol (IP) is a set of rules describing how data is sent via the internet. It is made of five layers and describes how data is dealt with on each layer:

1 Application – this layer defines standard internet services and network applications that anyone can use. These services work with the transport layer to send and receive data.
2 Transport – this layer's protocols ensure that packets arrive in sequence and without error by swapping acknowledgements of data reception and retransmitting lost packets.
3 Internet – also known as the network layer, this layer accepts and delivers packets for the network. This layer also provides IP addressing and the path a packet must take.
4 Data link – this layer identifies the network protocol type of the packet and provides error correction.
5 Physical – these protocols are about the physical connection, including, for example, the encoding of data into voltages. This layer is responsible for physically transferring data between nodes.

The details of the protocols of each of these layers is probably of little interest to most musicians, but it does highlight the complexity of sending data via the internet and gives an overview of the processing done on the data as it travels between musicians. Figure 2.3 shows how a signal may travel through the layers to get from one user's video conferencing software to another's, including potentially multiple times through the data link and physical layers.

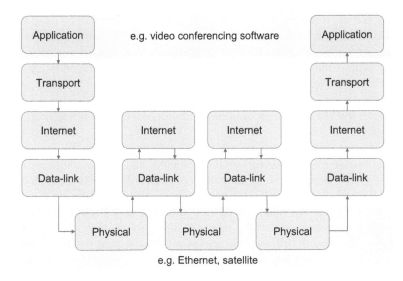

Figure 2.3 Internet Protocol layers.

IP is designed as a best-effort delivery service and is deliberately kept as simple as possible. This means that there is no guarantee that every piece of data will make it to its destination or that it will arrive at a specific time. A reliable network (i.e., one that guarantees timely delivery of packets) would require considerably more complexity. This does, however, have an impact on using the internet for synchronous NMP, as we explore in the following sections.

Packetisation of audio and video data

In order to send audio and video data through the internet, it must be split into small segments called packets. IP defines the structure of these packets. IP packets contain a header (either 20 or 24 bytes) and the data itself (variable length). The header contains the IP addresses of the source and destination as well as other fields that help with routing of the packet and error correction. The data is the actual content, for example, the audio or video in NMP. The packet size is typically determined by the application, but will be limited by the network itself. The maximum size of the data component of an IP packet is 65,535 bytes. In practice, packet sizes are much smaller than this due to other parts of the internet infrastructure, with a maximum of around 1,400 bytes (corresponding to around 63 packets per second of mono 44.1 kHz, 16 bit PCM).

There are advantages and disadvantages of different packet sizes. For large packet sizes, there is a lower proportion of header data compared to audio

and video data, meaning more of the available bandwidth can be used for the useful data. Larger packet sizes result in a longer delay in the packetisation process, and there is a big impact if single packets are lost.

Data with smaller packet sizes have a lower latency, and there is a lower impact of packet loss on the audio or video signal. However, a higher proportion of the signal is header data, and therefore a larger bandwidth is needed to transmit the same amount of audio and video data than if this proportion was lower.

The internet is an example of a packet-switching network. This type of network is capable of dealing with multiple devices attached to the same cable, multiple destinations, and unanticipated connections. Packets are routed separately through the network. The packets have address information directly attached to them in the header, and they find their way through the network, with different packets potentially taking different routes through the network (similar to the way that letters are addressed, sorted, and delivered through the mail system). The advantage of this routing is that in the event of failure of part of the network, the data can still reach its destination.

Routers and switches within the network make sure the packet is delivered to the intended destination. Routing is the process used by networks to determine the path the packet should take to find its destination (Bailey, 2001). The destination address is included in the IP header, and each router examines this address and works out the next hop that will bring it one step closer to its destination. To make this work, there are two mechanisms. The first is a table of addresses known to each router and the second is a way in which routers can exchange information about the status of routes. There are multiple routing protocols that deal with this routing, which are beyond the scope of this book, although may be of interest to network engineers.

Connections to the internet

Once the signal is ready to be sent to the internet, there must be a connection to the internet itself. This is often via a router. In addition, the end user may also use a wireless connection, for example, Wi-Fi to connect to the router, adding another connection into the signal chain. The speed of wireless connections is impacted by the distance between devices, radio interference, physical barriers, and the number of devices on the network. Due to this, wired Ethernet connections are usually faster than Wi-Fi connections.

The end user can connect to the internet in various ways, including:

- Copper cables, for example, in an ADSL (asymmetric digital subscriber line) connection – These were very common, and are currently the least expensive method of having a physical connection to the internet. Basic ADSL encoding adds latency of around 10 ms.

- Fibre optic cables – These are expensive but becoming more common. They are low latency, with data travelling at the speed of light (which in a fibre optic cable is approximately 172 km/h). Some connections might use copper cables for the last part of the journey to the house, which will add some latency. Hybrid fibre-coaxial (HRC) is a system that combines optical fibre and coaxial cable.
- Mobile, for example, 4G – Access to this depends on mobile coverage in specific locations. The 4G has a latency of around 40 ms, while 5G has a theoretical latency of 1 ms.
- Satellite – This is used particularly in rural areas where other internet access is problematic. The latency is at least 800 ms and the weather can impact connections.

An internet service provider (ISP) serves as a gateway to everything that is available on the internet. They provide the connection to the internet in various packages, based on the infrastructure available at a particular address. This may include ADSL, fibre optic, or satellite connections. All the data sent from a user's location will travel via the ISP's network, which may not be physically located nearby. This means that even for neighbours who are located geographically very close to one another, data may travel thousands of miles via multiple countries to get from one computer to another.

One of the features of the connection to the internet is whether it is symmetrical or asymmetrical. In a symmetrical connection, there is equal upload and download speed, whereas in an asymmetrical connection the download speed is greater than the upload speed. An asymmetrical connection is appropriate for many users of the internet, because in most cases there is more data downloaded than uploaded. Consider, for example, browsing the internet or streaming audio or video. For video conferencing, however, data will be travelling equally in both directions, and therefore the quality of the outgoing signal will be limited by the upload capacity of the network connection, so a symmetric connection will be more appropriate.

Server configurations

Designers of NMP software will need to consider server configurations. This is not something the end user can control, however, an understanding of different configurations may help to explain some of the limitations that users face in NMP environments. If two nodes in a network communicate directly with one another, this is called a peer-to-peer configuration. If nodes communicate through a server, acting as a hub for data, this is known as a client/server configuration (Figure 2.4).

In a peer-to-peer network, individual nodes communicate directly with one another. This means that each node will send and receive audio and/or

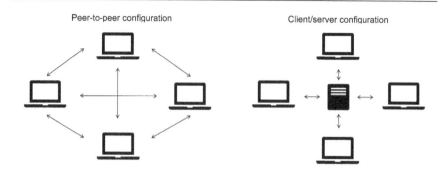

Figure 2.4 Server configurations.

video data to and from every other node on the network. This can cause large amounts of data to and from the individual nodes, putting a strain on network bandwidth. From a latency perspective, however, this configuration is more efficient as it prevents the extra latency of the data travelling through a server.

In a client/server configuration, each node sends and receives information to a central server. This means that each node sends one stream of audio and/or video data and receives one stream of audio and/or video data, which is mixed in the server itself. This has the advantage of reducing the amount of data sent and received by individual nodes of the network, no matter how many other connections there are on the network. If, however, there are only two nodes on the network, then there is additional latency added between these two as the data must travel through the server.

Packet queuing/processing/dropping in routers

When packets arrive at a node in a packet switching network, a packet scheduler manages the sequence of packets in transmit and receive queues based on a series of rules. These rules might be based simply on the order that the packets arrived at the router or they may prioritise packets containing different kinds of data (which can be determined because the packet header contains this information about the data). For example, real-time video or audio packets used for video conferencing may be prioritised over email packets, for which a small delay is unimportant.

If a network is busy, then IP allows for packets to be dropped by routers. In a busy network, it is possible that packets could arrive faster at a router than they can be sent out, for example, if the bandwidth of the incoming interface is higher than the outgoing one. In this case, packets are queued, and once the queue is full, packets are dropped. Packets may also be dropped if they are corrupted. When packets are dropped, this causes missing information in the audio or video stream, resulting in a glitch in the sound or visuals.

Quality of service

While all packets sent over IP are likely to be impacted by delays and losses, sometimes it is helpful to prioritise some data over others, for example, time-critical communications such as the real-time audio and video in NMP. Real-time senders are likely to have constraints on bandwidth, loss rates, and delays, and applications might fail if these constraints are not met. Quality of service assurances are arrangements made in advance that assure a certain minimum level of network services. This means that audio and video may be prioritised over other less time-critical data being carried on the network.

Asynchronous NMP is not time-critical, as files are accessed in the musicians' own time. Audio and video files can be built up from packets delivered from the source to the destination, which is not restrictive in terms of time and packets may also be in the wrong order. From the end user's perspective, this is unimportant, as long as the file is pieced back together without error, in which case the audio and video information is unaffected by the delivery process.

The impacts of packet delay and loss on synchronous and asynchronous NMP are therefore different. Real-time video and audio (such as in synchronous NMP) are delay-intolerant – a packet arriving late may as well be lost. In asynchronous NMP, a late packet has little impact. Real-time video and audio are loss-tolerant to a degree – a lost packet will cause a dropout in audio and a repeated frame in video, which is tolerable if this happens only occasionally. In asynchronous NMP, lost packets can be resent and will have no impact on the audio or video file. Real-time video and audio are rate-adaptive: audio and video compression codecs can increase the compression (with corresponding loss of quality), based on network conditions. In asynchronous NMP, busy network conditions may result in a delay in the file arriving at the destination, but this will have little impact on the project.

IP addressing

An IP address is a unique address that identifies a device on the internet or a local network. IP provides a global mechanism for addressing and routing, so that packets can be delivered from any location on the network to any other location. IP addresses are made up of four 8-bit bytes, often written in dotted-decimal notation. IP addresses (within a local/home private network) are commonly assigned by a dynamic host configuration protocol (DHCP) server on the router. This allows network administrators to manage centrally and automate the assignment of IP addresses in a private network.

From a practical point of view, when a router in a musician's home is switched on, the ISP will allocate the IP address of that router. When a device then joins the local network, for example, by connecting to the router in the home, the router assigns this device an IP address, which may be different

each time it joins the network. The only IP address that can be seen from outside the local network is that of the router that connects to the internet.

Devices on a network and their individual IP addresses can be accessed through the router configuration settings. Instructions on how to log on to the router as an administrator and access the router settings can usually be found on the router itself or within the router documentation.

Port numbers

Port forwarding is a method of redirecting a communication request from one address and port number to another while the packets are passing through a network gateway, such as a router or firewall. This allows remote computers (e.g., computers on the internet) to connect to a specific computer or service within a private local area network, for example, in the case of some dedicated synchronous NMP systems. This is also common in gaming, but is unlikely to concern musicians using generic video conferencing software for NMP.

The advantage of connecting remote devices directly together is that this can reduce latency. In order to make this connection, one of the devices must be configured as a server (a programme or device that provides a service to another device and its user), while the other acts as the client (device that requests access to a service provided by a server). In peer-to-peer applications, such as some synchronous NMP software, all devices are doing the same job, so they are configured to act as both client and server, which is coded into the NMP software.

In networking, a port is a number assigned to uniquely identify a connection endpoint and to direct data to a specific service. A port number is assigned to a specific IP address and the type of protocol used for communication. For example, ports 25 and 110 are used for email delivery and port 80 is used for web browsing.

As discussed above, in most domestic and commercial settings, devices are connected to a local network (commonly through Wi-Fi) and a router provides a connection to the outside world. The router has a visible IP address, but it hides details of the local network from the wider internet. This is problematic when attempting to connect server and client – the remote client has no knowledge of the local network on which the server resides.

Port forwarding solves this problem by exposing the server to the outside world. The router is configured to specify which devices (identified by their local IP addresses) and which ports on each device are exposed this way. If using NMP software that requires port forwarding, then musicians will need to know how to configure this in their router and possibly in a firewall. This needs to be configured correctly at both ends of the connection for successful communication between server and client. The port number and address must be provided to anyone who wishes to connect to the service and should be provided with any NMP software used.

Port forwarding is configured in the router's configuration page. This can be accessed by logging on to the router as an administrator. To do this, the IP address of the router (which can be found in the router documentation) should be typed into a web browser and then administrator username and password used to log in (also often found in the router documentation).

Each individual router is different, but there will often be a section named either 'port forwarding' or 'applications and gaming'. Here, a new rule can be added, based on the IP address and port numbers provided with the NMP software if port forwarding is required. Different internet providers will have different configurations, so, if in doubt, guidance should be sought from the ISP.

A firewall is a network security system that monitors and controls incoming and outgoing network traffic based on predetermined security rules. It usually acts as a barrier between a trusted network and an untrusted network, for example, the internet. There may be a firewall in a router or it may be a piece of software running on a device such as a laptop. If port forwarding is required for the NMP software being used and a firewall is in place, then ports also need to be opened in the firewall.

Reconstructing the audio and video signals

Once the data has travelled through the internet to its destination, the packets must be assembled in the right order to recreate the transmitted signal. There are several potential problems in the reassembly of the signal: packet loss and jitter, both resulting in interruptions to the audio and video streams.

Not all the packets may make it to their destination. Packets may be lost during transmission for several reasons, including network congestion, hardware issues, and software bugs. When a network reaches its maximum capacity, a connection might fall so far behind that it will ignore or discard packets to try and catch up. These may be able to be resent later, when the network congestion eases, although this will not be helpful in real-time applications such as synchronous NMP. Packet loss will cause glitches in the audio stream and missing frames in the video stream.

Since each packet may have taken a different route to its destination, they may not arrive in order. Jitter occurs when packets arrive in the wrong order and the receiving end waits for a missing packet. This results in variable latency, which is more difficult for musicians to deal with than consistent latency. Jitter can be reduced by using a buffering system.

A buffering system stores the received packets, reorders them, and waits for any late ones before sending them to the hardware for playback (Figure 2.5). The larger the buffer, the more accurate the playback (the jitter is smoothed out) but the longer the latency. In non-real-time audio and video applications (e.g., video or audio streaming services), there is no disadvantage to relatively long buffers, however, in real-time applications, such as synchronous NMP,

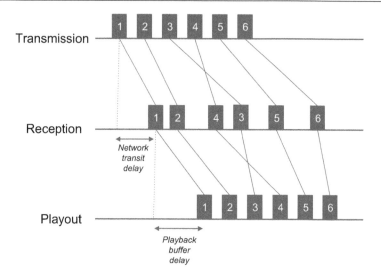

Figure 2.5 Buffering.

these can add unacceptable delays which impact on the musicians. Asynchronous NMP is unaffected by these issues, as the musicians are not working on projects in real time, so long buffer times have no impact.

A trade-off must therefore be found in synchronous NMP systems to balance these factors, as large latencies can be disruptive to musicians (although it is possible to adapt to consistent latencies), but glitches and jitter may also impact on musicians.

Digital to analogue conversion

After the digital audio signal has been reconstructed at the receiving end, it needs to be converted back into an analogue form so that it can be heard by the receiving musician. If data compression has been used in the system, the signal will be decoded by the relevant codec. In PCM, the analogue waveform is reconstructed by passing the samples through a low-pass filter, which acts to smooth the step-like digital signal. If any samples are missing, they can be estimated by a process called interpolation, which uses the midpoint between the sample before and after the missing sample as an approximation. This process happens in either the audio interface (if one is used) or the soundcard of the receiving device.

Monitoring

Once the digital signal has been converted to an analogue signal, the musician can then use either loudspeakers or headphones (both are transducers – this time converting electrical energy into acoustical energy) to listen back.

These can be connected to an audio interface if used or be connected to or built into a device such as a laptop or phone.

If using an audio interface, musicians can also hear the sound of their own instrument through direct monitoring, before the signal is sent into the NMP system. This is important for electronic instruments, for example, which may have no audio output into the room. This avoids the problem of hearing one's own instrument with the latency of the NMP system, which may be very distracting.

As with the input signals from microphones, the output signal may need to be routed in any software that is being used. In video conferencing software, this is often found in the audio settings and often defaults to the built-in speakers of the device. These settings can be changed to send the output to the audio interface if appropriate, where there will be a level control for adjusting the volume. When using a DAW, this output will need to be specifically routed in the software.

The choice of loudspeakers or headphones for monitoring will depend on the individual musician's preference as well as pragmatic considerations around the availability and the cost. It will also depend on the role of the musician in any NMP project. If, for example, they are mixing a large virtual ensemble to a high standard, then they may wish to use studio-quality loudspeakers. If they are working synchronously with a video conferencing system, then audio quality is probably less important.

In Chapter 3, there is a detailed discussion on the advantages and disadvantages of using loudspeakers or headphones for synchronous NMP. There are additional considerations when playing in real time with other musicians compared to working asynchronously on recording projects, relating to how musicians hear themselves and other people when playing together.

Latency

Each stage of the signal chain described above introduces latency into the system. Issues of latency between musicians are only applicable in synchronous NMP approaches. Asynchronous NMP approaches bypass the issue entirely by having no real-time elements that are time-critical. Latency is often seen as a barrier to participation in synchronous NMP, but as we explore in Chapter 3, there are creative ways that musicians can deal with this latency.

The total latency in a system is made up of many elements in the signal chain (Figure 2.6). For the purposes of NMP, it is important to consider the round-trip time, that is, the time between sending a packet and receiving a response – double the latency of sending a signal one way.

> Round-trip delay = 2 × (ADC + encoding + bandwidth delay (speed of connection, e.g., to a house) + propagation delay (approximately 5 ms per 1,000 km) + store-and-forward delay (sum of bandwidth delays out of each router along the path) + queuing delay (usually up to approximately 10 ms) + decoding + DAC)

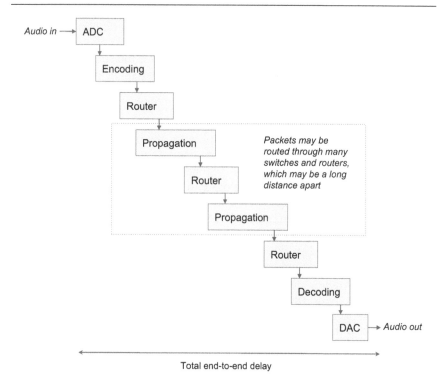

Figure 2.6 Sources of latency in a synchronous NMP system.

Given the wide range of latencies possible at each part of the signal chain and the unknown number of hops a packet takes through the internet, it is not possible to define a typical latency in any given situation. This can, however, be measured using the command line function *ping*, which will calculate the round-trip time of a packet to a specified destination and back. This, however, will only provide the latency for the exact time that the *ping* was carried out and may change at any time due to network conditions. It also does not take into account system latencies or those that occur in the ADC or DAC. Typical round-trip latencies for superfast broadband are up to 10 ms, 20 ms for ADSL broadband (Ofcom, 2021), and mobile connections around 60 ms.

When using video conferencing systems for speech communication, 300 ms latency is tolerable (Jisc, 2018). Latencies of this order are very disruptive for musicians working in synchronous NMP, where maximum latencies that are tolerable range between 25 ms (Carôt et al., 2006; Chafe et al., 2010) and around 75 ms (Chew et al., 2004), depending on the musical content and the musicians themselves. Above these ranges, musicians must actively manage the latency in their approach to performance. This is discussed in detail in Chapter 3. For software engineers designing synchronous NMP systems,

latency minimisation is a major consideration, however, propagation delay (the time the signal takes to travel along a cable) cannot be eliminated.

Multichannel formats

Audio sources may be mixed together into a single mono signal. The same signal is sent to the left and right loudspeakers or headphones, and the signal appears to be coming from the middle point between the two (assuming the listener has two working ears). Spatial information can be carried in audio signals by the use of more than one channel. The most common multichannel audio format is two-channel stereo: one for the signal that is delivered to the right-hand loudspeaker or headphone and one that is delivered to the left-hand loudspeaker or headphone. Level differences between the two channels give the sense of the sound taking up space between the speakers (or headphones).

Immersive audio techniques take this a step further by creating a 3D (three-dimensional) soundscape for listeners. These require specialist playback systems, with more than the two stereo speakers that most people will be familiar with. There are multiple standards for this, with different speaker requirements. These will be beyond the scope of most people in domestic situations.

Binaural recording is a technique that recreates a soundscape by recording exactly what would be heard by someone with two working ears, often by placing two omnidirectional microphones in the ears of a model of a head and torso known as a dummy head. When played back over headphones, this can recreate a remarkably accurate audio image of the original setting.

Immersive audio techniques can be used to render any number of sources into a binaural soundscape for headphones. This is called spatial audio. A limitation of this approach is that in most cases, it can only represent what someone in a fixed position would hear. It can also be used in combination with a piece of equipment called a head tracker, so that the sound stage can be stabilised against a listener's head movements. Position information could also be provided by a virtual reality (VR) headset.

In synchronous NMP, most audio feeds will either be mono or stereo, depending on the software used. It is possible to transmit more than two channels (3D information can be sent in four channels – the Ambisonics B-format), although, of course, this uses correspondingly more bandwidth, so will have an impact on audio quality and latency. Therefore, spatial audio is theoretically possible in synchronous NMP (see, e.g., Gurevich et al., 2011). There are probably more practical uses for these techniques in asynchronous NMP, where bandwidth and latency are less important. An example of this is given in the Lyndhurst Singers case study in Chapter 4.

It is important to note that the number of channels is not related to the number of musicians taking part in an NMP session. There may be hundreds of participants with a mono audio feed or just two using immersive formats and multiple channels.

Practical implications

Many of the parts of the NMP signal chain are not within the control of the end user, for example, the design of the system or how the internet works itself. It is useful to be aware of the limitations of any system when deciding how it is going to be used practically as well as being aware of the aspects of the system that are within control of the end user.

If using a synchronous approach to NMP, then reducing latency can be important. Specific methods for dealing with the latency that is present are discussed in Chapter 3. The biggest impact on latency will be the choice of software and whether this is designed as low latency. Individual musicians can reduce latency by choosing wired internet connections rather than Wi-Fi, whenever possible. This requires musicians to use devices with Ethernet connections and to have equipment set up near routers or use long Ethernet cables.

Individual musicians may also have some control over the audio and video quality of their contribution to a project. If audio quality is highly important in a project, then all musicians should use external microphones and audio interfaces, and this brings associated costs into a project. Videos should be well framed and lit, and good microphone techniques should be used to get the best sound going into the system.

The choice of software will also have a large influence on the overall success of the project. This choice should be based on the technical skills of the musicians as well as the intended outcome of the project, and this may require compromise to ensure that the aims of the project are met.

Ultimately, because the internet was not designed for NMP, there will be many compromises in any NMP project. Asynchronous NMP is more suited to the networked environment, with limited impact of the internet on the technical output, provided the parts are well recorded. There are, of course, compromises in this approach around communication between musicians and the creative way that musicians can work together.

Basic fault-finding in an audio system

Due to the number of links in the signal chain in an NMP system, there are likely to be occasions when there are faults. These can be frustrating and time-consuming to solve for musicians, especially if they have limited technical knowledge. There are some basic steps that musicians can use to trace and solve faults. The first step in fault-finding is to follow a signal through the signal chain and work out the most likely location of the fault. In NMP, these could be divided into three main parts: capture of audio at the musician's end; transmission across the internet; and playback of received audio.

At the musician's end, common faults include a lack of phantom power to external microphones, audio routing problems, and microphones that are

muted. The level of sound going into the software used for NMP can usually be checked through metering. In video conferencing software, this is usually found in the audio settings, and there is often a tool for checking the microphone. If there is no sound arriving at the software, then connections to the audio interface that (if used) should be checked as well as checking the audio routing, that is, that the software is connected to the correct audio device (e.g., the audio interface or in-built microphone). In video conferencing systems, if audio appears to be going into the software but other participants cannot hear the instrument or voice, then the audio may be muted. This is often accompanied by an icon on the screen which is shown to other participants, so, often this will be highlighted quickly by them.

Internet connectivity problems are often very apparent either by losing the connection completely or by a connection that drops in and out often. If this is only experienced by one person in a synchronous NMP session, then it is likely that the problem is at their end. If using Wi-Fi, then they should make sure they are close enough to the router and that their router is connected to the internet. Sometimes, faults at the ISP's end can cause dropouts in an otherwise reliable connection.

If the connection to the internet is stable and there are problems hearing all other participants, then there is probably a fault in the monitoring system. This may be related to audio routing or attempting to listen through the wrong device (e.g., the headphone output of a laptop instead of an audio interface). If using a video conferencing system, then there is often a facility for checking the audio output, which can often be found in the audio settings. Again, the audio routing should be checked to see where the output sound is being sent.

Example of an NMP system

The following example outlines the technology behind LoLa, a low-latency audiovisual system specifically designed for musicians to play together in real time. This example was chosen to demonstrate the difficulty in using the internet for transmitting real-time audio and video and outlining the engineering required to create a system that achieves this. It also demonstrates that although low-latency systems do exist, they are not easily accessible for the majority of musicians working online.

LoLa

LoLa (which is a shortened version of the words low latency) is a project specifically designed to enable musicians to play together in real time over high speed networks, with both a video and audio connection. The system was first conceived in 2005 as a collaboration between Conservatorio di Musica Giuseppe Tartini in Trieste, Italy, and GAPR, the Italian Research and Academic Network, and was first demonstrated in public in 2010 (LoLa, 2020). LoLa is

licensed software and is available free for academic and educational non-profit uses. This example will describe the LoLa system using uncompressed video and academic networks, although it is possible to use it on symmetrical domestic internet connections with the use of lossy compression (and the corresponding increase in latency and reduction in audio and video quality).

Signal processing and transmission of data through the network has been optimised within the LoLa system to reduce latency as much as possible. Because of this, LoLa has very specific hardware and network requirements. For uncompressed video, the network requirements are a 1 Gb/s end-to-end network connection: this is usually available only in academic networks available at universities and research institutes.

Specific hardware requirements are laid out in the LoLa manual (Conservatorio di Musica G. Tartini, 2019), and LoLa runs only on Windows operating systems. To reduce latency, very specific internal audio cards are suggested instead of external audio interfaces, with small audio buffers of 32 samples, resulting in a latency of 0.7 ms. Specific high-specification video cameras and video grabbers are also outlined in the manual. Low-latency monitors (with latency of less than 2 ms) are specified for the video playback, connected with VGA or DVI-D connectors.

The manual also outlines the network requirements and set up for LoLa. LoLa uses 1 K packet sizes, and therefore produces very high packet per second rates with uncompressed video. Cabling and network hardware should be compliant with 1 Gb/s connections. The LoLa workstation should be connected to the router or switch with no competing network traffic and connect as directly as possible to the outside network. There should be no firewall and the workstation should have a public IP address. These factors reduce latency by limiting the routing of the signals through unnecessary connections, although this also removes the protection from unauthorised access that a firewall offers.

LoLa uses very little data buffering to reduce latency. This means that a reliable network should be used that is error-free and low jitter, and the network itself should have the lowest possible latency. It is designed to be used on networks such as Internet2. LoLa also requires a very efficient computer, so it should be a dedicated machine and only have the drivers and tools for the audio and video cards and grabbers and no software other than LoLa itself.

Local audio and video settings can be configured, including video frame rates, video compression, audio sample rates, and number of audio channels. Once the hardware, software, and network is set up, the LoLa interface is very easy to operate. Users just need to enter the IP address of the remote machine and they can connect to the other system.

While this is a very brief overview of the LoLa system, it should give an indication of the level of understanding of networking required to optimise the system as well as the access to hardware and networks that are needed for the system to work. Even within academic institutions, it can be difficult to

get the access to direct network connections without firewalls or competing traffic, and usually requires a particularly understanding, helpful, and creative colleague in the IT department to assist with access.

Chapter summary

This chapter has looked at how music travels from a musician's instrument to the devices that are used to record or transmit and through the internet to its destination. It has examined some of the possibilities for the capture of the sound from an instrument, such as microphone characteristics and placement, and the use of audio interfaces.

As we have seen, the internet was designed as a best-effort system, meaning that there is no guarantee of data delivery and no guarantee of timely delivery of data. The data is split into packets, which may travel via different routes to the destination and may get lost along the way. The time it takes for the data to travel from its origin to its destination is called latency, and we have examined where the latency comes from on the internet. We have also looked at some of the specific information related to the internet that musicians working on NMP projects might need to know, such as port forwarding.

Finally, we have considered some of the practical implications of this on musicians in NMP, including what steps musicians can take to reduce latency as well as some basic fault-finding tips for musicians working in NMP.

References and further reading

Bailey, A. (2001) *Network Technology for Digital Audio*, Oxford: Focal Press.

Carôt, A., Krämer, U., & Schuller, G. (2006) 'Network Music Performance (NMP) in narrow band networks'. In *Proceedings of the 120th Convention of the Audio Engineering Society*, Paris.

Chafe, C., Cáceres, J.-P., & Gurevich, M. (2010) 'Effect of temporal separation on synchronization in rhythmic performance', *Perception*, *39*(7), pp. 982–992. https://doi.org/10.1068/p6465

Chew, E., Zimmermann, R., Sawchuk, A. A., Kyriakakis, C., Papadopoulos, C., François, A. R. J., Kim, G., Rizzo, A., & Volk, A. (2004) 'Musical interaction at a distance: Distributed immersive performance'. In *Proceedings of the Music Network Fourth Open Workshop on Integration of Music in Multimedia Applications*, Barcelona, Spain, pp. 1–10.

Conservatorio di Musica G. Tartini (2019) *Low Latency Audio Visual Streaming System Installation & User's Manual*. Available at: https://lola.conts.it/downloads/Lola_Manual_2.0.0_rev_001.pdf (Accessed: 21st September 2022).

Corbett, I. (2021) *Mic it! Microphones, Microphone Techniques, and Their Impact on the Final Mix*, Oxford: Routledge.

Gabrielli, L., & Squartini, S. (2016) *Wireless Networked Music Performance*, Singapore: Springer.

Gurevich, M., Donohoe, D., & Bertet, S. (2011) 'Ambisonic spatialization for networked music performance'. In *The 17th International Conference on Auditory Display*, Budapest.

Iorwerth, M. (2019) *Playing together, apart: An exploration of the challenges of Networked Music Performance in informal contexts*. PhD thesis, Glasgow Caledonian University, Glasgow.

ITU-T. (2003) *International telephone connections and circuits – General Recommendations on the transmission quality for an entire international telephone connection* (ITU-T SERIES G: TRANSMISSION SYSTEMS AND MEDIA, DIGITAL SYSTEMS AND NETWORKS). Available at: https://www.itu.int/rec/T-REC-G.114-200305-I/en (Accessed: 6th September 2022).

Jisc (2018) *Videoconferencing Traffic: Network Requirements*. Available at: https://community.jisc.ac.uk/library/videoconferencing-booking-service/videoconferencing-traffic-network-requirements (Accessed: 30th October 2018).

LoLa (2020) *LoLa Low Latency AV Streaming System*. Available at: https://lola.conts.it/ (Accessed: 11th February 2022).

Ofcom (2021) *UK Home Broadband Performance*. Available at: https://www.ofcome.org.uk/__data/assests/pdf_file/0020/224191/uk-home-broadband-performance-technical-report-march-2021-data.pdf (Accessed: 5th September 2022).

Chapter 3

Synchronous networked music performance

Introduction

Often, when people think of the term networked music performance (NMP), they automatically think of the synchronous approach – that is, musicians playing simultaneously but in different locations connected by the internet (or other computer networks). Specifically, this approach to NMP involves participants working in real time on collaborative music projects connected via a network. This may include performance, rehearsal, collaborative composition, improvisation, or any other type of musical activity.

Synchronous NMP may or may not include video alongside audio, may use specific software designed for NMP or generic video conferencing software, and may use multiple methods for approaching the challenge of latency (which will exist in all networks to varying degrees, as discussed previously in Chapter 2). The methods of approaching synchronous NMP are as varied as the music that is played using this approach. It is also possible at all levels of musical experience and all sizes of ensemble, however, the complexity increases as the ensemble size increases.

Synchronous networked music performance systems

It is worth reiterating that the internet was not designed for the real-time transmission of audio and video data. Because of this, NMP system designers have to make decisions around the trade-offs they are willing to make, based on the intended use of the system, the musicians who may use it, and the access to equipment that the musicians have. At the time of writing this book, it is simply not possible to have a low-latency, high-quality system that is accessible both in terms of cost and technical ability needed to set up and use the system for the average non-specialist musician (Figure 3.1). That is not to say that this type of NMP is not suitable for the average musician, just that certain trade-offs will need to be made around latency, quality, and accessibility, and careful decisions made around the suitability of particular software.

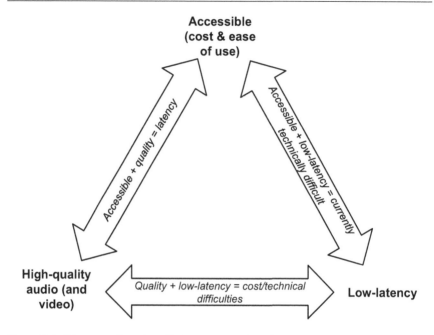

Figure 3.1 Diagram of trade-offs between quality, latency, and accessibility.

Not all synchronous NMP systems stream digital audio. Given the high bandwidth requirements for streaming audio (and the corresponding latency), some software developers have designed systems that use control signals, such as MIDI (musical instrument digital interface) (see, e.g., Weinberg, 2002; Blaine & Fels, 2003b; Gurevich, 2006). These send musical information, for example, the note played and the dynamic level of that note, hugely decreasing the amount of data sent through the network and therefore reducing latency. They can also allow novices to use the systems with 'user-friendly' interfaces, opening up musical communication to all. The disadvantages include the need to obtain specific equipment and that users at both ends require compatible interfaces. Contributors who are already competent musicians would be required to learn a new 'instrument', reducing any advantage to expert musicians, and the ability to become a virtuoso on the interface could be limited to allow accessibility for novices.

The trade-off between complexity and expressivity is further highlighted by NMP systems that use pre-composed musical events, for example, samples. These limit aspects of an individual's creative control but create a more cohesive sound space (Blaine & Fels, 2003a), that is, they reliably produce music that sounds pleasant in most situations, to most people, although this, of course, will depend on the cultural context.

Returning to acoustic instruments, a rather extreme version of this is the use of two Yahama Disklaviers (MIDI-controlled acoustic pianos). Two of these can be connected via a network so that a pianist can play another piano at a distance. While this may be an interesting use of Disklaviers, it is limited in practical use in a domestic NMP setting, given the requirements for these very specific types of instruments at significant cost. Examples where this has been done, however, are for a joint piano masterclass between two universities (Yamaha Corporation, 2021) and remote piano lessons (Kruse et al., 2013).

A particularly novel approach was also taken by Oda et al. (2013), using a high frame rate camera to identify the position of mallets above a marimba to predict the pitch and dynamic of a note played. The notes could be predicted 30 ms before they sounded, allowing a signal to be sent and the sound synthesised at the far end with minimal delay. Limitations of the system include the potential for jitter, which would affect the accuracy of the timing at the receiving end. Despite control signals being transmitted using this system, an acoustic instrument can be played, albeit a very specific and not particularly common one.

A similar but alternative approach was taken to the prediction of notes by comparing a solo performance to a reference recording and transmitting the deviations from the 'ideal' performance to the receiving end for playback rather than transmitting audio (Alexandraki & Bader, 2014). This was then taken a step further by using the predictions and deviations to provide a pre-recorded accompaniment (Alexandraki & Bader, 2016). A clear limitation of these systems is that only set repertoire can be played, severely restricting their practical and creative use for musicians as well as raising questions about musical interpretation and what an 'ideal' performance sounds like.

Some systems include a central metronome to avoid timing issues relating to latency. This means that all musicians will hear a common beat, and in theory, at least, play in time to this beat. A disadvantage of this is that it ties the musicians into using a fixed tempo and beat-based music, which may not be suitable for all types of musical collaboration.

Minimising latency and maximising audio and video quality is one approach in synchronous NMP. An example of a system that does this is LoLa (2020), which is used for NMP within academic environments and was originally designed for use on high-performance networks (see the case study in Chapter 2). The system consists of high-performance video and audio devices, optimised to minimise latency. A network jitter compensation mechanism is used, and no video or audio compression is applied to the signals to minimise latency. Delays are in the region of 5 ms for audio and 20 ms for video, not including network delay. Due to the large amount of bandwidth required for the system, the minimum end-to-end connectivity must be 1 Gb/s, which is currently usually found in academic networks rather than domestically (although connection speeds are always improving). The aim of LoLa is high-quality

connections with latency that is not perceived by musicians. It is used in music conservatoire settings for masterclasses and workshops, however, the network and equipment requirements mean that this is not a practical NMP solution for domestic users. A newer version of LoLa uses mpeg video compression, and therefore has a reduced bandwidth requirement of around 20 Mb/s and additional latency. This means it can be used on networks more likely to be found domestically, however, the equipment requirements will still be out of reach of most domestic users.

A system that also aims to minimise latency while maintaining high audio quality is JackTrip (2022). The original JackTrip system is a widely used and open-source NMP system, again focusing on high-quality audio but without provision for video. As with LoLa, the audio is uncompressed and the system is designed for use with high-speed networks. JackTrip can also be used on typical domestic broadband connections, and settings have been included to allow users to trade off reliability in favour of less latency. While JackTrip does not provide video links, it is often used alongside traditional video conferencing software for visual connections with corresponding video latency. JackTrip's appeal is its availability, that it can be used with domestic audio interfaces, and that it can be used with a variety of network conditions. There are, however, challenges for those with limited technical knowledge in installing and running the software in its original form.

Commercial collaborative tools based on the original JackTrip system are now available, for example, JackTrip Virtual Studio (JVS), which includes a video element and is designed to be easy to use for musicians. Courses are also available on how to use the original JackTrip system, and details can be found on the JackTrip Foundation website (2022).

There are some systems that are designed specifically with the domestic novice user in mind, and an example of this is NINJAM (Cockos Incorporated, 2022). Unlike the previous systems discussed, latency is not minimised, so compressed audio is used. The streams from each musician are delayed by a time interval that can be set to be the length of a musical bar. This means that the musicians are not playing entirely synchronously, however, they are also not affected by variable latency and can get used to the impact of the set latency. This therefore limits the styles of music that can be played, as the music is tied to a set tempo. A streaming server is used to minimise bandwidth requirements at the musicians' end.

While these specific systems have been designed to overcome some of the challenges of synchronous NMP, many musicians use generic video conferencing software (which they already have access to for work or social purposes) to play music. This offers musicians a straightforward and accessible way to access NMP. As these systems are designed for voice communication, there are specific challenges around their use for music, which is discussed later in this chapter.

Technical issues

Technical issues, especially latency, are often at the forefront of musicians' minds when considering NMP, so these will be tackled first. This section will consider latency in a musical context, approaches that musicians can take to work with it in synchronous NMP settings, and issues of monitoring and use of video.

Latency

Latency is the time difference between a note being played on an instrument and being heard. As discussed in Chapter 2, latency will always be present in an NMP system as signals are routed through the network. Musicians are accustomed to working with latency in their usual practice. This latency in acoustic performance comes from both internal and external sources, including:

- The delay between playing a note on an instrument and its sounding;
- The time for sound to travel from one musician to another;
- Deliberate anticipations and delays due to expression in performances;
- Errors in performance.

Latency results in unintentional time differences between apparently coordinated notes. Time differences of up to 50 ms in supposedly simultaneous notes are common in a normal musical performance (Rasch, 1979), a fact that may come as a surprise to many musicians.

Sound travels at approximately 343 metres per second or 34 cm per ms, meaning that duos in fairly close proximity will be dealing with less than 10 ms latency as a result of the physical distance between the musicians. Larger ensembles will have considerably more than this between their furthest musicians. The percussion and brass sections of an orchestra, for example, may be over 10 metres further from the audience than the violin section, adding an extra 30 ms delay above the aforementioned unintentional latencies. In addition, ensembles that move (such as pipe bands) will have potentially variable latencies (and echoes, depending on the environment), which must be taken into account when playing. These latencies are likely to impact on musicians' timing and are usually mitigated through the use of a visual timing cue (e.g. a conductor, the tapping of feet, or a drum major). Percussionists in orchestras, for example, are used to anticipating a conductor's beat in order to sound in time with the front of the ensemble. Given these unavoidable latencies, asynchronies of up to 30 ms could be considered normal and acceptable, and performance in a typical acoustic space is not impaired by them (Lago & Kon, 2004).

Latency is often cited as musicians' main concern in NMP. It is not surprising therefore that initial research into NMP focused on the impact of latency on musicians. This was initially attempted using clapping experiments: physically separating musicians and measuring their synchronisation with increasing latencies. These experiments found something interesting: below 11.5 ms the musicians sped up and above 14 ms they slowed down (Chafe & Gurevich, 2004). These results suggest that musicians actually need some latency in order to maintain synchronisation with one another. While these may be ideal latencies to aim for in an NMP system, they only account for specific rhythms repeatedly clapped and do not take into account factors such as melody, harmony, or timbre. In addition, Chafe (2009) suggests that the way musicians react depends on the context that they are working in, specifically that musicians react differently depending on whether a slowing in tempo is a result of a network delay or a deliberate expressive device used by musicians.

Maximum latencies that musicians can cope with without losing synchronisation have also been investigated. Several studies have suggested a maximum of 25 ms (Carôt et al., 2006; Chafe et al., 2010), which represents a physical distance of approximately 8 metres, and therefore reflects the time delays that would be experienced in a natural musical arrangement in a physical space.

The differences between these figures on latency and synchronisation suggest that rhythm and timing are not the only factors that allow musicians to synchronise in NMP. When different musical stimuli are used in similar synchronisation studies, the results become more complex. For example:

- A rhythm study with bass and drums found no overall maximum latency for synchronisation due to variations in individual players' styles (Carôt et al., 2009);
- Tempo impacts on acceptable latencies in classical music – 75 ms at 46 bpm and 50 ms for 132 bpm (Chew et al., 2004).

The wide-ranging values in these studies, along with the differing musical stimuli, suggest that there is no clear value for latency tolerance in musicians: it appears to depend on the type of stimuli (e.g., hand-clapping or music), style of music, and probably the individual's training and ability to draw their attention away from a delayed signal. It is, however, useful for equipment designers to aim for as low latency as possible, and 25 ms appears to be a reasonable aim, given the empirical data.

It is important to consider the practicalities of working in a real musical environment, beyond a laboratory that is trying to quantify the effects of latency on musicians, as neatly described by Chafe (2009, p. 415):

> We can observe the difficulties and formulate theories of what will work and what won't, but the behavior we expect in practical situations is not always what we get. For reasons not yet apparent, ensembles sometimes

adapt to delays that should be impossibly restrictive for a particular music. Trying to explain ensemble behavior only from the mindset of network engineering, we find that a mechanical concept of 'now-ness' is insufficient and something quite apart from a musician's perceptions.

By considering the practical reality, musicians can also open their minds to some of the creative possibilities of synchronous NMP, without being limited by what may or may not be 'impossible' network conditions to work with. Some of these issues are highlighted in the Heya case study below – a group of musicians who are working under extremely difficult conditions to work together across distances and cultures.

Most studies of latency in NMP have focused on fixed latencies, but in real network conditions, jitter – the variation of latency – occurs. Musically, this is more difficult for performers to deal with, as musicians can adapt to fixed latencies fairly easily (as discussed in the example of a percussionist in an orchestra), but it is impossible to adapt to a randomly varying latency. It is possible to reduce jitter by increasing buffer sizes, but this increases latency in the system, a trade-off that may not be worthwhile, depending on the network conditions and musical aims of the performance.

Methods to manage latency issues

Latency will always be present in NMP systems, so musicians must find a way to work with it. Just as musicians adapt to working in different acoustic environments, they can also learn to compensate for the latency and other impacts on audio quality as a result of audio transmission over the internet. There are several approaches to dealing with latency, including:

- Embrace latency as a unique feature of NMP with creative possibilities;
- Reduce latency to below around 25 ms, so it is unobtrusive and play together as if in a shared physical space;
- Have a leading and following musician, with the leader ignoring the delayed signal coming back to them;
- Add further delay, so the parts are in time with one another from the audience's perspective;
- Use an asynchronous approach, without any direct real-time interaction, so latency is not an issue.

These methods for dealing with latency can be roughly split into the teleological and ontological approaches, as described by Scholz (2021) and explored in Chapter 1. Teleological approaches attempt to use technology to reach a predetermined goal (e.g., by reducing latency and attempting to work as if in a face-to-face environment), while ontological approaches embrace the features of the technology and use these in a creative way (e.g., by using latency as a musical feature of the work).

Embracing latency (and other features of NMP such as jitter and other audio artefacts) is a pragmatic solution to the issue of latency. It gives musicians the freedom to explore creative possibilities of the internet without being constrained by the technical requirements of an NMP system and allows musicians to use accessible video conferencing software that was designed for verbal communication. The creative use of latency as a feature in music is explored later in this chapter and within the case studies.

Reducing the latency to below 25 ms is the aim for systems such as LoLa, which are designed for professional and academic use. This comes at a cost, both economically and to accessibility, however, these systems are likely to offer musicians an experience that is most similar to working in a physical space together. Given that the speed of light limits the absolute lowest level of latency possible to 5 ms per 1,000 km, even systems designed to reduce latency to an absolute minimum will still be impacted at global distances (and further, if interplanetary musical collaboration becomes a reality).

Once latency becomes detectable by musicians, the leader-follower approach can be used and is a natural way of musicians working together. One musician keeps time (using their own internal metronome) and ignores the delayed signals coming back from the second musician. The second musician plays in time with what they hear from the first musician. In this case, the second musician will have a very similar experience to playing together in a physical space, while it will be quite different for the first musician. In studies of duo musicians in NMP (Iorwerth, 2019), this approach was followed by the musicians without prior discussion and as a natural reaction to the difficulties of working with latency. Leadership in this context could shift between musicians (which may cause some inconsistencies) or may stay static, depending on the music and the musicians themselves. It should be noted that this is most effective for duos, and in larger ensembles with multiple latencies, then it may be more practical if only small groups within the wider ensemble play at any one time.

The addition of delay above what is naturally occurring in the network can be useful when there are more than two locations, allowing latency across multiple locations to be stabilised. This means that all musicians can play to a regular pulse, although their current beats will be at different locations in a bar (or any time division that is chosen). This is the approach taken by the Online Orchestra (Rofe & Reuben, 2017) and in the NINJAM platform (Cockos Incorporated, 2022). Compared to the previous approaches discussed, this requires the most change from the musicians' point of view and limits the type of music that can be played to improvisation or music specifically composed for this approach. It also means that there are multiple versions of a piece of music in different locations, raising interesting questions around which is the 'correct' version – if such a thing exists.

So far, this discussion has not covered jitter: latency that is not consistent. It is possible that this will be a feature of synchronous NMP, as packets are

lost or sent via different routes. Variable latency is difficult for musicians to adapt to using the methods above and requires musicians to resynchronise often, which in itself can be challenging. Due to this, it could be argued that for NMP, a stable internet connection with little jitter is more important for musicians than low latency.

As discussed in detail in Chapter 4, it is also possible to remove the issue of latency altogether by working asynchronously. In this approach, the internet is used to facilitate remote recording sessions, either with a central digital audio workstation and cloud-based recording or through musicians sending audio files that are recorded remotely and building up pieces independently. While there are many advantages to this approach, there may be no direct real-time interaction between the musicians, potentially impacting on some of the social benefits of ensemble music-making. Asynchronous approaches can be supplemented with synchronous communication (but without real-time musical interaction) to help mitigate this.

Practical considerations in relation to latency

In a practical NMP project, latency must be acknowledged and its mitigation considered. Given that latency will always be present, the first consideration must be whether the amount of latency will impact on the musicians in the project. While it may not be practical or necessary to measure this, 25 ms is a good rule of thumb and starting point for considering whether musicians will cope without major adaptations to the way they work. More practically, a conversation using whatever system is planned to be used for the project, followed by some simple warm-up exercises which require synchronisation, will easily alert musicians to any issues they may face. It is important to note that it is likely that duos will naturally fall into a leader-follower approach, so the follower may not notice the latency when playing, although the leader will. This leadership may be negotiated or left to develop naturally between musicians.

The size of the ensemble will also have an impact on approaches to latency. There are more options for smaller groups, as multiple musicians mean multiple latencies, which add complexity. For large groups, reducing the number of instruments heard at once (by muting some instruments) or considering the musical arrangement can reduce this to manageable levels.

Once the level of annoyance of the latency has been established, ways to deal with this can be established. The next stage is to consider the function of the collaboration: what are you trying to achieve by working this way? If, for example, the act of collaborating in real(ish) time is the ultimate goal and there is no concern for an audience's experience, then some degree of noticeable latency may not be an issue and could be addressed by considering the musical content of the collaboration. If a polished, synchronised performance is the goal, then an asynchronous approach may be more appropriate with the associated trade-off in spontaneous creativity.

The level of experience of musicians may also impact on choices in relation to dealing with latency. Highly experienced musicians may be more able to divide their attention between their own part and the parts of others (with associated latency). Alternatively, they may be less willing to accept variations or inconsistencies in ensemble (in the sense of synchronisation and togetherness). Less experienced musicians may, however, be able to deal with latency quite well, as they are focusing on the mechanics of playing their instrument and attending less to the sounds from other musicians.

Access to equipment may also have an impact on the approach to latency. While a low-latency, high-quality system may be ideal for a particular collaboration, this may not be accessible for the musicians involved. This accessibility may be related to the cost of specific systems or equipment or the technical ability to set up and use a particular system. Free software, designed for voice communication, for example, is extremely accessible, however, the impacts of latency may be considerable.

A flexible approach and some understanding of why there is latency can go a long way to help musicians to accept that the experience of NMP will be different (but no less valuable) than a face-to-face musical collaboration. Project organisers may want to consider how they go about educating their musicians on some of the limitations and benefits of synchronous NMP at the outset of any project.

Session etiquette

Working in synchronous NMP, particularly in large groups, requires all participants to be aware of and mitigate for potential audio problems that can be prevented. When using video conferencing software (which is not specifically designed for NMP), participants should use the mute option appropriately. When all channels are unmuted, the software allocates priority to one sound. This may be the loudest or the first to appear and reduce the sound of the others to prevent unwanted audio artefacts. During the conversation between music-making, it makes sense for all channels to be muted, apart from the person who is currently speaking, and in big groups, a chair or moderator may be needed to organise who speaks. Systems designed for voice communication often have useful tools to facilitate this, such as 'raise hand' functions.

When playing music, this muting and unmuting may need to be negotiated or planned in advance. In some cases, the very act of unmuting can focus the audio on the person unmuting even if they are not actively making a sound, so experimentation is important to achieve the desired effect. Importantly, these elements should not be left to chance and any audience considered. In addition, when using video conferencing software rather than specific NMP software, background noise in any participants' environment may trigger the audio to be switched to them if unmuted, therefore participants should be reminded to remove as much of this sound as possible.

Audio processing in video conferencing

An important area for consideration in NMP is how musicians hear one another. At the most basic level, there is a choice between loudspeakers (either integrated into the computer, tablet, or phone, etc. or standalone) or headphones. In video conference systems designed for speech, there is an expectation by designers that many users will use the default set-up for their particular system, which will probably be loudspeakers. There are several reasons this might be suitable for users, for example, so multiple people can join a call from one system and all hear at the same time, a lack of headphones, for natural communication, or a limited experience with working with video conferencing.

In any audio system consisting of loudspeakers and microphones, there is a potential for microphones to pick up signals coming from the loudspeakers. This can cause positive feedback (howlround) if the latency is extremely low, or ringing, or distinct echoes as the latency increases. For verbal communication, this is extremely annoying and can prevent natural conversation. In video conference systems designed for speech echo suppressors or echo cancellation are used to prevent these artefacts.

Echo suppressors work by detecting a voice signal going in one direction in the system and either muting or attenuating the signal in the other direction. Echo cancellation works by examining the sound picked up by the microphone and comparing it with the sounds coming from the other end of the system. It then cancels out the sound detected in both signals, meaning that only the sound of the person speaking into the microphone is sent to the other end.

Both echo suppression and cancellation have a large impact on musicians in NMP. Because these systems are designed to recognise speech, they can act unpredictably when the signals are musical. Results can include attenuation to the point that an instrument is inaudible, cutting between two instruments intermittently and unpredictably, or the introduction of a new instrument cutting off the sound of one already playing. These impacts can make playing as an ensemble very difficult.

In a video conference call, dynamic range compression is used to reduce the volume of loud signals and amplify quiet ones, and automatic gain settings are used in conjunction with audio compression so users do not have to manually set the gain of their microphone. This helps with speech intelligibility for voice users, but has an impact on musical signals. While some dynamic range compression can work well for music and is often used in recording, the amount of compression used in video conference systems can severely impact on the sound of particular instruments that have a wide dynamic range within an individual note. An example is a piano, where the sustain and decay of a note will be amplified as the level reduces, changing the nature of the sound. In addition, heavy compression will also impact on the dynamics that musicians include in their playing.

Noise suppression is used to reduce the impact of background noise in video conferences. This might include periodic sounds such as hums or buzzes or may be louder non-periodic sounds such as dogs barking or the sound of typing on a keyboard. The frequency content of some instruments can be interpreted as noise by the video conference system and suppressed completely, in particular (in the author's experience) that of the bagpipes (which some might argue is of benefit to other musicians).

Recognising that musicians use video conference systems for music (rather than or as well as speech), many equipment designers have included methods to either switch off or reduce the impact of these systems. These are usually found within the audio settings of the software. Recommended settings for music are:

- Switch off any automatic gain on microphone inputs – make these manual and set levels appropriate for the instrument being played;
- Switch off or reduce any echo cancellation or suppression;
- Switch off or reduce any noise suppression and ensure an environment that is as quiet as possible.

It is important to note that this has the potential to introduce the very artefacts these systems are designed to reduce, and other mitigation must be used by musicians to deal with echoes and noise. Given that these noise and echo reduction systems have been specifically designed to make voice communication easier, it would be prudent to switch these back on when conversing between any music-making, if this is practical to do so. Within large groups, this can be difficult to manage, as each musician must be responsible for their own audio settings, and any resulting audio artefacts (echoes, extraneous noises, etc.) will affect the whole ensemble. With some software, it may be possible for group leaders to mute other participants' microphone remotely. Some interruption of the audio and the resulting time spent dealing with the potential cacophony must be accepted as a feature of working in synchronous NMP.

Headphones versus loudspeakers for monitoring

The use of headphones will limit the amount of sound picked up through the microphone and fed back through the NMP system. This will be familiar to musicians who have recorded in a studio, where the priority is to isolate individual instrument's sounds. In terms of audio quality and control of individual parts, this may also be an advantage in NMP. In addition, it is a very effective way to eliminate echoes and ringing without using echo cancellation and suppression systems. Therefore, from a technical perspective, headphones are preferable for monitoring in synchronous NMP.

The disadvantage of headphones is that they isolate the musician from the sound of their own instrument and may make it difficult for musicians to blend the sound of their own instrument with those they are hearing through

the NMP system (Iorwerth, 2019). Therefore, from a musical perspective, loudspeakers are preferable for monitoring in synchronous NMP, allowing a more natural musical experience, with the sounds of all the participants blending in a natural space. Direct monitoring of one's own instrument is also possible if using an audio interface, where the sound of the instrument can be fed to the headphones without going through the rest of the NMP system. If this is not possible, a good compromise might be to wear headphones with only one earpiece or with only one earpiece covering an ear.

Clearly, there is a trade-off here between the technical and musical requirements of NMP and one that will need to be carefully considered by the participants. If loudspeakers are used for monitoring, then careful placement of microphones and loudspeakers is needed to avoid either echoes or ringing if no echo suppression is used.

Echoes and ringing that may happen can also be worked with as a creative aspect of the NMP system known as the 'internet acoustic'. Music is often composed with a particular acoustic in mind – for example, plainchant works in the reverberant acoustic of a cathedral, whereas a metal band with double drum kit would be less aesthetically pleasing in the same environment. The same is true of the internet acoustic – some music will work better in this environment than others, and this is explored further later in this chapter.

Use of video

So far, this chapter has concentrated on the audio side of synchronous NMP, however, musicians may also choose to include a visual element to their performances and rehearsals. Transmitting video over IP (Internet Protocol) uses considerably more bandwidth than audio (roughly by a factor of ten). It is therefore worth considering the role of video in NMP and whether the benefits outweigh the potential impact on the audio signal, especially if the available bandwidth is limited or reduced at any point during the session.

Music is primarily an audio phenomenon, however, musicians also communicate visually. Body language, facial expression, eye contact, musical cues, and gesticulation are all factors in non-verbal communication for musicians (Seddon & Biasutti, 2009), and this communication requires both the transmission of these cues and for them to be attended to by fellow musicians in order for the communication to be successful.

Particular functions of this visual communication may include:

- Coordination of timing, for example, through foot tapping;
- Communication around significant moments in the music, for example, structural boundaries;
- Gaining feedback from other musicians, for example, through eye contact and facial expressions;
- Benefiting an audience, for example, including gesture as part of the performance.

Despite these functions of visual communication, musicians do not always look at one another directly when playing together. Consider, for example, the many performance contexts where musicians cannot see each other clearly (due to seating arrangements or stage lighting, for instance), and in these cases, their visual contact may be through glances and peripheral vision while intently listening to their fellow musicians. This is often the case in larger ensembles or where there is a large distance between performers on a stage.

Latency has been discussed in this chapter in relation to audio. It will, of course, also be present in any visual aspects of NMP. Conventional video conferencing systems send audio and video streams simultaneously but independently, meaning that the two streams may not be synchronised at the receiving end. Video introduces further jitter to the audio stream, however, interleaving of audio and video can help avoid jitter problems (Carôt & Schuller, 2011). There is also a trade-off between compression and bandwidth in video, with video compression introducing further latency that must be matched with a correspondingly longer latency in the audio stream. In NMP, there is currently no established practice for synchronising audio and video streams. Systems such as LoLa do not interleave the audio and video stream, and audio-only NMP systems (such as JackTrip) require separate software for any video stream, therefore making complete synchronisation impossible. It is important, therefore, to consider how any system being used deals with the synchronisation between audio and video. Prior to any important NMP sessions, it is worth experimenting to see if the latency between the audio and video is troublesome or not.

Musicians must also consider that, depending on the camera set-up, the view other musicians see might not include the whole body. It is often intuitive to set up a camera to view just the face and instrument, although many cues might be lost through not seeing other parts of the body, for example, tapping feet. There are also examples in the author's experience where musicians have decided that the view of the instrument is more important than even the musician's face, so there is an impression of a headless torso playing a guitar, for example, which is somewhat off-putting.

Most musicians using NMP would intuitively argue that a good quality video link is essential for musical coordination and communication. Studies (see, e.g., Iorwerth, 2019) have shown that a video link is not essential for communication when musicians are playing and that NMP can be successful with no video link at all. There are, however, several major facets of video use in NMP:

- The use of video when actively playing music;
- The use of video when engaging in pre- and post-performance discussion;
- The perception of video use compared to actual use.

Video when playing

Coordination of timing is likely to be difficult or even impossible using the video in synchronous NMP due to the latency, both generally and between the audio and video. However, as discussed above, there are other functions for visual communication while playing, including communicating around structural boundaries in the music and gaining feedback from other musicians.

How musicians use a video link when playing has been part of several research projects in NMP, usually as fairly informal observations around specific performances. Cáceres and Hamilton (2008) found that the musicians in their study did not usually look at the video when they performed, however, in their performance, the video stream was provided primarily for an audience to watch. This was supported by Mills (2011), in that when musicians could see each other they rarely used the video to coordinate their ensemble playing, but instead they used the video as a stabilising object to focus on.

A more formal study by Iorwerth (2019) compared how much duo musicians looked at one another when playing in a synchronous NMP setting compared to a traditional performance setting. They found that musicians did use the video to look at their fellow musician, more so in an NMP setting than when playing in a room together – perhaps as a way of compensating for the additional communicative challenges of NMP, although it was not possible in this study to identify the function of this video use. These findings were as a result of observation of musicians in these settings, across musicians of different genres and levels of experience. One group of musicians who rarely used the video link were those who were playing from notation and were professional musicians, who only used the video to look at one another at structural changes in the music, if at all. It has been found in previous studies (not related to NMP) that when musicians are very familiar with one another, their perceived need for visual cues is low (Keller, 2014).

Iorwerth (2019) also considered the quality of the video connection in their study, and found that this had little impact on the musicians when playing – they still looked at the video when it was low quality and with high latency. This adds to the argument that the video is used less for communicating musical aspects of a performance and more as a social connection to the other person or an object to focus on as well as possibly to gain feedback – even if this is little more than checking that the other musician is still physically present (although, of course, hopefully the audio will also give clues to this).

So, purely from a performance point of view, is video needed when playing? Probably not most of the time and especially not for critical coordination of timing. However, if a video link is provided, it will be used by the musicians. It may be useful for communicating during structural boundaries, for example, if a section is to be repeated or there is a transition in the music coming up (of course, the actual function of this communication will be dependent on the performance conventions of the particular genre played).

If video is provided, then it probably does not need to be particularly high quality and some asynchrony between the video and audio will probably be acceptable to musicians. It is always worth experimenting to find out the practical limitations of any system used before any critical performances.

Video for pre- and post-performance discussion

Of course, a synchronous NMP session does not just begin and end when music is played. When musicians play together, particularly in a rehearsal situation, they spend time conversing and this is an important part of the rehearsal process (see, e.g., Murnighan & Conlon, 1991; Blank & Davidson, 2007; Ginsborg & King, 2012). This is no different in NMP: ensuring that all musicians are comfortable and ready to start playing requires verbal communication as well as discussions around the musical outcomes of the rehearsal. This also gives musicians an opportunity to form or develop relationships, which may be one of the main reasons for engaging in NMP in the first place, particularly for those who are isolated in some way.

Social interaction is important to musicians, both for successful performances and for longer-term relationship building and maintenance. In Iorwerth's study (2019), discussed in the previous section, observation suggests that musicians looked at the video link far more when discussing the music before and after their playing than during the playing itself. Using video conferencing for verbal communication is, of course, a far more common use of these systems than for NMP, so the musicians in the study would have been comfortable speaking to each other in this way. Video, therefore, is an important aspect of NMP, although perhaps not for the reasons that musicians may initially think of when considering its use in NMP.

If we need to specify the acceptable quality and latency of the video aspect of a video conference system for NMP, then these findings suggest that the speech communication is the most important aspect of video in NMP. Therefore, video quality suitable for video conferencing is likely to be adequate, and 300 ms latency is tolerable in traditional video conferencing applications (Jisc, 2018). This is not to suggest that a high-quality video connection would not be preferable in synchronous NMP: LoLa (2020), for example, aims for the most realistic NMP environment possible, that is, it attempts to recreate a traditional in-person experience with high-quality and low-latency video and audio. Rather, compromised video quality and latency should not be seen as a barrier to participating in synchronous NMP.

Perception of video use

An interesting facet of video use in synchronous NMP is the different findings of studies which ask musicians to self-report their video use and those that observe how often musicians actually use the video connection. Musicians want

to be able to communicate in a natural way in synchronous NMP (including through non-verbal and non-musical communication) and will discuss how important it is to see one another when playing (Iorwerth, 2019), but equally, when asked, placed little importance on the video when they actually take part in NMP (Cáceres & Hamilton, 2008; Iorwerth, 2019). We have also seen above that they *do* use the video link when it is provided for them (Iorwerth, 2019).

There appears to be some contradictory findings from these studies. Here is what we have found out so far:

- Musicians think a video link is very important in NMP, but then they report that they do not look at it much;
- What musicians say they do (not use a video link much) and what they actually do (look at each other in NMP more than they usually would in a physical performance space) are different;
- The video link is used more for discussion around the music than when playing music itself;
- Musicians rarely look at one another in NMP when using notation;
- Video links cannot be used for the coordination of critical timing elements;
- Low-quality video is sufficient for NMP.

So, what are the implications of this? And what is more important – what musicians think they do or what they actually do?

While NMP is possible without any form of video, video enhances the experience of musicians, allowing for social interaction, as well as giving the musicians a visual focus as they are playing. Given that a detailed view is not necessary for this type of social interaction, a high-quality video connection need not be a priority for those designing NMP systems; and a webcam and a typical domestic video conferencing system with associated latency is probably sufficient.

Convincing musicians that this is the case may be challenging, as it is likely that musicians overestimate how much they look at their fellow musicians in a traditional performance setting, and they may assume that they will need to use the video for critical aspects of timing, which, as already discussed, is problematic in NMP. As with many of the areas discussed in this book, education and experimentation can help with this process and for musicians to discover for themselves what works best within the technical constraints of the equipment available to them.

An important consideration for musicians is whether a video feed might impact too much on the quality of the audio (i.e., through using bandwidth that could otherwise be used for audio), particularly when using video conferencing software that is not specifically designed for NMP. Synchronous NMP is perfectly possible without video (which also helps musicians to concentrate on listening), although it is certainly useful to be able to see one

another for discussions around the music, and at this point, the audio quality is less critical. A pragmatic solution to this may be for musicians to switch off the video when playing and switch it back on again during discussion.

Video from an audience's perspective

So far, this section has focused on video from the musicians' perspective. This is only half the story, of course. An audience's experience of the video must also be taken into account. A live performance in a traditional performance space will always have a visual element, whether this is limited to the gestures of the musicians or includes lighting or projection elements, props, dancers, or any other visual aspect to the performance. This is often an overlooked part of synchronous NMP as musicians focus on some of the technical and practical elements of playing together.

The visual possibilities of NMP are as unlimited as the musical ones. The most obvious approach may be to share the video feeds from each individual musician, so the musicians and their gestures are seen by the audience, as in a traditional performance event. In this case, both the audience and the musicians would see similar views, perhaps using a split screen and the musicians equally visible as a segment of the screen. This has been the approach taken for many asynchronous NMP projects, especially using the virtual ensemble approach. This has the effect of very clearly signalling the remote nature of these projects, however, it is questionable how visually engaging they are for audiences.

It may be preferable that the audience see something different from the musicians, and this, of course, will be dependent on the software used. There may be a focus on individual musicians as they play (which can be achieved automatically in some video conferencing systems) or some entirely different visual contribution. Alternatively, there may be no visual element at all, although this may cause some disengagement of the audience.

In an algorave (an event where people dance to music generated from algorithms, using live coding techniques), for example, the visual element of the performance is considered as important as the musical elements and what differentiates it from other electronic music events (Collins & McLean, 2014). In an algorave, the music is created using live coding, and often the screen of the live coder is shared with the audience through projection (or screen sharing in online events), so the audience can see how the music is being created in real time.

The visual element of a synchronous NMP event may also depend on whether the performance is to be streamed live or recorded and played back at a later date. If it is the latter, then there may be more opportunities for editing the visual element.

A note about recording the video output from a video conference call: it is worth checking what video gets captured when recording these calls. It

may or may not be different to what the person who is recording sees on their screen, depending on the software. Remember that most video conferencing software is designed with speech communication in mind, and therefore what is shown on the screen will probably reflect who is making the most noise at any one point. This may not be ideal for ensemble music, for example, where a gallery view (where all or, at least, a larger number of participants are shown) may be more appropriate.

It is worth considering how the visual element of a performance will be presented at the outset of a synchronous NMP project, as this may influence both software choices and creative choices for the music itself. Conversely, the technology used may limit what is possible visually. Whether there is audience interaction may also influence these decisions.

Virtual reality in NMP

Virtual reality (VR) is a current area of research in relation to NMP (see, e.g., Loveridge, 2020). VR uses computer simulations of environments, with scenes and objects that appear to be real, giving the user a sense of immersion in their surroundings. A device known as a VR headset is used to display the environment and play back the sounds to the user. VR has possibilities in NMP in the context of musicians having a greater sense of immersion in the ensemble as well as an impact on the visual element of NMP, as previously discussed. It may also have applications in audience immersion and participation in NMP. Further research is required to investigate these possibilities as well as examine the impact of latency in the VR environment.

Musical issues

So far, some of the practical and technical issues of musicians playing together in NMP have been discussed. The music itself is another major factor in NMP as it is in any other acoustic environment, and this section will identify some of the musical issues that are a factor in the success of synchronous NMP. This not only includes the choice of music itself but also how musicians may consider ensemble – that is, the sense of 'togetherness' as a result of synchronisation, blend between instruments, and other factors – and how musicians may interact with audiences in NMP.

Listening in synchronous NMP

Listening is vital to ensemble musicians if they are to create cohesive performances: they must listen to the sound they produce themselves and the sounds of those around them. There is a constant process of monitoring and adjusting the balance of these sounds to maintain ensemble cohesion. NMP affects this listening process in several ways: it interrupts the usual monitoring

of one's own sound compared to the sounds of others, through audio degradation and addition of latency; it causes an unnatural sound separation between the instrument being played and those being heard; and it blends all the other instruments into one sound source.

In NMP, monitoring of one's own sound is unchanged: the musician will hear both the direct sound of their instrument plus the indirect sound caused by the reverberation of the room. In addition, the musician will hear the sound of other participants' instruments via headphones or loudspeakers. In NMP, it is possible for musicians to manually adjust the level of the sound arriving from the other musicians using a volume control, so absolute dynamic matching between musicians will be difficult. In some NMP settings, this is not problematic: where there is no audience, then the individual musicians can adjust the level of their monitors for a suitable listening level and the overall balance between instruments may not be important. Where there is an audience, balancing the sound from each source may require some experimentation or assistance from a sound engineer. If a video conference system that is designed for speech is used, then there is no way to balance the sounds coming from different sources, so it is important to include sound checks and adjust individuals' input levels to create a suitable balance. In other systems designed for NMP, there may be the facility to do this.

Musicians are accustomed to adjusting the way they listen: working in different acoustics leads to different ensemble sounds as well as needing to adjust one's sound to match the acoustics. In studies of synchronous NMP (Iorwerth, 2019), musicians changed the way they listened in NMP. Examples included listening more to the rhythm than the melody of the music. This is an indication that temporal coherence (i.e., rhythmic synchronisation) took precedence over other factors in ensemble coherence in that instance. There was also a focus on the musician's own sound rather than the collective sound of the ensemble. As well as listening for technical details, such as timing information and so on, the musicians also listened to the overall shape of the music, pre-empting sounds from the direction of the music, more than they would in a traditional performance setting.

'Prioritised integrative attending' (Keller, 2008) is considered to be the optimal way of listening when playing in an ensemble, allowing for the best ensemble cohesion. This refers to musicians prioritising their own sound when listening but also attending to (i.e., focussing on) the overall sound of the ensemble. 'Selective attending' happens where the musicians focus on their own parts and may be used when the parts of a piece of music are intended to sound independent of one another (Keller, 2001).

This description of 'selective attending' matches what the musicians described in the study above (Iorwerth, 2019). This implies that there may be an impact on the sense of ensemble coherence, as individual parts may sound independent of one another – at least to the performing musicians, which may not match the musical intentions. Whether this appears the case for the audience is an area for further study.

So, what are the practical implications of this? Perhaps musicians being actively aware of how they are listening and the impact on the performance will help to encourage prioritised integrative attending in NMP. It is also likely that musicians will adapt to the NMP environment over time and become more aware of the overall sound of the ensemble and the technical aspects of NMP that impact on this.

Coherent performances

An aim of any ensemble musician is to create a coherent performance with their fellow musicians. This will probably include coordination of timing, tuning, and dynamics, which requires communication between musicians. In a typical performance, musicians can easily judge the success of this because they hear roughly the same as what the audience hears (distance from instruments and therefore relative loudness and small amounts of latency notwithstanding). In NMP, this is not the case: it is possible that an audience may hear something entirely different to all performers, if the audience is based remotely. Where there is no audience (e.g., when rehearsing or collaboratively composing), the idea of a coherent performance is nebulous, as each participant will hear a different overall sound of the ensemble.

It is therefore important to define ensemble coherence in NMP and to consider who judges this. Synchronisation of musicians cannot be considered a prerequisite in NMP, however, coordination of musicians is still important. This may mean that musicians do not play to exactly the same beat (due to latency), but a regular temporal delay between the parts may be considered acceptable. Other musical factors may also be taken into account when defining ensemble coherence, including coordination of dynamic and tempo changes.

Coordination of timing has two aspects: the horizontal and the vertical (Keller, 2014). Horizontal timing refers to the timing of the music as it is played, for example, whether it has a strict pulse or rubato, and how closely the musicians adhere to this, while vertical timing refers to how well the musicians play in time with one another within this horizontal structure. In NMP, both aspects are affected. Coordination of timing is an issue in NMP, particularly in relation to difficulty synchronising after errors, and the use of typical timing cues, such as breathing in wind players (Iorwerth, 2019). Some musicians, however, will naturally fall into the leader/follower approach (Carôt & Warner, 2007), which causes few problems with timing. Musicians must be careful not to give specific timing cues through the video (e.g., gestures to indicate pulse) due to latency, and the fact that the audio and video streams may not be interleaved and that there may be a delay between them.

Coordination of tuning is a further aspect of ensemble cohesion. With reduced audio quality in NMP (as a result of compression or jitter and packet loss), subtle tuning details may be lost between performers, and musicians may not be able to perceive their own tuning in relation to their fellow

musicians' tuning. Coordination of tuning can also be made more difficult when using headphones for monitoring (Iorwerth, 2019): presumably as it is harder to perceive tuning when the sounds are not blending in an acoustic space.

Coordination of dynamics is the final major factor in ensemble cohesion. Different styles of music have different dynamic ranges, which are also affected by the individual players, with more experienced musicians generally having more awareness and sensitivity when using dynamics. Dynamic changes can be used communicatively to highlight moving towards pivotal points in the music, particularly in improvisation. Blending of instruments, which relies on matching dynamics as well as tuning, can be particularly challenging in NMP, as each musician will have control over the level of their monitoring as well as the use of headphones interfering with the musicians' abilities to match dynamics (Iorwerth, 2019). The implications of this depend on the NMP context. It is likely that any distortion to the audio link (particularly if dynamic range compression is used as part of the transmission chain) will make coordination of dynamics more difficult. Without an audience, however, this may not be important, provided that the musicians are still able to communicate with one another through dynamic changes. If an audience is present, then consideration should be given to monitoring arrangements and loudspeakers used wherever possible to help musicians to blend their sounds and respond to dynamic changes.

Lack of ensemble cohesion in synchronous NMP may also have an impact on the emotional connection between musicians. This was a finding of Daffern *et al.* (2021) when investigating community choirs' reactions to working in NMP during the COVID-19 pandemic. Whether this applies to professional musicians, whether this emotional connection can develop over time in synchronous NMP, and whether this would be the case if musicians were choosing to work in NMP (rather than being forced due to the pandemic) would require further research.

Audiences in synchronous NMP

In a conventional music performance, there is a clear sense of who the audience is. An audience usually sits or stands separately from the performing musicians and takes on a role of listening (and often watching) while a performance takes place. Synchronous NMP has the potential to change this dynamic in several ways.

First, they may be contributing to the performance itself, and second, while they will be physically separate from the musicians (as the very nature of NMP is in its separateness), the audience will not be together in a group, but rather distributed geographically and potentially temporally if watching a video of a performance. In addition, due to different latencies and internet connections, each member of the audience may hear a slightly different

version of a performance. This raises questions about the 'correct' version of a piece of music or whether this is important at all.

In a traditional performance space, interaction with an audience will be very dependent on the performance conventions of the genre. These will govern, for example, how much the musicians speak directly to the audience; the sounds and movements that the audience makes; whether they are seated or standing; and how much and the timing of applause. How an audience accesses an NMP performance will have a large impact on the interaction between musicians and audiences. If a performance is recorded and then streamed, then there will be no live interaction. If the performance is streamed live, then there may be interaction through the use of live text comments from audience members during a performance. If the audience members are included as participants in a video conference call, then there is fairly unlimited potential for interaction (apart from around the practicalities of audience wrangling).

Synchronous NMP, and its lack of hierarchy in the performance environment, lends itself well to audience interaction. If a video conferencing system is used, then audience members attending a performance can be given the same precedence as musicians (or this can be limited, depending on the software used) with two-way audio and video. Audiences can also interact with performances in different ways, for example, through websites that accept inputs from participants. Barbosa (2003) describes these as shared sonic environments, and highlights how suitable these can be for audiences with no musical knowledge or instrumental performance skills, as they can participate by manipulating or transforming sounds and musical structures or just by listening.

One of the fairly universal ways that audiences show appreciation at the end of a performance is through applause. This collective sound is not possible in synchronous NMP, even if every audience member has a two-way audio feed, as the software will prioritise one sound over another. An equivalent perhaps is using comments and reaction emojis to show appreciation, however, this is quite different for the musicians to the aural experience of hearing applause.

There are no current performance and audience conventions for NMP, but these may develop over time and may be dependent on genre as in more traditional performance spaces. This is perhaps an area for further research, from both the audience and musicians' perspective. At the outset of any NMP projects, the audience should be considered, taking into account how they will access the performance and the level of interaction required.

Music suitable for synchronous NMP

Music is made up of multiple elements that combine to create the sonic and aesthetic experience that makes up a particular piece. These elements include melody, harmony, rhythm, timbre, and structure, and are governed by

conventions of the genre of the music. Not all these elements are going to be impacted equally by the technical challenges of synchronous NMP.

It is worth considering music that is suitable for synchronous NMP due to the temporal impacts of latency and other audio artefacts on musicians as well as the difficulties communicating. While some music has been composed specifically for NMP (the specific challenges of which are discussed in the next section), in some situations musicians may aim to avoid letting the use of NMP dictate the musical content of what they play.

The broad rhythmic overview, or the beat of the music, is an important factor in the success of synchronous NMP. Musicians have suggested that music with an obvious beat is suitable for NMP (Iorwerth, 2019), because musicians are able to lock into the beat and internalise it, therefore being less reliant on fellow musicians for timing cues. This works well for the leader-follower approach to NMP (Carôt & Werner, 2007), where the leading musician focuses on their own sound, and ignores any delay. Alternatively, music with a much looser beat and the use of rubato may also be appropriate, where latency is unimportant in the musical interplay. This aligns with the laid-back approach to NMP (*ibid.*).

In addition to the broad rhythmic content of the music, in studies there has been difficulty discerning fine rhythmic detail when the quality of the audio link was low (Iorwerth, 2019). An example offered in this research was the sometimes irregular rhythm of Gaelic song, where the music is made to fit around the words of the song rather than vice versa. This causes some inconsistencies in the beat of the music, which varies slightly for every verse. Of course, there are many other examples of rhythmically complex music which may prove challenging in NMP. The limits of possible repertoire for NMP are still to be explored, however, some types of music are completely impossible – for example, some contemporary music that requires instruments to be in the same physical space and influence one another acoustically.

The importance of the rhythmic content of music in NMP is not surprising: rhythm is most likely to be affected by latency and synchronisation difficulties can arise when musicians are not in visual contact (especially at structural boundaries in the music such as fermatas). In addition, rhythm is the driving force behind music, with temporal accuracy being the most apparent aspect of ensemble cohesion. Entrainment, where independent signals interact (Clayton, 2012), is a mechanism that allows musicians to synchronise rhythmically. It requires musicians to both listen and look at one another while making adjustments to their playing, and musicians must process information and predict consequences simultaneously to allow this to happen (Maes *et al.*, 2014). This simultaneous processing and prediction is likely to be affected by the use of audio and video links in NMP and is likely to be particularly affected if jitter is present in the system. In addition, if the video signal is not synchronised with the audio signal, visual cues may cause timing difficulties.

Renaud *et al.* (2007) discuss the need for an internet performance style and cite John Cage's *Number Pieces* as an example of a model of this. In these pieces, the performers are instructed to start and finish at a set time in the piece or within a time bracket. Some of the notes are overlapping, while some have silence in between. This style of composition would be very suited to the synchronous NMP environment, because the performers use absolute time values to decide when to play their notes rather than playing relative to other instruments. Other approaches are described in the case studies below. In the *Mosaic* case study, each phrase is played when the musician has heard the previous phrase, so while musicians are playing relative to one another, there may be a variable time gap between each individual phrase, depending on the particular network conditions and latency at the time. In *F. not F.*, machine learning is used to recognise the phrases that the musicians are playing, and it adapts and provides new score information in real time, depending on what the musicians have played. Latency therefore becomes irrelevant within this particular performance environment.

John Cage's ideas on silence in music (Cage, 1968) may also be an interesting area for exploration in synchronous NMP. The use of silence in music encourages listeners to focus on the sounds in their environment, and in a concert situation, listening to the ambient sounds in the company of a large audience can be an enlightening experience. In the NMP environment, this will be quite different, as each audience member will hear their own individual sonic environments as well as any residual sounds from the network. Perhaps an alternative to a traditional setting of Cage's *4'33"* would be for musicians to all leave their microphones unmuted and remain quiet and allow the software to shape the sound of the network 'silence'.

Expression

The rhythmic content of the music is not the only consideration within synchronous NMP. An element of performance that is likely to be impacted by working in NMP is expression, or the ability to convey emotion through the music played. Body movements are vital for conveying expression to an audience (Schutz, 2008; Broughton & Stevens, 2009). If an NMP performance does not have a video component, we can assume that it will be very difficult for musicians to convey expressive intentions either to their fellow musicians or to an audience. This may be easier with a video connection, but given the view of a video connection is unlikely to include the musicians' whole bodies, some expressive movements may be lost. In addition, constraints on the body movements of musicians are likely to impact on musicians' expression, and in NMP, these constraints may come from using microphones (as is typical in many conventional performance settings) or by musicians limiting their movements to remain in view of a camera.

As well as an impact on body movements, NMP has the potential to lead to a lack of ensemble cohesion (in terms of rhythmic synchronisation as well as matching of dynamics and intonation), which, in turn, leads to reduced expression (see, e.g., Keller, 2014). Ensemble cohesion is also about cohesive communication of each individual's expression (*ibid.*). In some cases, for example, where musicians have prepared in advance, this may already be negotiated, however, in music with an improvisatory element, this expression may emerge as the musicians play and becomes part of the musical conversation. In the latter case, it is likely that it will be difficult to coordinate these expressive intentions in synchronous NMP.

Additional cognitive load (i.e., having to think more than usual) on musicians results in reduced expression (Çorlu et al., 2014), and it is likely that this will be a feature of working in NMP. For example, as well as playing, musicians must think about monitoring audio levels and maintaining good camera angles as well as dealing with any distractions if they are working at home. As discussed previously, they may also listen differently, which requires conscious thought, possibly distracting them from musical issues. It is likely that these factors will reduce over time as musicians become accustomed to working in NMP.

A final impact of NMP on expression is the potential for the loss of fine rhythmic detail, particularly when working with latency and jitter. As small variations in tempo and rhythm are part of expression (Poli, 2004), it is possible that the audio artefacts present in NMP as a result of latency and jitter may prevent musicians from conveying and perceiving expressive intentions accurately. So, latency and jitter may have impact on expression in two ways: by affecting ensemble cohesion and therefore expression; and the direct transmission of expressive intentions.

While these may seem like insurmountable challenges, there are some things that musicians can do to help improve their expression in NMP. An understanding of the impacts may be a good place to start, along with familiarity and practice within the NMP environment. Musicians may also wish to actively discuss expression as part of the rehearsal process rather than expecting it to be perceived in a way that it would be in a typical performance environment. Expression in NMP would benefit from further research, both from the perspective of the musicians and the audience.

Composing music for synchronous NMP

This chapter has raised many areas for consideration for composers of music for NMP, including how latency will be managed, what a coherent performance means for musicians, how an audience might experience a performance, and technically how musicians might work within the NMP environment. Different composers have taken different approaches to composing music for NMP, such as free improvisation inspired by sounds and images

triggered by musicians in *Flight of the Sea Swallow* (Mills et al., 2016). Other pieces, such as those composed for the Online Orchestra project (Rofe & Geelhoed, 2017), use a variety of compositional features that suit the distributed and latency-rich nature of NMP, including polyrhythm, slow rates of harmonic change, layered textures, and improvisation. It is also possible to include input from other sources, such as audience participation through online interfaces to trigger samples or the inclusion of artificial intelligence, such as in the case study of Rebekah Wilson's work *F. not F.* included below.

One area that has not been examined so far is how music is scored in synchronous NMP. For an ensemble, traditional scoring would involve a conductor's score and individual musicians' parts. The individual parts would usually include only the information needed for that particular player – usually the notes to play and occasional cues if there is a long series of rests (orchestral percussionists and brass players will be particularly familiar with this convention). In synchronous NMP, this causes a potential problem. How will a musician be able to count a series of bars of rest if there are no visual timing cues (e.g., from a conductor) and the music is not based on a regular beat? Another factor is whether individuals need to mute or unmute their microphones at specific parts of music.

The scores of The Hub, a networked band discussed in Chapter 1, have been published in full in *The Hub: Pioneers of Network Music* (Brümmer, 2021), spanning from 1986 to 2014. The band members describe their compositions as specs and the scores consist of instructions to be followed. These are varying levels of detail, but describe the technological set-up rather than the music itself, and require improvisation from the musicians:

> One member writes up a 'spec' (short for 'specification') for a new piece, which is a text document outlining the information to be exchanged in the piece, how that information is to be generated and distributed through the network, and how each member should respond to it. Anything not delineated by the spec is left up to each performer's discretion.
> (Stone, 2021, p. 328)

This method of scoring moves away from traditional notation and allows flexibility for the musicians within the particular technological set-up they have. Their music, therefore, may be very different each time a piece is performed.

With many musicians using electronic scores, it is also possible to have dynamic scoring, that is, scores that change over time with input from various sources. An example of this within NMP is described in the *F. not F.* case study below. This is a rather neat way of approaching synchronisation – where the score adapts to the musicians' playing and provides moments of synchronisation that are not necessarily predetermined. This mirrors the uncertainties and the adaptations that are made by musicians within NMP and embraces these as part of the music.

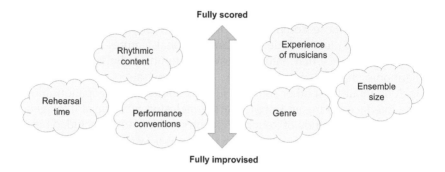

Figure 3.2 Considerations for scoring in synchronous NMP.

As a rapidly developing area of music, there are no specific conventions that have emerged so far in scoring for NMP, however, the composer must consider the practicalities of how the music is going to be performed and include enough information for musicians to accurately represent the music as intended by the composer (Figure 3.2). In particular, how will elements that may or may not be synchronous be scored for musicians to understand how 'together' they should be? Additional scoring elements may be required, such as instructions to mute or unmute microphones (as seen in the *Mosaic* case study below), as well as ways to indicate timing information that may be variable.

Graphic scores (the representation of music through the use of visual symbols outside traditional music notation) may be very appropriate for the synchronous NMP environment, allowing some elements to be left to chance and up to individual musicians to interpret. Using these methods, they can then play music in a way that is appropriate to the network environment at the time of performance.

The biggest impact of the NMP environment is on rhythm, as timing is disrupted through latency and jitter. Composers must consider how they might deal with this. Examples include the use of improvisation and no strict rhythmic content; using a metronome within the NMP software to keep all musicians in time with one another; use of rubato and pauses to reduce the importance of strict timing; or specifying time brackets that notes are to be played within.

Composers must also consider the meaning of a coherent performance in the context of NMP. As has been discussed earlier, traditional ideas of synchronisation, both in terms of timing and of dynamics and expression, are not necessarily possible or maybe even desirable in the network environment, so composers must consider other ways that ensembles can achieve a sense of togetherness.

As in more traditional forms of performance, composers must also consider the levels of experience of musicians and how they are used to working.

For example, in the *Mosaic* case study below, which was composed for musicians playing in a community orchestra who were used to performing orchestral music, a composition that involved extensive improvisation would have been inappropriate. Equally, a composition that is beyond the instrumental skill level of the intended performers is unlikely to engage the musicians or the audience – as is the case in traditional performance settings.

Synchronous NMP also encourages multi-authorial work, as described by Wilson (2020). As network conditions will vary very much between locations and even times of day, it makes sense that the individuals involved in performance will also be active in the creative process of writing music. It is likely that it will be impossible to recreate a networked performance exactly the same way twice, and therefore even if a fairly fixed score is used, the technical network conditions of each individual player will impact on the overall sound of a performance, even if the musicians are not taking an active part in interpretation or improvisation.

Some criticisms of synchronous NMP are that it is not possible to play in a traditional way as if musicians were in a room together and that the music produced in NMP environments is unconventional and experimental. As highlighted throughout this chapter, this gives opportunities for new and creative ways of working. This is not a new phenomenon for musicians, and it seems appropriate that John Cage should have the last words in this section:

> New and original sounds will be labeled as "noise". But our common answer to every criticism must be to continue working and listening, making music with its materials, sound and rhythm, disregarding the cumbersome, top-heavy structure of musical prohibitions.
> (Cage, 1939, 1968, p. 87)

A framework for communication in NMP

Clearly, there are many issues that impact on musicians working in NMP, and many of these are as a result of the impacts of working physically separately in a network environment on the communication between musicians. A framework (the Playing Together, Apart Framework) to encompass the factors affecting musicians in NMP was developed by the author (Iorwerth, 2019; Iorwerth & Knox, in press), based on duo musicians working with an audio and video connection. This overview of communication in NMP was proposed as a framework for future exploration of the issues in NMP, and in particular could be developed with larger ensembles in mind.

Shannon and Weaver's theory of communication (1949) has three levels that are applicable to communication systems in general, including the communication between musicians. The first level corresponds to the technical accuracy of communication, which in the case of NMP would include the video and audio link and corresponding difficulties with latency and so on. The second level corresponds to the transmission of meaning, which in this

case corresponds to the sounds and movements produced by the musician, bounded by the conventions of the genre known to both musicians. The final level relates to how the meaning is received and the effect of the received meaning on conduct, in this case how the receiving musician sees, understands, and reacts to the transmitted information. In music performance, the transmission and reception of information happen simultaneously, allowing the coordination of action, which requires exchange of information between individuals to facilitate understanding and predictions of others' intentions (Volpe et al., 2016). While a simple transmission model of communication in music may be outmoded, with new models taking into account the culture of the context and environment of performance (Hargreaves et al., 2005), it works well for the NMP system to describe the interruption of the communication between musicians by the use of audio and video links.

The framework shows the audio and video communication paths and the influences on each part of the communication chain in NMP (Figure 3.3). This is based on Shannon and Weaver's elements of a communication system (1949), which includes an information source (a musician), who transmits information via a channel (the NMP system), with the addition of noise (the latency and audio/video artefacts caused by transmission via the internet), which is received at its destination (another musician).

Each musician transmits and receives information simultaneously, and in the diagram, the communication chain is pictured as a continuous loop, with the receiving affecting the transmission, iteratively. Where there are more than two musicians, there could be a continuous loop between all pairs within the group, with musicians dividing their attention between each individual as they play.

There are three parts to the diagram: the two musicians at each end, with their actions mirroring one another, and the NMP system itself between the two musicians. There are influences on the two individuals, including their own experience and confidence in playing, which, in turn, affect what the musicians transmit through their body movements and the music played. These are also affected by the instrument played, conventions of the genre, and so forth, and the rhythmic content of the music will affect how successfully it is transmitted through the NMP communication chain. The body movements and music played is transmitted to the co-performer through the audio and video connections.

The impact of the audio and video link is affected by technical issues such as latency, jitter, and compression artefacts as well as the reduced field of view caused by the framing of the video camera and monitor. For example, how well these degraded signals are received is affected by the receiving musician's knowledge of the other player as well as how well they are able to listen to musical elements such as tuning and dynamics. Receiving musicians must then process this information and predict the consequences of their actions simultaneously (Maes et al., 2014). They react and play their part while making their own body movements, and the loop continues.

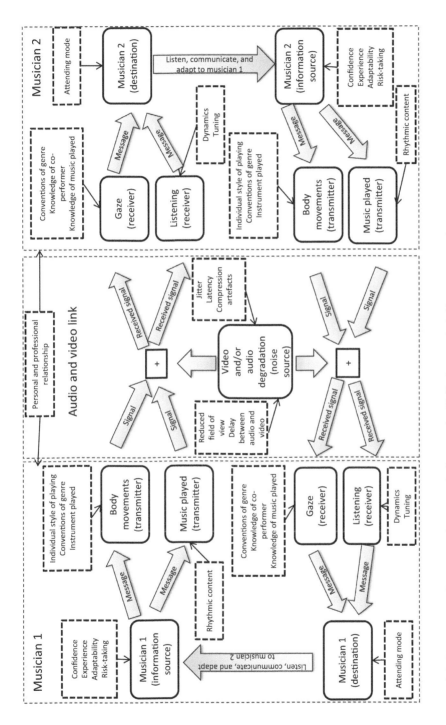

Figure 3.3 Playing together, apart framework (Iorwerth, 2019; Iorwerth & Knox, in press).

While some impacts on the communication chain are related to individual idiosyncrasies when playing (e.g., individual playing style and confidence), there are some more general effects, such as the rhythmic content of the music; the expertise and experience of the musicians in terms of their ability to divide their attention; the use of video (or not); and the socio-emotional and professional relationships between the musicians.

Practical considerations for synchronous NMP

In any NMP setting, the technical approach will need to be considered. In some cases, the availability of software and hardware may dictate the approaches taken, and in others, the level of experience of the musicians or the music itself. The following questions might be helpful when deciding on how to approach a project:

- What software and hardware do you have available? Do you plan to use dedicated NMP software? Does that software aim to reduce latency or deal with it in a different way? Are you planning to use software designed for speech communication?
- How experienced are your musicians? Will they be willing and able to alter their approach to playing music to fit the system you have in mind? Are your musicians able to play while hearing a delayed signal?
- How experienced are your musicians with setting up software? Do they have experience of recording?
- What music are you planning to play? Is it composed for a traditional performance setting, improvised, or composed specifically for NMP?
- What is the intended aim of the NMP? Is it for a performance in front of an audience? Is it for rehearsal or workshopping? Is the social interaction of the musicians more important than the musical outcome?
- How large is your ensemble? Is the planned approach accessible to all participants?

Case studies

The following case studies provide examples of projects that have used synchronous NMP in different contexts. They have been specifically chosen as they demonstrate synchronous NMP in a number of contexts, including for a large ensemble of amateur musicians, and for smaller groups of professional musicians. They also include a range of music, including traditionally composed and scored music, music using adaptive scores that react to what the musicians are playing, and more improvised sound art. They also use a range of synchronous NMP software, including accessible video conferencing systems, such as Zoom, as well as systems designed specifically for the particular composition performed. Finally, they include musicians in a range

of geographical locations and cultural contexts, although, of course, given the nature of NMP, they could be performed anywhere there is an internet connection.

Mosaic: Aria, Footsteps and Bells – *for Orchestra on Zoom by Peter Longworth*, 2021

Mosaic: Aria, Footsteps and Bells by Peter Longworth is a piece of music for orchestra to be performed on the video conferencing software Zoom, commissioned by the Helensburgh Orchestral Society and funded by Creative Scotland. The piece was premiered on 31 October 2021 as an online stream by the Helensburgh Orchestral Society, conducted by Robert Baxter.

The programme note explains the background to the piece:

> *Mosaic: Aria, Footsteps and Bells* is a celebration of community, and consists of three main strands which interact with one another throughout the piece. The work's principal idea is the aria (or perhaps, more accurately, "song without words") which pays homage to the unifying power of melody – particularly in the context of community music-making. Contrasting this is a livelier, musical depiction of footsteps: a reference to the notion of human movement or activity. These "footsteps" predominantly take the form of a walking bass, although occasional outbursts of castanets also provide a more literal imitation of the clatter of heeled shoes on cobbled streets.
>
> These two ideas, one lyrical and expressive, the other, playful, are punctuated at regular intervals by blocks of bell-like music, which represent the role that bells – and, by extension, music – have long played in bringing communities together in times of joy, grief, and even danger. The material for these episodes is derived from transcriptions that I made of bells in the Northern Italian town of Bergamo, shortly before the coronavirus hit the city. Bergamo was one of the first places in Europe to be affected by COVID-19, and suffered devastating casualties. It seemed, therefore, appropriate to include these allusions to the city's bells in this Covid-time work, as a small tribute to a place that has, for many years, been very close to my heart.
>
> "Mosaic", refers to my impression of the piece as a musical "image" comprised of many different timbres, all of which are heard in their purest, unaccompanied form (given that, on Zoom, it is essentially only realistic to hear one instrument at a time). The role of every instrument is, therefore, to contribute small musical "tiles" to a larger picture, but the technological limitation of only being able to hear each player individually also creates a sense of the piece as a prolonged conversation between an array of instruments – thereby showcasing the orchestra as a community of distinctive characters.

The piece was written specifically for the Helensburgh Orchestral Society to rehearse and perform entirely on Zoom. Before the piece was composed, the composer and the conductor of the orchestra had extensive discussions around what might work for the orchestra, including musically and socially, given that the orchestra could not meet up in person due to the COVID-19 pandemic.

From the outset, inclusion was an important factor in the project. Prior to the commission, the orchestra had been meeting on Zoom for rehearsals of orchestral repertoire. Clearly, using this system prevented the whole ensemble – of around 40 players – being heard at once due to the multiple latencies of Zoom. Under Baxter's lead, the orchestra would play as usual, with the exception that only one instrument would be unmuted at any one time. This might be for a phrase or a whole section. This had some advantages over the traditional rehearsals in a hall: members of the orchestra developed confidence to be heard playing on their own as well as listening carefully to their fellow musicians, and Baxter ensured the online environment was supportive for all players through encouragement and celebration of individual successes. In addition, the quality of playing was high as members perhaps practised more thoroughly as they knew they would be heard individually. Once this system of rehearsal was established, it was decided to commission a piece of music specifically for this environment.

Inclusion was at the heart of the project: any orchestra member who wanted to could take part, no matter what equipment they were using to access the video calls. Due to this, there was an expectation during the performance that any audio artefacts from Zoom would be accepted and used as part of the performance. Each individual was encouraged to use 'original sound' settings on Zoom – to switch off echo cancellation, noise reduction, and audio compression, and less technically proficient members were supported to do this. There was a range of equipment used to access the rehearsals and performance, including mobile phones, tablets as well as some musicians who had access to microphones, audio interfaces, and computers. There were some specific audio issues that kept recurring, mostly with musicians who were using iPads, where the original sound settings did not appear to be working. In some cases, audio quality fluctuated wildly between weekly rehearsals. These were accepted as quirks of working on Zoom and did not impact majorly on rehearsals.

Discussions between Longworth and Baxter included identifying strengths of the orchestra and writing parts that would both challenge and be achievable for individual members. Due to the method of only hearing one instrument at once, Longworth had to consider how to include harmonic elements within the piece, and did this by including piano and tuned percussion parts as well as using melodies to imply harmony. The melody of the piece moves between instruments, and given the small geographic area covered by the orchestra (around 30 km between the most distant members of the orchestra),

latency caused by physical distance was not a major factor in this project, although, of course, the signals will have travelled much further than this due to routing of packets in the internet. Small pauses between the parts did not impact on the piece, and the conductor's role was to help the musicians with the structure of the piece through hand signals rather than specifically give timing cues.

Given that there was only one instrument heard at once, the distribution of melodies around the orchestra was fairly even between different instruments. This caused some consternation in some sections of the orchestra who were used to playing constantly in orchestral music, however, this gave an opportunity for the conductor to discuss how the piece allowed everyone's part to be equally important.

Scoring of the piece was slightly different to a conventional orchestral piece. Included on each part were indications of where musicians should mute and unmute, with some phrases having multiple options for instruments, and therefore these were negotiated during rehearsals and marked on individual parts. Given the limited amount each part was playing, in conventional orchestral parts, multiple bars of rest would be marked in blocks throughout the piece. As there was no beat kept by the conductor and many tempo changes throughout the piece, it was not possible for the musicians to count multiple bars of rests. This meant that every part had to include cues in every bar of the piece (Figure 3.4).

From a performance point of view, the piece required a great deal of concentration from all the members of the orchestra to ensure they muted and unmuted their microphones at the correct time as well as following the cues throughout the piece. One of the challenges of performance of this piece was ensuring the correct tempo of each individual segment. In an orchestral setting, the conductor sets the tempo with their hand signals, but as this was not possible through Zoom, each player had to follow the tempo markings on their score. Some of the musicians tended to play slower than the tempo markings, perhaps due to the additional concentration required following cues. This could have been resolved fairly easily with further rehearsal time.

F. Not F. *by Rebekah Wilson, 2019*

For two or more musicians in two or more locations

Rebekah Wilson is a composer and co-founder and director of technology for Source Elements, who specialises in high-fidelity, real-time audio delivery over IP. She embraces the network environment in her compositions, and uses technological tools to overcome some of the challenges of working through the internet as well as take advantage of the creative possibilities of the environment.

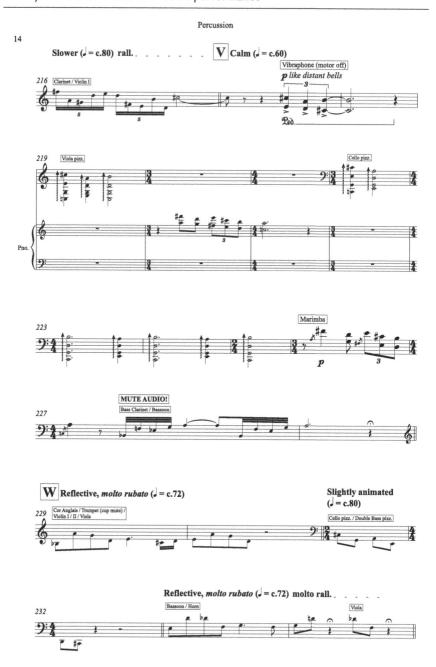

Figure 3.4 Excerpt of *Mosaic* score by Peter Longworth.

F. not F. was originally an experiment in exploring whether machines can facilitate the experience of being together while at a distance. Musicians use visual and audible cues to communicate with one another around synchronising their performances, which are interrupted using NMP. This composition uses machines to manage these cues and to communicate these to the performers. The composition has several versions, each building on the ideas of the previous one, and can be modified for different combinations of instruments.

In this piece, the score both mediates the performance and provides timing cues (rather than timing cues coming from other musicians or a conductor in a typical co-located performance). This piece can be performed with musicians at any distance – from separate rooms in the same building to across continents. Latency is not an obstacle to the performance, rather, it is embraced as part of the performance, so even large distances (and therefore longer latencies) do not impact on the ability of musicians to perform the piece.

The process of performing the work includes several stages. In the first, Wilson provides a number of phrases for the musicians, suitable and adaptable for the particular instruments and musicians who are performing: a series of notes to select from, a tempo, and a rhythmic series. Electronic scores are provided to the musicians through tablets, which change as the piece develops. Prior to the performance, short recordings of these phrases are also used to train a machine learning model in order to recognise positive alignment of two of these phrases.

The performance note for the piece explains what happens next:

As the musicians begin they play the first iteration of the series independently according to their own preparation. As the remote interpretation arrives, the musician hears new possible formations and may choose to reiterate or modify their interpretation. As the series repeats, the musicians' notes build upon each other, creating unexpected harmonic and rhythmic coincidences due to the latency and interaction of the repeating structures and the differences in interpretation. Simultaneously, the software engine listens to the intersection of notes and determines an ever-changing correlation ratio: as the interpretation ratio gets higher, i.e., synchronisations occur between musicians, elements of the score begins to blur, twitch and animate—becoming increasingly illegible—and on those notes where that synchronisation occurs the computer emits a sympathetic accompaniment. The musicians may choose to purposefully de-synchronise or strengthen their synchronisation towards a growing intensity. Eventually, the section might become completely blurred and the musicians may decide to end that section. When a certain duration of silence is detected, the score moves to the next section where the cycle repeats with a new

series. After a fixed number of cycles the work ends. The length of the performance is determined by the musicians, who may choose to work with a timer for each sequence for example.

There are particular technical requirements for the piece that go beyond a typical live performance. First, each musician must have a tablet to display the score, which is generated in real time by a computer. Each musician's computer and tablet must be on the same Wi-Fi network, in order for the tablets to receive the scores. As the score reacts to the incoming sounds from each performer, each instrument requires a separate microphone or other audio output which feeds into the sound engine producing the score. The sounds from each of the instruments are also sent across the internet to performers in other spaces. The musicians also require monitors to be able to hear the other players, both in the same space and remotely.

Despite the seemingly highly technical nature of the piece, none of the equipment requirements to perform it are particularly specialist, and it would be possible for most sound technicians or musicians to set up fairly easily. Wilson provides the specialist software and technical guidance needed to perform the piece.

This piece is an excellent example of an approach to synchronous NMP for several reasons:

- The use of intelligent scores to provide timing cues is a clever way of embracing the latency that will be present in the broadband connection;
- Performances of the piece are possible with typical broadband connections that might be found domestically – it does not rely on superfast internet that might be found in academic institutions (although if available, these can also be used);
- The piece is flexible in its number of performers, their locations in relation to one another, and the instruments used;
- The piece has an improvisatory element that is suitable for NMP environments; however, this is guided by the score, so the composer is able to at least guide, if not dictate, the musical content and style of the piece.

HEYA. Performing agency: women, networks, and experimental music and sound art

Heya ('she' in Arabic and also a friendly greeting in English) is a project that works towards bridging women who make sound, noise, field recordings, experimental music, and electronic music with a global audience. The project aims to broaden people's understanding of women in the Middle East in different contexts within music, including electronic and experimental music and also technology. The aim is for audiences to relate to the musicians as individuals rather than 'other', and to address the visual representation of

women in general, women of colour, and women from the Middle East in the areas of music and technology.

There are currently four musicians who are part of the group:

- Jilliene Sellner (UK) – field recordings, vocals, clarinet;
- Zeynep Ayşe Hatipoğlu (Istanbul) – cello, vocals;
- Nour Sokhon (Beirut) – field recordings, spoken word;
- Yara Mekawei (Cairo) – field recordings, spoken word.

The project started in 2018, and at the time of writing (2022), not all the musicians had met one another in person. Live networking was used in the project to overcome the difficulties of freedom of movement for some of the participants, whether this was due to the cost of travel, the need for visas, or permission from their home country to leave to work on a project of this kind. Since the project started, the COVID-19 pandemic has also impacted on the ability of the musicians to travel.

The musicians work together sharing their sounds through the internet, on improvisational, live jammed music using acoustic instruments, recordings, and electronics. They each use the DAW (digital audio workstation) Ableton to process field recordings, their own instrumental sounds, or those received from others in real time. They do not rehearse, but sometimes run through ideas in advance of a performance. There is no creative leader within the group, and they sometimes use Open Scores to allow creative direction from different members of the group. Works written for Open Score are flexibly scored, which means that the parts are not instrument-specific; instead, the composer specifies the range of the instruments (e.g., high, medium, and low) and each ensemble decides upon which players should play each part (Jones, 2022).

Each performance by the group is an experiment with no fixed methods for connecting online. The group originally used liveSHOUT, an interactive audio streaming mobile app, designed to facilitate multiple streaming points which can be mixed together via the Locus Sonus sound map. Each group member streamed sounds from their mobile phone using the app, which were then mixed together by Sellner. This worked well for the streaming of acoustic instruments such as the cello or for local environmental sounds of the cities, however, there was no direct input to the app from DAWs. The output of the DAWs had to be played back through loudspeakers and then picked up through the microphone of a mobile phone before streaming, therefore impacting on the sound quality.

Pre-COVID, Heya attempted to use Zoom for their jams, but found that the sound quality was not good enough for their purposes. Recent improvements in the software (including the 'original sound' feature) mean that they have used it subsequently. They route the sound from Ableton directly into Zoom (those with Macs use Soundflower for routing and those with Windows

use Virtual Audio Cable), which results in no sound from the device's microphone being routed into Zoom. This means that the musicians cannot speak to one another when playing, and they use the chat function for text-based communication.

The group's first live public performance was in January 2020 at Arts Birthday. The musicians were located in Vienna and Berlin (at radio stations), and Istanbul and Cairo (at the musicians' homes). The radio stations were connected through European satellites used for radio broadcasting and the musicians in Istanbul and Cairo used liveSHOUT to connect to Sellner's computer in Vienna. A team of engineers were balancing the sound at the two radio stations, which had much higher levels than the sound coming from liveSHOUT as well as far more latency than the audio feeds from the satellites. The performance was to a live audience, and was used as a demonstration of the possibilities of the ensemble, with a talk afterwards to explain the rationale of the performance.

The group often use text-based chat apps to communicate when technical issues arise. In some cases, not all musicians can hear each other, however, performances go ahead despite major technical issues, and this highlights the importance of the musicians listening to one another. They do not use video to communicate visual musical cues – the musical content is entirely derived through listening and responding to one another through improvisation and call and response using sound. The video elements of any performances usually feature the locations where the musicians are based. Given the nature of the music they produce, which is experimental, entirely improvised, and not beat-based, latency does not cause any challenges for Heya, even up to several seconds.

Heya do, however, face some particular technical challenges in the way they work. The electricity supply in Beirut is very intermittent, with Sokhon often having to use just her mobile phone and a 3G mobile internet connection (the average speed of a 3G connection is 3 Mb/s), therefore reducing the audio quality of her stream and increasing latency. These issues highlight how unreliable internet and electricity supplies can be in the Middle East. The musicians expect imperfect performances, and challenges are part of the process for the musicians, so are enjoyable to them, and they are open to spontaneity. Given that the performances are live jams and each musician hears something different in their own locations, they do not know how the audience experiences the music, which is part of the experimental aspect of the project. They counteract technical challenges by trying to listen very well to one another and allow spaces for each other to play.

In addition to Heya's live performances, they have also used asynchronous NMP to produce a showreel of work, free from some of the technical challenges of working live and allowing for a more polished final performance. Using Ableton, one musician produces one or two audio parts that are then sent to the next person, who also adds one or two parts, and so on. This compositional process repeats and usually goes around to every musician twice. Usually, each musician would work with the separate parts, allowing

for mixing at each stage; however, there are specific issues in parts of the Middle East around access to the internet and power outages. In order to reduce file sizes, these parts are sometimes mixed to a stereo file that can then be added to.

The philosophy of the group is to find accessible and creative ways to use the devices they have available to them and that suit the musicians' skills and experience rather than to obtain specialist equipment. They work together to overcome significant technical challenges and embrace these challenges as a feature of the music. The musicians have had to accept that there is an element of not being in control of performances: it is not just the musicians influencing the performance but also fluctuations in internet connections and potentially the input of sound engineers at multiple locations.

This project has taught the musicians not to be perfectionist about how they work and not to be fixed in their ideas of whether the performances should be live or not. Sometimes, live performances just do not work at the time of a performance, so they revert to using recordings instead. If the traffic is particularly bad in Cairo and she cannot get home in time, Mekawei will record from her car. They are constantly adapting to difficult situations, and because the project started off in such difficult conditions, this adaptation is now seen as a normal and welcome part of the project.

Chapter summary

In synchronous NMP, musicians interact with one another musically in real time (or very close to real time). This chapter has examined some of the challenges and affordances of working this way. It has looked at latency and how musicians can manage this through approaches to working. It has also looked at some of the practical elements of working synchronously, including issues of monitoring and video use. Musical issues have also been discussed, including music that works well in the synchronous NMP environment and approaches that composers might take when writing music for synchronous NMP settings. Communication between musicians is a major facet of synchronous NMP, so a framework for communication was discussed as a way of examining the many different impacts on communication for musicians working synchronously. Finally, three case studies were included in which the composers and participants take very different approaches to the challenges of synchronous NMP.

References and further reading

Alexandraki, C., & Bader, R. (2014) 'Using computer accompaniment to assist networked music performance'. In *AES 53rd International Conference*. London, UK, pp. 1–10.
Alexandraki, C., & Bader, R. (2016) 'Anticipatory networked communications for live musical interactions of acoustic instruments', *Journal of New Music Research*, 45(1), pp. 68–85.

Barbosa, Á. (2003) 'Displaced soundscapes: A survey of network systems for music and sonic art creation', *Leonardo Music Journal*, *13*, pp. 53–59. https://doi.org/10.1162/096112104322750791

Blaine, T., & Fels, S. (2003a) 'Collaborative musical experiences for novices', *Journal of New Music Research*, *32*(4), pp. 411–428.

Blaine, T., & Fels, S. (2003b) 'Contexts of collaborative musical experiences'. In *Proceedings of the 2003 Conference on New Interfaces for Musical Expression (NIME-03)*. Montreal, pp. 129–134.

Blank, M., & Davidson, J. W. (2007) 'An exploration of the effects of musical and social factors in piano duo collaborations', *Psychology of Music*, *35*(2), pp. 231–248.

Broughton, M., & Stevens, C. (2009) 'Music, movement and marimba: An investigation of the role of movement and gesture in communicating musical expression to an audience', *Psychology of Music*, *37*(2), pp. 137–153. https://doi.org/10.1177/0305735608094511

Brümmer, L. (2021) *The Hub: Pioneers of Network Music*. ZKM | Hertz-Lab, Karlsruhe.

Cáceres, J.-P., & Hamilton, R. (2008) 'To the edge with China: Explorations in network performance'. In *ARTECH 2008, 4th International Conference on Digital Arts*, pp. 61–66.

Cage, J. (1968) *Silence: Lectures and Writings*. London: Calder and Boyars Ltd.

Carôt, A., & Schuller, G. (2011) 'Applying video to low delayed audio streams in bandwidth limited networks'. In *Audio Engineering Society Conference: 44th International Conference: Audio Networking*, San Diego, CA, pp. 1–6.

Carôt, A., Krämer, U., & Schuller, G. (2006) 'Network Music Performance (NMP) in narrow band networks'. In *Proceedings of the 120th Convention of the Audio Engineering Society*. Paris, France, pp.1–9.

Carôt, A., & Werner, C. (2007) 'Network music performance – problems, approaches and perspectives'. In *Proceedings of "Music in the Global Village" Conference, September 6–8, 2007*. Budapest, Hungary, pp. 1–13.

Carôt, A., Werner, C., & Fischinger, T. (2009) 'Towards a comprehensive cognitive analysis of delay-influenced rhythmic interaction'. In *Proceedings of the International Computer Music Conference (ICMC) 2009*, Montreal, Canada.

Chafe, C. (2009) 'Tapping into the internet as an acoustical/musical medium', *Contemporary Music Review*, *28*(4–5), pp. 413–420.

Chafe, C., & Gurevich, M. (2004) 'Network time delay and ensemble accuracy: Effects of latency, asymmetry', In *Proceedings of the 117th Convention of the Audio Engineering Society*, San Francisco, CA.

Chafe, C., Cáceres, J.-P., & Gurevich, M. (2010) 'Effect of temporal separation on synchronization in rhythmic performance', *Perception*, *39*(7), pp. 982–992. https://doi.org/10.1068/p6465

Chew, E., Zimmermann, R., Sawchuk, A. A., Kyriakakis, C., Papadopoulos, C., François, A. R. J., Kim, G., Rizzo, A., & Volk, A. (2004) 'Musical interaction at a distance: Distributed immersive performance', In *Proceedings of the Music Network Fourth Open Workshop on Integration of Music in Multimedia Applications*, Barcelona, Spain, pp. 1–10.

Clayton, M. (2012) 'What is entrainment? Definition and applications in musical research', *Empirical Musicology Review*, *7*(1–2), pp. 49–56.

Cockos Incorporated (2022) *NINJAM*. Available at: https://www.cockos.com/ninjam/ (Accessed: 30th June 2022).

Collins, N., & McLean, A. (2014) 'Algorave: A survey of the history, aesthetics and technology of live performance of algorithmic electronic dance music'. In *Proceedings of the 14th International Conference on New Interfaces for Musical Expression*. London, UK, pp. 355–358.

Çorlu, M., Muller, C., Desmet, F., & Leman, M. (2014) 'The consequences of additional cognitive load on performing musicians', *Psychology of Music*, 43(4), pp. 495–510. https://doi.org/10.1177/0305735613519841

Daffern, H., Balmer, K., & Brereton, J. (2021) 'Singing together, yet apart: The experience of UK choir members and facilitators during the Covid-19 pandemic', *Frontiers in Psychology*, 12, p. 303.

Ginsborg, J., & King, E. C. (2012) 'Rehearsal talk: Familiarity and expertise in singer-pianist duos', *Musicae Scientiae*, 16(2), pp. 148–167. https://doi.org/10.1177/1029864911435733

Gurevich, M. (2006) 'JamSpace: A networked real-time collaborative music environment'. In *Proceedings of ACM CHI 2006 Conference on Human Factors in Computing Systems*, Montreal, Canada, pp. 821–826.

Hargreaves, D. J., MacDonald, R., & Miell, D. (2005) 'How do people communicate using music?'. In Miell, D., MacDonald, R., & Hargreaves, D. J. (eds.), *Musical Communication*. Oxford: Oxford University Press, pp. 1–31.

Iorwerth, M. (2019) *Playing together, apart: An exploration of the challenges of Networked Music Performance in informal contexts*, PhD thesis, Glasgow Caledonian University, Glasgow.

Iorwerth, M., & Knox, D. (in press) 'The Playing Together, Apart Framework: a framework for communication in Networked Music Performance', *Journal of Music, Technology and Education*.

JackTrip (2022) *Welcome to JackTrip*. Available at: https://jacktrip.github.io/jacktrip/ (Accessed: 30th June 2022).

JackTrip Foundation (2022). *JackTrip Foundation*. Available at: https://www.jacktrip.org/ (Accessed: 30th June 2022).

Jisc (2018) *Videoconferencing traffic: Network requirements*. Available at: https://community.jisc.ac.uk/library/videoconferencing-booking-service/videoconferencing-traffic-network-requirements (Accessed: 30th October 2018).

Jones, H. (2022) *Open Score (1)*. Available from: http://www.coma.org/wp-content/uploads/Open-Score-Aboutx5.pdf (Accessed: 7th February 2022).

Keller, P. E. (2001) 'Attentional resource allocation in musical ensemble performance', *Psychology of Music*, 29(1), pp. 20–38.

Keller, P. E. (2008) 'Joint action in music performance'. In Morganti, F., Carassa, A., & Riva, G. (eds.), *Enacting Intersubjectivity: A Cognitive and Social Perspective on the Study of Interactions*. Amsterdam: IOS Press, pp. 205–221.

Keller, P. E. (2014) 'Ensemble performance: Interpersonal alignment of musical expression'. In Fabian, D., Timmers, R., & Schubert, E. (eds.), *Expressiveness in Music Performance: Empirical Approaches across Styles and Cultures*. Oxford: Oxford University Press, pp. 260–282.

Kruse, N. B., Harlos, S. C., Callahan, R. M., & Herring, M. L. (2013) Skype music lessons in the academy: Intersections of music education, applied music and technology. *Journal of Music, Technology and Education*, 6(1), 43–60. https://doi.org/10.1386/jmte.6.1.43_1

Lago, N. P., & Kon, F. (2004) 'The quest for low latency'. In *Proceedings of the International Computer Music Conference*, Miami, FL, pp. 33–36.

LoLa (2020) *LoLa Low Latency AV Streaming System*. Available at: https://lola.conts.it/ (Accessed: 11th February 2022).

Loveridge, B. (2020) 'Networked music performance in virtual reality: Current perspectives', *Journal of Network Music and Arts*, 2(1), pp. 2–20.

Maes, P.-J. et al. (2014) 'Action-based effects on music perception', *Frontiers in Psychology*, 4 (January), pp. 1–14.

Mills, R. (2011) 'Ethernet Orchestra: Interdisciplinary cross-cultural interaction in networked improvisation performance', *The 17th International Symposium on Electronic Art*, Istanbul, Turkey.

Mills, R., Slawig, M., & Utermöhlen, E. (2016) 'Flight of the sea swallow: A crossreality telematic performance', *Leonardo*, 49(1), pp. 68–69. https://doi.org/10.1162/LEON

Murnighan, J. K., & Conlon, D. E. (1991) 'The dynamics of intense work groups: A study of British string quartets', *Administrative Science Quarterly*, 36(2), pp. 165–186.

Oda, R., Finkelstein, A., & Fiebrink, R. (2013) 'Towards note-level prediction for networked music performance'. In *Proceedings of the International Conference on New Interfaces for Musical Expression*, Daejeon, Korea, pp. 94–97.

Poli, G. de. (2004) 'Methodologies for expressiveness modelling of and for music performance', *Journal of New Music Research*, 33(3), pp. 189–202. https://doi.org/10.1080/0929821042000317796

Rasch, R. A. (1979) 'Synchronization in performed ensemble music', *Acta Acustica united with Acustica*, 43(2), pp. 121–131.

Renaud, A., Carôt, A., & Rebelo, P. (2007), 'Networked music performance: State of the art', *AES 30th International Conference*, 4, pp. 1–7.

Rofe, M., & Geelhoed, E. (2017) 'Composing for a latency-rich environment', *Journal of Music, Technology and Education*, 10(2+3), pp. 231–255. https://doi.org/10.1386/jmte.10.2-3.231

Rofe, M., & Reuben, F. (2017) 'Telematic performance and the challenge of latency', *Journal of Music, Technology and Education*, 10(2+3), pp. 167–183.

Scholz, C. (2021) 'One upon a time in California'. In Brümmer, L. (ed.), The Hub: Pioneers of Network Music. Karlsruhe: ZKM | Hertz-Lab, pp. 42–66.

Schutz, M. (2008) 'Seeing Music? What musicians need to know about vision', *Empirical Musicology Review*, 3(3), pp. 83–108.

Seddon, F., & Biasutti, M. (2009) 'Modes of communication between members of a string quartet', *Psychology of Music*, 37(4), pp. 395–415. https://doi.org/10.1177/1046496408329277

Shannon, C. E., & Weaver, W. (1949) *The Mathematical Theory of Communication*, Urbana: The University of Illinois Press.

Stone, P. (2021) 'Non-mathematical musings on information theory and networked musical practice', *Organised Sound*, 26(3), pp. 327–332. https://doi.org/10.1017/S1355771821000418

Volpe, G. et al. (2016) 'Measuring social interaction in music ensembles', *Philosophical Transactions of the Royal Society B: Biological Sciences*, 371(1693), https://doi.org/10.1098/rstb.2015.0377.

Weinberg, G. (2002) 'The aesthetics, history, and future challenges of interconnected music networks'. In *Proceedings of the 2002 International Computer Music Conference*. Gothenburg, Sweden, pp. 349–356.

Wilson, R. (2020) 'Aesthetic and technical strategies for networked music performance', *AI & Society*, pp. 1–14.

Yamaha Corporation (2021) *Yamaha Disklavier Connects Continents for Premium Musical Education*. Available at: https://europe.yamaha.com/en/news_events/2021/yamaha_disklavier_connects_continents.html (Accessed: 30th June 2022).

Chapter 4

Asynchronous networked music performance

Introduction

Asynchronous networked music performance (NMP) can be described as any ensemble musical project that uses networks to share audio or video files, where the musicians are not working in real time. There are many methods within asynchronous NMP, and these may include sending and receiving audio files and building up multitrack mixes in individual musician's digital audio workstations (DAWs); using online collaborative recording apps or cloud-based shared file storage; and assembling virtual ensemble videos for sharing online. Asynchronous NMP is different to the synchronous approach, in that the output is often a completed musical product – an audio or video recording – rather than a real-time event. This, of course, may be an element of a wider project with live elements, but the main characteristic of asynchronous NMP is that it does not happen in real time.

Asynchronous NMP may include both audio and video or may be audio only. Musicians at all levels can take part in this approach, however, some technical expertise is required at the mixing stage to produce the final audio or video file. There is theoretically no limit on the number of participants when working asynchronously, although larger numbers will result in more complexity in the mixing process or the collaboration process for fully collaborative projects.

As discussed in Chapter 1, not all approaches to NMP include performance in the traditional sense – that is, live and to a gathered audience. The performance element of asynchronous NMP comes through recordings that are made by the participants. In some forms of music, such as electronic dance music, recording is the main method for the creation and presentation of the music, and is therefore well-suited to asynchronous NMP.

Asynchronous NMP methods

Methods for asynchronous NMP include:

- Virtual ensemble – musicians send audio/video recordings to a central location for mixing and production of a final audio/video file. This is suitable

DOI: 10.4324/9781003268857-4

for pre-composed music, and the musicians play along to a guide audio or video file.
- Collaborative recording – audio files are sent to collaborators, responded to, built upon, sent backwards and forwards, and the remote collaboration is part of the creative process. Musicians may be working on different DAWs.
- Software to connect DAWs for remote recording – the equivalent to multi-tracking in a studio, but remotely.

The aim of some recordings produced this way is to highlight what can be achieved at a distance and to celebrate community. In other cases, the methods used are incidental (e.g., when recording a piece of music for release) and listeners may never know that this was the method used. In some ways, asynchronous NMP has similarities to overdubbing tracks in a studio, where musicians are playing along to pre-recorded tracks rather than playing together simultaneously.

Many virtual ensemble recordings have been produced as a result of the COVID-19 pandemic as projects to keep community music groups active while they could not meet to rehearse. This approach is fairly straightforward for the musicians involved (although less so for the person assembling the recording), so was very suitable for many groups during this time. Asynchronous NMP is not new, however.

The first documented online band project – ResRocket – took place in 1994 with over 1,000 participants, who exchanged ideas and files via a mailing list and FTP (file transfer protocol) server (Hajimichael, 2011). Considering the speeds of domestic internet at this time (dial-up internet has a maximum speed of 56 kb/s), this project must have required a lot of patience when downloading and uploading files. Since then, access to asynchronous NMP has greatly increased due to the development of accessible and affordable DAWs and improved access to the internet.

Composer Eric Whitacre's *Virtual Choir* was the first large-scale asynchronous NMP project to reach a wide audience, starting in 2010 with 185 singers and building to 17,500 in 2020 (Whitacre, 2022). Contributions for this choir are recorded by the singers using mobile phones and the videos edited together centrally by Whitacre's technical team. This method and format of presentation became the conventional way of approaching virtual ensembles, however, there are many other creative possibilities that can be explored in virtual ensembles.

As Klein (2015) highlights:

> In reality, projects like The Virtual Choir were not radical. Whitacre used mainstream technologies and located his undertaking within the world's largest online video platform; the premise was not unique; and the first

three works Whitacre presented on this medium stylistically conformed to the classical a cappella choral genre without any confrontation beyond their medium of performance.

They admit however that the online medium challenges traditional divisions between audience members and performers – in the *Virtual Choir* they are often both – by using YouTube as a replacement for the concert hall environment. It could also be argued that the accessibility of the *Virtual Choir* was radical: anyone with a mobile phone can make a submission to the recording wherever they are in the world and whatever their musical experience.

Klein (2015) goes on to note that some elements of classical performance are still evident in these projects: Whitacre assuming the role of conductor (although, of course, in the final video this serves no functional purpose) and the arrangement of the singers on the screen in a more or less conventional choral set-up. This confirms the sense of hierarchy and the lack of interaction by the singers in the process. Whitacre's use of social media and audience engagement (the audience are also the participants) has, however, allowed him to reach many more people than most contemporary classical composers.

The process of a virtual ensemble is shown in Figure 4.1. There is a producer and/or editor, who prepares the materials to be sent to the contributing musicians. Each musician uses these materials (usually a guide audio track and perhaps a guide video track) to play or sing along to as they record their contribution. The musicians then send their individual audio/video files back to the producer and/or editor, who mixes all of these contributions into a final audio or video file. In these types of recordings, the musical content is very fixed at the start of the project, and is therefore suitable for large groups of musicians, where the performance element is more important than group creativity. It might also be used for large-scale recordings where there are multiple musicians singing or playing the same parts – in a choir, for example.

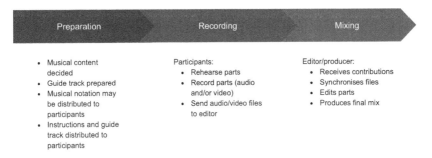

Figure 4.1 Virtual ensemble process.

In contrast, a collaborative recording involves musical contributions that get passed between musicians and added to. The process of a collaborative recording is much more open than that of a virtual ensemble, in that the musical content will probably not be fixed by the musicians at the outset of the project, with new contributions impacting on the development of the music, in an iterative process. At each stage of the process, the musicians will hear all the parts that have been contributed previously and there may be many mixes of the final recording. This process lends itself well to collaborative composition and gives space for a great deal of creativity. It is likely that in a setting such as this, musicians are likely to contribute unique parts to the collaboration, unless they are aiming for a specific sound, such as layering an individual part multiple times.

There are no set ways that musicians work within a collaborative recording, and two examples of ways to approach the collaborative process are outlined below. There are, of course, many ways that these two approaches could be combined, and theoretically, any number of musicians could take part. However, there are practical limits to this, based on the musical content of the collaboration as well as track limits for DAWs.

Figure 4.2 shows an example of a collaborative recording with three collaborators taking a cycle approach to the recording. At each stage of the cycle, the musicians receive audio files from the previous musician, create their own contributions, and send these to the next musician. In this example, the third musician creates a mix of all the parts.

Figure 4.3 shows an example of a hub approach to collaborative recording, where the audio files are stored in a central location for all contributors to

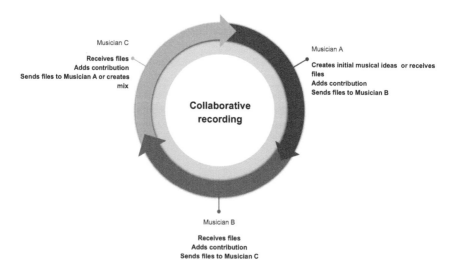

Figure 4.2 Collaborative recording cycle approach.

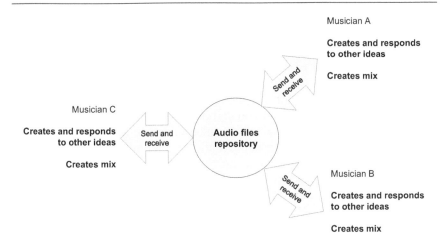

Figure 4.3 Collaborative recording hub approach.

access at any time. Musicians can add to this repository of files and work with files from other musicians as they see fit, and all musicians can make their own (potentially contrasting) mixes from the available audio files.

In both virtual ensemble and collaborative recording, the musicians taking part may already be known to one another or they may come together specifically for the project as a result of a call for contributions. There are many online collaborative platforms that also include a social element to build communities around music performance and collaboration and are not limited by geographical location. Within these communities, individual musicians may request contributions from specific instrumentalists or they may look more generally for collaborators.

The two approaches above suggest a fairly equal role between all collaborators, but there may also be approaches where one musician takes creative control, acting as a producer on the project. Koszolko (2015) provides a detailed account of the process when working on online asynchronous projects with unknown musicians. This process includes pre-production, initial composition, inviting collaborators, collaboration – additional composition, adjourning, mastering, and distribution. Working in this way provides opportunities for new musical relationships, however, there are some pitfalls compared to working within already established partnerships. In particular, Koszolko (*ibid.*) highlights the transient nature of some of these relationships. Although they are easy to form through online connections, without a pre-existing relationship there may be little incentive for musicians to follow through on offers for contributions to a project. The biggest impact of this is likely to be on the time taken to complete a project, which is likely to be much greater than in a conventional, in-person, collaborative music project.

In remote recording sessions, the process of file sharing might happen in the background and in some cases, in almost real time. Despite this, remote recording sessions are still a subset of asynchronous NMP because musicians will record individual parts separated both geographically and temporally (i.e., they will not be recording parts at the same time as others in different locations), and they are not designed to be presented to a live audience. Despite the geographical separation of musicians, for the musicians involved in sessions like this, there may be very little difference in their way of working compared to working in a traditional studio setting where the parts are recorded separately using overdubs. In studio recordings, the engineer and producer are usually in a separate control room, so the difference in remote recording is that the control room may be on a different continent rather than the room next door.

The level of experience of musicians and their available equipment will have an impact on the audio and video quality of an asynchronous NMP project. It is possible to create recordings at a professional level using these methods with appropriate equipment, suitable recording techniques and environments, and experienced musicians. However, it is also possible to produce acceptable recordings with minimal recording equipment and experience, as long as musicians are willing to follow guidance on how to use the equipment that they have available and that a suitably experienced person is available to edit together the recordings.

There is much less academic research on asynchronous NMP than synchronous NMP. There may be several reasons for this, including that it is seen as having fewer technical challenges than synchronous NMP, and is perhaps less interesting to researchers. Many of the participants may also be working commercially, such as through remote voice-overs or as music producers, and are therefore not in the academic field. It may also be seen as an activity that is a fun addition to in-person collaborative music making rather than a potentially serious part of a musician's portfolio of activity. There are, however, many potential research questions around asynchronous NMP, particularly in respect to the creative affordances it offers musicians.

In a virtual ensemble, often the output of the project, that is, the final recording, is the most important aspect of the project, and the underlying processes are hidden from public view. There is also a risk of these processes becoming entirely technical, with little focus on the musical aspects of a project. In a collaborative recording, the creative process must be important or no music would be created, while the technical processes – although important – are secondary.

Technical issues

This section is focused on the technical issues around virtual ensemble and collaborative recording approaches. Those working in a remote studio set-up

will probably be familiar with recording in a professional environment. Specific issues relating to remote studios are discussed later in the chapter.

Latency is not a consideration in asynchronous NMP, as files are transferred at the musicians' leisure via the internet. It may, therefore, be tempting to believe that asynchronous NMP is more technically straightforward than synchronous approaches. Whether this is true will very much depend on exactly what approach is taken to any collaboration. In a virtual ensemble recording, for example, this may be the case for the musicians recording their individual parts, but perhaps not for the person who has to assemble each part into a finished recording. The use of video alongside audio adds an extra layer of complexity in this respect. For more collaborative recordings, where the musicians are familiar with the technical processes required to share files, this is a fairly straightforward process.

There are some key musical issues that must be considered before starting a recording of this nature. These include ensuring there are common tuning and timing references for the musicians to work from. In some cases, this may be provided through the use of an audio guide track (which may include a metronome as well as a melody line or accompaniment) or a video guide track with a conductor, for example. What is provided to the contributing musicians will very much depend on the overall approach to the recording. For example, in a virtual ensemble, all the musicians will work independently, while in a more collaborative recording, individual parts may get sent backwards and forwards and refined many times.

It is important that during the recording stage, the guide track does not spill onto the recording to avoid problems at the mixing stage, and for those inexperienced at recording, this should be explicitly stated. Unless the musicians are recording using a DAW, the guide track will need to be played back on a separate device and headphones should be used to monitor this playback. As in synchronous NMP, the use of headphones can impact on the musicians' ability to hear themselves playing and affect tuning, for example. In this case, musicians can either remove or partially remove one headphone to allow them to hear the sound of their own instrument or their voice better. It may be worth asking participants to try this out and check that the guide track is not spilling into the recording before they submit it to the producer/editor.

Depending on the equipment available to musicians, parts may be recorded using the microphones built into devices, such as mobile phones or tablets, or using microphones and audio interfaces. Chapter 2 includes further details on specific recording techniques that may be encountered in NMP. Whatever equipment is available to musicians, good recording techniques should be considered, including microphone placement. Options, however, may be limited if using a device to record audio and video simultaneously. It will be up to the producer of the recording to consider what is most important to them and provide instructions to participants accordingly. It would always

be advisable to ask musicians to play back and listen to their own recordings to check for obvious technical issues before submission.

It may be obvious to those experienced at recording that each part should be recorded independently. Particularly among inexperienced musicians, there may be a sense that recording two parts in the same audio/video might be more efficient, however, this adds difficulty in balancing the parts in the mixing stages. Even for those musicians who are sharing the same physical space and playing or singing the same musical part, each individual contribution should be recorded and submitted as separate audio/video files.

At the recording stage, musicians should also consider their recording environment. This includes both background noise and the acoustics of the recording space. Background noise should be minimised by switching off noisy household electrical appliances, such as washing machines, and closing windows and doors to prevent the spill of sounds from other parts of the house and beyond. Some contributors may live in inherently noisy places, and noise can be reduced by considering microphone placement and aiming for as much direct sound from the instrument as possible.

Musicians may be tempted to record in reverberant spaces (such as bathrooms or hallways) as these are pleasant places to hear oneself play. Deader acoustic spaces, such as living rooms and bedrooms with soft furnishings, are better for recording parts of NMP projects as they reduce the effect of multiple acoustic spaces 'competing' in the mix, as we explore later in this chapter. Again, placing microphones closer to the musician will increase the ratio of direct to reverberant sound.

Guide tracks

A guide track is a recording that musicians play back while they are recording to provide tuning and timing references as well as a structure to the piece they are recording. Guide tracks are relevant to both virtual ensemble and collaborative recording approaches to asynchronous NMP, as they provide a framework to record multiple tracks around and provide a structure for other musicians to work with. Often, these guide tracks are not used in the final mix, as they are not part of the intended output of the recording. An example of this may be a piano reduction of an ultimately unaccompanied choir piece or a MIDI (musical instrument digital interface) drum track that is used instead of a click track. Sometimes, if the musical content of the guide track is to be included in the final recording, then it will be re-recorded when all the other parts are complete. An example of this might be a guide vocal track for a song, which gives the other musicians a sense of the structure of the song to play along to.

The content of these guide tracks will vary from project to project and will depend on the musical content of the project as well as logistical issues such

as the time available to complete the project. The guide track may include just the part that the musician is to record (e.g., just the alto part in an SATB [soprano, alto, tenor, bass] choir), be a reduction of all the parts, or be one of the other parts (e.g., a vocal part of a song that a band is recording).

A fairly quick and easy way to produce a guide track is by using a MIDI track played through virtual instruments, which can be easily produced using a DAW. When creating MIDI tracks, a tempo should be set up in the DAW and the parts recorded to a grid. This allows the tempo of the MIDI tracks to be changed at a later date and quantise functions to be used. Quantise functions move the inputted notes to the closest grid location (set up by the user and related to musical note lengths, e.g., quavers or semiquavers). The sound of each of these tracks can easily be changed by allocating a different virtual instrument to the MIDI track. Once the track is completed, these can be bounced or exported (this will depend on the particular DAW software being used) to an audio file that can be distributed to other musicians.

Although the use of MIDI and virtual instruments may not produce the most realistic instrument sounds, it has the advantage of being strictly in time if the parts are recorded to a click track and quantising functions are used. The disadvantage of a MIDI guide track is that the timing is mechanical, and there would be no room for interpretation or expression by the musicians or a musical leader within the guide track itself. It is, however, possible to include tempo changes in MIDI tracks, either sudden or gradual, such as a ritardando, that is, gradual slowing of the tempo.

Alternatively, a guide track could be recorded using acoustic instruments. An example of this may be a piano accompaniment for a choir. This would allow room for some expression in the performance and gradual timing changes, such as rubato or ritardando, for the musicians to follow as they record. If this is to form part of the final recorded output of the project, then it is worth putting some time and energy into producing this to a standard that is as high as possible.

Click tracks can also be included in guide tracks, if this would help the musicians. In most cases, however, the guide track should provide enough rhythmic cues to allow musicians to play in time, as for some people, playing to a click track can feel unnatural and difficult. It is important for guide tracks to provide enough structural information to allow musicians to know when to start their part. This might include a count-in at the start of the track or an instrumental introduction, depending on the musical context. For musicians using DAWs to record, the provided guide track should correspond exactly to the first beat of the bar to allow others to import it easily and set up appropriate tempo grids.

Some projects include a video as a guide track. Video guide tracks provide visual timing cues alongside an audio track, for example, through a conductor or a visual metronome. Providing a conductor video can also allow for

some direction of musicians in expression, phrasing, and dynamics, which can be useful when trying to create a cohesive ensemble sound. Video guide tracks can also be used to provide visual synchronisation information, as we see later on in the case study of the Lyndhurst Singers.

A practical consideration around the use of guide tracks is that the musicians who are contributing to the asynchronous NMP project, must be able to play them back as they are recording their own part. For musicians using a DAW, this is a very simple process of importing the audio (or video) track into the project and then playing back and creating new tracks to record on, as usual. For those not using a DAW (and this may be the majority of musicians who take part in virtual ensemble recordings), they must be able to play back the guide track on a different device to the one they are recording on. This is because most mobile devices such as phones and tablets do not have the audio routing capabilities to playback and record simultaneously.

Recording levels

As with any recording project, setting the correct levels when recording is vital for good quality audio. If signals are recorded at too low a level, then there will be audible noise present, and at too high a level, there will be clipping leading to distortion of the audio signal, neither of which can be easily removed in the mixing process. For those recording using a DAW and an audio interface, these levels are usually set using the gain control of the audio interface. For those using mobile devices, these levels may be set manually or automatically by the recording software.

If the levels are set automatically by the software, then this is likely to introduce compression to the signal, where high-level signals are reduced to avoid clipping and low-level signals are boosted, so overall the level is more consistent. Alternatively, a limiter may be used that just reduces the high-level signals. Either way, using automatic levels should avoid problems with clipping. It may, however, change the nature of the musical signal by affecting the way each note decays as well as having an impact on the dynamic range of the music.

In most cases, setting levels manually would be beneficial in NMP. Compression algorithms cannot distinguish between signals that are reduced in level due to the dynamics of the music or for some other reason. This means that the software may attempt to boost the level of quieter passages of music to match the level of louder ones. It may also work on individual notes, changing the amplitude envelope of the sound (i.e., how the level of a note played changes as the note evolves). By setting levels manually, these issues can be avoided. Chapter 2 contains practical information about setting levels, as this information is relevant for musicians in both synchronous and asynchronous NMP.

File formats

Many audio and video file formats and resolutions may be encountered when working asynchronously. If possible, the required file format should be specified at the outset of any project. For musicians working on DAWs, this will be a fairly straightforward matter of setting sample rates, word lengths, and file types when exporting or bouncing files. This may not be so simple for those recording using mobile devices, where the file formats may not easily be changed.

In many mobile devices, efficient storage of files may be the priority, as phones and tablets are often used as multipurpose devices. This means that audio and video are saved in compressed formats that will impact on the quality and may introduce audible and visible artefacts. Given that audio files (even uncompressed) are considerably smaller than video files and that the focus of NMP is primarily about the music, it makes sense that uncompressed audio should take priority over any video files.

Sending audio and video files is the most flexible way to share contributions to a project, as this allows musicians with different DAWs to import files easily. In a collaborative recording, if all musicians are using the same DAW, it is possible to use project files stored on the cloud, as long as only one musician is editing it at a time. This avoids musicians having to keep track of sharing audio files, as these will be saved alongside the project.

When using audio files to create the final mix, uncompressed audio should be used where possible, for example, WAV files. Artefacts caused by the encoding of lossy data compression can cause an audible loss of quality, which will compound with each compressed track used. Where file sizes and the use of data is a consideration, compressed audio files could be used during the creative process to send ideas backwards and forwards and then these replaced with high-quality files once the musical ideas are finalised.

Often, it is considered good practice to record audio files at the highest possible quality, that is, high sample rates and large word lengths. The impact of high sample rates is an increased frequency range and the impact of large word lengths is a lower noise floor within the digital domain. The other impact of increasing these two parameters is an increase in file size. The recording environment should be taken into account when deciding these parameters – any increase in audio quality within the DAW may be negated through the noisy home recording environments and the frequency response and noise floor of the microphones used (which are unlikely to be high-quality microphones designed for professional recording studio use). A pragmatic approach should be taken, but usually CD-quality settings – 44.1 kHz sample rate and 16-bit words – will be more than sufficient for most NMP projects.

Portability of audio files is also a consideration when working on asynchronous projects. Most DAWs will accept multiple different audio file formats, but it is worth checking this at the outset of any project. Waveform audio file

format (commonly known as WAV files) are suitable for NMP projects, as they are portable between devices and offer uncompressed audio in different sample rates and word lengths.

Devices save video in many different formats, which change over time as new formats are released. Currently, the most common video format for mobile devices is the H264 format, which may be saved as different file types, for example, MOV or MP4 (this is known as the *container* which is usually defined by the audio format contained within the video file). Often, video editors will be able to import multiple different file formats.

File size is a consideration for those working in asynchronous NMP and a video file size is as a result of the combination of frame rate, aspect ratio, and resolution. There are standard frame rates (the number of frames of video that are recorded per second), with the lowest to represent movement in a realistic way being 24 fps (frames per second). Another common frame rate in video is 30 fps, and higher than this is used for slow motion video or for smoother motion capture. As the frame rate increases, so does the amount of data that is stored, and therefore the file size increases. 24 fps is adequate for most NMP applications. Aspect ratio is the ratio of the width to the height of the video, with a common ratio being 16:9. If different aspect ratios are used, then some images may need to be cropped to fit neatly with other videos on a screen. The video resolution is the number of horizontal lines a video frame has from top to bottom, or the number of pixels per line, with four common resolutions: 360, 480, 720, and 1080 (a higher number means a sharper picture). Modern smartphones usually default to either 720 or 1080. The horizontal and vertical resolutions are also linked as a result of the aspect ratio used. This means that halving the vertical resolution also halves the horizontal resolution, reducing the data by a quarter (rather than a half).

It is worth considering how the video might be edited in advance of making any recordings and providing participants with instructions on which video settings to use, or alternatively, considering how different formats may be dealt with at the editing stage. The Lyndhurst Singers case study outlines a method for doing this. Another consideration when recording video is whether the video is recorded in landscape or portrait orientations. Given that video monitors are usually in landscape, it may make sense for videos to be recorded this way as well, but this will depend on the arrangement on screen of the participants in the final video. Clear instructions should be provided for participants on the orientation of their video.

File transfer and storage

Before a project is started, it is worth considering how participants will transfer audio and video files and where they will be stored. If the project includes video, then participants will be required to transfer large files, and therefore using a cloud-based file transfer method will probably be more suitable

than sending files via email, for example. Participants should be notified that this may take some time, depending on the file sizes and their internet connections, and this should be factored into meeting any deadlines. Some file transfer methods (e.g., through some chat services) use lossy data compression to reduce bandwidth requirements, and these should be avoided where possible.

There are also some accessibility issues around the transfer of large files. When planning a project, it should not be assumed that all participants have equal internet access and the ability to use large amounts of data to transfer files. If in doubt, priority should be given to high-quality audio files over large video files.

It would also be worth considering how participants should label their files so that they can be easily identified when constructing the final piece. Depending on the particular project, this file name might include the name of the participant, the part they are playing, the name of the piece of music, or whatever might be appropriate for the specific piece. Instructions for file naming should be given to participants at the outset of the project.

An example might be *PieceName_Part_Name*, for example, HarkThe-Herald_Alto_Iorwerth.wav. From this file name, it is possible to immediately identify the piece and save the file locally in an appropriate place. It can then be imported into the DAW and grouped with the other alto parts, and the name is clear so that if there are any issues with that particular recording, then the musician can be easily identified and contacted.

Each DAW will store imported audio (and video) files in a specific folder, and it is worth finding out from the DAW manual where this is. If these files are inadvertently moved, then the DAW may need to find them again before playback. It is also worth noting that if a DAW project file is sent elsewhere, the corresponding audio and video files must also be sent.

For those working on collaborative recording projects, there will probably be more file transfer between individual musicians than in a virtual ensemble project. Participants should consider whether their fellow collaborators are using the same DAW software and the best method for sharing their work. In some cases, this may mean sharing project files of the particular DAW being used or audio files. Depending on the way the musicians like to work (see the cycle and hub examples above), it may be possible to store all the audio files in a location accessible to all participants and each musician download the files that they need at any one time. In this case, a method for version control would be very helpful. This should be considered at the outset of any project as part of a discussion around working methods.

There are also options to use cloud-based DAWs, although these are unlikely to match the number of features available in offline versions. Koszolko (2015) suggests combining online and offline DAWs to use the more complex features of offline DAWs alongside the convenience of the collaborative functions of an online DAW.

As with any project, backing up work regularly is advisable. This should include the audio and video files as well as the project file, and can be done using an external hard drive, cloud storage, or both.

Synchronising recorded tracks

There are several methods for synchronising audio and video tracks when putting the final recordings together. If synchronisation has not been considered before the musicians start recording, this will undoubtedly cause problems later on, as it is extremely difficult to align parts without a specific timing reference. When musicians play together, there may be time differences of up to 50 ms in supposedly simultaneous notes (Rasch, 1979), which means that synchronising parts through listening or looking at waveforms in a DAW is very difficult.

Consider trying to synchronise 20 parts without any other timing reference by lining up the start of each of the first notes in a DAW. While the first note may sound in time, it will be highly likely that many of these notes are slightly early or slightly late. This will result in the errors in timing of the first note impacting on the synchronisation of the rest of the track. So maybe it makes sense to synchronise the second note instead – which, again, might be slightly early or late, and timing errors are compounded over the whole piece. The result is likely to be frustrating and messy. Instead, if all musicians have a common timing reference (e.g., a count-in), then there is no need to rely on the musicians being accurate on every single note they play, and any slightly early or late entries will not impact on the synchronisation of the entire piece (Figure 4.4).

If the participants are working with DAWs on collaborative projects, they may wish to discuss at what point each audio track should start, for example, one or two bars before the first note of a piece, and prepare a corresponding guide track. Each contributor can then send individual audio tracks with the appropriate amount of silence at the start of the track, so they automatically line up when imported into a DAW. There are several methods for doing this and there will be slightly different procedures for each DAW, however, a common method is to bounce the project to an audio file with only the wanted track unmuted, which includes any silence at the start. In addition, multiple audio files from one collaborator must be sent separately for mixing later.

If in a virtual ensemble project with less technically knowledgeable participants or if recording using phones or tablets, then other methods are required. A reasonably straightforward approach would be to ask participants to include a bar count-in and a clap on the downbeat (e.g., 1–2–3–4–clap), with the impulse on the clap being used to visually line up each track in the DAW during the mixing process. This requires participants to be able to complete this task in time and would have to be included at the start of the guide track.

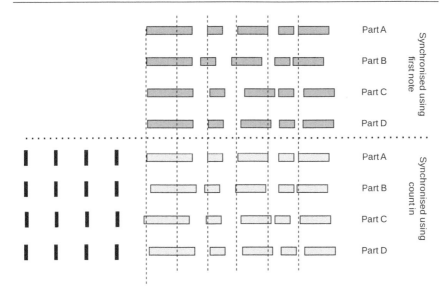

Figure 4.4 Synchronising tracks with timing errors.

Potential problems may arise if the musicians do not understand that it is critical this is included at the start of their recording without any breaks before the musical guide track starts (which could happen if the musician pauses the recording). Unlike recordings made in a DAW, which can have very accurate timings at the start, recordings from phones will always require some manual lining up of audio tracks before the mixing process. A semi-automated synchronisation method is described in the Lyndhurst Singers case study below, which is particularly useful when assembling a recording with hundreds or even thousands of participants.

If there are problems with timing and synchronisation in a virtual ensemble recording, it is almost always quicker to ask for a new recording from a participant – reiterating instructions for synchronisation rather than attempting to edit individual notes of a submission.

Mixing

A detailed exploration of mixing techniques is beyond the scope of this book. There are some excellent resources available with further details (see, e.g., Izhaki, 2018), however, the basic elements of mixing and some of the particular issues that may be encountered when mixing an asynchronous NMP collaboration are included here. This section is aimed at those who have little experience of the mixing process and are involved in the mixing of virtual ensemble projects, although much of it will also be relevant for those mixing collaborative recordings.

The first step in putting together the final piece will be to listen to all the individual contributions and to identify both musical and technical issues that may either need further attention or will mean that the contribution is unusable. Potential problems include:

- Background noise;
- Clipped signals;
- Errors in timing;
- Errors in tuning.

Depending on the scale of the project, errors may need to be communicated to the musician and a new part recorded or that particular contribution not used in the final mix. As with any collaborative project, sensitivity and clarity in communication is important at this stage: requiring new recordings to be made can severely impact on the timescale for a project, so minimising the number of times this is needed will be helpful. Clearly indicate what the problems are with the recording (including bar numbers or section, as appropriate to the musician) and set a deadline for the new recording to be submitted. As with any mixing project, starting with good raw recordings is preferable (and much more time efficient) than trying to 'fix it in the mix'.

When making decisions about mixing, engineers and producers should also consider how audiences might be listening to the recording. Of course, there will be no way of controlling this once the recording is in the public domain, but audiences may listen on headphones, loudspeakers, in noisy or other suboptimal listening environments, on phones, and through streaming videos, the platforms of which may have their own way of compressing the audio. It is worth listening to mixes in many different listening environments to check that it sounds as expected.

Digital audio workstations

In order to mix each individual contribution to a project, a DAW is needed. This is a combination of hardware (such as a computer and an audio interface if also recording) and software. There are many DAWs available for home use with varying levels of complexity and cost. Most DAW software comes supplied with detailed documentation on their use and there are also many tutorial videos available online for most of the popular DAWs. There are usually very useful 'getting started' guides available for all major DAWs, which are worth using if one is a complete beginner with the software.

Within a DAW, it will be possible to create an audio track for each individual contribution to the project and make adjustments to these tracks, including editing and the effects and processing discussed below. The relative level between each track can be adjusted to create the final mix of the piece.

Dealing with background noise and technical issues

Many asynchronous NMP projects involve musicians recording in suboptimal recording environments, including in the home where background noise cannot be eliminated. Producers of asynchronous NMP projects can expect to receive recordings that have evidence of domestic life embedded within them (sounds of animals, children, washing machines, doorbells, aircraft, wildlife, and cuckoo clocks are all examples that the author has experienced). It will be up to whoever is mixing the final piece to decide what is acceptable to them, but it is possible to listen to each individual track and mute areas where the noise is intrusive and there is no musical content. Depending on the number of contributions, this may or may not be practical. This may also have the effect of actually making the noise more annoying to the listener, as it comes and goes with the musical content. It may also be appropriate to include some noise in the final recordings, highlighting the methods of home recording and accepting that this noise is part of the life of the contributors.

Noise gates may also be used as an automatic way of eliminating noise when there is no musical content. As the name suggests, a gate opens (i.e., lets sound through) when the level of a signal is above a certain threshold and closes (i.e., does not let sound through or attenuates the sound, depending on the settings used) below this threshold. These can be useful when receiving tracks with background noise, however, it is important to set the threshold correctly and listen to the results to avoid an audible effect of 'pumping' as the gate opens and closes.

If a signal is clipped (i.e., reached the maximum level possible), it will probably be unusable in a mix. Digital clipping produces harsh harmonics that are extremely intrusive. If a clipped recording is received, advice on how to reduce the recording level should be given and the part re-recorded.

Dealing with errors in timing and tuning

Expression is a combination of timing of musical events and tempo, dynamics, articulation, and vibrato, which gives a musical performance character. When playing in an ensemble, this is expressed collectively (perhaps with the guidance of a conductor or through verbal and non-verbal communication in rehearsals) and requires communication between the musicians for its coordination. When recording each part separately, it is likely that each individual musician will interpret their own part with some expression, and in particular, this may result in apparent errors in timing that do not match the other contributions.

These issues are likely to be most apparent when working with virtual ensembles, with multiple musicians contributing to the same parts without hearing the other contributions. In a collaborative recording, the musicians

will be able to hear all the previously contributed parts and add their own expression to complement this.

As with other issues with recordings, it will be up to the person mixing to make a pragmatic decision about how they deal with timing errors. If, for example, the number of contributions is small and one musician makes a small number of timing errors, for example, early or late entries, then it may be possible to edit individual notes to correct these errors. This is a time-consuming process, especially for inexperienced audio editors. This would probably not be practical over a large number of contributions with multiple errors. In a large ensemble with amateur musicians, it may have to be accepted that a recording made in this way will not produce as polished a performance as when playing or singing live together and that somewhat untidy timing is a feature of the asynchronous NMP process.

Level balancing

Normalisation is a function of a DAW that applies equal gain across an audio signal to bring the signal up to a target level (Figure 4.5). When mixing audio contributions that may be at many overall levels, it can be used to match the peak of each contribution to the same level. This is a useful first step when mixing asynchronous NMP projects and makes subsequent mixing processes easier.

One of the fundamental parts of the mixing process is balancing the level between each part to create an appropriate musical balance. This can be made more difficult than in a conventional recording session, because each part may not be recorded at an optimal level. If the part is recorded at a very low level, increasing the level of the music in the mix (either manually or through normalisation) will also increase the level of the background noise. This should be taken into consideration when mixing and may require a part to be re-recorded.

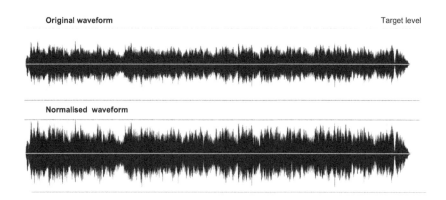

Figure 4.5 Normalisation.

The aim of level balancing in the mixing process is to achieve a musical balance between hearing each individual part and the blend between the parts. There are no strict rules for how to achieve this, but the producer/editor must consider how each part contributes to the recording and make creative decisions about the level of each part in relation to the others. In terms of process, a rough mix can be made before any of the processing, discussed below, is applied to individual tracks, but the final mix will be made once these are complete. This is because compression and equalisation (EQ) will impact the level of each track and therefore its relative level in the mix.

Many DAWs provide facilities for automation of mixes. This means that level changes (and pretty much any variable parameter) can be changed dynamically as the track plays. It is worth spending some time looking up how to do this in the DAW's manual as it is a very useful tool.

Equalisation

EQ is a tool used to manipulate the frequency spectrum of a signal, to increase (or boost) the level of certain frequency bands and reduce (or attenuate) the level of others. Most DAWs offer parametric EQs as plug-ins, which have controls for frequency, level, and width of the frequency band affected. These make them very flexible tools for shaping the sound of each individual track.

There are two main uses for EQ in a mix. The first is to correct deficiencies in the recorded signal and the second is a creative tool to mould the sound into something different. An example of the first approach is attempting to remove a problematic frequency from the recording that was as a result of the recording environment. This may be achieved quite successfully by sweeping through frequency bands with that band boosted to find the offending frequency and then attenuating this narrow frequency band. This will, of course, also affect any of this frequency band that is present in the musical signal.

The second approach is more creative, where the frequencies of the signal are manipulated as a creative effect. One application for this might be where two instruments sit within a similar frequency range (an example in Scottish traditional music might be fiddle and the higher end of the accordion) and each part is EQ'ed differently to make them clearly separate in a mix.

An important factor to consider when using EQ is that the output level of an EQ will be different to the input level. It is important to make sure that this level is not too high, which can cause clipping. This can happen easily if many frequency bands are boosted. A better approach is to consider the overall shape of the frequency response and aim for a similar level on the output as the input. Most EQ plug-ins include level meters, so one can check this.

A more detailed discussion on how to use EQ is beyond the scope of this book, but there are many online and print resources available providing information on how to use EQ in a mix.

Use of compression

Dynamic range compression of the audio signal (note that this is different to data compression, discussed elsewhere) is used to smooth out level differences in a recorded track and has the impact of raising the level of the quieter parts. This can make tracks easier to mix as they are more consistent in their level. The use of compression depends on both the type of music that is being recorded and the particular instrument. Because compressors work only on the level of a signal, they cannot distinguish between level changes as the result of dynamics in the music, the amplitude envelope (how the level of an individual note develops over time), or inconsistencies in performance. They should therefore be used with care to avoid impacting on the musicality of the performance.

Controls on a compressor include threshold, ratio, attack, release, knee, and gain make-up. The threshold is the level at which the incoming signal causes the compressor to start having an effect. The ratio is the amount of gain reduction applied by the compressor. With a ratio of 3:1, for example, an increase of 3 dB on the input of the compressor results in a 1 dB increase at the output. The attack and release are the time taken after the signal reaches the threshold for the compressor to act and then stop acting. The knee is how sharply the compressor starts acting when the threshold is reached. A soft knee means that the compressor does not immediately reach its full ratio when the threshold is met, which is helpful to avoid audible transitions at the threshold level, especially when the ratio is high. The gain make-up is used to increase the compressed signal back to its original peak level.

The use of compression can also impact on noise levels – raising the level of the noise during quiet sections, which is another reason that it may be worth muting sections of tracks that contain noise but no musical content. Compressors can have a significant impact on the overall sound of an instrument, so compression should be used with care.

Panning

When creating final mixes of asynchronous NMP projects, spatial elements must be taken into account. In most cases, this will involve considering the stereo image of the recording or how the musical elements are represented in the space between two loudspeakers or headphones. There are also possibilities for spatial elements beyond this, using immersive mixing techniques, an example of which is included in the Lyndhurst Singers case study below.

There are two main ways of adding spatial information to a mix: placing individual instruments within a space using panning; and using reverb that contains spatial information to give the impression of the music being performed in a particular space.

Most contributions to an asynchronous NMP project, especially those received from musicians with minimal recording experience, will be mono

recordings. These have no stereo information in them and are therefore point sources. These can be placed within a stereo image by using a panning control on the track. This works by sending different levels to the left and right speaker, giving the impression of the instrument being in a specific position between the two speakers. For example, if the panning control is set to the centre, then there will be an equal amount of signal sent to the left and right output and the instrument will appear in the middle.

When mixing the project, the engineer or producer will have to consider how they wish to pan each track. This will depend on the musical content of the project. If, for example, the project is a recording of a choir, it may be decided to pan each part to reflect where each individual singer might be placed if they were in a traditional performance context. Alternatively, panning may be used as a creative effect and not necessarily reflect a conventional physical layout of musicians. It is also possible to move parts in the stereo image during the mix using automation on a DAW. While this can be an interesting creative effect, care should be taken to avoid fast moving parts, which can be off-putting to the listener.

It is also possible to create mixes that have spatial information beyond a conventional stereo image, with placement of sounds in a 3D (three-dimensional) space. This requires specialist plug-ins for DAWs as well as a consideration of how this will be played back to listeners. In the Lyndhurst Singers case study below, an Ambisonic mix was created that was attached to a 360-degree video. This extra spatial element in the mix meant that as viewers move around within the video, the audio elements also move accordingly, to create a realistic impression of moving around in a space. Specific techniques around this are beyond the scope of this book, but there are many excellent resources that explain the theory and practice of spatial audio (see, e.g., Rumsey, 2001).

Artificial reverberation

Reverberation (shortened to 'reverb') is the combination of all of the reflections of sound from surfaces in a space. Music is often written to be performed in a particular acoustic space (e.g., choral music in a church) which has a characteristic reverb. The musical content of an asynchronous NMP project will therefore have an impact on what reverb is included in the final recording. Music that is usually recorded with very little reverb in a studio (e.g., pop music) with artificial reverb added later or music that might be usually recorded in a very reverberant space (such as sacred choral music) tends to work well for asynchronous NMP, while it can be more difficult to make convincing final mixes with music between those two extremes.

The contributions to an asynchronous NMP project are likely to be recorded in different acoustic spaces, which may be very audible on the recordings. When recordings are made, the microphones pick up both the direct sound of the instrument being played as well as reflections from the surfaces

in the room that the recording was made. In NMP, musicians are likely to be playing in domestic environments not designed for recording. Ideally, for asynchronous NMP, as little of the room sound should be in the recordings as possible by using close miking techniques to have the ratio of direct to reverberant sound as high as possible.

Inevitably, multiple different acoustics will need to be dealt with in the mixing stage. The impact of these multiple acoustics is that all the parts will sound like they are recorded separately, giving a sense of fragmentation to the overall recording. Artificial reverb can be added to a mix to give the sense of a common acoustic space for the individual parts, to give a sense of continuity to the recording, and to contribute to the stereo image. Reverb can also be used to 'blur the edges' of a recording, obscuring some of the potential timing issues that might be present in a recording, although this is no substitute for attempting to achieve accurate timing in the recordings themselves.

Artificial reverb usually has multiple settings, including type of reverb (e.g., church, hall, chamber) and size of room. There may also be other controls, including the ratio of signal to reverb and decay time (how long it takes for the reverb to die out). It is worth looking in the manual for the DAW or particular plug-in to find out what the parameters are for the particular reverb being used.

In a DAW, it is very easy to add reverb to each individual channel of a recording by using an insert. This is a rather inefficient approach, as it means adjusting the settings on each individual channel if the type or overall level of reverb needs to be adjusted. Instead, a stereo effects channel dedicated to the

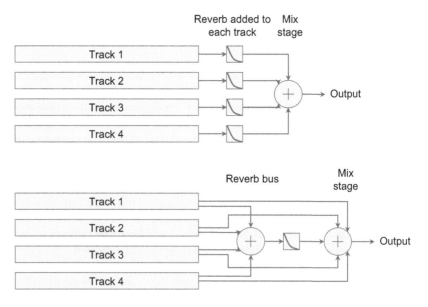

Figure 4.6 Bussed reverb.

reverb should be set up and all channels sent, post-fader, to this reverb channel through a bus. The reverb level is then adjusted using the fader on this reverb channel and the type of reverb set through the insert section (Figure 4.6).

As with many of the aspects of mixing, deciding the right settings for reverb, such as the size of room and level of the reverb, are creative decisions. The style of music will have an impact on this, and perhaps a good starting point is to consider the acoustic environment that an ensemble might perform in, for example, a choir in a church or hall. Of course, this should not be seen as a fixed method, and it will depend on whether the producer is aiming for a natural or more creative effect in their mix.

Video in asynchronous NMP

While NMP is primarily a musical activity, many NMP projects include a video element. Unlike in synchronous NMP, any video element is unlikely to be about communication with fellow musicians, perhaps with the exception of a guide conductor track. These video elements are therefore almost entirely for an audience's benefit.

A video element to an asynchronous NMP project may serve several purposes. First, it gives an audience something visual to attend to. In their research on music videos on YouTube and audience engagement, Liikkanena and Salovaaraba (2015) found that music videos are the most popular type and that still videos (i.e., ones with a photograph or other still image in place of a moving image) had the least audience engagement compared to other forms of music video. While some audience members might specifically seek out a recording from a particular ensemble and not be concerned about the video element, a moving image is most likely to engage audiences.

Another function of the video might be to explicitly show the musicians who are involved in the project as a way of giving credit to their contribution. It may also give an insight into the homes and lives of the participants, as many of the musicians involved are likely to be recording in their domestic spaces. This raises questions over privacy and how much people are willing to share their private spaces (albeit with perhaps careful curation) in a public arena.

Video may also act as a method for both achieving a sense of togetherness by bringing all the participants, visually at least, into the same online space. Conversely, the video may highlight exactly the opposite – that the musicians are physically dislocated from one another. How the video is organised and edited can have a large impact on this sense of connection or disconnection. If we think back to the two desires in NMP described by Lewis (2021) – both to hide and to assert the distance element – these are extremely relevant in the way the video is presented in asynchronous NMP.

Finally, the use of video is an opportunity to add to the aesthetics of any given project, as the visual possibilities of a moving image are virtually endless. This does, of course, depend on the particular project and the expertise

within the ensemble. Many musical ensembles will wish to focus on the musical aspect of a project and may not consider the visual side of it to be as important. This is particularly the case for collaborative recording projects where the musical elements are the primary focus. Throughout the collaborative process, there may be no visual elements captured at all.

One of the first asynchronous NMP ensembles to become popular was Eric Whitacre's *Virtual Choir* (Whitacre, 2022), with the first iteration of the project happening in 2010. This included thousands of vocalists, all of whom appeared in small boxes in the final videos. This has become a common aesthetic for this approach to NMP and gives a sense of belonging in musical communities – it is a way of showing each individual's contribution to the project as well as alluding to the bringing together of remote participants. Of course, there are other possibilities for any video element of a collaboration, which may avoid some of the difficulties of editing and perhaps allow a more creative and interesting video outcome.

As with synchronous NMP, perhaps it is somewhat futile to attempt to recreate a conventional recording experience, and with a recording of this type, it is often very clear that the participants were not in the same physical space. A potential alternative approach might be to highlight an individual's contributions by cutting between musicians rather than including everyone at once or perhaps some other entirely different approach to video.

It would be worth having a discussion between the collaborators about what the function of the video is in the project, whether the visual element is particularly important, and the additional technical issues that video adds for the person assembling the final output. It may be decided that the audio elements are more important, however, this will depend on the aims of the project.

Audiences in asynchronous NMP

At the outset of any asynchronous NMP project, it is worth considering who the intended audience is for the final project and how they might be reached. In some cases, especially in virtual ensembles, the audience might be the musicians themselves (see, e.g., Klein, 2015). Often, especially for community ensembles, musicians may never actually hear themselves, unless they have the opportunity for recording (whether live or in a studio). Asynchronous NMP gives a fairly accessible way for musicians to hear themselves perform in an ensemble, as an audience might. This gives an opportunity for musicians to get an overall impression of the ensemble as well as a chance to evaluate the sound (and potentially the look) of the ensemble which would otherwise not be possible (Daffern et al., 2021).

For more general audiences, a consideration for the final output of a project is how the separateness, or indeed togetherness, of a project is highlighted. Should the methods of the recording be highlighted as a feature of the project or should these not impact on the musicality of the project? This

will, of course, depend on the aims of the project and the philosophy of the musicians themselves.

During the COVID-19 pandemic, when many groups were producing virtual ensemble recordings, these were highlighted as a way of maintaining continuity within community groups and providing a sense of social cohesion and purpose for members (Daffern et al., 2021). In many of these examples, the groups wanted to highlight the separated nature of the recordings and use this to celebrate how they overcame adversity to continue to produce performances. Now that most groups can rehearse and perform together in physical spaces, the focus of virtual ensembles may have changed, with a greater consideration of the musical and technical quality, and therefore perhaps a better experience for audiences.

Examples of where attitudes have changed around the separateness of asynchronous NMP are in the recording of professional tracks and albums remotely. In many cases, these will be released to the public in the same way as a recording made in a studio, with the audience never being aware of the methods of recording. This is so common in some forms of music that the musicians do not consider it as unusual.

Although separate from the NMP process, reaching audiences and marketing music has been made much easier with the internet and distribution of digital files compared to when recordings had to be accessed in physical formats. Hajimichael (2011) points out that:

> Guerrilla music making and self-marketing techniques are nothing new. They were deeply embedded in so many popular music scenes from punk rock to reggae. But the Internet suddenly gave that much more power to musicians to simply make, share and raise awareness of their existence.

This ease of distribution and sharing of music still requires musicians to actively market their music to their intended audience, which may be harder than ever with so much musical content being available online.

Remote recording with connected DAWs

Remote recording, where musicians are recording in one location but files from the recording are being uploaded to a DAW elsewhere, is a slightly different approach to NMP, which has both synchronous and asynchronous elements. It has been included here because the musical element of this approach to NMP is asynchronous, that is, musicians will be recording at separate times. There is likely also to be a synchronous element in the communication between the musician(s) and the engineer/producer, perhaps through a separate video conferencing system. Depending on the system used, the uploading of the audio files to the storage destination can be close to real time.

The difference between this approach and the collaborative recording approach is that the musicians are not working independently of one another and recording their own parts. The remote recording approach will usually involve the musicians working alongside a producer and/or engineer, albeit in different locations. If there is no engineer at the musician's end, then they will need to set up their own microphones and other recording equipment, although they can be guided by the engineer and/or producer on microphone placement.

ISDN (integrated systems digital network) connections have been used for real-time audio connections for radio applications and for remote connections between studios since the 1990s. ISDN lines were specialist telephone lines that could be used to transmit high-quality audio signals, in a similar way to the synchronous NMP described elsewhere in this book. They were mostly confined to specialist environments rather than domestic ones due to the cost, and have now been superseded by broadband internet connections.

Unlike the synchronous NMP methods discussed in Chapter 3, remote recording sessions usually have only one musician playing at a time, therefore eliminating any challenges of latency. Often, the audio file is saved locally at the musician's end and then uploaded to the cloud later on (either automatically via software – which may be close to real time – or manually copied over) for the engineer and/or producer to use. There are many tools that allow this to happen in the background of a session, including Source Connect (Source Elements, 2022) and Steinberg VST Connect (Steinberg Media Technologies GmbH, 2022).

In some ways, remote recording (musicians in different physical spaces recording onto a common DAW) is no different than the approach taken in many 'pop' recording sessions (in its widest possible sense and to distinguish it from the approach taken in 'classical' sessions where the parts are generally not multi-tracked or overdubbed). Complete recordings are built up from multiple layers of tracks recorded at different times from one another. In a multi-day session, the musicians may never meet, even in conventional, in-person recording sessions.

Campelo and Howlett (2013) investigated the role of the producer in a professional remote recording session, where the recording session took place in Lisbon and the producer was in New York. One of the differences they noted between a typical co-located recording session and a remote session was the number of physical spaces. In a typical studio, there is a recording space and a control room that are acoustically isolated from one another. In a remote recording, there is an additional remote space. In their study, they noticed that this impacted on the communication process, adding more complexity, and made the producer more difficult to fully integrate into the discussion between musician, engineer, and producer as communication was less spontaneous.

They also highlighted that most of a producer's direction is conveyed through a talkback system during a traditional session, so this should not impact on a remote session. They noted, however, that it is sometimes useful for the producer to go into the studio to communicate with musicians more directly, and not being able to do this was frustrating for the producer. Although a remote recording session has much in common with recording in a studio environment, it should be noted that musicians and engineers/producers will need to adjust their working practices to suit the remote environment.

Musical issues

One advantage of asynchronous NMP over synchronous NMP is that there are very few limits on the type of music that is suitable for the approach. The only exception to this is that music that requires real time interaction between musicians – some forms of improvisation, for example – is not possible with asynchronous NMP. Music that is pre-composed (whether specifically for the NMP environment or otherwise) works well for virtual ensemble recordings, as guide tracks are used to ensure each musician is in time with one another. More collaborative approaches – for example building up pieces in a DAW either through cloud storage or directly sending and receiving audio files – are suitable for collaborative recording and this method can be part of the creative process.

As all the parts of an asynchronous NMP project will be recorded separately, there may be issues around blending of parts in ensembles – this is the reason that classical recordings are generally made in a single acoustic space rather than overdubbed in a studio (aside from the practical implications of recording more than 50 separate parts in an orchestra). Whether this is an issue for a particular collaboration or not will depend on the context – a small ensemble with no doubling of parts and a musical piece that the contributors know well may be less likely to encounter problems with this than a choir with multiple singers contributing the same parts. Blend may also be less of a problem with extremely large ensembles, where the sheer numbers of contributions mean that individual contributions cannot be heard.

Guide tracks for coordination of timing between individual contributions solve a technical problem of musicians playing separately. There are, however, musical implications of using them. A guide track needs to be rigid in its timing: while flexibility in timing is possible when there is communication between ensemble musicians (e.g., through the use of a conductor or gestures between musicians), unpredictable timing flexibility in an audio guide track would be extremely difficult for musicians to record to, probably resulting in many different timing deviations between musicians. One element of musical expression, however, is fluctuations in timing, giving music a sense of

life. This, of course, depends on the style of music being played. Beat-based music, for example, has rigid timing as a stylistic feature, so is perhaps particularly suited to asynchronous NMP. For music where expression is important, a potential way to overcome rigid timing could be to include a video guide track with a conductor or musician who is playing one part and can give gestures that the recording musicians can follow. This, of course, is more technically demanding to produce than, for example, a guide track produced using MIDI tracks.

Guide tracks should also include a tuning reference for musicians. Tuning and intonation is, however, not necessarily straightforward in ensembles. Ensembles (particularly string players who can adjust the tuning of individual notes as they play) require explicit or implicit negotiation of intonation (e.g., Pythagorean or equal temperament tuning systems) to achieve harmonic consonance (Papiotis et al., 2012). Groups of unaccompanied singers, for example, will modify their tuning in relation to one another and this tends to move towards just intonation (Howard, 2007). Variation in intonation can also be used for expressive effect, however, to maintain ensemble cohesion, this must be coordinated across all players. Tuning, therefore, may be problematic for some ensembles in asynchronous NMP, and this may need to be explicitly discussed at the outset of a collaboration. Careful consideration should therefore be given to the musical content of the guide track, if tuning is likely to be problematic. In some cases, it might also be appropriate to include a dedicated tuning reference at the start of a guide track for instrumentalists to tune their instruments to.

Articulation – how individual notes sound – can also be used as an expressive device and will affect ensemble cohesion. In other areas, depending on the individual amplitude envelopes of the instruments involved, musicians can aim for this to be matching or mismatching for creative effect (Keller, 2014). This is important to consider in asynchronous NMP, because this must be discussed and agreed upon in advance if it is relevant to the style of music being played.

While this section has so far concentrated on some of the musical pitfalls of asynchronous NMP – particularly in relation to virtual ensembles, there are also some creative advantages of working in this way, particularly for collaborative composition and the exchange of musical ideas through NMP. The pace of asynchronous NMP is inherently slow – parts need to be recorded and files exchanged and imported to DAWs, which takes time, or in the case of remote recording, different sessions need to be arranged for each individual musician. This time can allow space for individuals to develop ideas and work on individual parts rather than working in real time in synchronous NMP or even face-to-face. As with any creative process, this will depend on the styles of working of the individuals and how they respond to the uncertainty of working remotely.

Sawyer (2007) discusses seven key characteristics of effective creative teams, and alongside each of these is an example of how this may relate to asynchronous NMP:

1 *Innovation emerges over time*: in asynchronous NMP, there is time between sending and receiving submissions, giving participants time to reflect and refine their submissions;
2 *Successful collaborative teams practice deep listening*: in asynchronous NMP, this may include listening to musical contributions as well as listening to the ideas of other musicians during discussions around the music;
3 *Team members build on their collaborator's ideas*: this is a particular characteristic of collaborative recording, where the musical outcome of the project is not defined in advance and musicians respond creatively to what they hear;
4 *Only afterwards does the meaning of each idea become clear*: in asynchronous NMP, the sum of the parts is greater than each individual contribution;
5 *Surprising questions emerge*: in collaborative recording, surprising directions in the music may happen;
6 *Innovation is inefficient*: not all ideas will be appropriate or accepted in the final musical output;
7 *Innovation emerges from the bottom up*: this is relevant in collaborative recordings where there is no one leader – the musicians organise themselves and their ideas as a reaction to each other.

These are applicable to creative working in asynchronous NMP, particularly in the collaborative recording approach, highlighting how the building up of ideas and time is important in the creative process. While sending ideas backwards and forwards may be a slow process, both risky to the individual and inefficient, the results can be unexpected and imaginative – better than any individual could have created.

Coherent performances

Coherent performances require coordination of many elements of music, including timing, dynamics, intonation, articulation, and coordinated expression. In a typical performance setting, these are coordinated in real time between the musicians through a combination of listening, non-verbal communication, and for some ensembles, input from a conductor. These factors must be considered in asynchronous NMP, and the practicalities are quite different in virtual ensembles and in collaborative recordings due to the nature of the communication between musicians in these two approaches.

In virtual ensembles there are two major barriers to coherent performances. First, participants submit their recordings to a central editor/producer based

on a guide track, which is a one-way process. Only at the end of the process, when the recording is complete, can they hear other people's recordings, and then it is only as part of a final mix. There is no opportunity to listen to and modify one's own performance based on other musicians. Of course, this is a result of the practicalities of the process – it would be an almost infinite process if all musicians heard all other parts and modified their own to match. Second, in many virtual ensembles, there are multiple tracks of the same part, for example, in a choir. This means that there may not be coherence and blend within an individual part let alone between the different parts of the music. In addition, all musicians will be recording in different acoustics, which leads to further incoherence between the recordings.

It must be accepted that these are issues that cannot be solved easily. The musical director of an ensemble has a role to play before the individual parts are recorded. This includes detailed negotiation with and instructions to participants about detailed musical aspects of the performances. For example, are there any areas where a particular articulation is required? How should musicians approach this? Or perhaps the dynamic range of a piece is particularly important. This sense of direction probably needs to be articulated more strongly in a virtual ensemble than when performing live, because there is not the ability to feed back to an ensemble in real time and make adjustments to the performance.

There are also technological approaches that can be taken to enhance the coherence, such as the use of a common reverb across the whole recording, to give a sense of bringing the musicians into a common acoustic space. Careful synchronisation of the individual tracks may also help with this, within the parameters that have previously been discussed around musicians' synchronisation.

The importance of ensemble coherence in a virtual ensemble will vary, depending on the function of the recording. For some, the process of learning and rehearsing music or playing with a group may be more important than the recorded outcome. In these cases, musical details in the recording may not be important at all.

Coherence in a collaborative recording is perhaps easier to achieve. The advantage of working this way is that the recordings evolve throughout the process, and musicians will usually hear all of the previous parts and are able to musically react to other contributions. They can decide whether to accept, reject, or modify contributions and ideas, and they can specifically add new musical ideas to bring a sense of cohesion to the music. It is also unlikely that multiple versions of the same part will be recorded, unless this is for a specific creative reason, and then coherence between these parts can be taken into account in the recording process. Recording in different acoustic environments is an issue in this approach to asynchronous NMP, however, it is likely that musicians will be using microphones and DAWs for the recording, and therefore can use microphone techniques that minimise room sounds.

Coherence in remote recording is probably easier to achieve than in collaborative recording. This approach is often used for professional projects, and therefore the recording environments are usually appropriate for the recordings being made, so the acoustic environment is likely to be less of an issue. The parts will be recorded asynchronously, so there will be no real-time musical interaction between the different musicians, although this is potentially no different to working in a conventional studio environment. There is likely to be real-time verbal communication between the musician and engineer and/or producer to gain feedback on the recordings. It is likely that listeners of the final mix from this approach to NMP will not be aware that the music was recorded remotely.

Communication issues in asynchronous NMP

Unlike in synchronous NMP, there is potential for no direct real-time communication between musicians when working asynchronously, meaning that musicians will need to adjust how they work compared to collaborating in a room together. The approach to asynchronous NMP will also impact on the communication between the musicians. For example, in a virtual ensemble, each contributor may have no direct communication with the producer of the recording, apart from sending in their contribution. In a collaborative recording, however, there will be constant communication between the musicians as they provide contributions and feedback to one another, and the composition evolves over time.

Specific communication methods will depend on the platform being used – some websites and apps designed specifically for asynchronous NMP include chat and video functions, for example – as well as the individuals taking part. These may include asynchronous methods, including email or text message, or synchronous methods such as telephone or video call. Martin and Büchert (2021) looked at the success of different methods of communication in students' asynchronous NMP projects. They found that email and text messages were easy to misinterpret when dealing with the nuances of musical performance and composition, and the lack of non-verbal communication led participants to be confused and unsure about feedback from fellow participants. These methods of communication were also not useful for dialogue (as opposed to merely transmitting information), so as a result they recommend video calling as the best form of communication for remote collaborators. This method allows for real-time dialogue and opportunities for asking for clarification on anything that is not clear. While not mentioned in this particular study, it also offers musicians a chance to share musical ideas using synchronous NMP, even if this is not the main aim of the project.

Practitioners of asynchronous NMP emphasise the importance of good communication for the success of a project. Hajimichael (2011) provides a detailed account of their experiences of online music production and

collaborative composition and highlights specific aspects of communication as particularly important. In their projects, there was constant daily contact, including detailed discussion on the work – they found that the more the musicians talked, the quicker the work progressed and that the amount of communication was more important than the time available to complete the project.

> **Author's perspective**
>
> In my experience of working with students on collaborative recording projects, constant communication does not always lead to more efficient musical work. In some ways, long discussions about musical ideas can sometimes get in the way of moving the project on creatively. This, of course, will depend on the personalities of the musicians involved and perhaps also group size. In smaller groups, it can be easier to factor in everyone's ideas in a short amount of time.

Martin and Büchert (2021) found, in their study on students working on collaborative music projects online, that participants tended to start immediately with discussions around the musical aspects of a project – either musical ideas or reporting their own musical strengths and weaknesses – rather than the small talk that may be typical in a traditional, in-person musical collaboration. The authors highlight the importance of social connections between musicians later on in the creative process and encouraged their participants to spend time getting to know one another without discussing the project. This had benefits later on in their project, as they felt more comfortable working together.

Hajimichael (2011) outlines the need for collaborators to have effective communication in terms of sharing a common language around musical content, as they describe it, 'being on the same wavelength with someone'. They go on to say that the most important element in the creative process, apart from the creation of the music itself, is the dialogue between the musicians. The methods for nurturing this in an asynchronous NMP project will, of course, depend on the previous relationships between the musicians, however, it is clear that this element should not be left to chance, and intention discussions should happen between participants to both develop a common language and to move the creative process forward.

Koszolko (2015) highlights an interesting point around giving credit for musicians' work in asynchronous NMP. They suggest that in the asynchronous process, it is easier to 'draw demarcation lines though the final compositional work and establish with greater precision the creative input of each participant', which may be important when dividing any income derived from a collaboration. For many musicians who play recreationally, this may not be

a factor to take into consideration, but for professional musicians, this could be important when considering income from NMP collaborations.

While this chapter has highlighted some of the possible technical methods for the creation of virtual ensembles and collaborative recordings, there is no single correct way of working in these environments. In particular, collaborative recordings require a creative process of give and take that requires input from all musicians. In order for this to be successful, Hajimichael (2011) suggests that groups should set parameters around deadlines for tasks as well as coming to a consensus on the final output of a project. These can prevent problems of knowing when to end a project as well as help to reduce conflict between ensemble members over expectations.

Koszolko (2015) suggests that some of these areas can be discussed before musicians agree to work together. This, of course, will be dependent on the previous musical relationships between collaborators and the artistic hierarchy that may be present in a collaboration. Koszolko's work focuses on collaborations that have clear artistic direction from the organiser of the piece with open calls for contributions to the music. This perhaps requires a slightly stricter approach than if the musicians are all known to one another and/or have worked together before.

Martin and Büchert (2021) suggest specific guidelines to be agreed in advance for collaborative recording projects (p. 176):

- Adopt a non-hierarchical approach;
- No musician should bring any pre-existing musical material to the collaboration;
- Dedicate some time to get to know fellow collaborators;
- Plan times for individual and collaborative work and include contingency;
- Share expectations on the outcome of the project and how much time each collaborator is going to dedicate to it;
- Agree on a communication platform;
- Keep lines of communication open, including during breaks;
- Agree on a technical working method (e.g., file sharing or shared DAW).

While these recommendations may seem rather formal and will be dependent on the existing relationships between the musicians, they highlight the need for good communication throughout a project and a shared understanding of expectations. There are no doubt many collaborative musical projects that have either not been completed or have caused disagreements between musicians as a result of poor communication.

Social aspects of asynchronous NMP

This chapter has so far examined some of the technical and musical aspects of asynchronous NMP, however, there are also social benefits and challenges to working this way. Daffern et al. (2021) looked at choir member's experiences

of NMP (both synchronous and asynchronous) during the COVID-19 pandemic. Although they did not split the findings into the two approaches to NMP, some are clearly relating to asynchronous methods, particularly the virtual ensemble approach.

For some choir members, participation was easier than in-person choir events. They found participation more convenient, flexible, and with no travel, which was particularly relevant when the weather was bad. For others, participation was more difficult due to lack of experience using the technology required to engage. This area of accessibility in NMP is explored in depth in Chapter 6.

Daffern et al. (ibid.) also highlighted how participation during the COVID-19 lockdowns provided a lifeline towards well-being and a sense of purpose and connection for individuals. This, of course, is a benefit of participating in NMP for anyone who is isolated. In the asynchronous context, there is also a benefit of being able to work on projects flexibility rather than having to work with others at a set time, as is the case in synchronous NMP. This means projects can easily happen across time zones, around other commitments, and at a suitable time for those with fluctuating physical disabilities.

Creative affordances of asynchronous NMP

Unlike synchronous NMP, asynchronous NMP is not affected by the potentially disruptive effects of working with latency and other artefacts caused by the internet. Therefore, the creative affordances of working this way are slightly different. Returning to Scholz's categorisations (2021) of the teleological and ontological approaches to working in NMP that were examined in Chapter 1, we can see how these might fit with asynchronous approaches to NMP. As a brief reminder, in the teleological approach, there is a fixed goal in mind and technology is used as a tool to complete this goal. In the ontological approach, the output is not predetermined and technology is part of the process and is allowed to impact on the creative output of a project. These descriptions fit neatly with the virtual ensemble approach (teleological) and the collaborative recording approach (ontological).

A major creative opportunity in asynchronous NMP is the ability to work with other musicians who are not local, and unlike in synchronous NMP projects, time zones that the musicians are working in have the potential to have little impact on a project. As discussed elsewhere in this book, this allows for both cross-culture collaborations and those within very niche musical cultures where musicians may be geographically dislocated from one another. Hajimichael (2011) highlights the openness of the internet as a major appeal of asynchronous NMP, with the ability to explore musical avenues in an accessible and democratic way. Access to the internet is obviously a limiting factor to the accessibility of any form of NMP, but if this is available, then all musicians can take part, no matter what their background.

Unlike synchronous NMP, asynchronous methods allow musicians time and space for individual creativity and refinement of musical ideas as well as all the creative opportunities offered by DAWs, although this is limited in the case of a virtual ensemble, where contributions are usually fairly fixed in terms of their expectations. As Koszolko (2015) highlights, in relation to collaborative recordings (although also relevant in virtual ensembles), participants must have a certain level of technical proficiency in sound engineering tasks to allow for usable contributions.

The potential for group creativity is different in virtual ensembles and collaborative recording, as outlined in Figure 4.7. In a virtual ensemble, there is generally a fixed outcome in mind for a project, for example, making a recording of a particular piece of music that is composed in advance. In order for this to happen, creative decisions must be made centrally and in advance of the participatory element. This may be as a result of discussions between the participants (e.g., in a community ensemble) or decided without the input of the participants (e.g., when there is a call for participation in a particular project). The musicians then cooperate to record submissions and send them to a central point for the mixing stage – a one-way process. There may be some dialogue, although this is likely to be around technical issues rather than creative ones.

In a collaborative recording, the end result is not set in advance. Although some of the participants may have creative ideas in advance that they share with others, the final output of the project emerges as a result of the inputs of all of the musicians. There is a shared ownership and shared interest in the musical outcome. The process is interactive, with development of musical ideas as parts are shared and responded to. This is a similar process to

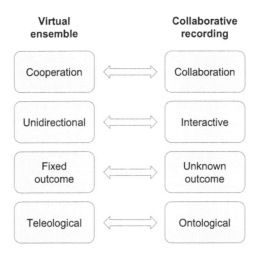

Figure 4.7 Virtual ensemble versus collaborative recording.

in-person forms of musical collaboration, however, working online allows musicians to easily move between the togetherness of listening and interacting with others' musical ideas and the time and space for individual creativity, which can then be brought back to the group.

There are, of course, opportunities for hybrid approaches between virtual ensembles and collaborative recordings. This is perhaps the case for the kind of collaboration described by Koszolko (2015), where a project is initiated by one musician who retains creative control and other musicians are sought out to make contributions. In these projects, the end result in terms of musical content may be relatively fixed (e.g., recording a particular song), while details of the arrangement or the exact way it is performed emerges over time.

Remote recording also falls somewhere in between the virtual ensemble and collaborative recording approaches. Remote recording usually requires musicians and producers or engineers to be working on the project synchronously, even if the individual parts are recorded asynchronously. In these cases, usually the musical output would be fairly fixed and prepared in advance (as it would be in most recording sessions), to allow a focus on the recording aspects of the music rather than composition or arrangement.

Asynchronous NMP offers opportunities for creativity in any video element. In a similar way to the audio aspect of a project, the asynchronous nature of this approach allows for time and creative space to work on the video element of a project and is not dictated by use of particular video conferencing software, for example, or videos of musicians.

Asynchronous NMP perhaps lends itself less to opportunities for the unexpected than synchronous NMP, especially in relation to the performances themselves. It offers musicians opportunities for multiple takes and perfecting of performances. For those inexperienced at recording, this can be time-consuming and frustrating, as highlighted by Daffern et al. (2021) in the context of community choirs' virtual ensembles, with some musicians not wanting to submit recordings of themselves as they did not like the sound of their own singing. This aim for perfection may impact on inclusion in asynchronous NMP in the cases of musicians who feel they are not 'good enough' to take part. Those working in asynchronous NMP may wish to consider how they deal with mistakes in recordings and whether these should be edited out or used to creative effect, decisions that are obviously dependent on the musical context.

Hajimichael (2011) highlights immediacy as one of the creative advantages of asynchronous NMP, and they state that they created, recorded, edited, mixed, and mastered a track in different places within 24 hours. While this may be possible, it would require a great deal of commitment from the musicians involved, and often the lack of immediacy in an asynchronous environment allows musicians time and space to develop creative ideas, without the pressure that is present in a real-time environment.

Management of asynchronous NMP projects

Asynchronous NMP projects can be complex and require careful management. As well as dealing with technical issues to do with the recording and sharing processes, musical and social factors must be taken into account. Collaborative recordings are probably a little more complex to manage than virtual ensembles because they are more flexible in both musicians' contributions and the roles of the participants.

Technical issues that might arise in a collaborative recording might be around version control, particularly if different musicians are working on a piece simultaneously. It is worth spending some time at the outset of a project to discuss how this will be managed as well as basic technical parameters such as file types.

Musical issues might arise during the collaborative recording process as a result of the group dynamics and individual's particular musical interests. This is not necessarily a bad thing, as this unpredictability can lead to new forms of creative expression. Again, the musical direction of the collaboration can be discussed in advance, with regular discussions between the musicians to redirect the collaboration, if need be.

Often, projects will be happening in musicians' spare time or sometimes professionally with strict deadlines. There are many opportunities for conflict in musical projects, but probably more so when working asynchronously online. It can sometimes be difficult to gauge individual musicians' engagement with a project, until a recording is submitted to the group. While conflict is not necessarily a bad thing in creative projects, in order to maintain momentum, musicians must carefully communicate to resolve conflicts efficiently.

An element of some asynchronous NMP projects is finding suitable musicians to work with. One of the benefits of online working is that there are no geographical boundaries that impact on who works on a project; some musicians choose to advertise for collaborators openly and work with musicians unknown to them. An advantage of working this way is that specific instrumental, compositional, or production-based skills can be sought to help complement skills of musicians already involved in the collaboration.

Working with new people also presents specific challenges. Koszolko (2015) suggests that a musician will decide to join a collaboration based on several pragmatic factors: an interest in a particular style of music; the timing of an advert; the availability of the musician; and the musician's set of skills. What is unknown in these factors is the musicians' methods of communication and styles of working and their level of interest in the project, which may have a large impact on the success of the project. To mitigate these problems, good project management techniques should be used, for example, setting goals and deadlines, although these should be negotiated with the musicians involved to avoid disrupting the creative process.

Virtual ensembles are probably slightly easier to manage than collaborative recordings, mainly because the stages are fairly fixed and the roles for each participant have clear boundaries. For the producer/editor, the stages are:

1 Prepare a guide track for musicians to listen to while recording. Include both tuning and timing references. Consider the use of a visual guide track.
2 Prepare detailed instructions for participants on how to record. Include details to allow synchronisation of parts, acceptable file formats, file names, and tips on a suitable recording environment.
3 Collect together recorded parts. Provide details to participants on how to submit the recordings and the deadline.
4 Import individual parts into DAW and synchronise them.
5 Listen to parts and identify any technical or musical issues. Decide whether to ask for replacements, attempt to fix, or discard.
6 Mix the track.
7 Distribute final mix.

Practical considerations for asynchronous NMP

Given the multiple options for asynchronous collaborative projects, some practical considerations are worth weighing up before starting on a project. To decide between the virtual ensemble and collaborative recording approaches, the following flowchart may help (Figure 4.8).

These further questions may help when deciding on the particular methods within the two approaches above to use for a project and the resources required:

- Who are your musicians? Do you know them already or are you looking for contributors to your project?
- What recording equipment is available to your musicians? Do they have access to microphones, audio interfaces, and so on or will they be recording on phones, tablets, and so on?
- What practical experience and skills do your musicians have in recording? Are they able to play along to a click track or guide track?
- What music do you plan to record? Is this predefined or will it emerge as part of the recording process?
- Have you considered the time it will take for both the recording and mixing process?
- How will you create a guide track? Will this be an audio or video track? Does it include both timing and tuning references?
- Who will put together all the individual audio tracks? Do they have experience of doing this?
- How will you synchronise the parts? Have you included clear instructions for the musicians?
- If you are using video, how will this be edited together? What is your rationale for this?

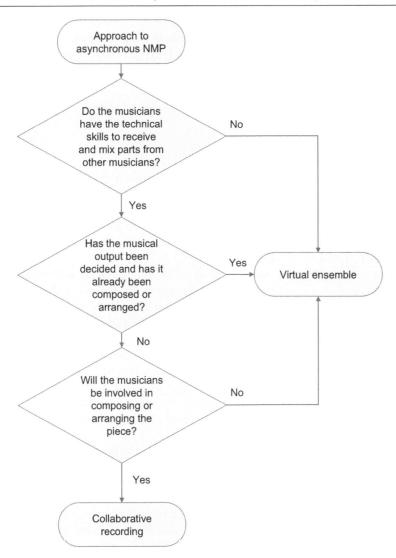

Figure 4.8 Asynchronous NMP approaches flowchart.

Case studies

The following case studies outline some asynchronous NMP projects covering the three approaches that this chapter has examined: a virtual ensemble, a collaborative recording, and a remote recording session. They cover a range of musical genres and geographical locations as well as levels of technical expertise. The first case study is of a virtual ensemble that took place during the COVID-19 pandemic and has a particularly interesting approach to synchronisation and presentation of the final video. The second is the approach

taken by a house DJ and producer who works on collaborative projects with other producers around the world using file sharing methods. The final case study involves a remote recording session between the UK and USA which uses only easily accessible tools to produce a professional recording.

Lyndhurst Singers: Gibbons – O Clap Your Hands – Virtual Church

Produced and engineered by Will Anderson

Based in Lincolnshire, UK, the Lyndhurst Singers are a group of classical singers who sing mainly unaccompanied choral music. One of the members of the group, Will Anderson, was furloughed from his job as a classical recording engineer during the first part of the COVID-19 pandemic, and decided to use the time to develop his technical skills and produce a creative virtual ensemble recording of the choir.

Prior to the pandemic, Anderson was aware of Eric Whitacre's *Virtual Choir* projects, and as a recording engineer, he knew the technical challenges of working this way. He had also seen many other virtual ensemble projects produced during the pandemic, and wanted to move away from the video convention of many small boxes on the screen, so decided to create a 360-degree video that could be shared on YouTube and Facebook with associated spatial audio. He also decided to develop his programming skills by automating as much as the process as possible, as he was aware of the considerable time requirements of putting together a virtual ensemble recording. He later went on to use the programmes he had developed, described here, on much larger projects with hundreds of participants.

There were ten singers involved in the project, and the piece is for an unaccompanied split SATB choir, so there were two parts for each voice type. This piece was chosen because the use of two separate choirs gave opportunities for clear spatial elements, both in the video and audio elements. The music was written around the early 17th century to be performed in a large reverberant space, such as a church or cathedral, which could easily be represented in the 360-degree video. This also meant that it was stylistically appropriate to use a relatively large amount of artificial reverb when mixing the piece, which also has the advantage of helping to smooth over any small timing errors in the recording. The polyphony in the piece was also an advantage in the virtual ensemble setting, as it does not require the singers to coordinate entries or breaths en masse. The choir had briefly rehearsed the piece for live performance before the pandemic.

For a guide track, the choir used an existing recording that they liked, which included expression and tempo changes. They discussed in advance of starting any recording specific dynamic changes to this recording (which were adjusted in the guide track by changing the overall level) as well as articulation and the locations of breaths. Anderson converted the recording

from stereo to mono, so that the singers could record their parts with one headphone on and one off, so they could hear themselves well to ensure good intonation.

Anderson developed a semi-automatic method for synchronising the videos made by the singers. This required the singers using a video guide track (which also included the audio guide track), so each singer needed two devices: one to play back the video guide track with headphones plugged in and another to make the video recording of their parts. Included in the guide track were spoken instructions of what the singers needed to do at each stage.

The first stage was to allow for synchronisation. Embedded in the video track was a QR code and timecode that the singer held up to their camera to be included on their recording. The background of this changed from white to red to green to blue and back to white over an 8-second period. After this, the guide track asked the singers to join in with a '1,2,3,4' count with a clap on the next beat, which could be used as a back-up method for synchronisation. After plenty of time for the singers to get ready to sing, there was a chord played as a tuning reference, then a bar of metronome clicks before the piece started. At the end, the instructions ask the singer to hold their position and smile, to allow the editor to fade the video with the singers still in position. The singers could then upload their videos into a Dropbox folder.

To maintain video continuity and to reduce the time burden on Anderson, multiple takes from one singer could not be edited together. This meant that the singers had to record the whole piece from start to finish, including the synchronisation stage (which took approximately 45 seconds), multiple times until they were happy with their performance, and the synchronisation added significant time to this process.

This is when the automated process could start with the following steps with Anderson writing the automation programmes:

1. A tool checks the Dropbox folder for new files and immediately starts the processing when one arrives.
2. The video is converted to a consistent frame rate (30 fps), resolution (1920 × 1080), and aspect ratio (16:9), and saved as a H.264 mp4 file. To change aspect ratio, a programme for intelligent cropping tracks the face to keep it in the middle of the frame throughout the video.
3. A programme looks in the first minute of video for the QR code, then at the colour of the background. Once the programme has identified the position of the QR code, it takes its best guess as to whether the background colour is red, green, blue, or white. The script then presents a human user with the frame it thinks is 00:26:00 into the backing track video (where the background colour changes from red to green) and a frame on either side and asks the human to select which one actually is 00:26:00 or lets the user

skip forward or backwards to the next set of three frames. Rejected files – if there is no synchronisation information present, for example – are moved to a folder for manual synchronisation.
4 The videos are truncated to start at the 00:26:00 point. They are then imported into a video editor, each on their own track with the audio waveforms showing. The clap waveform can then be visually checked and files manually lined up, if necessary.
5 Finally, each video file can be exported with 100% certainty that they are synchronised.

The next step in the process was the audio mixing, which had the following stages:

1 The audio mixing took place in the Reaper DAW. First, the clap was removed from the start of each track and then each file was normalised. Small musical corrections were made, the tracks balanced, and fades added at the start and end.
2 The Ambisonic toolkit was used as a plug-in on each track, placing each singer in the correct place in relation to the video using the 360-degree panner. Stereo artificial reverb was used.
3 First order ambix files (four channels) were exported along with the stereo reverb (six channels in total) which were compatible with the 360-degree video players and decoders on YouTube and Facebook.

The final stage was creating the 360-degree video, using the 3D creation suite Blender:

1 Anderson used an incomplete 3D model of a church and completed the image, including adding stained glass windows. This was chosen to suit the music and the environment that the choir usually perform in and allows viewers to explore the space.
2 The individual synchronised videos were imported and positioned.
3 To save rendering time, the background and the videos were rendered separately and then put back together and rendered again.
4 The command-line ffmpeg tool was used to attach the six-channel audio to the video file.
5 The file was uploaded to social media.

While this may seem like a complicated procedure, most of the steps described here reduce the time commitment by the editor/producer of the virtual ensemble, especially in relation to synchronisation. This is particularly helpful when there are hundreds or even thousands of submissions to a project. In

addition, the standardisation process at the start meant that the system could deal with multiple file formats, meaning that the singers were not required to change any settings on their devices, again reducing the time burden on Anderson for technical support. This also had an impact on accessibility – choir members could use the default video settings on their devices rather than needing any specific technical knowledge around video settings.

Funky Transport: house music collaborations

Based in Scotland, Funky Transport (Iain Macpherson) is a house DJ and producer. He works from his home studio and collaborates with musicians both locally in Scotland and around the world, including in Europe, USA, and South America. He has always worked remotely with other musicians, having started file sharing as part of his creative practice in 1997 as well as using this method with young people when he was working at the community music project Station House Music Unit in Aberdeen in the early 2000s. Originally, he used a private IRC (internet relay chat) server and other internet chat services such as MSM messenger to share files, but now uses Dropbox as the main repository for project and audio files, with folders synchronising automatically to local machines.

He usually works with one other producer on the arrangement of a track, with each producer bringing in recordings from other musicians as necessary, but the two producers having the overall creative control of the project. They first decide on a DAW to use, with Ableton, Logic Pro, and Pro Tools being common choices. While it is possible for each producer to use a different DAW and share audio and MIDI files, using the same DAW means that the project file can be stored on Dropbox and alterations to this file update for both producers. This also avoids problems with using MIDI files and virtual instruments that may not be common to both DAWs. Typical audio settings are 44.1 kHz sample rate and 24-bit word length, saved as AIFF files.

Where other musicians are contributing to the track, audio files are used, which the producers then import into the project. They always require audio files that start from the zero point of the track to avoid problems with synchronisation. They also require the files to be at a maximum level of −6 dBFS to avoid problems with clipping. Depending on the musical content of the contributions, they may be unprocessed or they may have processing such as compression and EQ applied at the source.

When collaborating on a project, the two producers take a fluid approach, depending on the project, and may take turns dealing with the technical aspects of the mix while the other works on the arrangement. They do not work on the same project simultaneously, as this would cause there to be multiple versions of the project file and it would be difficult to keep track of changes. The communication around this is important, especially when making edits to the track, to avoid one producer working on a part that is subsequently

edited out of the final track. Most of their communication takes place through phone calls or messaging services and is ongoing throughout a project.

There are several advantages to this approach. The first is that it allows Macpherson to work with people in different locations and saves time and money on travel. It has also been the only way he was able to work musically during the COVID-19 pandemic, which had little impact on his musical work due to the methods that he already had in place for working. He also highlights that the asynchronous method gives him more time to consider his work away from the studio than if he was either working on his own or in person with another producer. Time zone differences between collaborators can also be helpful, as each producer can take time slots to work on projects that can fit in well with the collaborator.

Macpherson has built relationships with all the producers he has worked remotely with prior to starting any remote collaborations, although he has not always met them in person. He has met some of his collaborators through DJing in clubs, and in his early days of collaboration, he made contact with musicians through the House Music List, an invite-only IRC channel with several hundred members, and the Underground House forum in the 1990s and 2000s.

Brandywine Baroque: solo harpsichord video

In March 2022, Brandywine Baroque commissioned BMP Recording to record and produce a 40-minute video programme for subsequent online presentation. Brandywine Baroque are an early music ensemble based in Delaware, USA, and offer live concerts and recordings on period instruments.

The recording was made in Flintwoods Barn in Wilmington, Delaware, USA. The audio engineer and producer, Ken Blair, was based in Lincoln, UK, at the BMP Recording headquarters, and the videographer, Oliver Bowring, was based in his studio in London, UK. The recording was of two pieces for solo harpsichord by Bach – Toccata in D, BWV 912, and Partita No. 2, BWV 826 – performed by Leon Schelhase playing a Joannes Goermans harpsichord made in Paris in 1768.

Prior to COVID-19, Brandywine Baroque hosted a series of live concerts in the recording venue, and initially during lockdown they produced video programmes online aimed at their regular audience. As restrictions eased, they were able to have an audience present, but decided to continue to offer online edited video programmes in addition to the live concerts. These programmes were able to reach a worldwide audience, who have a specialist interest in their historic collection of instruments.

BMP Recording had visited the venue in October 2021 and worked with musicians from Brandywine Baroque when travel restrictions were still in place, as they had national interest exemption visas. In March 2022, however, there was a COVID-19 resurgence and one of the Brandywine Baroque

staff members was medically vulnerable, so it was decided to record the session remotely to reduce the risk of spreading COVID-19.

Brandywine Baroque and BMP Recording have been working together on audio recordings in Flintwood Barn since 2014, so the audio engineer knew the venue very well and had established optimal positions for each harpsichord in the room for audio recordings. They had also kept very detailed records of where microphones were placed in relation to the harpsichord for each of the instruments. The videographer had only visited the venue once before and had completed a six-camera shoot at that time. The manager of Brandywine Baroque, Robert Munsell, had previous training in technical theatre, so he was based in the Barn and acted as the recording assistant: placing and adjusting instruments, microphones, cameras, and lighting with instructions from the UK.

Several days in advance of the session, BMP Recording sent floor plans showing the desired position of the instrument, microphones, and cameras. The day before, the session was spent online with the assistant, setting up in the venue and no musicians present. The position of the microphones was fine-tuned, followed by the positions, framing, and focus of three video cameras. On the recording day, two further hours were spent setting up, followed by a three-hour recording session with the musician. There was a five-hour time difference between the venue and the location of the engineers, so the session started in the morning at the venue and lunchtime in the UK.

The audio set-up was as follows (Figure 4.9). Two DPA 4011s were used in an ORTF configuration (a stereo microphone technique) on a single microphone stand. These were connected via tie lines in the venue to a Focusrite Saffire Pro 40 interface, which was connected to a local MacBook Pro, running Reaper DAW. This computer was remotely controlled from Lincoln with Zoom video conferencing software using the remote control feature. This allowed the engineer to be in charge of running the DAW. The assistant in the venue moved microphones and adjusted gains on the audio interface as well as starting the DAW software. Skype video conferencing software was used for communication between the engineer and assistant, with the assistant using this on his phone so he could move around the venue. The output of Reaper was connected to Audiomovers Listento software for monitoring in Lincoln, but recorded locally to hard drives in the USA. The monitor feed was in stereo broadcast WAV quality, with approximately one second delay. Audiomovers Listento creates a link so anyone with the link can listen to the feed.

The video set-up was as follows: there were three camera positions with a keyboard shot, face shot from the tail end of the harpsichord, and a wide shot. The cameras recorded locally onto memory cards in each camera. There was no video equivalent of Audiomovers Listento for video, so the assistant shot five seconds of video on each camera, removed the memory cards, and sent the clips to the videographer in London via Dropbox to allow him to check focus, framing, and lighting. Communication between the assistant and videographer was via Skype.

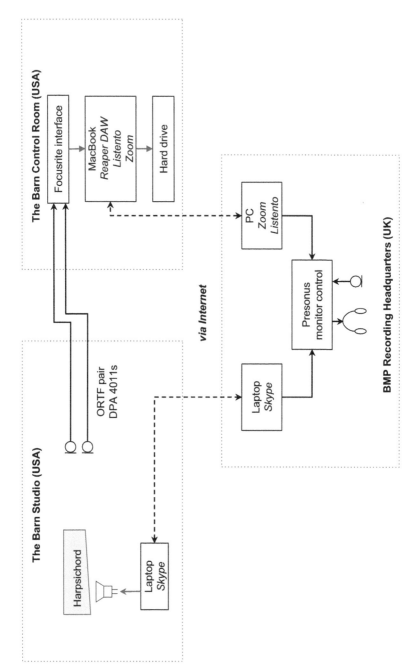

Figure 4.9 Audio set up for Brandywine Baroque recording.

Communications were also required during the session between the producer in the UK and the musician in the USA (Figure 4.9). A Skype call was left open between the producer and a laptop in the studio, with the audio output of the laptop connected to a talkback speaker. The mic feed from the producer was controlled by a talkback key, similar in a conventional recording session. The producer could hear both the output of the Skype call and the Audiomovers Listento feed. These were not synchronised due to the different latencies and were fed to a mixer so the producer could switch between the feeds. During the takes, he listened to the high quality feed, and during conversation and discussion, he listened to the Skype feed.

At the start of each take, the assistant started each camera while the producer started recording the audio. The assistant announced each take in view of a camera and clapped to provide synchronisation between the cameras and the audio. After the session, all the audio and video files were sent by the assistant to the producer and videographer via Dropbox. The videographer colour graded the video and synchronised the audio and video, ready for the edit. The synchronisation and colour grading files were also saved in Dropbox. BMP Recording also used digitised scores on iPads and marked these up with Apple Pencil, with the files held in Dropbox, allowing the audio editor to immediately see any marks that the producer has made.

Throughout this session, all the software used was easily accessible, with no particular technical knowledge needed beyond that of the engineer. There were some difficulties around the clarity of communication from the musician: it was difficult to understand him speaking at a distance to the laptop used for Skype in a reverberant environment, as this laptop had to remain out of camera view. Due to the set-up times and the need to transfer video files for feedback, the session was more time-consuming in its set-up than a conventional recording session. Working across time zones also caused some minor logistical issues.

The producer noted how the session itself felt very natural, describing it as if he was in a control room next door to the studio, not across the Atlantic. There was also an advantage of using Skype for communications, in that there was always a visual link between the musicians and the engineer/producer, which may not always be the case in a recording session, as there may not be a window between a control room and a recording space in location classical recording.

The BMP Recording staff had already built up relationships with the Brandywine Baroque staff, although they had not previously met the musician in this case. These relationships helped the session to run smoothly, although it was noted that the usual social interaction and bonding of an in-person session was missing, and the engineer/producer found it more difficult to get a sense of the mood of the session than when working in a more conventional way. Despite travel restrictions being lifted, they will probably occasionally work this way in the future, and it may be particularly useful if BMP

Recording need to make any small fixes to a project they have recorded in person without having to travel to the USA. Although they noted that working this way comes with some artistic challenges, the engineer/producer noted that it offers environmental and cost benefits of not needing to travel, and they were happy that they were able to help protect their medically vulnerable colleague from COVID-19. The artists and management of Brandywine Baroque were looking forward to working in person again, demonstrating the importance of the social aspects of these recording sessions.

Chapter summary

This chapter has looked at two main approaches to asynchronous NMP: the virtual ensemble and collaborative recording approaches. It has also briefly touched upon remote recording, which is more likely to be found in professional recording environments than domestic settings.

We have looked at the technical issues around asynchronous methods, including making guide tracks and the technical considerations for musicians making recordings that will become part of a larger project. We have also looked at the process of putting together a virtual ensemble recording from the point of view of the editor/producer and some of the information that participants will need for the smooth-running of a project.

Communication issues and ways to overcome challenges were examined as well as the social aspects of asynchronous NMP that might be encountered. We also looked at some of the creative opportunities for asynchronous NMP and the type of music that might work well in this setting. Finally, we considered some of the overarching practical implications of these issues and how these might be taken into account when choosing an approach for a project.

References and further reading

Campelo, I., & Howlett, M. (2013) 'The "Virtual" producer in the recording studio: Media networks in long distance peripheral performances', *Journal on the Art of Record Production*, 8.

Daffern, H., Balmer, K., & Brereton, J. (2021) 'Singing together, yet apart: The experience of UK choir members and facilitators during the Covid-19 pandemic', *Frontiers in Psychology*, p. 303.

Hajimichael, M. (2011) 'Virtual oasis-thoughts and experiences about online based music production and collaborative writing techniques', *Journal on the Art of Record Production*, 5.

Howard, D. M. (2007) 'Equal or Non-equal Temperament in a Capella SATB Singing', *Logopedics Phoniatrics Vocology*, 32(2), pp. 87–94.

Izhaki, R. (2018) *Mixing Audio: Concepts, Practices, and Tools*, Oxford: Focal Press.

Keller, P. E. (2014) 'Ensemble performance: Interpersonal alignment of musical expression'. In Fabian, D., Timmers, R. & Schubert, E. (eds.), *Expressiveness in Music*

Performance: Empirical Approaches across Styles and Cultures. Oxford: Oxford University Press, pp. 260–282.

Klein, E. (2015) 'Performing nostalgia on record: How virtual orchestras and YouTube ensembles have problematised classical music', *Journal on the Art of Record Production, 9*, pp.203–204.

Koszolko, M. K. (2015) 'Crowdsourcing, jamming and remixing: A qualitative study of contemporary music production practices in the cloud', *Journal on the Art of Record Production, 10*, pp. 1–23.

Lewis, G. E. (2021) 'The hub's telematic socialities'. In Brümmer, L. (ed.), *The Hub: Pioneers of Network Music*. Karlsruhe: ZKM | Hertz-Lab. pp. 156–158.

Liikkanen, L. A., & Salovaara, A. (2015) 'Music on YouTube: User engagement with traditional, user-appropriated and derivative videos', *Computers in Human Behavior, 50*, pp. 108–124. https://doi.org/10.1016/j.chb.2015.01.067

Martin, A., & Büchert, M. (2021) 'Strategies for facilitating creative music collaboration online', *Journal of Music, Technology and Education, 13*(2–3), pp. 163–179. https://doi.org/10.1386/jmte_00021_1

Papiotis, P., Marchini, M., & Maestre, E. (2012) 'Computational analysis of solo versus ensemble performance in string quartets: Intonation and dynamics', *Proceedings of the 12th International Conference on Music Perception and Cognition (ICMPC) and 8th Triennial Conference of the European Society for the Cognitive Sciences of Music (ESCOM)*, Thessaloniki, Greece, pp. 778–784.

Rasch, R. A. (1979) 'Synchronization in performed ensemble music', *Acta Acustica United with Acustica, 43*(2), pp. 121–131.

Rumsey, F. (2001) *Spatial Audio*, Oxford: Focal Press.

Sawyer, R. K. (2007) *Group Genius: The Creative Power of Collaboration*, New York: Basic Books.

Scholz, C. (2021) 'One upon a time in California'. In Brümmer, L. (ed.), *The Hub: Pioneers of Network Music*. Karlsruhe: ZKM | Hertz-Lab, pp. 42–66.

Source Elements (2022) *Time to Shorten Distances. Source-Connect.* Available at: https://www.source-elements.com/products/source-connect/ (Accessed: 30th August 2022).

Steinberg Media Technologies GmbH (2022) *Connect to the World. VST Connect.* Available at: https://www.steinberg.net/vst-connect/ (Accessed: 30th August 2022).

Whitacre, E. (2022) *The Virtual Choir*. Available at: https://ericwhitacre.com/the-virtual-choir (Accessed: 14th February 2022).

Chapter 5

Online music teaching and community music

Introduction

While the topic of this book is networked music performance (NMP), music education and community music encompass far more than performance. They are about creativity, participation, and communities as well as expression through music. Therefore, this chapter will examine some of the ways in which educators and community musicians can embrace online work in terms of instrumental teaching and learning, but it will also look at the wider context of online music education and community music.

Quality online music education is not just about transferring existing (in-person) resources, teaching methods, and assessment onto an online environment. As with other forms of NMP, it must be recognised that the environment is different and therefore the approaches and outcomes will be different, both for learners and teachers – although no less valuable. As with NMP, in its performance and composition contexts, online music is not a direct replacement for traditional forms of music education, however, it can be used to open up opportunities and enhance existing provision, and be used alongside traditional face-to-face methods.

There are many commonalities between music education and community music, but there are also some key differences, namely the relationships between teachers/leaders and learners/participants and the intended outcomes. Online music education will be explored first in this chapter, followed by specific issues relating to community music delivered through the internet, however, many of the areas discussed here will be relevant to both settings.

The role of music education and community music

Music education and community music are characterised by their relationships between teachers and learners and between music leaders and participants. Traditionally, these have taken place in face-to-face environments, but increasingly the opportunities for working remotely and via the internet have become more attractive to both educators and to community leaders. As

discussed in Chapter 1, some forms of distance music education have been in existence for many decades, in particular in remote and rural locations where learners may be physically isolated and unable to travel to school, college, or university. Increased access to broadband internet, both in schools and domestically, has led to practical and easy access to online music education for many people, even those who are not living in remote areas.

Community music may be seen as a continuation of music education for those who have moved on from a formal music education but have not gone on to a professional life in music. Myers (2008) argues that the primary goal of formal music education should be to enable lifelong music learning and music participation in adults' lives. This requires children being engaged in independent and authentic music-making in their school music education as well as providing opportunities for adults to begin and continue this same process. Music plays a crucial role in intergenerational cultural transmission. Online music education has a role to play in this musical journey, as it opens up opportunities for participation where there may be barriers preventing this.

Music education is not just about solo and ensemble performance and instrumental skills. It also includes creativity in the form of composition, arrangement, and improvisation of music, music listening and how music fits into a societal context, and the use of music technology as a creative and practical tool for performance and creativity. Consider how people engage with music in their adult lives: for the majority of adults, this will involve rather more music listening than performance, for example, and this may be for entertainment or to reflect or alter mood. There are also clear benefits of engagement with music on health and well-being (see, e.g., Macdonald et al., 2012), and this engagement can be nurtured through music education.

Online music education

Online music education offers access to resources for learning across genres, levels, and geographical areas. It can be accessed by teachers and learners alike and can be used to focus on specific musical interests as well as widen perspectives on music. Online music education encompasses many different aspects of learning music. While the COVID-19 pandemic has forced many music teachers to embrace the possibilities of online teaching, especially in relation to video-conferenced instrumental tuition, this form of music education is not new. An example of pre-COVID online music education is given in the Applied Music case study below. Online music education is possible across different settings and contexts. This includes formal, curriculum-based education that is most commonly seen in schools, colleges, and universities as well as informal peer-to-peer learning, which might happen between members of a band, for example.

When considering online music education, it is worth remembering that it is unlikely that music learning will take place entirely online without the

physical presence of other musicians at any time. It is likely that there will always be a blend between online and in-person learning environments. This may be through the combination of online instrumental lessons and informal peer learning in an ensemble environment, or supplementing a formal course in music with online course in specific skills (e.g., on how to use a particular DAW [digital audio workstation] or specific training in harmonic techniques).

Any group size can take part in online music education, from one-to-one up to potentially unlimited numbers. The methods and content for these will be different, of course, with synchronous instrumental tuition being suitable for one-to-one settings, while asynchronous massive open online courses (MOOCs) are designed specifically for huge numbers of learners.

Online music education is suitable for any level of musician, from total beginner instrumentalists up to professional-level musicians. Again, the methods and approaches will vary depending on the level being taught and also the age and maturity of the learners. Music education at different levels of schooling can be quite different. For example, at primary school level, there is a focus on general music education, with full class singing, for example, while at secondary school level this may be supplemented by individual or group instrumental tuition. In tertiary education, it is common to include specialist one-to-one instrumental tuition, alongside lectures and workshops. As we see later on in this chapter, online education requires more independence from learners than face-to-face tuition, so it may be more suitable beyond a certain level of maturity in the learner, or with specific in-person support from parents, carers, or teachers.

Online music education is suitable for any style or genre of music and methods of transmission. This refers to how music is transmitted from one generation of musician to another. For example, some styles of music rely on an oral/aural transmission, where music is passed between musicians by listening and learning by ear. Other styles rely on notation for this transmission. This is also dependent on the style of learning and teaching of particular musicians and may vary from person to person within a musical tradition.

Both practical and theoretical aspects of music are suitable for the online learning environment. This includes instrumental skills, composition and arrangement techniques, and learning about the background style and context of music. Ensemble music teaching can be a challenge in the online environment, but NMP approaches discussed in Chapters 3 and 4 can work well in music teaching. The approaches taken will depend on the subject being taught, with some areas more appropriate for synchronous delivery and others for asynchronous delivery.

Contexts for learning

While we often think of learning happening in schools and other educational establishments, learning can be categorised as formal, non-formal, and informal. We can see through these definitions that there are clear links between

music education and community music and that learning may happen in both of these contexts as well as in day-to-day life.

Formal learning involves systematic, curriculum-based teaching that leads to a qualification, such as school or college-based education, or in instrumental teaching, perhaps lessons that are leading to a graded examination. Applications of NMP in this environment include distance learning for a qualification or online instrumental tuition as part of a wider course of study.

Non-formal learning happens outside a formal learning environment but within an organisational structure. In music, this might include the music that happens within a community group, such as an amateur orchestra or choir. NMP projects in these environments are likely to be project-based, such as 'virtual ensemble' projects or similar.

Informal education refers to learning that happens in day-to-day life and which is not the main aim of the activity. This type of learning may happen in NMP through perhaps working on a collaborative project and learning a new technique from a peer. It may also happen through participating in a community music project.

Online teaching tools and methods

So, what might different methods of online music education look like to learners? This describes the format of the learning and teaching rather than the content that is taught. It includes examples such as:

- Video-conferenced instrumental lessons;
- Video-conferenced general music lessons;
- Online instructional videos;
- Instrumental masterclasses;
- Group instrumental instruction;
- Informal music learning;
- Websites of learning resources;
- Music learning apps;
- Communities of practice.

Synchronous video (or audio) conferencing techniques can be used for online music education. This may include all learners and teacher being visible to each other or only the teacher being visible, with possible live sharing of resources such as videos or other visual resources. This may also include instrumental tuition in a one-to-one setting.

Instructional videos are a method of online music education that may be accessible in many ways, either publicly through video-sharing websites or privately as part of specific educational websites. These may be instructional videos on a variety of musical topics, including instrumental tuition. This method is asynchronous – the learners can access the resource whenever is

convenient for them – it does not rely on the teaching and learner being available at the same time.

Public websites can be used as repositories for musical learning materials. An example of this is the Online Academy of Irish Music (OAIM), which is described later in this chapter. These can be used to access a number of learning materials, including videos, notation, and written articles. A subset of these are virtual learning environments (VLEs) which are digital platforms that hold learning and assessment materials for particular courses of study, usually within an institution. These are also known as learning management systems (LMSs). They may also include facilities for synchronous video conferences, as described above, as well as tools for assessment and learner reflection.

MOOCs are aimed at unlimited participation and free accessibility to participants and are used to teach many aspects of music. These are structured courses of study that include a variety of learning resources, and often, forms of assessment. They often include some form of interaction with other participants through online discussion boards. Many areas of learning in music are available through MOOCs, including music technology, theory, harmony, ear training, performance, and improvisation.

Apps for music learning are another important area of online music education. There are multiple types of music apps which may have a direct or indirect role in music education and may be used as stand-alone learning tools or to complement other forms of teaching. There are apps that are specifically designed for music education, which may include lessons (practical or theoretical) or resources such as notation and chord charts. Music games may have a role to play in education to introduce potential musicians to musical concepts, which may develop into an interest in learning music more formally. Music tools such as tuners and recording platforms can be valuable to both learners and teachers and used alongside other resources. Finally, online DAWs can be used to develop musical ideas, learn music technology concepts, and collaborate with other musicians, which contribute to the user's music education.

Online collaborative music environments could also be considered as a tool for music education, although these are likely to play more of a role in informal peer-to-peer learning rather than including a structured course of study. Barbosa (2003) describes these as shared sonic environments, where members of an online community can participate by manipulating or transforming sounds and musical structures with little previous musical knowledge or instrumental skill. These may engage and inspire participants to develop their musical learning and are also very suitable for community music projects.

NMP in music education

Many of the approaches already discussed in this book are used within music education, however, different forms of NMP can be used together to create an optimal environment for teaching. For example, synchronous NMP can

be used in the form of video conferencing to deliver lessons to learners in real time, including discussion, demonstration, and coaching to a student. Combined with this, learning materials can be provided in advance, perhaps in the form of instructional videos and written resources. Students can record audio or video of themselves playing and send them to their teacher (a form of asynchronous NMP) for feedback.

As with other forms of NMP, online music teaching allows access to educators which may otherwise not be possible for individuals, perhaps due to playing a niche instrument without any local teachers, or through difficulty travelling for either the student or the instructor. One of the characteristics of online music education is its flexibility, both for students and teachers in terms of access, but also in the methods used.

LoLa (a high-quality, low-latency NMP system which uses academic networks and described in the case study in Chapter 2) was originally devised at the Conservatorio di Musica Giuseppe Tartini in Trieste, Italy (LoLa, 2020), with the aim of providing masterclasses for conservatoire students. These types of institutions often have the network infrastructure required to use the system and use it to provide expert tuition. The major advantage of using this system is that it allows access to specialist music educators from other institutions without the need to travel.

Generic video conferencing systems can also be used quite successfully for instrumental lessons, with minor modifications to teaching methods by the instructor. When using video conferencing designed for speech communication, latency will impact the ability of the teacher and student to play in time with one another (see Chapter 3 on synchronous NMP), however, this can be avoided in many instrumental lessons.

NMP as an area of study for music students in itself is fairly rare, although NMP methods are used in education for collaborative projects and as a teaching method – as this chapter will explore. Music technology as part of a general music education is relatively limited (in the UK, at least), so it is unlikely that NMP as a subject would be taught in schools, although it is more likely in a university environment where music can become more specialised. In particular, the very technical aspects of NMP (e.g., some of the networking methods used by groups such as The Hub) is most likely to be found in very specialised music and engineering courses at universities.

Online DAWs offer an informal way of learning about music production, as highlighted by Koszolko (2015). Working with an offline DAW can be an isolating experience, particularly for those who are learning about music production generally or how to use a particular piece of software. Online collaborative music production spaces offer a community of practice and an opportunity to learn from more experienced users.

Online music education can take the form of direct teacher-learner interaction in an online environment, but forms of NMP and online tools can also be used for practice and development of musicians. These can be used in formal

educational settings as well as informal, self-directed learning, and either as stand-alone tools or in combination with face-to-face teaching methods.

Online music pedagogy

Music education sometimes evolves very slowly in terms of pedagogy, with teachers teaching as they were taught, and slow adoption of technology. This is understandable, as there is often not enough time for teachers to experiment and take risks when following a curriculum: it is more time efficient to use tried and tested methods. While extremely disruptive to many music teachers and learners, the COVID-19 pandemic and the sudden need to switch to online methods of music education may have helped to change attitudes and allow risk-taking that teachers may not have felt comfortable about otherwise in music education.

Another example of this is the very slow uptake of music technology in general in music education, as highlighted by the low uptake of music technology as a qualification in Scotland (SQA, 2021). DAWs are incredibly accessible, although rarely used in the music classroom. It could not be easier for music students to make videos of performances or practice for tutor feedback using mobile devices or to develop a composition using multitrack recording techniques; however, this requires encouragement from music teachers, and the teachers need the technical skills to be able to do this. Perhaps as more music teachers have experienced using technology during the COVID-19 pandemic, there will be greater awareness of the possibilities of the use of technology in general in music education.

We have discussed Scholz's (2021) descriptions of the teleological and ontological approaches to using technology in music in Chapters 3 and 4. These are relevant in music education as well as more generally in NMP. Teleology has a predetermined goal in mind and the technology is a tool to reach that goal. In the context of music education, this would mean attempting to use technology to recreate a typical music classroom with associated interactions and minimal change to pedagogy. In ontology, new approaches are embraced that reflect the features of the technology. Surprise and the unknown are embraced. In music education, this would mean developing new pedagogy to reflect the affordances of synchronous and asynchronous methods of musical interaction. The ontological approach is probably a little more complex in teaching than in general NMP, because creative outcomes are sometimes secondary to learning outcomes.

Johnson's conceptual model for teaching music online (2020) encompasses four areas – the teaching approach, ways of learning, online tools, and the students' skills and knowledge (their learning) at the centre. This model recognises that there are many facets to music teaching, including instrumental learning, theory, and context, with different online approaches being most appropriate for each. It also recognises how the different layers influence one

another and that there will be fluidity in approaches, ways of learning, and online tools that are available, for example, synchronous video conferencing tools and online learning materials that have been discussed above. It also questions the assumption that online learning provides unavoidable limitations on arts education.

In Johnson's model, the teaching approach may be student-centred, teacher-as-expert, or subject-centred. In the student-centred approach, the student becomes responsible for the direction of their learning and the methods through which this happens with the teacher as a facilitator. In the teacher-as-expert approach, the teacher enables the learner, provides teaching content, and guides the overall learning experience. Johnson highlights that music performance has been proven to benefit from this specific approach to teaching. In the subject-centred approach, motivation to learn is driven by interest in the subject itself.

Ways of learning are the vehicles that will be used to get the student closer towards their goal, and in Johnson's model, these include constructivism, behaviourism, and cognitivism. Constructivism is learning that happens through collaboration and is based on personal experiences, with the learner interpreting and bringing meaning to these experiences themselves. In music education, this may be through ensemble performances that bring meaning of historical contexts to the student, for example. Behaviourism in music encompasses the modelling and practising that is inherent in learning a musical instrument to achieve agility and accuracy. At the heart of cognitivist learning are the actions of solving problems, starting ideas, and collecting information to organise, restructure, and derive meaning. In music education, this may be relevant in composition, arrangement, and theory subjects.

Johnson (*ibid.*) suggests that a suitable starting point for teachers in online environments is to know the objectives of their course and then identify an approach that will be effective in providing students with meaningful learning opportunities, considering all the layers of the model and how they interact. Throughout the following sections, we explore some of the specific issues for music teachers, and it may be useful to consider how these fit with Johnson's model.

Online instrumental tuition

Online instrumental tuition requires a different approach than general online education. It is practical, usually taught either one-to-one or in small groups, and often has a strong relationship between the learner and the teacher. Simones (2017) describes the process of teaching and learning to play an instrument as one that requires simultaneous learning of conceptual musical elements and the motor skills to be able to embody these abstract concepts physically, mentally, and emotionally. All these elements must be considered in the online environment.

Video-conferenced one-to-one instrumental lessons, specifically designed for individual learners, are often the first method of teaching that springs to mind when considering this form of education, but online instrumental tuition also encompasses asynchronous methods, such as instructional videos. These may be shared publicly on a website and not designed with a particular individual in mind and outside a formal structure of learning an instrument. In addition, masterclasses may be accessible online, where learners observe other musicians in a teaching environment.

It is important to consider that there are multiple ways of delivering instrumental tuition. Many of the studies around instrumental tuition are working in a one-to-one, master-apprentice type of environment (which Johnson (2020) describes as teacher-as-expert), with imitation being the main form of pedagogy and working with written notation. This is common in the classical tradition and conservatoire education. This is probably a result of the musical background of many of the academic researchers in the field (and the idea that many people teach as they were taught), although not exclusively: popular and traditional music pedagogy is gaining interest from researchers. Other musical traditions have other methods of teaching. Consider rock music, for example, where many learners are self-taught and learn by listening. In Western musical traditions, many accomplished musicians may never read music (e.g., in popular or traditional music), while many may also be unable to play by ear (in the classical tradition) as a result of their methods of learning. None of these approaches is more or less valid than others, and it is important not to prioritise one method over another in a discussion around online learning.

Many studies (see, e.g., Kruse *et al.*, 2013; Stevens *et al.*, 2019; Biasutti *et al.*, 2021) have highlighted that students need to be more independent learners for success in the online environment, both within music education and in more general online education. This perhaps suggests that the master-apprentice (or teacher-as-expert) model – where the learner is reliant on the teacher for the direction of their studies – may be less suitable for online instrumental learning. Johnson (2020), however, argues that the teacher-as-expert approach may be the best method for some instrumental teaching, even in the online environment. Often, the constructivist approach is taken in online environments, empowering students to take control of their learning, with the teacher as a facilitator and mentor rather than a leader to be followed.

When considering any studies on online instrumental tuition, the methods used and the participants may have an impact on the results. For example, prior to 2020 and the COVID-19 pandemic, most instrumental tutors would probably have little experience of working online – it was a niche activity, mostly undertaken by those with enthusiasm for technology and perhaps niche teaching interests. During the pandemic, many instrumental teachers were *forced* to start teaching online, and coercion is rarely successful at

fostering an enthusiastic approach to anything. That said, most teachers could see the value of continuing to teach in difficult circumstances and take their learners' needs very seriously, so taught online, if not completely willingly. During this time, several studies were undertaken looking at online instrumental teaching, and the stress that these teachers were under at the time should be taken into account when considering the findings, alongside the fact that many of these teachers had no training or preparation time for moving their teaching online. As Redman (2021) points out, there is a risk that these studies may actually undermine decades of previous research, showing the effectiveness of online music learning when it is carefully planned and intentional.

Technical issues

As with other forms of NMP, technical issues are usually the first consideration for practitioners when considering online teaching for the first time. There are some clear differences between the practicalities of online and in-person instrumental teaching, both in synchronous and asynchronous environments.

In a synchronous teaching environment (i.e., using video conference methods):

- The learner and teacher are not in the same physical space, and so will see hand and body position, for example, through a video link, which should be two-way;
- The teacher will not be able to touch the learner or their instrument for adjustments in body position or for making adjustments to the instrument itself (although this is sometimes prohibited in face-to-face environments for safeguarding purposes);
- The audio quality of the video link may be impaired, so there may be an impact on hearing the instrument and nuances of playing both for the learner and the teacher;
- There may be latency in the system, which will make it difficult for the teacher and learner to play together in time with one another;
- Spoken communication will happen through an audio and video link, with associated reduction in audio quality and possible impact of latency, which may impact the relationship between teacher and learner;
- The learner and teacher may both have access to online learning materials during the lesson through screen sharing or other methods;
- Lessons can be easily recorded using record functions in the video conferencing software.

In an asynchronous environment (i.e., instructional videos):

- The process is one-way in relation to teaching – there is no interaction between learner and teacher;
- The learner can repeat the lesson as many times as they like;
- There is no immediate feedback on the learners' progress;
- The learner must use self-reflection to assess their own progress;
- There is time within a lesson for the student to practice and refine their skills by pausing the lesson at appropriate points and replaying sections as many times as the learner needs.

While there are some physical differences in the online environment, there are many teaching methods that can be used in a very similar way to in-person learning environments, such as demonstrating and breaking down techniques, slowing down passages, and using repetition. It is also clear to see from these lists that there are some benefits of teaching online compared to in-person, specifically the availability of tools that can help learners consolidate their skills and knowledge during and after a lesson.

Instructional videos for instrumental teaching

Instructional videos are an accessible way for learners to access music education, often at no cost. Waldron (2012) examined YouTube videos in informal music learning and categorised them based on their content and intention. The first category was amateur peer-to-peer performances, which were created by learners for either sharing with a community of musicians for commentary or sending to a tutor for critique. Second, there were professional or semi-professional performances (e.g., recordings of concerts) that were used by community members for informal music learning and/or for sharing commentary. The final category was professional musician-instructors who made intentionally structured lessons for teaching reasons. An interesting characteristic of all these videos is that they encouraged discussion and commentary as well as collaboration in online discussion. This shows that while the use of online instructional videos may be seen as a solitary activity, there can be a community aspect around this.

Kruse and Veblen (2012) examined the content of YouTube instructional videos in North American folk music. They noted that there was a range of instruments and that the videos were aimed at multiple levels of learners. They found that the content of the videos mostly focused on technique, but that they also contained some music theory and teaching of specific tunes (which is a common method of transmission of the music in the traditional music

genre). Pedagogical techniques included modelling and repetition as well as slowing down of playing for students to play along to. The authors suggest that this mode of learning might suit beginners best, as more advanced players are likely to be part of a physical community of musicians. While this may be the case, advanced players may also benefit from learning specific techniques or tunes in the online environment.

Instructional videos can be seen as the online equivalent of instructional books and manuals on instrumental technique. These are valuable tools for musicians to refer both to supplement their learning with a teacher or as stand-alone tools. Videos, of course, have the advantage that musicians can see techniques being performed and hear the results. As with any instructional material, the quality of these can vary and it can be helpful for students to develop reflective skills to discern the quality of these materials.

Comment sections alongside videos can be a useful way for learners to engage with the creators of videos and to ask questions as well as gain encouragement. Communities of practice (as described by Wenger [1998] and explored later in this chapter) can be built by learners posting their own videos of the techniques learnt and joining in discussions. As with any open forum online, there is always a chance of comment sections being used in a less positive way, and participants should be aware of general etiquette for online discussion.

Use of video in synchronous instrumental teaching

Stevens *et al.* (2019) carried out a review of online music teaching systems to inform a project for synchronous instrumental teaching of secondary school students in rural Australia. They highlighted a list of technological requirements that appeared to be important for the success of online instrumental tuition. This included 360-degree camera views of the student and a mobile camera controlled by the teacher. More practically achievable requirements included MIDI (musical instrument digital interface) keyboards to allow low bandwidth transfer of notation and audio codecs designed for music. Clearly, such high-quality and flexible video equipment is not practical for many teaching situations, and many teachers have demonstrated success in online instrumental tuition using standard built-in webcams in laptops and portable devices.

Unlike synchronous NMP in the performance sense, where video is a positive addition but not vital for the interaction between musicians, video is very important in online instrumental teaching. A clear view of the student is important so that the teacher can give feedback on body position as well as technique for playing the instrument. If possible, multiple camera views of the student could be helpful for the teacher, including a view of the student's whole body and a closer view of the instrument and the student's hands (as appropriate to the instrument). Stevens *et al.* (2019) also suggest that cameras

should have zoom functions controlled by the teacher, however, this is not practical in many online teaching situations and does not appear to be vital for positive learning outcomes.

Despite the seeming importance of the video element of online teaching, both from an intuitive and research perspective, Redman (2021) found that audio-only drum kit lessons were possible. In their study, an audio-only connection was used due to network problems at the student's location and was followed up with a face-to-face lesson. They highlighted that, although audio-only lessons were possible, the visual element of video conferencing was essential for checking posture and diagnosing potential physical problems early on. Audio-only lessons may, therefore, be used quite successfully alongside face-to-face lessons or those with a video component, particularly if there are bandwidth issues affecting the use of video.

Latency and audio quality in online instrumental teaching

One of the key challenges of online instrumental teaching specifically, and synchronous NMP more generally, is the difficulty in playing in time in more than one location as a result of latency in the system (the origin of which is described in Chapter 2). If there are participants in more than two locations, then the multiple latencies cause further complexities in timing. This is often seen as a major barrier to instrumental teaching online, however, both the teleological and ontological approaches described by Scholz (2021) are possible in this respect. Separate but related to this issue are the impacts on rhythmic detail that may result from packet loss and jitter.

The use of LoLa (2020) for instrumental teaching solves this problem from a teleological point of view, allowing high-quality, low-latency audio and video connections between the teacher and learner, and therefore allowing them to play together in time. As discussed previously, this comes at a cost, both in terms of the financial outlay required and in terms of accessibility. The need for a high bandwidth network and infrastructure as well as suitable technical support means that it may be prohibitively expensive for smaller institutions (Redman, 2021).

JackTrip is another low-latency solution, which can be operated on standard networks and computers and facilitates large ensemble rehearsals and performances. In its original form, it is an audio-only system, but can be used in conjunction with standard video conference platforms for any video that is required. It is, however, difficult to operate for those unfamiliar with it, and there is a recognised need for training programmes for teachers, especially if being deployed in educational establishments (Redman, 2021). JackTrip Virtual Studio is a commercial product (JackTrip Foundation, 2022), which uses the JackTrip engine and includes a video element as well as being more user-friendly to set up and use, which may solve some of these issues. However, the more complex low-latency platforms require more time to learn how

to use and also more time to physically set up the extra equipment such as microphones and monitors.

Kruse et al. (2013) explore a one-to-one piano teaching environment that uses a Disklavier piano with a MIDI connection as a way of reducing latency and allowing student and teacher to play together on the same piano (while physically separated). A Disklavier contains sensors that record the movements of the keys, hammers, and pedals of the piano and save them as a MIDI file. This file can then be played back – in the case of this study, on a different piano – reproducing the performance exactly. MIDI files are much smaller than audio files, so are more suited to sending in real time through the internet and result in almost perfect reproduction of the original performance, subject to latency, jitter, and packet loss. This is an excellent technical solution to playing together, although it does require both teacher and learner to have access to a Disklavier, which is not an insignificant cost.

The ontological approach is to consider what is possible with the technology available and the creative ways to either work with or eliminate difficulties of latency. Examples may include the teacher providing backing tracks that can be at the student end of the video conference so there will be no impact of latency. If there is a need for the teacher to give feedback on specific aspects of ensemble, for example, the student may make recordings of themselves playing along to the backing track.

Another challenge of synchronous online instrumental lessons is the potential reduction in audio quality that happens as a result of audio being transmitted through the internet. This may include glitches, dropouts, and jitter caused by packet loss and a reduced frequency range and audio artefacts caused by compression codecs. Stevens et al. (2019) highlight the need for high-quality audio in an online teaching environment. This may be possible with systems such as LoLa, however, this will usually not be available to many teachers and learners, especially outside academic environments.

Given that high-quality audio will be important for a teacher to hear aspects of a learner's playing such as tone quality and intonation, other methods may need to be found to provide appropriate feedback. This might include the learner creating audio or video recordings that can be shared with the teacher or by arranging some face-to-face lessons to work on these particular aspects of playing.

Teachers and students must be aware of and prepared for occasional inevitable disruptions to lessons caused by poor internet connections or other technical issues when using video conferencing platforms. If the bandwidth is reduced due to network conditions, either the teacher or the learner may need to switch off their cameras to prioritise the audio connection. If the network conditions make a lesson impossible, then there should be some alternative way to contact the student(s) to make them aware of the problems. A positive, flexible attitude to such technical problems can help to make the online teaching environment more successful.

Pedagogical issues

Similar to some of the arguments against synchronous NMP, some educators attempt to recreate in-person experiences in online environments and are frustrated by the results. It is important to remember that online teaching is not the same as in-person teaching, and different methods are needed. If an instrumental teacher has never taught through video conferencing, they may have preconceived ideas about what is possible and what is not.

Given the differences between the online and face-to-face teaching environments, it is inevitable that pedagogy will be different in these environments also. One of the factors of pedagogy is how time is spent in lessons. In a study of experienced instrumental instructors teaching secondary age students, Orman and Whitaker (2010) compared time usage in face-to-face and video-conferenced lessons. In both settings, instructors spent the most time in lessons talking, followed by performance. Students in the study spent more time talking than engaged in performance during the face-to-face lessons. In the video-conferenced lessons, there was more time spent on student performance and less time spent on instructor performance, and strikingly more than a 50% decrease in instructor off-task comments.

Dye (2016) observed synchronous online lessons provided by undergraduate student teachers to secondary- and university-level students and categorised their behaviours in these lessons. They categorised teacher behaviours as demonstrations, instructions, discussions, and those that were off-task. The student behaviours were categorised as demonstrations, discussions, and those that were off-task. They found that teachers spent most of their time giving instructions, then discussions, and only a small amount of time on demonstrations. Students spent most of their time on discussions, followed by demonstrations. This study is useful because it looks at how time is spent in online instrumental lessons, however, it raises some questions around the methods used. The teachers in this study were not experienced – they were undergraduate student teachers. They may, therefore, not have considered their pedagogy deeply when delivering the lessons and relied on discussion over demonstration as it was easier to facilitate using the generic video conference system that was used. It is unclear whether they had specific training in teaching in online environments.

Given that more time is spent talking in lessons than playing, and video conferencing systems are designed for speech communication, this suggests that the synchronous online environment may be well suited for instrumental instruction. In addition, it is also fairly straightforward for both teacher and student to play to one another, although there are serious challenges when attempting to play together.

From the teacher's perspective, Redman (2021) also found that online lessons were intensive and tiring due to hyper-focus, which is perhaps reflected by the reduced instructor off-task comments noted by Orman and Whitaker (2010). In online lessons, teachers are required to verbalise their instructions

more than they might do face-to-face, where they are unable to use typical methods such as demonstration for specific tasks. Redman (2021) highlights the positive benefits of this: teachers had to think more critically about their instructions and how to effectively communicate this to learners. It is likely however that this becomes easier and more habitual as teachers become more accustomed to the online teaching environment.

Stevens et al. (2019) also highlighted some of the pedagogical requirements for synchronous online music teaching, specifically that synchronous teaching requires more preparation time than asynchronous teaching. As synchronous and asynchronous methods of teaching are quite different, it is difficult to be able to evaluate the difference in time needed for preparation for each method, but other studies (see, e.g., Redman, 2021) have shown that synchronous online instrumental teaching does require more preparation time than the in-person equivalent. This may be a result of teachers having less experience of online teaching or it may be that preparation is needed to allow access to resources that could easily be accessed in a classroom. There is no doubt that online instrumental instruction requires careful planning and preparation. For example, learners need to be given resources in advance in electronic form, which they may wish to print out to use within the lesson.

One of the major concerns for teachers moving to the online environment is that they will be unable to touch, mark, or point at specific places in the music that the student is playing. A study by Orman and Whitaker (2010) found that these activities happened during less than 1% of the time spent teaching in face-to-face lessons, so the impact of being unable to do these activities is probably fairly minimal. In addition, it is possible to work around these by sharing screens and using electronic copies of music, or by including bar numbers in parts provided so the student can easily navigate around the piece. In fact, this may be a useful skill for instrumentalists who rely on notation to learn early on for later use in large ensembles when receiving instructions from a conductor.

It is useful to examine some of the issues in face-to-face teaching to consider how these might be impacted by the online environment. Carey and Grant (2015) examined conservatoire-level one-to-one instrumental teaching in a face-to-face environment to elicit student and teacher's views on pedagogy. They highlighted four themes, which emerged from interviews and focus groups: individualised learning, student-teacher relationships, independent learning, and placing instrumental learning. These themes also appear when considering online music teaching, although the context is slightly different. While the authors focused on conservatoire-level teaching, these themes are also relevant at other levels and wider contexts for learning.

The first theme was customising teaching to the individual. Teachers and learners highlighted the value of teachers adapting to the needs of their students (whether related to technique, musical issues, or learning wider professional

skills), although some students felt they had to adapt to the teaching style of the teacher. In an online environment, this is no different, although there may be additional constraints that teachers and learners need to navigate.

The second theme was the student-teacher relationship. Particularly at the conservatoire level, this can be a complex relationship, where the music teacher is a musical, professional, and sometimes personal role model, mentor, or advisor. Much of this relationship is likely to be developed through spoken communication, for which video conferencing was designed. Despite this, there may be an impact of the use of video conferencing on communication between teacher and student. Alongside any consideration of this relationship in general, the impact of the difference in communication must also be considered by the teacher.

The third theme was student dependency versus self-sufficiency. Often, mimicry is used as a pedagogical approach in the conservatoire environment, with an over-reliance on demonstration and modelling. This fosters dependency on the teacher and a teacher-centred approach. The online environment may prove to be beneficial in this respect. The limitations of audio quality online (apart from when using highly specialised systems such as LoLa) mean that mimicry and modelling can be more difficult online, so teachers will need to adapt their pedagogical approaches away from these methods. This is likely to have a positive impact on learners, as both the environment and the teaching encourage learners to be more self-sufficient (see, e.g., Kruse et al., 2013; Stevens et al., 2019; Biasutti et al., 2021), an area that we explore in more depth later in this chapter.

The final theme was situating one-to-one instruction in a broader context. Both students and teachers saw the benefit of one-to-one teaching being part of a wider suite of pedagogical tools in performance teaching, for example, masterclasses, workshops, studio seminars, team teaching arrangements, and informal and peer learning. Many of these methods are also suitable for the online environment, and face-to-face teaching may also complement lessons online. Some of the approaches to synchronous and asynchronous NMP, described elsewhere in this book, may also be beneficial for collaborative creativity and ensemble work.

Many researchers have highlighted the importance of independence in learners when working in an online environment, and Kruse et al. (2013) specifically highlight the need for learners (and teachers) to be able to solve technological issues with the software used for the lessons, for example, as well as any issues with the instruments themselves. For those with few skills in technology or very young learners, then support around this should be considered, and perhaps in these cases, lessons should be accessed from somewhere where this support is readily available, for example, a school.

Redman (2021) highlights the need for studio environments to be planned for different instruments. As a percussion teacher, Redman is particularly

aware of the space that these instruments take up and the difficulties of finding good camera views. This is particularly the case when percussion students are learning multiple instruments (e.g., perhaps timpani, tuned percussion, and drum kit). There are also accessibility considerations for students with less portable instruments, who may not be able to access lessons from home.

Learner engagement

Much of the focus of the research into online instrumental teaching has been from the teacher's perspective, such as how teachers reacted to online instruction and what methods they use. The learner's perspective has largely been ignored in formal studies. A positive learner experience is vital for students to feel engaged, in control of their own learning, and wanting to continue their learning when studying inevitably gets difficult. This learner experience is important not only in the lesson itself but also in their wider learning. How do students engage with their learning when they are not in the (virtual) classroom supervised by a teacher?

While many of the studies on instrumental learning focus on the lessons themselves and the time spent with learner and teacher together (in an online sense), self-regulated practise is an important component of instrumental learning. Learning an instrument requires daily practise to develop the co-ordination and motor skills to master an instrument, and the teacher has a role in developing these practise routines. In some cases, a teacher may also need to engage with parents or other carers of children and involve them in their learning. In an in-person setting, this may involve discussion with the guardian when the child is dropped off or picked up at a lesson or they may be present throughout the lesson. These are also considerations in the online environment, and teachers may wish guardians to be present for some or all of the lesson time so that they can help to guide practise time. As learners progress, practise becomes more independent. There are helpful online tools that can help with this self-regulated practise, including learning portfolios that can be used to store scores, journals, video recordings, and backing tracks. These can also be accessed by teachers to provide feedback or by students for self-reflection (Redman, 2021).

As with any form of NMP, the start and end of synchronous instrumental lessons have the opportunity to be a jarring experience. Due to the way of connecting, there is no physical or temporal transition between being in the lesson and outside the lesson. In an in-person lesson, this would usually involve some sort of travel as well as conversation between student and teacher (in the UK, usually involving the weather) that acts as relationship-building time. At the end of the lesson, this might involve some sort of informal reflection on the lesson itself. While these activities may be seen as inefficient and a waste of precious teaching time, they serve an important

part of the learning experience, as good relationships between teachers and students are likely to impact positively on the learning experience. Teachers should consider this in their online interactions while still maintaining professional relationships.

As we have seen earlier in Johnson's conceptual model for online music teaching (2020), there are different approaches to instrumental teaching, including the teacher-as-expert approach which is common in conservatoire teaching. In many cases of instrumental teaching, the teacher takes the role of leader: they decide on the direction of the lessons, the repertoire played, and techniques that need developing. They do this based on listening to the student play and discussion around musical tastes and goals as well as using the curriculum of any formal qualifications as a guide. They provide feedback on the student's playing during the lesson as well as providing help with practice routines and exercises to improve technique.

While this approach takes into account the student's needs, it also places the responsibility for learning firmly in the hands of the teacher, where the teacher is the master and the learner is the apprentice. In a student-centred approach, the student is the expert in their own learning experience, and the teacher offers guidance and mentorship based on the needs and wants of the student. The responsibility for learning is in the hands of the student, and they choose what they want to learn and how they want to learn it. This encourages self-reflection, creativity, and critical thinking.

In the context of instrumental learning, practical strategies for this may include video recording performances (formal or informal) and using them for self-reflection rather than relying on the teacher to provide feedback. This can be discussed with the teacher, with the teacher offering suggestions and different perspectives. It may include the student choosing their repertoire and identifying techniques that they need to develop. It may include the student identifying the needs of the curriculum rather than the teacher prescribing how these needs might be met. It may also include the teacher engaging in discussions in which they guide the student and make suggestions on how they may meet their goals.

This approach is beneficial to students, as it allows them to take control of their learning and learn skills for learning and self-reflection. This will help them throughout their musical journey, both when they engage with teachers and when they are working independently. It helps them to develop lifelong practices for engagement in music, whether professionally or in the community.

Student-centred learning can happen in both online and in-person environments. The online environment offers many tools that can help students in their learning and which promote learner autonomy. Within online instrumental teaching, the use of videos (both of the student and of other performances) is valuable for self-reflection and the development of technique. The

lessons themselves can also be easily recorded through video conferencing platforms to allow the student to revisit aspects of it. Methods can be synchronous or asynchronous, as suitable to the learner's needs and the teacher's availability.

There is no doubt that this approach to learning may be quite different to what many instrumental teachers, and indeed students, may be used to, and requires flexibility and openness from both. There is the potential for preparation for lessons to be more time-consuming for teachers as they may not be able to rely on an existing bank of learning materials. Lessons should include discussions around the expectations of the learner and the teacher and what is realistically possible for both within the time available.

Attitudes to online instrumental tuition

Biasutti et al. (2021) examined conservatoire-level music teachers' perspectives of giving online music lessons during the COVID-19 pandemic. They highlighted some of the challenges of working this way, broadly split into technical and pedagogical challenges, but also identified some of the affordances of teaching online. As discussed previously, many teachers were totally unprepared for the move to online teaching, and this would have influenced attitudes towards this model of teaching, however, it is notable that this study highlights some of the teachers' positive attitudes. Unsurprisingly, the technical challenges of latency and audio quality were noted by the participants in the study, particularly as during the pandemic most teachers and students were working from home and therefore had to rely on whatever home audio set-up they had available to them.

The teachers' perspectives on learning and teaching challenges were interesting, with particular challenges for group work and assessment. They recognised that teaching methods must be different online, with a move from non-verbal teaching (i.e., demonstration of techniques) to verbal teaching (i.e., explaining concepts). They highlighted the need to be clear and focused in the lessons and that lessons required more concentration and planning, an aspect of online learning that was also acknowledged by Kruse et al. (2013) and Redman (2021). These are interesting points, as the move away from teachers' usual mode of teaching appears to have required teachers to examine and adjust their own practice in a reflective way rather than rely on their established pedagogy. While there may have been technical challenges in implementing these changes, the reflective practice in itself is likely to have been beneficial to the students.

In Biasutti et al.'s study (2021), the teachers recognised strengths of flexibility and improved time management in their lessons, although they also noted that it took longer to prepare learning materials for online use. This may have been a result of the administration needed to convert materials to an online

format, and of course, once this has been done, then they can be reused in future for other students.

Most instrumental tutors wish their students to succeed, and in this study, the teachers' focus on the students' needs was highlighted as a strength of their work during the pandemic. To promote student success, they used co-operative learning and individualised teaching. They also encouraged their students to be more responsible for their own learning and be independent, which demonstrates a move towards a more student-centred approach.

Kruse et al. (2013) highlighted that enthusiasm and ingenuity during online adult piano lessons increased over time. As an inherently creative subject, musicians are used to creative problem-solving, so music as a subject is probably well suited to the challenges of working online. Redman (2021) also highlighted attitude as an important factor in the adoption of new technology for music teachers and that teachers were surprised at how easily they adapted to online teaching.

Biasutti et al.'s study (2021) also highlighted that music teachers had recognised the value of virtual learning tools in the wider field of music education, and had used these to develop their own community of practice, sharing pedagogical approaches with their peers in music education. This collaborative approach is in contrast to the often competitive nature of music conservatoires and other music education institutions.

Despite studies such as these demonstrating the positive outcomes for learners of online lessons, many teachers are reluctant to teach online. Whilst a terrible time for many, both personally and professionally, the COVID-19 pandemic was an unprecedented opportunity for the development and uptake of online education in all subjects. Even prior to the pandemic, many educators believed that practical arts subjects, such as music, were impossible to teach online, however, there have been courses doing this for decades before the pandemic (see the Applied Music case study below). Johnson (2020) also outlines a conceptual model for teaching music online, which we looked at in detail earlier on in this chapter, showing how this is possible.

There are likely to be many factors that impact these attitudes. First, any changes in practice come with risk and the fear of the unknown. As discussed above, most instrumental teachers are highly invested in wishing positive outcomes for their students, whether this is in a particular performance or more generally in their musical careers. Many teachers will want to avoid impacting on these outcomes for their students, and therefore want to avoid risk.

Second, many teachers may not want to change the teaching practices they have developed over years and sometimes decades. Often, instrumental teachers have other jobs, including as performing musicians, and need to work as efficiently as possible. As highlighted above, the move to online teaching takes extra preparation time, which some teachers may simply not have available. While the lack of time to prepare online lessons may be a

barrier, this time investment does pay off later, as banks of learning materials are built up for the teacher to revisit. It may also be possible to combine in-person and online lessons to reduce some of this burden.

Third, instrumental teachers may lack the technical skills required to set up and use the equipment required for online teaching. Particularly when teaching adults, instrumental teachers are usually quite autonomous when it comes to the practical arrangements for lessons (such as timetabling and teaching locations), so there may be a lack of technical support available for teachers and students alike.

So, what can be done to help remove these barriers? Partly, this comes down to exposure to online teaching, which happened automatically during the COVID-19 pandemic. It is clear from the studies above that the move to online learning actually improved the learning experience in some ways, making learners more independent and in control of their learning. Even if the teaching methods have moved back to in-person delivery, it makes sense that some of these teaching approaches should stay. Redman (2021) noted that many instrumental teachers who moved to online teaching during the COVID-19 pandemic were surprised at how easily they adapted and planned to retain some elements of online teaching in the future.

Continuing professional development

Both Stevens et al. (2019) and Redman (2021) highlight the need for teacher continuing professional development (CPD) in working in online environments. This includes technical skills that would probably not be part of a general teacher education, including elements of computer networking (if there are problems with internet connections) as well as audio and video skills. They will probably also require skills in fault-finding, and doing this remotely if attempting to help a learner with connectivity problems. Specific CPD for music teachers on online methods would help teachers to become more confident in using the equipment needed and using it in an efficient way. Technical support should also be offered by institutions that are offering online music education, and this should be accessible to both staff members and students.

One of the benefits of online instrumental learning is that lessons may be easily available for other teachers to watch either live or as a recording, which can be used as CPD for music teachers. Observation of lessons is a common form of CPD, but there can be difficulties in scheduling as well as the potential for teachers and learners to change the way they are working when observed. While these issues are not completely eliminated in online environments, working online make these opportunities more accessible through simple functions such as recording lessons.

Perhaps the most important factor in attitudes to online learning is to not force teachers into working this way. Peer support and communities of

practice may help music educators to discover the benefits of online learning and use appropriate technologies at a pace that is suitable to them, their technical abilities, and the needs of their students. The learners may also drive the move to online learning, as they see the benefits of flexibility and independence.

Assessment

Assessment forms a major part of music education, whether that is the final assessment of a student's skills that provides them with a mark or grade (summative assessment) or whether it is the ongoing feedback that is provided by teachers throughout the learning process (formative assessment). Scott (2012) discusses the role of assessment in the constructivist perspective on learning, where students do not passively absorb knowledge from a teacher, rather, they expand their musical understanding through actively engaging with peers and teachers in a community of practice (see also Wenger, 1998). Constructivism requires an emphasis on student-centred learning methods, which requires a wide approach to assessment and one which involves students' active engagement. This includes three methods of assessment:

- Assessment of learning – summative, used for administrative control (i.e., marks and grades), is teacher-centred, criterion-referenced;
- Assessment for learning – formative, helps students to learn, is student-centred, criterion-referenced;
- Assessment as learning – self-reflective, helps students to learn, is self-centred, criterion- and self-referenced.

Assessment of learning in relation to solo performance plays a large role in formal music education, with most school and higher level music qualifications requiring some proven level of instrumental ability. In the UK, there is also a strong tradition of a formal grade system provided by exam boards such as the ABRSM and Trinity College of Music. Originally, these were solo performance exams in the classical tradition, with grades 1–8, where grade 1 is suitable for musicians who are just starting to learn and grade 8 is the approximate level of performance required for entry onto a music course at a university. These have been expanded to encompass multiple genres, including jazz, traditional, and rock and pop music.

Assessment for learning happens in instrumental tuition through feedback from teachers on students' work within the lesson itself. This may be around making adjustments to technique or discussions around approaches to the music played. It may also involve feedback on practise routines and other activities that happen outside the lessons. This form of feedback is often in the moment and may also involve questioning from the teacher to check understanding.

Assessment as learning may have had less attention within music education, particularly in instrumental tuition, where the master-apprentice (or teacher-as-expert) model is common. In this form of assessment, the student reflects on their own learning and playing with help from peers and uses this reflection to inform their own development. They may assess their own skills against criteria that are linked to course outcomes, but also to their own goals and aspirations as musicians. This fosters skills for lifelong learning, as students progress into their own independent musical life.

It follows therefore that if instrumental lessons are possible using online tools, then assessment in all these forms should also be possible for successful learning. In order for assessment to take place, information needs to be gathered in order to give feedback. In relation to instrumental teaching, this may involve playing for the teacher (or other assessors in a summative assessment), making video or audio recordings, using practice and rehearsal notes as a tool for reflection, or writing narrative reports about the learning process.

In an online environment, all these methods of gathering evidence are possible:

- Live performance assessment in front of panel of assessors – possible using video conference software;
- Video or audio recording of a performance – either live performances or recordings made in the student's own time can be submitted electronically to the assessor by the student;
- Practice or rehearsal notes for reflection – could be in the form of an electronic portfolio submitted electronically;
- Narrative reports – written by either the student or teacher and submitted electronically.

It is clear that there are no great barriers to any of these forms of assessment online, although there are advantages and disadvantages to each, particularly in relation to the use of live video-conferenced performances and videoed performances as a method of assessment of learning (summative assessment).

Arguments against live video-conferenced assessments are mainly technical and are similar to those around synchronous NMP in general. The first is audio quality. It may be the case that the audio quality possible through a video call is not good enough for assessors to make judgements on some of the finer musical elements of a performance, for example, use of expression. This will very much depend on the video conference codec used, and even domestic systems with music modes enabled can provide a relatively high audio quality. Care must be taken in these situations that the audio equipment at the student end does not have an impact on the assessment made of the performance.

Generally, latency would not be an issue when assessing performances, as in most cases there will be no musical interaction between the assessor and the student. In cases where there are, such as in practical listening tests or rhythm tests, some adjustments may need to be made to the assessment in an online environment compared to a face-to-face setting. For example, audio files could be sent to the student to be played back at their end to avoid problems with audio playback over the internet. Jitter (variable latency) may impact the assessor's experience of a student's performance, however, this usually has a fairly obvious audible effect, and a pragmatic approach can be taken to how this impacts the assessment of a performance.

There is also a practical issue around the use of accompanists. Latency in a video conference system would prevent an accompanist being in a different physical location to the soloist. It is perfectly possible for an accompanist to be in the same room as the soloist, as long as the balance between the two instruments has been checked through the video conference system.

Some high-quality systems, such as LoLa, do not suffer from these problems with audio quality, and would therefore be very suitable for high-level performance assessments. Given the nature of these systems, the musicians would need to travel to a specific location where there is a system installed rather than accessing the assessment from home. While not entirely accessible, this could be a suitable method to reduce travel time and environmental impact of assessor and student travel with hubs for assessment in multiple locations.

Assessment of a videoed performance is another method of summative assessment of a performance. The student prepares for the assessment in the usual way and submits a video of their performance to the assessors, which may include a requirement that it is unedited. This form of assessment is fairly common, particularly for auditions, and has some benefits for both the student and the assessor.

First, although there will often be a deadline for submission of the video, it gives students agency to record the performance at a time they wish (subject to practicalities). This means that they can organise their time to balance preparation time and opportunities for making new recordings if the first did not go to plan. This is also one of the arguments against using video as a form of summative assessment – the student can make as many versions of the video as they like and choose the best one. This assumes that students will do hundreds of takes and get better each time and that there is no pressure on the musician when playing to a camera.

There are several reasons why this may not be a valid argument. First, it is unlikely that students will make almost unlimited videos – these take time and effort, and the student must make each video a performance in its own right, with the associated performance conventions of the genre. Second, if the student does make multiple takes and improves each time, then this is a

valid method of music learning and a valuable method of reflection. In order for a student to accept or reject a particular recording, they must carefully reflect on their performance and decide how to modify their performance as well as whether they are likely to improve in subsequent takes.

For the assessor, having a video of a performance allows them to organise their time and assess each performance when suitable. A video also allows them to revisit any performance, which may be particularly useful if there is a dispute over marks or grades. Performances may also be compared against one another for quality control purposes.

An argument against video as a method of performance assessment is that it does not prepare students for the pressures of live performance. This view perhaps implies that live performance to an audience (and preferably solo) is the only kind of performance that musicians will do and has the highest value of all musical activities. It does not take into account the value of having good performance technique for a camera and that many musicians will spend more time recording than playing live in their musical careers. Whether or not video is a suitable method for performance assessment in any particular situation comes down to the criteria of the assessment and whether it is possible to meet the criteria with this method.

When setting criteria for performance assessments, there must be a consideration of what is meaningful for the student and the teacher and what is relevant for the particular genre of music or style of performance. If working towards a formal qualification, this may be set by an exam body. If working in a more informal learning environment, then these can be agreed between the student and teacher and based on the student's goals and aspirations.

It may be possible that some criteria of a performance assessment may not be able to be met in an online environment. An example of this may be some specific forms of ensemble performance that are not suitable for either synchronous or asynchronous NMP projects. Online teaching may then need to be supplemented by face-to-face ensemble opportunities and appropriate methods chosen to assess these.

In many formal music education environments, ensemble opportunities may be set up by the institution (e.g., consider school and university bands, choirs, and orchestras). Where these are not available, for example, if a course is delivered online, learners may need to be proactive and create their own opportunities or join in community initiatives. There may be some advantages to learners being involved in these community activities rather than organised opportunities through educational establishments, as they encourage lifelong contributions to music, as discussed by Myers (2008). These community links can continue even after the learner has finished their formal course of education.

Negotiated assessment – where the learner and teacher work together to reach the assessment criteria – has a large role to play in online music

education. Depending on the educational context, this may be used for summative assessments, or for formative assessment by the teacher, or as areas for self-reflection for the student. This form of assessment is student-centred, and focuses on the learner's goals and aspirations as well as using the teacher's professional expertise to inform the criteria. This is also very suitable for the online environment because it can take into account the learning environment and methods when deciding on the criteria for assessment.

Affordances offered by online instrumental tuition

While many of the studies on online instrumental tuition, especially during the COVID-19 pandemic, have focused on or at least mentioned some of the barriers that teachers have found, there are also some affordances offered by this method of teaching. As with other NMP contexts discussed in this book, accessibility is a key benefit of online study.

As with any instrumental tuition, learners need access to instruments to learn, both during their lessons and to practise in their own time. Learners who play particularly big or immoveable instruments, for example, pianos, percussion, and the organ, may need to access these through music schools, and therefore may not be able to access online instrumental lessons from home. There may be technical difficulties in accessing online instruction in formal educational establishments through limits to internet access.

These issues aside, online instrumental tuition allows access to teachers in niche genres or instruments who may not live locally to the learner. Even within relatively populated areas, there may be considerable travel time needed for face-to-face lessons with a preferred teacher. Online instrumental tuition can eliminate the need to travel for both learners and teachers. In some local authority areas in Scotland, for example, peripatetic instrumental tutors were spending more time driving to lessons than the time spent teaching learners prior to the COVID-19 pandemic. Clearly, this is a situation where a blend of face-to-face and online lessons would have a benefit to all parties as well as a positive environmental impact.

Online instrumental tuition also offers flexibility for learners and teachers in terms of timing. Lessons can be fitted around other commitments, and the reduced travelling time means that lessons may be easier to attend. For those with caring responsibilities, for example, it may be possible to attend a lesson without having to arrange cover for this, with the associated costs and time spent making these arrangements.

In relation to online teaching during the COVID-19 pandemic, the reach of higher education was broadened, including auditions, masterclasses, trial lessons, and supplementary lessons (Redman, 2021). The convenience of working online, particularly for these activities, has allowed access for potential students who may not live close to universities or conservatoires and is likely to make these courses more accessible.

The wide take-up of online instrumental tuition during the COVID-19 pandemic has also provided an opportunity for teachers and researchers to develop specific pedagogies for online music teaching as well as form online communities and share learning resources easily. As with any educational development, it may take a long time until the long-term impacts on learners of online learning become apparent. What is clear though, is that many teachers and learners do see the benefits of working this way, and we are unlikely to return to a situation where online learning (particularly in music) is seen as inferior to face-to-face learning.

Practical tips for online instrumental tuition

So far, this chapter has looked at some of the theory and research behind online instrumental tuition, but how does this translate into a practical approach for teachers? These tips may provide a starting point:

- Take a student-centred approach to teaching where appropriate, giving responsibility to the student for their own learning;
- When planning a lesson, focus on the learning that is taking place and use appropriate teaching methods that work with the technology used;
- Encourage self-reflection and teach methods for doing this;
- Do not attempt to directly move offline, work online – the pedagogy is different, and more discussion may be needed even if using demonstration;
- Use the affordances of the online environment (e.g., ability to record lessons, and the more structured and focused environment);
- Use assessment appropriately – do not assess things that are impossible using a particular method – change the method if necessary (e.g., move from live to recorded assessments);
- Use synchronous learning environments in combination with asynchronous environments (e.g., online portfolios, videos, and other resources);
- Consider alternative methods of demonstrating/observing elements of rhythm that are disrupted by latency and jitter (e.g., pre-recorded video both ways);
- Consider the best camera views and use more than one camera if necessary (these can be switched between in video conferencing software);
- Spend time at the start of a series of lessons finding the best audio and video set-up for the student, ensuring they return to these settings for each lesson;
- Accept that there will be some technical difficulties at times;
- Allow space for silence, but be aware of technical issues that mean instructions and feedback may have not been heard;
- Prepare learning materials in advance and share with students early;
- Create a community of practice between students;

- Use synchronous and asynchronous NMP approaches for ensemble work (see Chapters 3 and 4);
- Combine in-person and online lessons, if possible;
- Spend time at the start and end of lessons on relationship building between teacher and learner;
- If applicable, charge the same fee for teaching online as in a face-to-face environment (Musicians Union, 2022).

General online music education

As outlined at the start of this chapter, practical instrumental skills are not the only area of music that can be learnt through an online environment. Theoretical aspects of music, ensemble work, music technology, and collaborative musical projects can all be learnt online and often in larger groups than instrumental teaching. Many of the issues around online music education apply to other forms of online education too, however, perhaps the unique aspects of music teaching are the practical and collaborative elements, which at first thought may seem difficult to approach online.

There are many formats for online teaching, which – like NMP – can be split into synchronous and asynchronous methods. Synchronous methods include video conferencing, and within this, there are many different pedagogical approaches. For those in higher education, it may be tempting to translate the lecture format directly into a video conference environment, where the lecturer imparts their knowledge to the students, perhaps using visual aids, such as slides. In an online environment, this is rather unengaging, and with little or no interaction with the students, has little advantage over a recorded lecture that can be viewed repeatedly at any time (a potentially useful asynchronous method).

More engaging methods of using video conferencing include highly interactive sessions, with discussions between the students and the lecturer, based on materials provided in advance. This approach is known as the 'flipped classroom'. The flipped classroom approach can also be used in face-to-face teaching, with materials often provided in electronic format for students to access from home in advance of lessons. In traditional teaching methods, the information is distributed in the classroom by the teacher, while the learning happens later in the form of reinforcement activities, usually as homework. It can be argued that the time spent with the teacher is more valuable than time studying alone, so this is where the learning should happen.

Weiger (2021) explores some of the opportunities and challenges for using the flipped classroom approach in music performance classes at the secondary level. Their approach uses a video prepared by the teacher as the

background materials, although these materials can be in any format appropriate to the students. They outline the positives of the flipped classroom as follows:

- There is better student preparation for class;
- There is a positive effect on student/teacher interactions;
- Students have a better ability to use new knowledge to better solve problems.

They also note that this approach gives students more control over their learning and the pace and methods they use, and that students using the flipped learning method are more willing to seek out teacher help.

There are certain challenges inherent in this approach:

- It requires technology to be available to allow students to access resources;
- It takes time for planning and creation of learning materials, particularly videos;
- Students must buy-in to the method and prepare in advance for lessons.

Author's perspective

From my experience of using the flipped classroom approach with synchronous online teaching at the university level, it has the benefit of making the video-conferenced aspects of learning more engaging than if the lecturer was delivering a lecture online. These sessions are interactive, and students feel informed to take part in discussions as they have the learning materials available in advance. As long as the students have prepared in advance and the lecturer keeps discussions on topic, there is little chance of feeling 'put on the spot' when being involved in discussions. There is also an opportunity using this approach to follow the students' areas of interest and the application of these interests during the discussions.

Asynchronous methods can be accessed at any time by students, and these include materials that may be accessed through a VLE. Students may also do their own research on topics and access the huge number of scores, videos, audio recordings, and other materials that are freely available online. Making judgements about the quality of these materials is a skill that can and should be taught to students and helps them to become more reflective and in

control of their own learning. Asynchronous methods of teaching and learning can also be interactive and include the use of discussion boards, which learners and teachers can use to interact with one another and give feedback on tasks. Contributions from these can also form part of the assessment of a course, both from a formative and summative perspective.

Practical subjects such as composition and music technology skills can also be taught in a similar way with practical tasks that take place between interactive sessions involving the students and teacher. These subjects require students to have access to equipment to complete these tasks outside class time, which must be considered when designing courses. There are many accessible online music technology tools that can be used for teaching, including online DAWs that offer many of the features of their offline counterparts, as well as opportunities for collaboration. There are also online synthesisers, for example, which can be used to teach practical synthesis skills in accessible ways.

Collaborative learning

Music education in an in-person environment often has an element of collaborative work, whether through performance, composition, or other creative tasks. This reflects how musicians might work in their professional careers, for example, when developing music for recording in a studio or when planning community music projects. This type of collaboration is also possible in an online environment.

From a practical point of view, it is easy to set up small group working in a video conferencing environment through break-out rooms or by allowing students to set up their own sessions for collaboration. Many students will be very familiar with communicating in online environments, so it may be appropriate to allow them to adopt whichever communication tools they are familiar with, or specific approved tools may be dictated by institutions.

Synchronous or asynchronous communication methods may be suitable, depending on the project outcomes, and many of the concepts and approaches outlined in Chapters 3 and 4 may be suitable for collaborative work in educational music projects. It can be tempting for teachers to consider the technical barriers of working online when delivering learning in collaborative projects and to try and provide the students with a solution to these. This can result in project briefs being overly prescriptive and complicated. A better approach is to provide a brief for the output of a project (e.g., a performance, recording, or composition) and allow the methods to emerge as the group work towards their goal. The teacher's role is then to facilitate and be available for guidance, especially around any technical problems that are encountered by the group.

Another important consideration is how the output of these projects is shared. The online environment offers many opportunities for sharing collaborative projects, including live presentation through video conference or by sharing videos and audio files through websites and social media. This sharing is an important aspect of the collaborative process, as it demonstrates the value of the students' work as well as potentially providing realistic deadlines as when working to a creative brief in the professional world.

Pedagogical issues in video conferencing

Live video conferencing is a valuable tool for interaction between students and the teacher and allows a human element to be brought into online teaching that has the possibility to feel detached from humanity at times. It also gives an opportunity for teachers to get a sense of how well students are engaging with learning materials and other members of the class.

If possible, students and the teacher should have their cameras on during video conferencing. There may be genuine reasons for keeping cameras off (e.g., privacy, if accessing the video conference from home, and there is not a private place for the student to work or through bandwidth issues), and it is important that the teacher remains sensitive to the students' needs. However, being able to see the students leads to better engagement from the students and allows dialogue between students and the teacher as well as between students. There is a tendency to focus on the students who are visible because this provides clear evidence that they are present and engaged.

Using visual tools, such as reaction emojis, and raised hand tools can also help with engagement as well as providing feedback to the teacher. Many video conference systems also have a text chat function, which can be very useful for ensuring engagement from those who are not able to have their cameras on. This can also be useful to allow students thinking time, if answering a question, for example.

It can be quite difficult for both teachers and learners to divide their attention between the text chat and the video aspects of the conference, so careful management of both is important as well as outlining expectations of how they are used. It is useful to have a discussion at the very start of a class outlining expectations of behaviour during video conferences, so that these behaviours become part of the class culture. These might include factors such as:

- Use of cameras;
- Use of the chat functions;
- Expectations of engagement;
- Allowing all voices to be heard;
- What to do if interrupted or if a student needs to step away from the class temporarily.

> **Author's perspective**
>
> In my experience, some classes use the text chat as an informal way of communicating during classes while the formal elements are kept in the audio and video part of the call. With one particular group, it was extremely difficult to keep up with the pace of the text chat, and some of it was very funny as well as insightful. Although there was sometimes a sense that this chat was distracting and off-topic, it was also a place where the students' personalities could shine through, and they used it as a way to share specific meaningful musical examples.
>
> I felt that this was very helpful for community building during this time as well as giving me links and examples to follow up and build upon in future classes. I was quite open that I could not always keep up with the pace of the chat, and probably some of the students felt the same. Students are always going to communicate with one another during video conferences, and I would prefer that this was open and inclusive by being part of the class rather than students using other methods for communicating in the background that may not include everyone (although realistically this is likely to happen at the same time).

On a practical note, when sharing pre-recorded videos in a synchronous learning environment, it usually provides a better experience to the student if a link is provided and they are able to access the video directly through this link. When playing a video through a video conferencing platform, there is an additional layer of data compression added, reducing the quality of the video. When each individual accesses a video through a link, then suitable buffering can be applied for smooth playback.

Learner experience

Much of the research around online learning highlights the need for learners to be more independent than they would need to be in a face-to-face environment. In some cases, the learners in an online environment are self-selecting for their independence: it is unlikely that a learner would sign up for a course that requires self-motivation and independence, if they did not already have those attributes. Despite this, dropout rates for MOOCs are around 90% (Goel & Goyal, 2020). While there may be many factors affecting dropout rates across all courses, encouraging and developing learners' independence can help them to remain engaged and get the most out of the learning opportunities they have available to them.

Course design has a major impact on helping learners become more independent. As discussed previously, the flipped classroom approach fosters independence by requiring students to prepare in advance for lessons through engagement with learning materials. This is followed up with discussions between the learners and teachers around these materials. If these discussions are engaging, both in format and content, then this can help foster independence. Within these discussions, allowing learners' voices to be heard and, particularly in music, encouraging students to link theory to their own practice and musical interests can help foster deeper levels of thinking on topics.

Within these discussions, the teacher has a responsibility to maintain a space where students feel safe to share their thoughts and gain feedback from peers. This can be encouraged through stating expectations and boundaries of participation and using the multiple tools available through video conferencing platforms. This may include encouraging students to have their video cameras on, use the chat functions, or speak out loud as well as use of emojis and hand-raising tools. Some specific synchronous teaching environments also have useful tools such as whiteboards and facilities for polls of students.

As with online instrumental lessons, the start and end of a group video-conferenced lesson can feel awkward and uncomfortable, as the usual transitionary activities such as moving in and out of a classroom do not happen in an online environment. Teachers may wish to consider how they mark the transition into learning as well as how they deal with latecomers to sessions. Potential options to avoid awkward silences at the start of a session include playing background music, starting with a group activity to encourage engagement, or providing a question on a virtual whiteboard for consideration and engagement in the chat facility. This time is also an opportunity to build relationships between teachers and learners and set boundaries around expectations for student engagement.

Stevens et al. (2019) highlight that student engagement and participation need to be closely evaluated in online environments. This, of course, is also important in in-person environments, but it is perhaps more intuitive and easier when looking around a physical classroom than in an online environment. A particularly challenging situation can be when students stop engaging completely: it can be difficult to re-engage a student who has decided to remove themselves from the online learning environment, particularly without peer support. They also highlighted the need for teachers to expect more responsibility from learners for their own learning than in a face-to-face teaching environment.

Gaining feedback on the learning experience is a vital part of the teaching process so that teachers can critically reflect on their own teaching practice. In a typical in-person classroom, this may happen in multiple ways, including formal methods such as surveys and questionnaires, but also in informal ways, for example, through gauging student engagement in particular activities or reflecting more generally on aspects of a lesson. These methods might

get overlooked as teachers concentrate on the technical aspects of teaching online. VLEs often offer useful tools that teachers can use to gain feedback, including anonymous replies to surveys. Students may feel more confident to offer feedback if it cannot be traced back to individuals, although there is the risk that this may not be constructive.

Assessment

Assessment must be considered for general music education in an online environment as well as in instrumental lessons. Methods for assessment must be appropriate to the environment, and administration of assessments is one of the factors to consider. Considering assessment of learning (or summative assessment) first, timed closed-book examinations are probably not suitable for the online spaces due to the controlled environment required to undertake these sorts of assessment.

VLEs offer many tools for assessment, including submission deadlines that are flagged if missed. Administration of these is easy, and students can upload documents, portfolios of work, contributions to discussion boards, audio and video files, scores, and many other items for assessment. Teachers can set deadlines, and the time and date for submission are recorded with the assessment.

Educators may also want to consider the use of authentic assessment. This is the idea of using creative learning experience to test learners' skills and knowledge in realistic situations. In music, these might be activities such as putting on a concert, producing an album, taking part in a recording session, or a collaborative project. This idea, of course, is relevant to both online and in-person teaching, however, in an online environment, there are extra considerations of how evidence might be provided for assessment. This will very much depend on the nature of the assessment itself, but educators must ensure that the evidence is appropriate for the outcomes of the assessment and that additional technical barriers are not in place when working online.

Returning to the role of assessment in constructivist learning (Scott, 2012), discussed previously in relation to instrumental tuition, possibilities for assessment methods in music in online learning environments include:

- Assessment of learning – essays, projects, compositions, recordings, portfolios, open-book examinations;
- Assessment for learning – quizzes, questioning in video conferences, formative tasks;
- Assessment as learning – journals, self-reflection, discussion board contributions, peer assessment, collaborative projects.

It is clear to see from these examples that there are many crossovers between assessment methods in online and face-to-face learning environments.

Communities in online music education

Groups of learners and educators who are linked together through particular courses of study can form learning communities. This does not happen in all online music education, for example, communities are unlikely to form where there is little interaction between learners on an asynchronous online course. However, interaction between learners, both directly relating to study and in areas of wider musical interests, can help these communities to form, which may extend into relationships outside the confines of any course of study. Wenger (1998) describes these communities as 'communities of practice', where the primary focus is on 'learning as social participation', which comprises four components: meaning, practice, community, and identity. These communities come together through shared interests (and not necessarily specifically to learn), and through their interactions learn how to do what they do in a better and more meaningful way.

An example of an online community specifically designed for learning is described by Ward (2019) in their article on the Online Academy of Irish Music (OAIM). This website, which is accessed through a subscription, aims to replicate the communal music-making qualities of the Irish music tradition. Like many other worldwide traditional or folk communities, music is passed from generation to generation orally/aurally and usually includes informal learning both in and outside the home as well as more formal individual or group lessons. Learning is supported through recordings, tunebooks, and tutorial books.

The OAIM takes a blended learning approach and moves some of these resources directly online and supplements these with face-to-face resources, such as a summer school. The online offering includes a bank of video lessons and audio recordings as well as text-based resources and notation for tunes. It also includes interactive resources such as discussion boards, play along virtual sessions, and live broadcasts of pub sessions with interaction through chat functions.

While many traditional musicians would consider face-to-face playing with other musicians a vital part of their tradition, websites such as this can offer beginners and those without access to the tradition locally a stepping stone to becoming involved in a physically based community. In addition, it can be used as a method of communicating with other interested musicians and a way to learn specific tunes and techniques. It also demonstrates that online music learning can include multiple tools that may suit different learners in different ways as well as recognising the multiple facets of music learning that include context as well as specific instrumental skills.

While the OAIM can be seen as a repository for learning materials that can be accessed by individuals (and it can certainly be used that way), it also facilitates community building by offering interaction with other learners.

This happens both online and through their face-to-face courses, so reflects the in-person communities that are so important in traditional music. Within learning communities, individuals can support one another as they learn and become an important part of the learning process itself.

Learning may also happen in communities that are not specifically designed for learning. Waldron (2010) describes the informal learning that happens in online traditional and folk music communities. These communities evolved organically through contributions to online discussion boards and video-sharing websites to share performances and repertoire. Waldron outlines how the discussion and interaction around these materials lead to learning and specifically to the development of communities of practice described by Wenger (1998).

NMP in community music

Community music is characterised by musicians working with people to engage them actively in participation and enjoyment of music. It can happen anywhere and with anyone, including online, and the 'community' in community music does not have to be related to a geographical community. Community music focuses on inclusion and attempts to avoid barriers to participation in the enjoyment of music. There are links with music education, in that community music allows access to music participation for those who may have enjoyed learning music at school, who may not have continued it in a professional sense as well as those with no formal musical education.

Community music can also be facilitated online in many different forms, including:

- Online musical communities that do not necessarily play together;
- Groups who play together synchronously;
- Groups formed to produce virtual ensembles;
- One-off online workshops;
- Longer-term musical communities that may use online work in between conventional in-person meetings.

Community music often has a focus on collective creativity where everyone's voice is heard and participants work together to achieve the group's musical goals. This is often facilitated by a leader who may be a professional musician. As well as fulfilling the many roles of a community music leader in a face-to-face environment (such as mentor, teacher, administrator, etc.), online community music leaders also require some technical skills and the ability to help others technically.

Participatory and community music

Matarasso (2019) discusses the difference between participatory art and community art. They define participatory art as 'the creation of art by professional artists and non-professional artists' (p.48). This term is wide ranging and encompasses many different activities: in the field of music, this might include music education, music for health, community ensembles, and many other musical activities. Crucially, there must be some creation of music (i.e., not just learning about or discussing music), and all participants are seen as musicians, not just those who are professionals.

Matarasso's definition of community art goes further: 'Community art is the creation of art as a human right, by professional and non-professional artists, co-operating as equals, for purposes and to standards they set together, and whose processes, products and outcomes cannot be known in advance' (2019, p.51). There are several key differences between this definition and the one of participatory art. First is the creation of art as a human right, which implies a strong sense of inclusion. Second, the professional and non-professional artists must cooperate as equals and work together to set their own standards: it is not a professional artist imposing their ideas on a group of participants. Finally, the processes, products, and outcomes cannot be known in advance: these emerge as the project develops.

While the aim of this book is not to delve into the philosophical definitions of participatory and community music, these can be useful when considering how these ideas may be facilitated through the use of NMP. They can also be useful from the opposite perspective: by looking at existing projects (or even project plans) to see if they offer the opportunities in terms of equality and participation that leaders hope for.

The first characteristic of community art – in this case, music – is the creation of music. As we have explored throughout this book, there are many opportunities for the creation of music in NMP, including performance, composition, and recording. This might be through synchronous methods – playing together live through the internet – in small or large groups and using improvisation, or playing pre-composed music, or elements of both. Asynchronous approaches suitable for community music include virtual ensemble and collaborative recording methods, each of which has the end product of a recording of music.

Second, access to community music as a human right can be addressed through NMP. As we explore in Chapter 6, NMP has accessibility at its heart, allowing access to ensemble music that may not be possible for individuals in any other way. This was clear during the COVID-19 pandemic, when this was the only way that many people could play with other musicians. There are, of course, many people for whom physical access to other musicians is difficult, whether through physical barriers such as geographical distance,

health, or financial barriers to participation. The use of NMP has the potential to allow access to community music to those who would not be able to participate in in-person projects. An example of this is given in the Fischy Music: Gresco Agape case study, a collaboration between hospice patients and school children.

Third, community music requires cooperation as equals, both in terms of the music produced and the aims and objectives for any project. Here, the approach to NMP is important to allow this equal cooperation. A virtual ensemble, where parts are provided for musicians to sing or play along to and then are assembled by someone outside the group who makes decisions on the quality of contributions, may be considered to be participatory rather than community music, as it does not fulfil the requirement of equal cooperation. A similar project, where the musical content is democratically decided and there is a group effort in preparing materials and individuals cooperate to make the recordings and mix them, may meet this requirement more fully. A synchronous rehearsal, where the leader is the only musician heard with others playing or singing along with microphones muted, is also not likely to be considered to allow for equal cooperation. Alternatively, a similar approach but with the platform shared and with all voices heard (perhaps at separate times) may allow for a more equal (and probably more supportive) environment.

The final requirement for community music is that the processes and outcomes are not known in advance. This is a potentially difficult criterion to fulfil using NMP, because of the technical and creative risks that must be taken in this environment. It may be tempting to plan exactly how NMP equipment might be used and give detailed instructions on the process to avoid technical problems that might disrupt the musical flow. This may be appropriate in some participatory music when the outcome is known in advance. An example of this may be Eric Whitacre's *Virtual Choir* recordings, where the parts are clearly provided with little room for creative interpretation because the outcome is fixed. Other approaches have much more room for creative freedom, and in fact, some methods, such as synchronous NMP and collaborative recording, work best when the process and outcome are left to evolve. By doing this, technical challenges become creative opportunities.

There is, of course, a great deal of value in participatory music, which does not necessarily meet all of the requirements for Matarasso's definition of community music. The NMP environment is well suited to participatory music due to its ensemble nature and technical accessibility. It may be worthwhile for leaders of participatory projects to consider what happens once a contribution to a project has been made, and to think about the longer-term impact on the musician, the group, and wider society.

It may be worth considering this for in-person participatory music and think of the equivalent in the online environment. Let us consider a community

orchestra. When working in a typical in-person environment, the process might look something like this:

- A committee might work with any professional musicians involved in the group such as a conductor to discuss repertoire;
- The group will meet on a regular basis to rehearse and will probably also offer opportunities for social contact between members;
- The musicians will practise their parts individually, increasing their instrumental skills;
- The musicians will gain feedback during rehearsals from the conductor and possibly other section members and will have the opportunity to ask questions;
- The orchestra will put on a performance for friends and family, which may also be open to members of the public;
- The orchestra members will gain feedback from the audience and probably discuss between them afterwards about how the performance went.

Throughout this process, there are many benefits for the individuals, the group, and the wider community. Individual musicians improve their musical abilities through individual practise and ensemble rehearsal, possibly encouraged by their peers and not wanting to let the group down. They also get the social benefits of regularly meeting with a group. The group benefits from each individual member playing their part to create music that is more than the sum of the individual parts. The wider community gets to experience live music as well as provide support to the group of musicians. There are also health and social benefits to playing music that ultimately impact positively on the wider community. There are, of course, similar benefits across all sizes and styles of ensemble.

These benefits can also be examined in the context of online community music projects to see what methods might suit each individual stage. For example, if a musician makes a contribution to a virtual ensemble, how much will they know about the process that happens to make this into a final recording? Will they get any feedback on their contribution? How will they know that the piece is finished? Will they get invited to a showing of the piece? How will the piece impact the wider community? Social contact may happen through synchronous online meetings, while individual practise will likely still take place without other intervention. Performances may be live or recorded, and audience feedback may be gained through comments on videos, for example.

One of the characteristics of community music is that it aims to be inclusive. In an in-person environment, this may include aspects of physical accessibility, financial accessibility as well as considering carefully any other barriers to participation. In an online environment, there are further barriers

to participation that must be considered. The equipment needed to access an online community music environment may cause barriers to participation in itself. There are several possible reasons for this:

- The cost of equipment;
- Access to the internet;
- Either the technical skills to use the equipment or support to do this.

In addition, participants need a quiet and suitable environment for musical participation that does not cause nuisance or inconvenience for other household members or neighbours.

Online community music research

Crisp (2021) discusses how community musicians in the UK responded to the COVID-19 pandemic, specifically how they used online opportunities to facilitate this. They raise many questions for further research into online community music, highlighting the lack of research into the possibilities for community music online. They also suggest that working online is considered to be experimental, which demonstrates that there is perhaps a disconnect between the practices in community music and the wider developments in music, specifically NMP.

As discussed previously in relation to music education, this apparent lack of uptake of NMP technology for community musicians may be partly due to the perceived risk involved, both to the participants and the leaders. The risks to participants might be around inclusion or difficulties using NMP equipment. Risks to leaders might be around their own confidence in using technology, worries about how they might engage participants online, and the impacts of online working on the creative process.

The community music case study below – Fischy Music: Gresco Agape – gives an example of a successful online project. The use of technology created severe risks to the completion of the project, but the organisers approached these with a problem-solving mentality rather than focusing on the barriers to success. It resulted in meaningful collaborations, with long-term positive outcomes.

Safety issues in online teaching and community music

Music teachers and community music leaders, particularly those who work with children or vulnerable adults, are obliged to safeguard their students and clients from harm, and this is also applicable in the online environment. In all cases, teachers and leaders should follow guidance from their employer on online safety policies, but freelance educators and practitioners should also

consider how they will make the online teaching environment safe for their students.

The online environment can be seen to be more informal than a traditional learning or community music space, although many freelance instrumental teachers also teach face-to-face from home. Similar principles around professionalism should apply to those when working in a face-to-face environment. These include dressing professionally and maintaining a tidy background for any video conferencing. This may also include either blurring the background or using a picture as a background in video conferencing systems.

Relevant to both online and face-to-face teaching and community music is a consideration of how social media is used and communication outside sessions. This may mean setting up separate professional and personal profiles on social media. Teachers and leaders should avoid contact that is unrelated to teaching or facilitating outside the lessons themselves, although they may share files for feedback between sessions and contribute to group discussions, for example, if building a community of practice between learners and participants. This may well happen via social media as an accessible way for participants to be in contact with one another. Teachers and community music leaders should set and articulate boundaries around when they will engage with these communities and how long learners or participants should expect to wait to get a reply.

From a technical point of view, video calls should require a password for access, so that only the teacher and learner or facilitator and participants can access the call. Most video conferencing systems also allow recording of sessions, and particular institutional guidance on this should be sought, if relevant. Recording can be very beneficial for learners and participants who may have specific support needs. Freelance teachers and leaders should consider the purpose of the recording and how it will be stored and accessed as well as ensuring they have permission to be recorded from anyone in the session.

It may be helpful to have parents, guardians, or carers either in the video-conferenced session or nearby, both for practical help with the technical aspects of the sessions and to be a proactive part of their charge's musical education or community involvement. Some teachers are concerned that this may impact on the way the learner interacts with the teacher (Redman, 2021), although it may impact on the learner's ability to engage with online learning without that technical support.

Case studies

The case studies below outline some uses of NMP in educational and community contexts. The first looks at a university music course that has NMP methods at its heart to provide access to students in remote and rural areas of Scotland as well as those with caring and professional duties that make traditional university study difficult for them. The second is of music

teaching in schools in the US. The final case study is a songwriting collaboration between schools and hospices in Scotland and Greece, exploring themes of grief and loss, and again used a combination of synchronous and asynchronous NMP methods. The case studies were chosen for their approaches to accessibility as well as their use of multiple approaches to NMP within the projects. None of the case studies used specialist NMP software.

Applied Music courses – University of the Highlands and Islands, Scotland

The BA Honours Applied Music course at the University of the Highlands and Islands started in 2012, with students and staff spread geographically across Scotland. This was followed in 2013 with the introduction of the Masters Music and the Environment. The multi-genre courses are led from the university campus on the island of Benbecula in the Outer Hebrides. These courses are examples of where NMP is used holistically throughout the curriculum to facilitate ensemble work and instrumental tuition.

The courses were designed from the outset as courses that would be taught using a blended learning model, including a blend of video-conferenced, online, and face-to-face learning. Students are based in their local communities (in Scotland and around the world) and access ensemble music-making locally (e.g., through community ensembles or forming their own bands). They also engage with online learning materials and a timetable of weekly video conferences. Four times a year there are intensive study weeks, either face-to-face or through video conference, where students across different academic years of the courses work together in small groups on creative tasks. In addition, students have individual instrumental tuition with a tutor of their choice, who may or may not be based locally to them.

NMP is embedded into the course in several ways:

- Specific modules at all levels teach the skills of asynchronous NMP;
- Intensive study weeks require the use of NMP (synchronous and asynchronous) for collaborative projects;
- Some students elect to receive instrumental tuition at a distance via video conference.

When the course was first developed, there was some scepticism about how practical music degrees could be delivered at a distance, however, the courses have been extremely successful, and as of 2022 had received four consecutive 100% student satisfaction scores in the National Student Survey – a UK-wide survey that gathers students' opinions of their course. The success of the courses is partially to do with the careful use of NMP blended with face-to-face study, which individual students have control over.

Students are given the skills to take part in asynchronous NMP from the very start of their courses, which allows them to collaborate musically with their peers around the country and beyond. This includes:

- Use of DAWs;
- Recording techniques;
- Collaboration techniques;
- Specific methods for asynchronous NMP;
- Creative use of music technology.

Students are encouraged to take part in synchronous NMP for real-time collaboration, although this is not a specific part of the courses. Webex is used for video conferencing, as specified by the university. When working independently, students use whatever software suits them, and many find Zoom more appropriate for synchronous NMP because it allows stereo audio and works well for music in the 'original sound' mode. For asynchronous NMP, students use many different DAWs, and therefore mostly use file-sharing techniques when collaborating.

The student's choice of an instrumental tutor is an appealing part of the course for students – they are not bound by geography (although some students choose a tutor local to them, as they prefer face-to-face lessons). Students can be aspirational in their choice of tutor and can work with tutors with very niche specialisms as well as work with different tutors in different academic years. Many students of the course over the years have been based in the Highlands and Islands of Scotland, remote areas with low population density. This access to specialist tutors has allowed students to remain in their home areas without needing to move to the more populated parts of Scotland for specialist tuition.

Key parts of the course are the intensive study weeks that happen four times a year. Two of these weeks are held as in-person events and two are online. Students from all four years of the course (approximately 50 students) come together to work on collaborative creative projects. The students are split into small groups, which mix students from different levels of the course and different musical interests. The creative projects involve working to a brief and have included authentic musical outcomes, including writing and recording music for use by Community Land Scotland in their promotional material. It has also included collaboration with students from other creative courses in Senegal and Finland. During the online study weeks, students make use of synchronous and asynchronous NMP techniques to work together and to present their work to the wider student body. These techniques are chosen by the students, with those with more experience helping to guide and mentor students less familiar with the technology.

The use of NMP within these courses was designed to make them very accessible, despite being run from the rather remote location of the Outer

Hebrides. Students can study from anywhere in the world as long as they have sufficient internet connectivity to connect to video conferences. They can study around other commitments, for example, work and family caring obligations, and as a result of this, there are many mature students (defined as someone who is over the age of 21 when they start their undergraduate studies) studying the course. Most students stay living at home for the duration of the course rather than moving to a campus location.

A strong sense of community is also fostered across the Applied Music courses. This happens through the collaborative course work, intensive study weeks, and through online interest groups run by the students. Students are able to access the video conferencing and NMP methods to communicate and collaborate outside specific course time, and there have been groups formed which are dedicated to sharing specific styles of music and an algorave group.

The methods of study on this course give the students skills to work in a professional environment that is collaborative and dispersed, and many graduates go on to have portfolio careers in music, including performance, composition, and teaching.

Music technology education in Maplewood public schools

Maplewood Public School District in Maplewood, Minnesota, USA, is home to over 23 different schools with students from kindergarten to 12th grade (ages 4–18). Harmony Learning Center, a public school within the district, hosts a very diverse community of students, including 70% of students from foster care and 99% of students on reduced/free lunch. Music is a core part of the curriculum with every student enrolled in music classes (compared to the national average of 20% of school students enrolled in music programmes in the USA).

Music teacher Gillian Desmarais uses both classroom-based and online music technology tools to engage students and to create a collaborative environment for learning at all ages. Students use Ableton DAW and the Launchpad hardware in the classroom, both to learn and apply musical concepts as well as for composition and music production. They also use many online tools, including Soundtrap (an online DAW with collaborative features) and Chrome Music Lab (an interdisciplinary tool for music and sound learning), which are accessible both in the classroom and from students' homes. The VLE used by the school is Google Classroom.

Desmarais takes a blended learning approach, with materials used in classes also available on the VLE. She provides videos and slideshows for the students to revisit at their own pace, sometimes with the help of a learning support assistant, and can interact live with the students through the VLE to answer questions and to provide support and feedback. Students also

communicate through Google Classroom to offer support and feedback to one another.

Technology is embedded into the music classes from the earliest years, with the youngest students exploring sound and music and then relating this to technology in an interdisciplinary way (e.g., by using the Chrome Music Lab to learn about sound waves and applying that knowledge to the DAW). As the students progress through the years, they develop their technical and theoretical language and bring in their own cultures, for example, by recreating their favourite music on Soundtrap and starting to develop their unique musical voice. In the higher grades, they build on these aural and technical skills and develop creativity through music production presentations and performances.

Students collaborate both in the classroom and online. Desmarais has built up a supportive community of practice, and the learners are self-reliant: they use online materials from outside sources to solve problems and are supported to do this, both from the teacher and from their peers. The portfolio feature on Google Classroom is used as a reflective tool as well as a way to store students' work and to show the students' progress over the years. Outside the classroom, the students collaborate remotely using Soundtrap and are enthusiastic to continue their musical work outside timetabled lessons.

Desmarais has taken this approach to music technology throughout her teaching career, although the COVID-19 pandemic made her provide more of her materials online through the VLE. As a result of this, she has reduced the visual content in her presentations (which has the benefits of clarity for students and reduced preparation time) and has become clearer in providing instructions for students. She has seen improvements in learning by using the VLE and the blended learning approach with learners who are becoming more independent learners and thinkers, who hold themselves accountable for their learning. She can easily reuse and update materials used previously, and overall sees little difference in preparation time when using the blended learning approach.

Desmarais adapts the tools she uses in her teaching based on the interests of her students. Her students reflect this creativity and willingness to experiment because they have a teacher who understands the possibilities of the use of music technology and who is willing to push them to use this technology in creative ways.

Fischy Music: Gresco Agape

Fischy Music is a Scottish charity that creates songs to nurture positive mental health in children by helping them express and manage a range of emotions. They work directly with children in a range of settings, including schools and community settings. During 2020, they led a songwriting project that connected school pupils in Edinburgh, Scotland and Athens, Greece with

patients in St. Columba's Hospice in Edinburgh and Galilee Palliative Care Centre in Athens. The project was named Gresco Agape – a combination of Greek and Scottish with love at the heart.

The intergenerational project focused on themes of loss and grief and was carried out synchronously through Zoom and Microsoft Teams (this was the only video conferencing platform allowed at Edinburgh schools, although it did not provide specific audio settings for music). The students and patients wrote songs collaboratively with guidance and leadership from facilitators at Fischy Music, who structured the project through songwriting workshops. These took place via video conference, which included several workshops for the Greek participants and Scottish participants separately and then they were brought together as one group for the remaining workshops. There were around 50 participants in total, supported by project managers as well as translators.

There were multiple creative and practical challenges in the project. First, the project was international without a common language, so translators were used at the Greek hospice. Second, it was intergenerational and intercultural, causing different expectations about the musical outcome of the project. Third, the video conference environment caused technical challenges that needed to be overcome. There were additional communication challenges for the patients in the hospices as they were wearing face masks, which impacted on the ability for others to read emotion in their facial expressions.

The project used the musical communication between the participants to overcome these challenges. They used images as the stimulus for participants to explore their emotions and experiences of loss and grief and brought these together to develop the music and the lyrics of the songs. At times in the creative process there were conflicts on the direction of the music, which were overcome through negotiation and compromise and a focus on the value of each individual's contribution. Actions and movement were an important part of the project, which helped with communication between the participants. These could be seen clearly by all participants, even when the audio feed was compromised.

Initially, the facilitators from Fischy Music established protocols for using video conferencing, including muting microphones of participants, but as the creative process was established, they started allowing all participants to have their microphones on when singing. Although this produced an unpredictable and at times chaotic audio feed, the collective singing and relationships between the participants were considered more important than the audio quality during the video conferences.

Two musicians from Fischy Music were in different locations during the project and needed to play together to accompany the songs. They established a telephone call at the same time as the video conference and the musician who was following the leader listened to the audio from the telephone call (which had minimal latency) rather than the video conference to remain in time with one another.

The organiser and participants were surprised at how it was possible to work online in a creative, musical, emotional, and spiritual way. Relationships between the participants were key to making the project work, and the organisers had to find ways to establish those relationships that were culturally and generationally appropriate. This came about through a focus on the musical outcomes of the project rather than focusing on the particular technology that was used. Longer-term relationships have been established through the project, with gifts and cards being sent between participants after the end of the project, highlighting the deep connections that were made.

Given the multiple locations and contexts of the project, it required careful planning and coordination, which happened through online meetings between the project coordinators at each location and the musicians at Fischy Music. Each session was carefully planned and documented to highlight issues to be resolved. The project culminated in an online sharing event, where the songs were performed by the participants.

Fischy Music continues to work online, delivering training events for teachers and workshops online. This has resulted in a wider reach for the charity as well as reduced time and cost spent on travel. While they recognise the value of online work for accessibility, they also recognise the challenges of working online and the creative risks that this adds to projects.

Chapter summary

While NMP generally has applications in ensemble performance and creation of music, it also has applications in music education and community music. This includes both the teaching of music and the facilitation of music projects.

Instrumental teaching can be successfully carried out through synchronous methods such as video conferencing as well as asynchronously through instructional videos. There are particular challenges around student/teacher musical interactions in online environments, such as degraded audio quality, latency, and jitter. These can mostly be overcome through careful planning and preparation and using a combination of online methods.

There are also many applications for online learning in general music education, for example, music theory and history teaching, as well as practical subjects such as composition and music technology. Ensemble music can be taught through synchronous and asynchronous methods discussed elsewhere in this book. A student-centred approach is most suitable for an online learning environment, as it encourages learner independence.

Community music has many similarities to music education, and projects can be designed for online environments with consideration of inclusion, equality, and creativity. Multiple methods can be used for access to online community music, including synchronous and asynchronous NMP approaches and a combination of both.

References and further reading

Barbosa, Á. (2003) 'Displaced soundscapes: A survey of network systems for music and sonic art creation', *Leonardo Music Journal*, 13, pp.53–59. https://doi.org/10.1162/096112104322750791

Biasutti, M., Antonini Philippe, R., & Schiavio, A. (2021) 'Assessing teachers' perspectives on giving music lessons remotely during the COVID-19 lockdown period', *Musicae Scientiae*. https://doi.org/10.1177/1029864921996033

Carey, G., & Grant, C. (2015) 'Teacher and student perspectives on one-to-one pedagogy: Practices and possibilities', *British Journal of Music Education*, 32(1), 5–22. https://doi.org/10.1017/S0265051714000084

Crisp, M. (2021) 'The response of community musicians in the United Kingdom to the COVID-19 crisis: An evaluation', *International Journal of Community Music*, 14(2), 129–138. https://doi.org/10.1386/ijcm_00030_1

de Bruin, L. R. (2021) 'Instrumental music educators in a COVID landscape: A reassertion of relationality and connection in teaching practice', *Frontiers in Psychology*, 11. https://doi.org/10.3389/fpsyg.2020.624717

Dye, K. (2016) 'Student and instructor behaviors in online music lessons: An exploratory study', *International Journal of Music Education*, 34(2), 161–170. https://doi.org/10.1177/0255761415584290

Goel, Y., & Goyal, R. (2020) 'On the effectiveness of self-training in MOOC dropout prediction', *Open Computer Science*, 10(1), pp.246–258.

JackTrip Foundation (2022) *JackTrip Foundation*. Available at: https://www.jacktrip.org/ (Accessed: 30th June 2022).

Johnson, C. (2020) 'A conceptual model for teaching music online', *International Journal on Innovations in Online Education*, 4(2).

Koszolko, M. K. (2015) 'Crowdsourcing, jamming and remixing: A qualitative study of contemporary music production practices in the cloud', *Journal on the Art of Record Production*, 10, pp.1–23.

Kruse, N. B., Harlos, S. C., Callahan, R. M., & Herring, M. L. (2013) 'Skype music lessons in the academy: Intersections of music education, applied music and technology', *Journal of Music, Technology and Education*, 6(1), 43–60. https://doi.org/10.1386/jmte.6.1.43_1

Kruse, N. B., & Veblen, K. K. (2012) 'Music teaching and learning online: Considering Youtube instructional videos', *Journal of Music, Technology and Education*, 5(1), 77–87. https://doi.org/10.1386/jmte.5.1.77_1

LoLa (2020) LoLa low latency AV streaming system. Available at: https://lola.conts.it/ (Accessed: 11th February 2022).

MacDonald, R., Kreutz, G., & Mitchell, L. (eds.) (2012) *Music, Health, and Wellbeing*. Oxford: Oxford University Press.

Matarasso, F. (2019) *A Restless Art*. Lisbon: Calouste Gulbenkian Foundation.

Musicians Union (2022) *Teaching Rates should Still Apply for Online Education*. Available at: https://musiciansunion.org.uk/news/teaching-rates-should-still-apply-for-online-education (Accessed: 7th February 2022).

Myers, D. E. (2008) 'Freeing music education from schooling: Toward a lifespan perspective on music learning and teaching', *International Journal of Community Music*, 1(1). https://doi.org/10.1386/ijcm.1.1.49/1

Orman, E. K., & Whitaker, J. A. (2010) 'Time usage during face-to-face and synchronous distance music lessons', *American Journal of Distance Education*, 24(2), 92–103. https://doi.org/10.1080/08923641003666854

Redman, B. P. (2021) *The use of videoconferencing and low-latency technologies for instrumental music teaching*. PhD thesis, Royal Conservatoire of Scotland and University of St Andrews, Glasgow.

Scholz, C. (2021) 'One upon a time in California'. In Brümmer, L. (ed.), *The Hub: Pioneers of Network Music*. Karlsruhe: ZKM | Hertz-Lab, pp. 42–66.

Scott, S. J. (2012) 'Rethinking the roles of assessment in music education', *Music Educators Journal*, 98(3), 31–35. https://doi.org/10.1177/0027432111434742

Simones, L. L. (2017) 'Beyond expectations in music performance modules in higher education: Rethinking instrumental and vocal music pedagogy for the twenty-first century', *Music Education Research*, 19(3), 252–262. https://doi.org/10.1080/14613808.2015.1122750

SQA (2021) *Annual statistical report 2021 – Highers*. Available at: https://www.sqa.org.uk/sqa/files_ccc/asr2021-higher.xls (Accessed: 30th June 2022).

Stevens, R. S., McPherson, G. E., & Moore, G. A. (2019) 'Overcoming the 'Tyranny of Distance' in instrumental music tuition in Australia: The iMCM Project', *Journal of Music, Technology and Education*, 12(1), 25–47. https://doi.org/10.1386/jmte.12.1.25_1

Waldron, J. (2010) 'Exploring a virtual music community of practice: Informal music learning on the internet', *Journal of Music, Technology and Education*, 2(2), 97–112. https://doi.org/10.1386/jmte.2.2-3.97_1

Waldron, J. (2012) 'Conceptual frameworks, theoretical models and the role of YouTube: Investigating informal music learning and teaching in online music community', *Journal of Music, Technology and Education*, 4(2–3), 189–200. https://doi.org/10.1386/jmte.4.2-3.189_1

Ward, F. (2019) 'Technology and the transmission of tradition: An exploration of the virtual pedagogies in the online academy of Irish music', *Journal of Music, Technology and Education*, 12(1), 5–23. https://doi.org/10.1386/jmte.12.1.5_1

Weiger, E. A. (2021) 'Flipped lessons and the secondary-level performance-based music classroom: A review of literature and suggestions for practice', *Update: Applications of Research in Music Education*, 39(2), 44–53. https://doi.org/10.1177/8755123320953629

Wenger, E. (1998) *Communities of Practice: Learning, Meaning, and Doing*, New York: Cambridge University Press.

Chapter 6

Accessibility in networked music performance

Introduction

Networked music performance (NMP) can be used to address some of the accessibility issues that are inherent in ensemble music-making, however, there is the potential to introduce barriers to participation that may not exist in more traditional forms of group playing. This chapter will explore both the benefits of and barriers to participation in NMP.

As we have seen earlier in this book, musicians have been working in NMP since the 1970s, as soon as computers were available domestically. However, this remained a fairly niche activity until broadband internet was available in most homes and digital audio workstations (DAWs) were easily accessible for musicians. The majority of musicians who were involved in NMP prior to 2020 were in several key groups: in academia, researching the possibilities of online music; in niche musical communities, as a way of connecting to like-minded musicians; and in educational contexts for remote learning.

The COVID-19 pandemic has exposed many more musicians – both professional and amateur – to NMP in various forms, and it remains to be seen how this will impact on longer term use of NMP in musicians daily practice. Many musicians were forced to adapt to NMP very quickly, whether by employers, for example, through maintaining continuity of teaching, or through necessity to maintain an income, through streaming concerts. This lack of preparation for the change to online performance and teaching is likely to have had a negative impact on musicians' attitudes towards NMP, however, these may have improved over time as they have come to realise the benefits of NMP. This sudden move to working online led many musicians to take part in virtual ensemble projects, perhaps considered the 'easy option' (although the author would disagree with this description, particularly from the point of view of the person who has to edit and mix the project) rather than the comparatively riskier approaches. This meant they missed out on the creative and collaborative approaches of synchronous NMP or collaborative composition and perhaps have an inaccurate view of the possibilities of NMP.

DOI: 10.4324/9781003268857-6

As the world moves towards more mobile and flexible working for many occupations, with jobs less linked to geographical location, and more focus on flexibility and work-life balance, NMP gives opportunities for musicians to work in a similar way. Of course, NMP is not a replacement for in-person music-making, rather, it is a different approach that could complement in-person engagement and allow as much flexibility as possible for musicians.

Benefits of NMP

NMP is an ensemble activity that is not possible to engage in without other people as participants or collaborators. This, in itself, offers many benefits in terms of social interaction and learning from other musicians, although the approach to NMP (especially when considering asynchronous methods) will have an impact on the level of this interaction. As Koszolko (2015) states: 'mutually beneficial exchanges of thoughts and musical ideas are at the core of networked collaboration'. This idea suggests that the word 'networked' in NMP does not only refer to the electronic networks used to transmit the music but also the networks of musicians involved in the process. It can also be fairly straightforward to locate other musicians to work with online compared to finding local networks of musicians to work with in a specific geographic location.

There are multiple benefits to musicians working in NMP, specifically around accessibility to collaborative music, for musicians at all stages of music-making. NMP can give access to ensemble music-making for musicians who are not able to be physically present with other musicians, whether this is due to practicalities such as physical isolation or geography or due to concerns around the impact of travel on the environment. Musical and social relationships can be built through NMP, although there are also impacts on relationships that need to be managed. Working in NMP can reduce musicians' environmental impact through removing the need to travel, although online working is not without its own environmental impact. A key benefit of NMP is the creative opportunities for musicians to work in this unique environment, some of which are not possible in a traditional face-to-face setting.

Practical considerations

It is worth stating that there are some clear practical benefits to NMP compared to in-person music-making. The first is an economic benefit: NMP saves money on hiring rehearsal spaces and transport costs. This, of course, relies on musicians having access to their own instruments as well as space and a suitable acoustic environment (and sympathetic neighbours) for engaging with NMP.

Second, there is an element of time-saving in NMP. No travel time is needed and instruments do not need to be packed and unpacked. This is at

a cost to the social interaction that happens during these parts of a rehearsal, but may be of particular benefit from those juggling multiple responsibilities, for example, those who are caring for family members or friends.

Third, as highlighted by Wilson and Mcmillan (2019), musicians may have access to aids to music-making (e.g., specific pieces of equipment) that may not be available at a venue, which would present a barrier to music-making for musicians with disabilities. In addition, if musicians are not travelling to venues, then there is no need for assistance from other people moving instruments or musicians, which may be the case for those who are less physically mobile or have particularly large instruments.

Finally, there is the practical benefit of being able to easily stay connected with a musical community, even if physical meetings are not possible.

Access to collaborative music-making

NMP gives access to collaborative music-making where it might otherwise be impossible. There are many reasons why traditional, in-person ensemble music-making might not be possible for an individual or a community of people. For example, these might be as a result of:

- Geography – the musician might not be physically located near other musicians;
- Genre/style – the musician may be interested in a niche musical style where other musicians are few and far between;
- Physical isolation – as a result of lack of mobility, health issues, economic reasons, conflict, psychological reasons, and more.

These may be temporary or permanent barriers to inclusion, where NMP can be used in various ways to limit isolation. An example of this is the many community music ensembles who worked online during the COVID-19 pandemic, who had previously been meeting face-to-face and returned to this way of working as soon as they could. Some of these groups worked on asynchronous NMP projects while the musicians could not meet in person and some attempted synchronous NMP projects. Some projects were set up specifically during the pandemic, with strangers working together for the first time. These examples highlight the importance of community in music. Many of these groups had aims that go beyond musical performance: they are communities of people who use music as a vehicle for mutual support.

Daffern *et al.* (2021) investigated the experiences of UK choir members during the COVID-19 pandemic, including a detailed investigation of how using the various approaches of NMP impacted on their musical communities. They found that working online helped to maintain choir continuity and provide social opportunities for choir members. Unsurprisingly, they found that synchronous NMP methods were more positive for social interaction

than asynchronous NMP – although these were limited to the virtual ensemble model rather than more creative collaborative composition projects. This highlights how the virtual ensemble model is limited in its interaction, with musicians potentially having no contact at all with other participants.

While many of the projects produced during this time may not have produced high-quality outcomes in terms of recordings or musicality, the act of collaboration on a project with a common musical goal helped to prevent isolation in these communities. In the author's experience, weekly online meet ups of community music groups allowed the community to check in with vulnerable members and provide support if needed. If members were missing from the online meetings, a physical visit or phone call could be arranged. Daffern *et al.* (2021) also highlight the impact on choir participants' well-being, although this is focused on the well-being of the individual members rather than the collective community.

Musical communities

NMP has a particular role to play in niche musical communities. It enables individuals to work together across geographic boundaries to bring together common ideas and can supplement online communities. An example of this is the algorave movement: using live coding software to produce improvisatory live electronic music. While live coding can be a solo endeavour and algoraves can happen in physical spaces, many algoraves are streamed and take place on a global scale with people attending from any location in the world. It is unlikely that there would be large audiences in physical spaces, apart from perhaps in large cities, due to the niche nature of this activity. The online nature also means that algoraves are highly accessible in terms of geographic location of participants. There is also potential for collaboration in algoraves, with visual live coding used alongside the audio.

As highlighted in the algorave example, NMP offers a level playing field for musicians in relation to physical location and isolation. This may be as a result of lack of mobility, economic reasons, remote location, or conflict. Providing there is suitable internet access available, there is no impact from these factors on the ability to engage with NMP.

Cross-cultural collaborations are common in the musical world, bringing together different musical cultures, both within geographic boundaries and beyond. These collaborations often require a great deal of time and financial investment to physically bring musicians together and may take years to develop. NMP is a tool that can be used to facilitate this, offering instant connection between musicians without concerns for the practicalities of travelling. However, there are certain challenges that may be heightened when working online compared to face-to-face.

In particular, these may include language barriers, difficulties in non-verbal communication, time differences, and cultural expectations. Where

these may be an issue, extra time should be allowed during an NMP project to build relationships and establish working practices that take these factors into account. There are also useful online translation tools that can be used alongside chat functions for communication.

NMP offers opportunities for musicians to build and strengthen communities, whether this is the only way musicians within that community work or whether it is used to supplement face-to-face musical activities. An example of this is Eric Whitacre's *Virtual Choir*, mentioned previously in this book. What started off with one person sending in a video of them singing one of Whitacre's compositions has become a worldwide community of singers, with multiple albums being released. The case study of the Applied Music courses at the University of the Highlands and Islands in Chapter 5 highlights how NMP is used as a tool for collaboration alongside face-to-face teaching, and facilitates and strengthens the musical community between geographically dispersed students. Wilson and Mcmillan (2019, p. 4) explore this feeling of belonging:

> Cultivating relationships at a local regional level is one thing, and having the opportunity to expand and connect with communities beyond my own region is something else—something that can make me feel as if I am some sort of network intrepid explorer; an Internet highway traveler and artist, sharing experiences through performance and the sharing of cultural or other practices.

The sense of community and belonging goes beyond merely being in touch with other musicians, but is strengthened by the communal aspect of ensemble music-making.

So far, this section has examined informal musical communities – those who may have met online or in-person and formed bonds based on their musical practices or tastes. More formal community music, which fits a particular definition of community music and has at least a semi-formal structure, is also suitable for NMP, as was demonstrated during the COVID-19 pandemic when many community groups were forced to work online.

We explored Matarasso's (2019) definition of community art (and by extension, music) in Chapter 5, which has the creation of art as a human right, and professional and non-professional artists working as equals, with outcomes that are not known in advance. Crisp (2021) argues that there is nothing in this definition that is impossible to achieve in community music that is offered online and that community music can happen in any type of community, which includes online communities. There are specific questions that community music practitioners may wish to ask themselves before engaging in online community music, based on this definition. The first may be about equality and access. If professional and non-professional musicians

must cooperate as equals, then there must be a level playing field in relation to access to equipment and the skills to use it. As Crisp (2021) points out, wealthier participants may have a higher-quality experience, relating to the availability of fast broadband, for example, and leaders must consider ways to ensure equity.

The final part of the definition is around the processes, products, and outcomes not being known in advance. This is certainly important in the choice of approach for NMP and does not fit with the virtual ensemble approach, as described in Chapter 4. In the virtual ensemble approach, the outcome and processes are very much known in advance, with the use of backing tracks and possibly sheet music distributed to participants. Other asynchronous methods, such as collaborative composition, do fit this definition, however, as does synchronous NMP, which can be made accessible through careful choice of software.

It is interesting therefore that many community groups did resort to the virtual ensemble approach during the COVID-19 pandemic (see, e.g., Daffern et al., 2021). This was probably because it was seen as a quick and easy option compared to synchronous approaches. It is not surprising that many musicians in Daffern et al.'s study (*ibid.*) did not find this an engaging activity. Despite this, and highlighted by Crisp (2021, p.113), it is important to recognise that NMP for community music may be a way of engaging people in a different way rather than just as a temporary replacement for traditional methods:

> In the online environment, communities are being brought together by a shared experience of the crisis itself, an experience shared by the community musician who is facilitating the music-making. Perhaps these online communities should not simply be dismissed and dispersed when in-person community music resumes.

Crisp (2021) suggests that community musicians should ask themselves creative, practical, ethical, and reflective questions when engaging in NMP, which would be an excellent starting point for practitioners who are considering moving from an offline to an online environment.

Music education

Online music education has accessibility at its heart, allowing access to teachers at all levels, no matter where students are located. While there are some similar issues for performing musicians and music teachers, there are additional considerations in music education. Even in relatively populated areas of the world, some instruments are less common and it may be difficult for students to access high-quality tuition within a suitable travelling distance, and NMP makes this possible. Of all the approaches to NMP discussed in this

book, online music tuition is probably the easiest for both student and teacher to adapt to and therefore makes it a good choice for many students and teachers. It can also be used in combination with face-to-face lessons to address any issues that are more difficult online.

An important consideration for music teachers is the value that is placed on online tuition compared to traditional face-to-face tuition. The Musicians Union in the UK advises members that the same rates of pay apply to both online and face-to-face lessons (Musicians Union, 2022), and this highlights that the educational value of video-conferenced instrumental lessons is no less than in a traditional setting, even if the pedagogy may be slightly different.

NMP is accessible to musicians at all stages, from those who have never played a musical instrument before to professionals. NMP does not need to involve traditional acoustic instruments, and systems that can be used to trigger samples, for example, can help reduce the impact of latency. This approach also allows those who cannot physically play a traditional musical instrument to access NMP. Systems that do allow musicians to play instruments (rather than just trigger pre-recorded samples) have the potential for musical flexibility and the opportunity for musicians to play to a high standard in a way they are accustomed to and potentially be more creative. The exact way that an instrument creates sound is less important in this regard than the flexibility of it to respond to the needs of the musician.

Relationships in NMP

The relationship between musicians is an important part of ensemble playing, particularly in small ensembles that are most suited to synchronous NMP. Musicians can play together at all levels of social relationship, from strangers to those in long-term friendships and romantic relationships, but playing music together also helps to develop and strengthen social relationships. Wilson and Mcmillan (2019, p.5) highlight how NMP can be used alongside in-person ensemble playing, and the impact of relationships on this:

> … Networked music can—and should—become a motivation for musicians to build relationships, towards deciding to make the effort to travel to play together in the same location. The amount of effort required to make these journeys could be diminished with the support gained through relationships created online, enhanced through networked performances.

NMP can be used to initiate these relationships or build existing ones for those who already play together in-person.

Davidson (2008) suggests that musicians' social tasks include creating the correct atmosphere in rehearsals, developing musical material, and interaction with co-performers, and NMP impacts on all of these areas (Iorwerth,

2019). The social dynamics of the group are very important for successful performances, and they have more of an impact than technical aspects of playing on cohesion and performance quality (Volpe et al., 2016). Additionally, successful personal communication facilitates musical communication (Dobson & Gaunt, 2015). The socio-emotional and professional relationships between the musicians are key to the success of the NMP projects, but these relationships are also impacted upon by working in NMP.

Creating the correct atmosphere in NMP projects allows musicians to play successfully, and this can be done in several ways. Musicians can demonstrate their respect and support for one another giving each other 'musical space' (Davidson & Good, 2002). In other words, they can support their fellow musicians by allowing mistakes to happen and help them recover from these, while also allowing for an individual's interpretation of the music.

In studies on duos in synchronous NMP (Iorwerth, 2019), musical leadership was used as an explicit method of dealing with potential difficulties in synchronising parts. This was a dynamic process, with leadership shifting based on the musical content of the performances. The ability to share leadership is a feature of a professional relationship between musicians, although, in this study, shared leadership was apparent in all the musicians, at all levels of experience – from students up to professional musicians. This suggests that it is a natural way to deal with some of the technical difficulties of NMP.

In addition to any professional relationships between musicians, the strength of musicians' personal relationships can also impact on the success of NMP. Showing a willingness to compromise and support one another can be beneficial when musical situations are difficult. The physically separated nature of NMP can cause some aspects of these personal relationships to suffer, in particular the sense of pleasure of playing with fellow musicians and the light-hearted enjoyment that can come from playing with friends. In their study of community musical groups during COVID-19, Daffern et al. (2021) highlighted this as one of the areas that impacted on musicians the most.

The online environment has the potential to feel more formal than being in a space together, partly due to the need to mute and unmute microphones, for example. This can be mitigated through including social time at the start and end of NMP sessions, much as there would be during face-to-face musical encounters. Any sense of formality is likely to reduce over time as musicians become more familiar with what is possible and appropriate with NMP technology.

For many musicians, 'winding down' after a performance is a collective affair, where those who have collaborated in a performance solidify a sense of group identity (Dobson, 2011). Clearly, in an NMP situation, a physical meeting is not possible, which may have an additional impact on social cohesion of an ensemble. The impact could perhaps be mitigated by formal or informal discussions and reflection on sessions immediately after any musical

component rather than ending the encounter when the musical aspects are finished. Alternatively, as was common for many community groups during COVID-19, purely social online gatherings as part of a rehearsal schedule could be included.

Given that ensemble playing can be considered as a microcosm of social interaction, with musicians behaving in complex but rule-based ways (D'Ausilio et al., 2015), it may be that working in NMP requires new rules to be negotiated to compensate for the differences between collocated and NMP performances.

There are many hierarchies in music performance: the lead singer of a band; a soloist and an accompanist; or the entire structure of an orchestra with a conductor, a leader, and the hierarchy within individual sections of the orchestra. Working in NMP can reduce this sense of hierarchy, which in a traditional performance environment can be reinforced by the physical arrangement of musicians playing (e.g., a soloist standing behind a piano accompanist or a lead singer standing in front of the rest of the band on a stage). In NMP, the sense of hierarchy can disappear in favour of leadership that is based on the music that is being played. This can be achieved by, for example, having equal views of all musicians on the screen and allowing each individual part an opportunity to be heard equally. Even geographic location can have an impact, with many more opportunities for performance in the big cities than in more rural locations and music industry structures based around large centres of population. These structures can be broken down within NMP, with no physical arrangement of musicians to reinforce them.

NMP, both synchronous and asynchronous, also lends itself to collaborative composition and improvisation. As we have seen in the case studies in this book, some of the most successful NMP projects have collaboration at their heart. In Heya (Chapter 3), the musicians are equal, with no creative leader – all musicians are responsible for the creation of the music and adapting to the challenges they face. In *F. not F.* (Chapter 3), the score changes once all the musicians have completed their section rather than one musician making the decision to move on. In *Mosaic* (Chapter 3), all the musicians in the orchestra had equally important parts and all had to intensely listen throughout the piece – more so than in a more traditional performance setting. In both the Fischy Music: Gresco Agape (Chapter 5) and Rock DI and Stride: Abrazos (this chapter) case studies, musicians came together across cultures to collaborate on songwriting projects that reflected their lived experiences and celebrate this through the composition process and performances at the end of the projects.

While there are some clear benefits to NMP, it is not without its challenges, particularly in relation to working with fellow musicians in different physical spaces. Wilson and Mcmillan (2019, p.11) offer some clear practical

suggestions to help foster a sense of togetherness, or as they put it, 'becoming less un-together':

1 Develop a remote mindset, for example, acknowledge the presence of those who connect remotely as valuable and include remote participants in decision-making processes;
2 Accept that there is effort involved in achieving a successful networked music experience;
3 Repeating and practising challenging actions can lessen the perception of how much effort is actually required, that is, rehearse as much as possible with the technology;
4 Seek knowledge with others on how to achieve a successful technical setup as well as share tips on remote etiquette;
5 Generate and share your own documentation on your remote collaboration efforts;
6 Seek to extend remote relationships in real life, where possible;
7 Develop cultural systems that allow for multi-time zone experiences to promote cross-hemisphere collaboration, for example, 'breakfast concerts';
8 Develop or seek out ease-of-use technologies, for example, those that prioritise audio over video when bandwidth is limited and tools that detect and manage acoustic feedback;
9 Engage with technical developments such as using AI and machine-learning to discover and strengthen performance patterns in network-mediated presence;
10 Become 'latency native': fully embrace latency as a core aesthetic and functional characteristic of networked music.

These tips are specifically for synchronous NMP, but many of them are also relevant for asynchronous NMP, which may have even larger challenges around relationships, as there may be no communication in real time between musicians and in some cases, no direct communication at all between musicians.

While this section has so far focused on relationships within already-established NMP ensembles, online environments also allow musicians to make connections outside their own musical communities, which then may lead to NMP collaborations. In their study on COVID-19 era musical communities, Crooke et al. (2021) identified that online environments allowed for more connections outside one's own community (bridging capital) than within it (bonding capital). Furthermore, they discovered that they offered something that perhaps the traditional, in-person collaborative environment could not:

> These opportunities for bridging were valuable not only for reaching new audiences, students or participants but also for expanding participants' own creative and social networks. The value of such connections at the

personal and community levels was evident and often seen to offer something unique or not easily possible through in-person connection.

(Crooke et al., 2021, p.264)

As discussed earlier in this chapter, NMP allows musical communities to go beyond geographical areas, increasing the possibilities of connecting with musicians with similar or indeed, very different musical tastes and experiences. Crooke et al. (2021) go on to discuss how what each individual gets out of an online musical space depends on how they choose to engage with that space and how they identify with that space. These two factors will interact with one another and perhaps are quite different to traditional ways of relating to other musicians in physical spaces.

Environmental impact

An obvious benefit for anyone who has taken part in an NMP project is the reduced need to travel, along with the associated financial and time implications. This also affects the environmental impact of performing. Playing online is not without environmental impact, however. Using the internet and transferring and storing data requires electricity throughout the signal chain, and it is worth evaluating the environmental impact of NMP versus travelling. This, of course, does not take into account the added energy consumption of performance itself, including sound and lighting equipment, and so on.

To calculate the carbon footprint of NMP compared to travelling to a rehearsal, there are several factors we need to take into account. First, we need to know how much data a video conference uses. We then need to consider the amount of energy devices, data transmission, and data centres may use, and then convert this to a CO_2 (carbon dioxide) figure and compare this with driving. There are many variables within these calculations, however, using average figures will at least give some indication of the differences between the two:

- An hour-long synchronous NMP session using video conferencing uses approximately 1 GB per hour of data (Jones and Zhu, 2021);
- Devices use approximately 0.055 kWh/hr (International Energy Agency, 2021);
- Data transmission uses approximately 0.018 kWh/hr (*ibid.*);
- Data centres use approximately 0.002 kWh/GB (*ibid.*).

So the total power consumption for one participant in an hour-long NMP session using video conferencing is equal to:

0.055 kWh (*devices*) + 0.018 kWh (*data transmission*)
+ 0.002 kWh (*data centres*) = 0.075 kWh

The carbon intensity of electricity is a measure of the CO_2 emissions released per kilowatt hour of electricity consumed. Carbon intensity varies depending on the demand for electricity as well as the exact combination of methods of generation of electricity. At the time of writing, the average carbon intensity of the grid in the UK was 199 g CO_2/kWh (National Grid ESO, 2022).

Therefore, an hour of synchronous NMP emits about 15 g of CO_2. For comparison, an average new car emits around 112 g of CO_2 per km (European Environment Agency, 2020). It is therefore clear that there is a greatly reduced environmental impact of NMP compared to driving to meet other musicians. Of course, there are limitations to these calculations, and they do not include factors such as lighting and heating in each individual musician's location or the reduced impact of using public transport compared to individual car use.

Streaming of performances

Although this book has concentrated on NMP in the sense of participatory ensemble music, an area of music over the internet that has enhanced access to music in recent years is the streaming of performances. This can happen in very informal ways, from using social media streaming functions and mobile phones to professional organisations recording and streaming concerts through paywalls. There are multiple opportunities through the use of live streaming that may not be possible in traditional forms of live performance, including increased accessibility, audience engagement, and feedback to performers. In addition, streams can be recorded, allowing access across time zones and at times that fit around the audience members' other commitments.

Large productions have taken advantage of these opportunities to reach wider audiences through streaming live and recorded events to cinemas prior to the COVID-19 pandemic. Examples of this include The Metropolitan Opera in New York streaming to cinemas across the world (The Metropolitan Opera, 2022) and the National Theatre in London streaming to cinemas across the UK and Ireland (National Theatre, 2020). These opportunities have not only increased access for audiences but also for musicians and theatres to reach new audiences, no matter how limited they are by geography (with the caveat that they need access to a cinema) or any of the other factors that may limit accessibility to performance opportunities.

Live streaming tools on social media platforms make streaming live performances extremely straightforward for those with access to a smartphone. Performances can be videoed from a phone with no additional equipment and streamed directly to a musician's page. Skjuve and Brandtzaeg (2020) found that performance (including music and dance) was the second most common use of Facebook Live, and was mostly used to communicate with family and friends, to share experiences in a live setting, and also for entertainment and fun. Different social media platforms have different audiences (with Facebook

in particular aimed at connections with known people rather than strangers) and different uses, and many musicians also use these for marketing purposes and can live stream directly to followers.

An advantage of streaming a performance is that audiences can interact with the artist in a more direct way through the use of live comments and reactions during performances, however, this clearly depends on the scale of the performance and the audience. This engagement can be of benefit both to the audience members and to the performers themselves.

Vandenberg et al. (2021) discuss how the comment sections that may be available during live streams provide a way for creating social ties and feelings of community among the audience members, in the context of electronic music events during COVID-19 in the Netherlands. These comments have an element of transmission and reception: to communicate an individual's presence at an online event and to allow individuals to see that they are part of a collective audience of people they do not personally know. Emojis are also often used to communicate feelings during performances, with these being replicated by strangers in the audience, enhancing the sense of community during these live events.

Streaming performances also give artists and promoters opportunities that are not available in traditional in-person events. While comment sections may provide communication between audience members (perhaps analogous with talking to other audience members during a performance, which may or may not be part of the etiquette of concert attendees, depending on the conventions of the genre), there are other possibilities for audience interaction. Streamed performances in immersive online 3D (three-dimensional) spaces have increased, especially during the COVID-19 pandemic (also called XR or referred to as the metaverse), and offer up new creative potentials for performers and audiences.

Levordashka et al. (2021) highlight the fact that traditional physical spaces for performance may not provide everything the audience needs and that viewing online performances as a lesser experience than traditional setting is limiting. For example, conventional times for performance in the evenings and at weekends may be barriers to engagement as much as physical barriers such as travelling to performance venues.

Many streamed performances are one-way – that is, audience members can see the performers but not vice versa, apart from any engagement through the comment sections. In synchronous NMP, there are also possibilities for the audience members to be seen and interact with the performance itself by using video conferencing systems. Levordashka et al. (2021) discuss some of the issues around this from the perspective of both the audience and the performers. If all audience members can be seen via video, then this increases visual load and has privacy issues for these audience members. There are also possibilities for audience members to adjust the view on their screens (e.g., to see all participants or just the active musician, based on the sound they

produce), leaving the performers themselves with little control over what is seen by an audience.

Levordashka et al. (2021) studied some of these issues and highlight the tension between audience immersion and interactivity. They found that seeing all audience members in video form was overwhelming, but that seeing how other people react to the performance was enjoyable. They also discussed how traditional performance venues allow audience interaction in physical spaces (e.g., when queuing for a venue and in hallways) as well as through audience conventions such as clapping and perhaps dancing. Digital versions of this interaction (e.g., the comment sections, as discussed earlier) require attention to be drawn from the performance itself and potentially break immersion. As a solution to some of these problems, the authors suggest that audience visualisation is valuable for a sense of togetherness, but that it could be achieved in abstract ways (rather than full video images), which also protects the privacy of the audience members. They also highlight the need for audience members to opt out of any visualisation if they prefer to interact with the performance in a solitary way.

Streamed performances are also often available as recordings after a live event, although there still may be elements of a collective experience for an audience. Vandenberg et al. (2021) highlight an example of audience members planning to watch back a recording of a concert at a later date, but together (virtually) to maintain the sense of interaction even when the performance is not live. While this may not be common, it does emphasise the importance of the sense of being part of a collective audience as part of the experience of a performance.

Shamma et al. (2009) explored how DJs used live streaming to share performances and connect with viewers: the other side of audience interaction. They found that DJs actively benefitted from the viewers' live reaction and feedback in multiple ways. The interaction helped them to fuel dedication among fans, presumably through the sense of personal connection directly with the musician. They used the feedback provided by audience members to gauge reaction to their performance and feed into what they do next. This feedback came in the form of chat messages, view counts, and overall activity of the audience. There was, however, a balance to be found between focusing on the musical performance and being distracted by the chat conversation (as we explored previously in relation to online music education).

While distraction by audience members may be a common problem in more traditional performance settings, musicians have techniques to deal with this, which vary by genre. Dividing attention between playing and reading messages is, however, unique to online performances, and it may be very difficult to engage with comments while maintaining focus on the performance.

A further area for consideration for performers and promoters is the value attached to online performances and how this might translate into monetary income. There are, of course, costs attached to streaming performances, not

least the musicians' fees. There are many different models for charging for online performances, and the balance between accessibility and cost must be considered for online performances as well as performances in traditional venues.

Clearly, there are many areas for further research in the way that audiences engage with online performances, whether live or recorded and whether they are active participants in a performance or more passive listeners. It is possible that streaming of performances will lead to the development of new cultures and conventions for audiences, perhaps across genres, and it will be interesting to see the impact these have on more traditional performance settings. In addition, further research on the impact of the audience interaction with performers may lead to new online performance conventions.

Creative opportunities within NMP

NMP, particularly using synchronous approaches, is a musical environment that does not exist in a physical space:

> Sound propagation in the network differs from sound in air, along stretched strings or through other familiar media. Among its unique aspects are jittery arrival times of sound packet data and speed asymmetries in opposite directions over a given path. Where in physical media, distance-related delay affects signal intensity, spectrum and other qualities, in the Internet the sound remains the same even having traveled around the planet.
>
> (Chafe, 2009, p.414)

There is potential for each member of an audience to hear an entirely different version of a piece of music and for unexpected elements such as glitches and jitter to be introduced to the music. Echoes can appear and disappear, depending on the network conditions, and musicians can disappear and then suddenly reappear, unaware that this has happened. Musicians can play, but choose when they are heard by muting and unmuting their microphones. Physical distances can disappear and allow for cross-cultural collaborations that would otherwise not be possible.

The creative opportunities of NMP are often overlooked, with a focus on the technical challenges and what *is not* possible. Interesting acoustic environments often attract artistic responses. Consider, for example, the site of the world's longest reverb, the Inchindown oil tanks, near Invergordon, Scotland (Cox and Kilpatrick, 2015), and the musical experiments it has attracted, or the Acoustic Atlas (van Tonder, 2020) that allows people to send their voice (or instrument) sounds into virtual acoustic places across the world. The 'acoustics' of the internet are available to anyone with an internet connection to access. While some of the discussions in this book have been around how to avoid some of the acoustic challenges of NMP, these could equally be

capitalised on. For example, by using loudspeakers and moving microphones in relation to them (with echo suppression switched off), it is possible to deliberately create echoes and feedback, depending on the network environment at the time. This may also change from day to day or moment to moment, adding more creative possibilities to the environment.

Several of the case studies in this book have explored the ideas of imperfection in music and how the NMP can help musicians to embrace this imperfection and use it as a creative opportunity. Musicians often like to feel in control of their performances, through intense practice and rehearsal, to limit the chances of something going wrong. Unexpected events and mistakes do happen despite this preparation, and as discussed elsewhere, all performance involves some element of improvisation, even if this is as small as recovering from a perceived mistake. NMP encourages improvisation and careful listening as technical challenges are encountered. Musicians must pay attention to what is happening in the NMP environment and be prepared to adjust their playing accordingly.

As we saw in the Heya case study (Chapter 3), these imperfections and challenges can be embraced as part of the enjoyment of playing together. Problem-solving and adaptation become part of the musical experience, both in the moment while playing and longer term, as technology changes and software becomes available or unavailable.

Playing within the NMP environment can also open musicians' minds to questions around what music is and what is important within ensemble playing. The word 'ensemble' is often used by chamber musicians to describe the temporal synchronisation between musicians as well as other aspects of sounding together, such as matched articulation and phrasing, volume and balance between the instruments, and the use of complementary techniques for playing. This concept of ensemble and 'togetherness', therefore, is something that has to be considered in a different way in NMP.

There is also a long history of music rooted in environments, such as the traditional music of specific locations around the world, and NMP can be seen as music rooted in the networked environment. There are increasing numbers of musicians working in this environment, and this is supported through academic and artistic conferences and networks of musicians, such as NowNet Arts, which promotes 'contemporary network arts works, technologies, education programs, and publications' (NowNet Arts, n.d.).

Composer and academic Rebekah Wilson takes a particular interest in the aesthetic possibilities of NMP in her work, using technology to work with some of the technological challenges rather than trying to avoid them. As we have seen from the case study on her composition *F. not F.* in Chapter 3, she uses machine learning to generate scores for this work, which can equally be suited for musicians based in the same physical locations. She has also written about specific features of synchronous NMP that impact its creative possibilities and aesthetics (Wilson, 2020). She highlights that the digital nature of NMP means that signals can be transmitted and manipulated with ease and

that the musical nature of NMP means there are possibilities for being highly expressive, and the combination of these two factors results in highly creative possibilities.

Wilson (2020, p.5) outlines the primary characteristics of synchronous NMP as follows:

- Latency and uncertainty: the unavoidable artefact and unstable property of the network transmission.
- Multi-located, multi-authorial: the collision of sound images that exist on multiple temporal planes, creating new timbral experiences and questioning perceptions of authorship and ownership.
- Digital mediation: the deconstruction and reconstruction of the sound image, permits reproduction in any form.

As a result of these characteristics, Wilson offers four aesthetic approaches to the music of NMP, all of which can be identified throughout the case studies in this book:

1 Post-vertical harmony.
 Vertical harmony in music refers to the combination of tones that sound together, and disruption of timing in NMP impacts on how this happens across a number of instruments. The *Mosaic* case study (Chapter 3) highlights how this was approached – with the use of melodic lines that imply harmony and sections where single instruments can play vertical harmony uninterrupted, such as piano and tuned percussion.
2 Vital information and performative relationships.
 Without a doubt, NMP does disrupt traditional ensemble practices and ways musicians synchronise, as explored in Chapter 3. The case study of *F. not F.* offers a new way to do this, by using scores that provide synchronisation information and adapt to what the musicians are playing.
3 Resonance and new timbres through multi-located fusions.
 In a traditional, in-person performance space, audiences hear multiple sounds coming from multiple sources (whether this is individual instruments or loudspeaker arrays). In NMP, there is only one sound – a blend of all the musical sources combined with artefacts from the internet, including echoes, latencies, and glitches, all of which are part of the experience of NMP.
4 The post-digital aesthetic.
 Failure should be embraced and illuminated through NMP, and transformations that happen as a result of transmission of sound through the internet should be embraced as part of the music and the musical process. This is highlighted in the Heya case study (Chapter 3), where practical and musical challenges are not seen as failures, rather, they are part of the act of playing with the ensemble.

The specific creative affordances of asynchronous NMP are rather less obvious, as they are not impacted by the opportunities of latency and interesting internet audio artefacts and very much depend on the approach taken. In fact, in many asynchronous NMPs, the aim is to eliminate challenges related to the internet and focus entirely on the musical content of the project. Collaborative composition is by its nature multi-authorial and multi-located if undertaken through NMP, although much more conventional in terms of musical possibilities. In these cases, the creative possibilities are defined more by the musicians taking part than the environment it happens in.

Barriers to NMP

While NMP has many benefits for musicians, particularly around access to collaborative music-making, there are also barriers that may prevent musicians from engaging with NMP. These include attitudinal barriers (e.g., believing that the technical issues are too difficult to overcome), technical barriers (e.g., lack of fast internet connections), and musical barriers (e.g., experience as a musician). In this section, these barriers are examined in turn.

Attitudinal barriers

NMP has been a relatively niche musical activity until recently, and many musicians have been exposed to this way of working as a result of the COVID-19 pandemic. Prior to this, NMP was mostly carried out by those with specialist interests and skills in music technology. It is not surprising therefore that those who have not been exposed to this way of working before might be a little hesitant.

An initial reaction to NMP is that technical issues are too difficult to overcome, especially latency. As discussed in Chapter 3, this is clearly not the case for many musicians, provided that they are willing to accept and work with the differences of the NMP environment. Latency can be overcome using various methods, including the leader-follower approach and accepting latency as a creative opportunity. Potential problems arise when musicians have expectations that working in NMP will be the same as a conventional, in-person musical experience and are unwilling to alter their way of working. Even systems such as LoLa (which is high quality and low latency with audio and video streams), still require musicians to adjust to working differently. This includes aspects of working that are perhaps overlooked, such as sharing refreshments during breaks in working, which build social as well as professional relationships.

Accessing NMP, whether synchronously or asynchronously, requires musicians to engage with technology. Even for the most basic of set-ups, this might involve installing software and adjusting audio settings. For asynchronous NMP, musicians require a basic knowledge of file storage in order to send the

appropriate audio and video files to be mixed. For synchronous NMP, some understanding of the etiquette of communication through video conferencing (such as muting and unmuting microphones) is required for successful sessions. For many people who have grown up or work daily with computers, these are not difficult tasks. However, it is important to consider those without these skills when planning an NMP project. While musicians may be capable of working with computers, they may not perceive that they have technical abilities, and this may be enough to prevent them from engaging in NMP activities. This is particularly important to consider in community groups, where participants may come from many different backgrounds, and organisers should consider what support can be put in place to avoid excluding particular musicians.

A further barrier to participation may be the sense of exposure that is apparent in the online environment. For ensemble musicians who are used to playing in a large group, there is potential for individuals to be heard in the NMP environment. This is particularly true in an asynchronous project, where individual contributions are sent to be mixed together. The individual musicians can, of course, listen back to their contribution before submitting it, but this may in some senses make the process more difficult and time-consuming as musicians attempt to perfect their performance. In a typical rehearsal or performance environment, the music passes in the moment and mistakes cannot be corrected. What is colloquially known as 'red light syndrome' is musical performance anxiety that happens when a musician is being recorded and is a well-known phenomenon among recording musicians. This can result in multiple takes and increasing frustration as musicians do not perform as they wish when they are recording. Daffern *et al.* (2021) highlight the benefits to musicianship for choir members of hearing oneself in isolation, where it can encourage individuals to develop their technique, which may not have happened in a conventional choir environment.

For those playing in a synchronous NMP project, it can feel like a more typical performance, where mistakes pass without dwelling on them, however many of these projects will be recorded, whether to stream later or to document a performance. This perhaps makes these performances more exposing, as they could be potentially accessed from anywhere in the world, depending on how they are published.

These factors must be considered by group leaders and approached in a sensitive way, so that musicians can feel safe and play to the best of their abilities. Participants should be willing and positive about taking part, allowed to make mistakes, and supported in their contributions. These issues may be less of a factor for professional musicians, who are used to playing in high-pressure environments.

An interesting barrier to participation in NMP that has arisen in the author's experience, is those musicians who see NMP as a threat to in-person music-making. This has become more apparent during the COVID-19 pandemic and

is perhaps a natural reaction to the fear of restrictions to normal life. While NMP may not suit all musicians for the reasons already discussed in this chapter, it is important to remember the significance of the access benefits of NMP. NMP has not been a reaction to the pandemic – it was happening for decades beforehand – rather it has become clear that technology can help to bring people together musically as well as socially. It is also important for those who feel threatened by NMP to remember that some musicians may never be able to access traditional ensemble music-making for the reasons already discussed in this chapter: NMP is another way to access ensemble music, not a replacement for traditional, in-person music-making.

This is an area where education can help influence musicians. As online instrumental lessons become more acceptable at all levels (from beginner to conservatoire level), musicians may see NMP as less of a threat and more of a benefit. It is likely that many children who have worked this way from early in their musical careers will accept it as part of a musician's usual way of working. Crooke *et al.* (2021) describe the importance of 'showing up' in an online space: how what is gained from engaging in an online space depends on the intention of the individual as well as their own identity and what they are attempting to get out of the encounter. Educators and facilitators could perhaps help to influence participants in NMP by discussing some of these issues at the start of projects to ensure participant engagement and to help make sure the needs of the participants are met.

Interestingly, attitudinal barriers to NMP have also entered scholarly research since the COVID-19 pandemic. An example of this is the two studies referred to earlier in this chapter about DJs streaming sets online (Shamma *et al.*, 2009; Vandenberg, 2021). Prior to the COVID-19 pandemic, this research focused on the benefits of streaming DJ sets, with overwhelmingly positive experiences from the musicians, whereas the latter study includes more focus on the negative aspects and how it is inferior to attending a live event. This highlights the importance of choice on participation in NMP – prior to COVID-19, musicians (and audiences) could make active decisions about whether they wished to engage in NMP and focus on the benefits. When NMP was the only option, some participants focused on the more difficult aspects and compared it directly with live performance rather than seeing it as an entirely different approach to ensemble music-making.

Technical barriers

The most obvious technical barrier to accessing NMP is access to the internet. As of January 2021, there were 4.66 billion active internet users worldwide – 59.5% of the global population. Of this total, 92.6% (4.32 billion) accessed the internet via mobile devices (Office for National Statistics, 2021). Internet penetration rates – the proportion of the population with regular internet

access at home, school, or work – vary widely across the world, from 0.2% in Myanmar to 100% in the Falkland Islands (Warf, 2011).

In the UK, of those aged 75 and older, 54% are recent internet users of 2020. Twenty-two per cent of disabled adults are not recent internet users as of 2019. Ninety-two per cent of adults in the UK in 2020 are recent internet users (Office for National Statistics, 2021). These statistics highlight that access to the most important technical aspect of NMP is not equal across all demographics, with many older and disabled people unable to engage with NMP as a result of lack of connectivity to the internet. These figures do not take into account other technical barriers to NMP.

In addition to access to the internet, musicians also need somewhere where it is possible to play music while connected, preferably quiet and uninterrupted and without disturbing other people. Particular barriers to this may be shared housing, shift work, or caring responsibilities.

One of the many technical barriers to NMP is digital literacy. To engage with synchronous NMP in its most basic and accessible form, musicians at a minimum would need to follow these steps:

- Switch on the device;
- Connect the device to the internet;
- Navigate to suitable video conferencing software;
- Install this software if it is not currently installed;
- Navigate to audio and video settings;
- Route the correct microphone (and maybe camera) to the software;
- Make the call to connect to other musicians.

When these steps are laid out, it is clear to see that musicians require a reasonable amount of digital literacy in order just to connect to other musicians. Once in the session, there is also muting and unmuting to contend with as well as dealing with fault-finding and audio problems that may arise. This is before a single note has been played. While many people reading this book will take these actions for granted, it is easy to see how overwhelming the idea of NMP might be for someone who does not consider themselves technically savvy.

As discussed in previous chapters, in order to get the best audio quality and minimum latency, devices should use Ethernet connections (which probably means using a desktop or laptop computer) and specialist software such as JackTrip. This particular software requires a fair degree of knowledge and experience of operating systems to install (and was beyond the author's capabilities without assistance, despite some software engineering experience). Specific courses are now available in installing and using JackTrip as well as collaborative tools that are based on the original JackTrip software. This highlights the trade-off between audio quality, latency, and accessibility.

As we have seen in some of the case studies in this book, high-speed, reliable internet in domestic settings is not ubiquitous throughout the world. Apart from access to the internet through mobile devices, power is required for domestic internet connections. Forty-five per cent of the world's population do not have access to reliable power sources, with many of the unreliable power supplies being in South America, Sub-Saharan Africa, and Southeast Asia (Ayaburi et al., 2020), limiting the possibilities for musicians in these areas to access in particular synchronous NMP.

While physical access to the internet may be common across the world, around a quarter of the world's internet users live under governments that engage in very heavy censorship. The amount of internet censorship in any location is reflected by the extent of internet penetration rates, the social, cultural, and economic constitutions of various societies, and the degree of political opposition (Warf, 2011). Methods of censorship that might impact on NMP include banning fast internet connections, limiting access to common web services (e.g., Google) that might prevent musicians connecting with others, filtering of instant messaging, jamming of email systems, and blocking of internet telephony.

In order to access NMP in both synchronous and asynchronous approaches successfully, musicians require basic knowledge of audio. At a minimum, for asynchronous NMP using a mobile phone, this includes an understanding of basic recording techniques, if only to decide on the placement of the phone in relation to the instrument. For those working on collaborative compositions, more advanced skills are required, including the characteristics and use of microphones, use of DAWs (potentially including some of the more complex functions around audio routing and mixing techniques), and import and export of audio files. For those working in synchronous NMP, a minimum requirement is an understanding of audio settings and routing in video conferencing. Perhaps the most important skill of all is the ability to find and fix faults within these systems.

Recording skills are not taught as part of a general music curriculum in UK schools, although there are some specialist music technology teachers and specific music technology qualifications. There is not a high uptake of these, however. For example, in Scotland for Higher qualifications (a qualification taken at or near the end of secondary education) in Music in 2021, there were 5,219 entries compared to 913 in Music Technology (SQA, 2021). It is likely that due to the specific skills required to teach these subjects, this trend may be replicated in other locations. Hopefully, this book will go some way to helping musicians who have not gained these skills elsewhere.

Musical barriers

While NMP is suitable for musicians at any level of experience, there are musical challenges that may be experienced that may impact on less experienced

musicians in different ways to professional musicians, for example. When playing music in an ensemble, musicians must divide their attention between listening to their own playing, looking and listening to the playing of others as well as paying attention to the overall sound of the ensemble. Inexperienced musicians are likely to focus on the mechanics of their playing and pay little attention to what is going on around them – in this case, they are not likely to be affected by the use of NMP technology, as they concentrate on their own part.

As musicians develop experience, they become more aware of their surroundings by listening to themselves, then others, and then looking at others and reacting to others' actions. As this awareness increases, potentially so will the impact of the NMP technology. Synchronisation cues, for example, may get lost when non-verbal communication becomes difficult. At the far end of this spectrum, however, it is likely that something different will happen: when musicians are extremely experienced, they are able to adapt to difficult situations (including acoustics and working with many different players). This means that the impact may be less for highly experienced players than for intermediate musicians.

Some musicians may not be used to working in creative ways or find adaptation to different acoustic environments difficult. This may be a result of their education, their own particular musical practice, or their level of skill on their instrument. This may make NMP particularly difficult for these musicians.

Performing music involves constant improvisation, which results in dynamic, interesting performances. Even when a piece has been practised and an ideal mental representation has been formed, things can go wrong, requiring on the spot decision-making (Schiavio & Høffding, 2015). Reduced risk-taking of musicians in NMP is possible (Iorwerth, 2019), where musicians take fewer creative risks than they might if they were performing in a room together. This is as a way of compensating for technical challenges and the potential for difficulties in recovering from unexpected events. In addition, in some cases, the need to fit the music around the technology of NMP can be felt to be limiting. It is likely that the expertise of musicians is a factor in risk-taking, from the point of view of experience as a performer but also experience of NMP and knowing what the boundaries of possibility are in the NMP environment.

Seddon and Biasutti (2009) describe a form of non-verbal communication as being 'sympathetically attuned', which is characterised by a lack of risk-taking and lack of challenge to individual or collective creativity, with musicians adhering to previously rehearsed interpretations. Studies into synchronous NMP have found that musicians highlight a lack of risk-taking and reduced creativity in their playing (Iorwerth, 2019). When working with NMP over long periods of time, this may lead to less collaboration between performers and creative practices (such as composition) may be impeded.

If it can be assumed that musicians may prefer to be 'empathetically attuned', resulting in collective creative risk and spontaneous musical variation (Seddon & Biasutti, 2009), then musicians must be prepared to move away from previously rehearsed interpretations and take more creative risks. In the case of musical collaborations that take place entirely through NMP, this may be less challenging as features of the NMP 'acoustic' can be embraced within the music. It may also be that focused rehearsals are needed to concentrate on parts of the music that are particularly difficult in the NMP setting and that individuals may need to focus on getting to know and improving their abilities in their own parts to help achieve this.

Attempting inappropriate music for the NMP environment can be the downfall of an otherwise successful project. In asynchronous NMP, musicians can listen to guide tracks and other musicians' contributions many times to embed tempo changes or rhythmic inconsistencies, although the further away from a predictable, regular tempo, the more time and energy will be required to produce a contribution that fits seamlessly. For this reason, many styles and genres of music can be successfully included in these projects, although some will be more challenging than others.

In synchronous NMP, considerations of how to deal with latency must be taken into account when choosing the music to play. Steady, predictably rhythmic music works well, and the techniques for dealing with latency, such as the leader-follower approach discussed in Chapter 3, can be easily employed. Alternatively, music that does not rely on synchronisation of parts (including free improvisation and some music composed specifically for NMP settings) will also be suitable for the NMP environment.

The interaction required for free improvisation may be more challenging in NMP: without a framework for improvisation (such as a song or chord structure), the fine communicative details required for this type of interaction may be compromised, especially in relation to timing. Conversely, free improvisation also gives musicians the freedom to react to the conditions of NMP, for example, by using the acoustic properties of the network (e.g., latency and echoes) as part of the music produced (Chafe, 2009). In order to improvise successfully, musicians need to be able to anticipate musical events, express emotion through the music, and experience a flow state (Biasutti & Frezza, 2009), all of which are affected by the use of NMP.

Whatever music is chosen, those who are planning NMP projects should consider in advance what the musical challenges might be for participants and fully brief participants around what they may encounter. When working with less experienced musicians in particular, it may be worth considering steady, beat-based music as a starting point to make synchronisation as simple as possible – if, indeed, rhythmic synchronisation is an aim of the performance.

Accessibility considerations for practitioners

As well as the general barriers to participation in NMP, there are specific actions that practitioners can do to help improve the experience of all participants in NMP:

- At the outset of a project, consider an inventory of barriers to participation (including attitudinal, technical, and musical barriers) based on knowledge of the participants;
- Nurture an open, supportive environment for all musicians, building on individual strengths and supporting weaknesses;
- Include clear instructions for participants that encompass different equipment;
- Consider pairing more technically experienced participants with those less able for support;
- Consider using captioning in video conferencing when speaking;
- Speak one at a time in video conferences and mute when not speaking, use raise hand functions to facilitate this;
- Use accessibility tools built into the software;
- Allow time for participants to read chat, if used alongside video conferencing;
- Have a point of contact that participants can use if they encounter problems (preferably telephone or other non-computer-based methods);
- Consider the experience of those who have reduced internet access (maybe audio only);
- Consider ways to minimise 'exposure' for musicians who may not be used to playing on their own, if this is a barrier for them.

Case study

This case study outlines an example of an NMP project that includes both synchronous and asynchronous elements and embeds accessibility throughout. The project demonstrates approaches to accessibility that include communication in different languages, the use of accessible instruments, and the support of musicians with additional support needs.

Rock DI and Stride collaboration: Abrazos

Funded by the British Council Mexico, Abrazos was a collaborative project between Stride (based in Scotland and supported by Paragon) and Rock DI (based in Mexico and supported by Armonía E Inclusión AC), both inclusive rock bands made up of young and emerging musicians. The project involved around 30 musicians in total, working with synchronous and asynchronous NMP to compose, record, and perform an album of original music.

The project took place during the COVID-19 restrictions, which meant that initially the Scottish musicians all had to work from home. The first part of the process was for the Paragon practitioners to identify what instruments and equipment each musician had at home and provide extra equipment as necessary. They also provided one-to-one training on how to use the video conferencing and recording software and set out to keep processes as simple as possible for those with additional support needs. Some musicians used tablets as musical instruments and did not have other devices to access video conferencing, so the Paragon team found alternative ways for them to contribute to the project, when they were not able to play their instruments during the synchronous aspects.

The next stage of the project was a series of songwriting workshops. These happened synchronously through Zoom, with breakout rooms used for small groups to work on different aspects of the songs, for example, lyrics or musical content and whiteboards used to share visual content. Slack was used in the background for the Paragon practitioners to share and locate resources such as lyric sheets and chord charts. As there was not a common language between the musicians, Google Translate was used to communicate between Spanish and English. The chat function within Zoom was also important for communication for the musicians who were non-verbal. The practitioners ensured that each musician had an opportunity to contribute to the process, for example, by allowing space for a musician who used their iPad to sing for them to be recorded during the sessions. All the musicians also followed a code of conduct when working online to help with the smooth-running of the sessions.

The songs reflected the musicians' lived experiences, including disability and cultural identity. They also included some cultural references, for example, to the Mexican Day of the Dead, which allowed the Scottish musicians to learn about this festival and have their own reflections on death. They also recorded sounds of their own local environments that were used in the songs.

Once the musical content had been decided, the musicians rehearsed and recorded their parts in their own homes, using whatever device they had available. They provided synchronisation information with a count in and clap at the start of the recordings. Six tracks were edited and mixed by one of the Paragon practitioners using the Logic Pro DAW, while the other four tracks were edited and mixed in Mexico by Rock DI, before the final mastering of the album was completed by Paragon in Scotland. The musicians used file transfer methods that were familiar to them, including Google Drive, WeTransfer, and Dropbox.

The next stage of the project was to prepare for the live performances: one in Scotland in October 2021 and one in Mexico in December 2021. By this point, the musicians could meet in-person for rehearsals in Scotland and Mexico, although some musicians who could not attend the in-person rehearsals joined in via Zoom. The two locations connected via Zoom for their rehearsals. The whole performance was recorded in advance.

At the live performances, a hybrid approach was taken. The musicians who were physically located in the country of performance played live to an audience, with the remote musicians appearing on a screen above the live performers. To avoid problems with latency, an audio recording of the remote musicians was played, although they were playing at the same time and the video feed was live. The whole performance was live-streamed using OBS (Open Broadcaster Software), which, along with the video conferencing, put a strain on the available bandwidth at the venue. During the performance in Mexico, the Zoom connection from Scotland failed, but a backup video was used instead to show to the audience.

This project has resulted in a long-term relationship between the two groups of musicians as well as other international online projects by the supporting organisations, including online training courses on inclusivity in music. Rock DI are planning a visit to Scotland to play live with Stride, and their album Abrazos has been released on Spotify.

Chapter summary

This chapter has explored the accessibility benefits and challenges of NMP. NMP allows access to ensemble music that might otherwise not be possible for musicians by eliminating the need to travel to play with others. This has associated benefits of reducing costs and the environmental impact of travel. There are also community benefits to NMP, including bringing together musicians who would not have worked together without NMP and allowing access to niche musical communities that may be lacking in numbers in a geographic location for a viable ensemble. NMP also offers musical opportunities – including the use of the acoustic properties of playing over the internet – that may not be possible in other acoustic environments.

Barriers to NMP can be roughly divided into attitudinal, technical, and musical barriers, with some overlap between them. Having access to the technology required for NMP is not ubiquitous, and some technical skills are required to use the equipment. Attitudes around ensemble music and the benefits to the individual as well as some of the perceived ideas around NMP may not encourage participation. Ideally, NMP should be seen as complementary to in-person performance rather than as a direct replacement and the benefits to participants celebrated as such. Not all music is suitable for NMP, and carefully considering the musical content of a project can help to mitigate some of the challenges around this.

Practitioners must consider these benefits and challenges when planning NMP projects to make sure inclusion and accessibility is a major consideration in the approach they choose and do their best to mitigate any factors that make it difficult for musicians to engage in NMP.

References and further reading

Ayaburi, J., Bazilian, M., Kincer, J., & Moss, T. (2020) *3.5 billion people lack reliable power*. Available at: https://www.energyforgrowth.org/memo/3-5-billion-people-lack-reliable-power/ (Accessed: 27th June 2022).

Biasutti, M., & Frezza, L. (2009) 'Dimensions of music improvisation', *Creativity Research Journal*, 21(2–3), pp.232–242.

Chafe, C. (2009) 'Tapping into the internet as an acoustical/musical medium', *Contemporary Music Review*, 28(4–5), pp.413–420.

Cox, T. J., & Kilpatrick, A. (2015) 'A record "longest echo" within the Inchindown oil despository', *The Journal of the Acoustical Society of America*, 137(3), pp.1602–1604. Available at: https://doi.org/10.1121/1.4908218

Crisp, M. (2021) 'The response of community musicians in the United Kingdom to the COVID-19 crisis: An evaluation', *International Journal of Community Music*, 14(2), pp.129–138. Available at: https://doi.org/10.1386/ijcm_00030_1

Crooke, A. H. D., Hara, M., Davidson, J., Fraser, T., & DeNora, T. (2022) 'Fractured bonds and crystal capital: Social capital among COVID-era music communities', *International Journal of Community Music*, 14(2), pp.247–272. https://doi.org/10.1386/ijcm_00047_1

D'Ausilio, A. et al. (2015) 'What can music tell us about social interaction?', *Trends in Cognitive Sciences*, 19(3), pp.111–114.

Daffern, H., Balmer, K., & Brereton, J. (2021) 'Singing together, yet apart: The experience of UK choir members and facilitators during the Covid-19 pandemic', *Frontiers in Psychology*, 12. Available at: https://doi.org/10.3389/fpsyg.2021.624474

Davidson, J. W. (2008) 'Movement and collaboration in musical performance', in Hallam, S., Cross, I., & Thaut, M. (eds.), *The Oxford Handbook of Music Psychology*. Oxford: Oxford University Press, pp. 364–376.

Davidson, J. W., & Good, J. M. M. (2002) 'Social and musical co-ordination between members of a string quartet: An exploratory study', *Psychology of Music*, 30(2), pp.186–201.

Dobson, M. C. (2011) 'Insecurity, professional sociability, and alcohol: Young freelance musicians' perspectives on work and life in the music profession', *Psychology of Music*, 39(2), pp.240–260.

Dobson, M. C., & Gaunt, H. F. (2015) 'Musical and social communication in expert orchestral performance', *Psychology of Music*, 43(1), pp.24–42.

European Environment Agency (2020) *Average CO_2 emissions from new cars and new vans increased again in 2019*. Available at: https://www.eea.europa.eu/highlights/average-co2-emissions-from-new-cars-vans-2019 (Accessed: 27th June 2022).

International Energy Agency (2021) *Assumptions for energy intensity of data centres, data transmission networks and devices in 2019*. Available at: https://www.iea.org/data-and-statistics/charts/assumptions-for-energy-intensity-of-data-centres-data-transmission-networks-and-devices-in-2019 (Accessed: 27th June 2022).

Iorwerth, M. (2019) *Playing together, apart: An exploration of the challenges of Networked Music Performance in informal contexts*. PhD thesis: Glasgow Caledonian University.

Jones, D., & Zhu, J. (2021) *Hourly Data Consumption of Popular Video Conferencing Applications*. Available at: https://www.cablelabs.com/blog/hourly-data-consumption-of-popular-video-conferencing-applications (Accessed: 27th June 2022).

Koszolko, M. K. (2015) 'Crowdsourcing, jamming and remixing: A qualitative study of contemporary music production practices in the cloud', *Journal on the Art of Record Production*, 10, pp.1–23.

Levordashka, A., Stanton Fraser, D., Gilchrist, I. D., Hill, P., & Chadwick, E. (2021) 'Sensing the audience in digital streaming: Lessons from a global pandemic', *Extended Abstracts of the 2021 CHI Conference on Human Factors in Computing Systems*, pp.1–6.

Matarasso, F. (2019) *A Restless Art*, Lisbon: Calouste Gulbenkian Foundation.

Musicians Union (2022) *Teaching rates should still apply for online education*. Available at: https://musiciansunion.org.uk/news/teaching-rates-should-still-apply-for-online-education (Accessed: 7th February 2022).

National Grid ESO (2022) *Carbon Intensity API*. Available at: https://carbonintensity.org.uk/ (Accessed: 27th June 2022).

National Theatre (2020) *National Theatre Live*. Available at: https://www.ntlive.com/ (Accessed: 27th June 2022).

NowNet Arts (n.d.) *NowNet Arts*. Available at: https://nownetarts.org/ (Accessed: 28th June 2022).

Office for National Statistics (2021) *Internet users, UK: 2020*. Available at: https://www.ons.gov.uk/businessindustryandtrade/itandinternetindustry/bulletins/internetusers/2020 (Accessed: 11th February 2022).

SQA (2021) *Annual statistical report 2021 – Highers*. Available at: https://www.sqa.org.uk/sqa/files_ccc/asr2021-higher.xls (Accessed: 30th June 2022).

Schiavio, A., & Høffding, S. (2015) 'Playing together without communicating? A pre-reflective and enactive account of joint musical performance', *Musicae Scientiae*, 19(4), pp.366–388.

Seddon, F., & Biasutti, M. (2009) 'Modes of communication between members of a string quartet', *Psychology of Music*, 37(4), pp.395–415.

Shamma, D. A., Churchill, E. F., Bobb, N., & Fukuda, M. (2009) 'Spinning online: A case study of Internet broadcasting by DJs', *Proceedings of the 4th International Conference on Communities and Technologies*, State College, PA, pp.175–184.

Skjuve, M., & Brandtzaeg, P. B. (2020) 'Facebook live: A mixed-methods approach to explore individual live streaming practices and motivations on Facebook', *Interacting with Computers*, 31(6), 589–602. Available at: https://doi.org/10.1093/iwc/iwz038

The Metropolitan Opera (2022) *The Met: Live in HD*. Available at: https://www.metopera.org/season/in-cinemas/ (Accessed: 27th June 2022).

van Tonder, C. (2020) *Acoustic Atlas*. Available at: https://www.acousticatlas.de/experience (Accessed: 27th June 2022).

Vandenberg, F., Berghman, M., & Schaap, J. (2021) 'The "lonely raver": Music livestreams during COVID-19 as a hotline to collective consciousness?', *European Societies*, 23(S1), pp.S141–S152. Available at: https://doi.org/10.1080/14616696.2020.1818271

Volpe, G. et al. (2016) 'Measuring social interaction in music ensembles', *Philosophical Transactions of the Royal Society B: Biological Sciences*, 371(1693), https://doi.org/10.1098/rstb.2015.0377.

Warf, B. (2011) 'Geographies of global Internet censorship', *GeoJournal*, 76(1), pp.1–23. Available at: https://doi.org/10.1007/s10708-010-9393-3

Wilson, R. (2020) 'Aesthetic and technical strategies for networked music performance', *AI & Society*, pp.1–14.

Wilson, R., & Mcmillan, A. (2019) 'Being together – or, being less un-together – with networked music', *Journal of Network Music and Arts*, 1(1), 1–13. Available at: https://commons.library.stonybrook.edu/jonma/

Glossary

Analogue to digital converter (ADC) – an electronic system that converts an analogue signal (e.g., a sound picked up by a microphone) into a digital signal, represented by binary digits.
Asynchronous NMP – where musicians are not playing simultaneously to create a coherent ensemble sound. Instead, musicians record separately and bring the recordings together later.
Audio interface – a physical device that sits between microphones and a computer to allow signals to arrive at a digital audio workstation (DAW) in the correct format.
Codec – a device or computer programme that encodes and/or decodes a data stream or signal.
Data compression – the process of reducing the amount of data needed to store or transmit a given piece of information or file.
Digital to analogue converter (DAC) – an electronic system that converts a digital signal (represented by binary digits) into an analogue signal.
Digital audio workstation (DAW) – a device or software used for recording, editing, and mixing audio files.
Dynamic range compression – an audio signal processing operation that reduces the volume of loud sounds or amplifies quiet sounds to reduce the signal's dynamic range.
Internet protocol (IP) – a set of rules governing the format of data sent over the internet or other network.
Latency – the time delay between a data being sent by one user and received by another.
Networked music performance (NMP) – the practice of musical interaction over computer networks.
Ontological approach – embracing the features of technology and use these in a creative way, for example, by using latency as a musical feature of the work.
Protocol – a set of rules or procedures governing the exchange or transmission of data between devices.

Pulse code modulation (PCM) – a method used to digitally represent sampled analogue audio signals. It is the standard form of uncompressed digital audio used in computers.

Server – a piece of computer hardware or software that provides functionality for other programmes or devices called clients.

Synchronous NMP – where musicians are playing together in real time to create a coherent ensemble sound and communicate musically.

Teleological approach – attempting to use technology to reach a predetermined goal, for example, by reducing latency and attempting to work as if in a face-to-face environment.

Transducer – an electronic device that converts energy from one form to another (e.g., a microphone, which converts acoustical energy into electrical energy).

Universal serial bus (USB) – an external serial bus standard that establishes specifications for cables, connectors, and protocols for connection, communication, and power supply between computers and peripherals.

Virtual learning environment (VLE) – a web-based platform used in education to give access to educational content online, including resources, activities, interactions, and assessments.

Index

Note: *Italic* page numbers refer to figures.

accessibility: of music-making 200–1; of software and systems 34–6, 55–8, 222–4; in teaching and learning 154, 178, 191
acoustics 106, 120, 212
adaptive bit rate streaming 37–8, 43
ADSL 37, 40–1, 48
algorave 72, 192, 201
analogue to digital conversion 34–5
artificial intelligence 207
assessment *see* teaching
asynchronous NMP: challenges of 125–6; definition of 99; methods for 99–104
audience interaction 77, 210–12
audiences 72–3, 76–7, 122–3, 209–12
audio artefacts 27, 37, 66, 161, 215
audio interface 32–3
authorship 214
automatic gain control 65–6

bandwidth 37, 42–3, 56, 67
barriers to NMP 215–22
benefits of NMP 199–204
blended learning 14, 183, 190–3
blending 66–7, 76, 125, 128
buffering 45–6

Cage, J. 6, 79, 83
case studies: Applied Music courses 190–2; Brandywine Baroque 142–6; F. Not F. 89–92; Fischy Music 193–5; Funky Transport 141–2; HEYA 92–5; LoLa 51–3; Lyndhurst Singers 138–41; Mosaic: Aria, Footsteps and Bells 87–9; music technology in Maplewood public schools 192–3; Rock DI and Stride collaboration 222–4
chance 6–7, 10, 82
choirs 100–1, 107, 119, 131–2, 138–41
click track 106–7
codec 37–8
coherent performances 75–6, 127–9
collaboration 15–6, 102–3, 130–1, 178–9, 201–2
collaborative recording 102–3
co-located NMP 2–3, 11–12
communication 83–6, 129–31
communities: in education 183–4; musical 201–3
community music 148–9, 184–8
composers in NMP: Aitchison, J. 12; Chafe, C. 18–19, 60; King, R. 11; Longworth, P. 20, 87–90; Mills, R. 11; Pickard, J. 12; Reuben, F. 12; Sellner, J. 92–5; Whitacre, E. 12, 100–1, 202; Wilson, R. 89–92, 213–14
composing 80–3
compression: data 37–8, 180; dynamic range 28, 118
conductor 59, 87–90, 107
CPD 169–70
creativity 132–4, 212–15
cues 67–9, 75, 81, 89

delay *see* latency
digital audio workstation (DAW) 33, 114
digital to analogue conversion 46

232 Index

direct injection 32
Disklavier 57, 161
distance learning 13–14
dynamics 75–6, 108, 118, 127

echo cancellation and suppression 65–6
education *see* learning; teaching
ensemble cohesion *see* coherent performances
environmental impact of NMP 208–9
equalisation 117
Ethernet 28, 40, 50, 218
experimental music 6, 13–15, 92–5
expression 79–80

fault-finding 50–1
file formats 109–10
file management 110–12
file sharing 102–4, 131, 141–2
firewall 44–5, 52
flipped classroom 176–7, 181

genre 17, 77–8, *82*, 149–50, 172–4, 200, 221
guide tracks 106–8

hardware 27–9
headphones *see* monitoring
history of NMP 6–10

improvisation 80–3, 125, 213, 221
inclusion 88, 134, 184–5, 200
interleaving 38, 68, 75
internet: connections to 40–1; history of 26–7
internet acoustic 67
Internet Protocol (IP) 38–9
internet service provider (ISP) 41
IP addresses 43–44
ISDN 9, 124
isolation: of people 199–201; of sounds 31–2

JackTrip *see* software for NMP
jitter 45–6, 61–3, 68, 80

laptop orchestras 9
latency: acceptable amounts 60; dealing with 61–3; impacts of 63–4; in music 59; origins of 47–9; in teaching 160–1
League of Automatic Music Composers 7–8
learning: collaborative 178–9; independence 180–2
learning management system (LMS) *see* virtual learning environment (VLE)
listening 73–5
live coding *see* algorave
LoLa *see* software for NMP
loudspeakers *see* monitoring

metronome 57, 82, 105, 139; *see also* click track
microphones 29–32
mixing 113–21
mobile devices 36, 108–10, 154, 217–19
monitoring 46–7, 66–7, 73–6
multichannel formats 49
music lessons *see* teaching

noise suppression 28, 35, 66
notation 69–71, 81–2, 150

Online Orchestra 81
ontology 17, 61, 132, 154, 160–1

packetization 39–40
packet loss 40, 45, 160–1
panning 118–19
pedagogy 154–5, 162–5, 179–80
performance conventions 17, 77, 84, 212
phantom power 33, 50
port forwarding 44–5
practical considerations 86, 135–7, 175–6

quality of service 43

recording techniques 31–2
relationships in NMP 204–8
remote recording 104, 123–5, 142–6
research 8, 14–15, 60–1, 188
reverberation 10, 32, 119–21, 212
rhythm 60, 78–83, 221
router 40–5

safeguarding 188–9
sample rates 34–5, 109–10
scoring 81–2, 89
server configurations 41–2
social interaction 187, 204–6
software for NMP: Audiomovers Listento 143–5; Dropbox 139–45, 223; JackTrip 58, 160, 218; liveSHOUT 93; LoLa 5, 51–3, 57–8, 153; NINJAM 36, 58, 62; Source Connect 36; Zoom 87–9, 93–4, 223–4
sound art 92–5
spatial audio 118–19, 138–41
streaming 209–12
synchronisation: in asynchronous NMP 112–13; in synchronous NMP 61–3, 75–6
synchronous NMP: challenges of 59–61, 66–7, 217–19; definition of 55
systems for NMP 56–8; see also software for NMP

teaching: assessment 170–4, 182; constructivism 155, 170; general music education 176–82; instructional videos 158–9; instrumental tuition 155–76; methods 151–4; student–centred 155, 166, 170, 174–5
telematic music 2
teleology 16–17, 61, 132, 154, 160
The Hub 7–9, 81
tuning 75–6, 105–6, 126

video: cameras 33–4; in asynchronous NMP 121–2; in synchronous NMP 67–73; in teaching 158–60
video conferencing: equipment needed 27–34; for synchronous NMP 35–6, 58, 64–6, 70–3; teaching via 157, 159–67, 179–80
virtual ensemble 22, 99–101
virtual learning environment 152, 177, 182, 192–3
virtual reality 49, 73

Wi-Fi 28, 40, 51

YouTube 101, 121, 138–41, 158

For Product Safety Concerns and Information please contact our
EU representative GPSR@taylorandfrancis.com Taylor & Francis
Verlag GmbH, Kaufingerstraße 24, 80331 München, Germany